Sarah Knights' first book, a biography of the novelist David Garnett, was shortlisted for the James Tait Black Prize and the *Slightly Foxed* Best First Biography Prize. She lives in North Norfolk.

T0271794

THOROUGHLY MODERN

The Pioneering Life of
Barbara Ker-Seymer,
Photographer,
and her Brilliant,
Bohemian Friends

SARAH KNIGHTS

virago

VIRAGO

First published in Great Britain in 2023 by Virago
This paperback edition published in 2024 by Virago

1 3 5 7 9 10 8 6 4 2

A CIP catalogue record for this book
is available from the British Library.

ISBN 978-0-349-01149-3

Typeset in Dante by M Rules
Printed and bound in Great Britain by
Clays Ltd, Elcograf S.p.A.

Papers used by Virago are from well-managed forests
and other responsible sources.

Virago
An imprint of
Little, Brown Book Group
Carmelite House
50 Victoria Embankment
London EC4Y 0DZ

An Hachette UK Company
www.hachette.co.uk

www.virago.co.uk

In Memoriam
Richard Denyer
1950–2015

Contents

Picture List

Dramatis Personae

Ashton, Frederick: influential ballet dancer, choreographer and founding Choreographer of the Royal Ballet; developed a distinctive 'English' style bringing British ballet to the fore.

Banting, John: surrealist artist, and designer.

Burra, Edward: painter, draughtsman, designer and printmaker; favoured subjects depicting low-life; travelled widely despite poor health.

Chappell, William 'Billy': ballet dancer, designer and director, primarily for Frederick Ashton and Ninette de Valois. After World War Two he directed for ballet and theatre.

Cook, Beryl: artist who came to prominence in the 1970s, known for her affectionate and humorous paintings of people.

Cunard, Nancy: poet, publisher and civil rights activist; also known for her dramatic sense of style.

Daniels, Jimmie: Harlem Renaissance cabaret singer and nightclub host; worked in London in the 1930s.

Dawson, Beatrice 'Bumble': a talented artist, Bumble went on to become an Academy Award and BAFTA nominee for her work as a costume designer, dressing such iconic figures as Marilyn Monroe and Ava Gardner.

Dove, Geoffrey: former athlete with a degree in Geology, Dove retrained, becoming a popular London GP. He pioneered the early use of computers in General Practice.

Garnett, David 'Bunny': award-winning writer, editor and publisher, Garnett was a prominent member of the Bloomsbury Group and a self-declared 'libertine'.

Hahn, Emily 'Mickey': American journalist and writer, she wrote for the *New Yorker* for more than sixty years and was the author of fifty-four books. Widely travelled, she crossed Central Africa alone in the 1930s.

Harmsworth, Madeleine: journalist and friend of Barbara Ker-Seymer and Barbara Roett.

Highsmith, Patricia: American novelist and short-story writer renowned for her psychological thrillers.

Lambert, Constant: composer and conductor, musical director of the Vic-Wells ballet (later the Royal Ballet), where he worked closely with Frederick Ashton.

Lehmann, Rosamond: acclaimed novelist and translator.

Lye, Len: New Zealand artist, film-maker, animator and sculptor. Lye moved to London in 1926 where he began making experimental films, leading to work for the GPO Film Unit. After moving to the US he worked primarily as a kinetic sculptor.

Mann, Marty: American writer and journalist who later founded the National Committee for Education on Alcoholism in the USA.

Morrison, Allan: American journalist, jazz and classical music authority, and civil rights activist; editor of *Ebony*, the African American cultural magazine.

Nash, Paul: surrealist painter, war artist and critic. He taught briefly at the RCA and championed fledgling artists (across the arts) including Burra, Chappell and Ker-Seymer.

Partridge, Ralph: Bloomsbury Group member, known primarily for his relationships with Dora Carrington and Lytton Strachey, and for being the husband of the diarist, Frances Partridge.

Pease, Humphrey: artist, Mass Observer and pacifist, Pease was a keen lepidopterist and ornithologist.

Philipps, Wogan: communist and aspiring artist. On inheriting his father's title, becoming 2nd Baron Milford, he was the only member of the Communist Party of Great Britain to sit in the House of Lords; his maiden speech called for the abolition of the House of Lords.

Powell, Anthony: novelist and diarist, best known for his multi-volume tour de force, *A Dance to the Music of Time*.

Pritchard, (later de Nagy, Pertinez), Clover: art school friend of Ker-Seymer, she later moved to Spain where she worked as an editor, writer and translator.

Rees, Goronwy: Welsh writer, journalist, academic and putative spy.

Rhodes, John: Cambridge-educated, served in the Intelligence Corps in World War Two, later becoming a successful businessman based in the US.

Roett, Barbara: sculptor and carpenter; born in New York, raised by her mother in Guyana, before coming to the UK where she studied at the Royal College of Art.

Saddler, Donald: award-winning American dancer, choreographer and theatre director, worked on Broadway, in the West End of London and for the cinema.

Spencer, Peter, 2nd Viscount Churchill: actor, playwright and journalist; a socialist, he established the Spanish Medical Aid Committee which sent medical supplies to Spain during the Civil War.

Spender, Humphrey: photographer, photojournalist and artist; 'Lensman' for the *Daily Mirror* and a Mass Observation photographer; later worked for *Picture Post* and taught textile design at the Royal College of Art.

Strachey, Julia: writer and niece of Bloomsbury's Lytton Strachey; was briefly Ker-Seymer's studio assistant.

Tomlin, Stephen 'Tommy': British sculptor known for his 'heads' of Bloomsbury luminaries.

Wilde, Dorothy 'Dolly': socialite and witty conversationalist, niece of Oscar Wilde, whom she closely resembled.

Wyndham, Olivia: society photographer and 'Bright Young Thing'; hailed from a wealthy and privileged background; employed Ker-Seymer as her assistant before moving to New York.

I thank everyone who has ever saved a scrap of handwriting, an old love letter, or a fragment of photograph from the half-forgotten life of an unusual woman in the hope that it might be important; in the hope that she might be important.

<div align="right">JOAN SCHENKAR, Truly Wilde</div>

The photograph implies the photographer.

<div align="right">LAURA CUMMING, On Chapel Sands</div>

It is – or was – the photographer's ideal: to be highly regarded – literally, much looked at – yet almost anonymous.

<div align="right">GEOFF DYER, See/Saw</div>

Of course, you know people are going to write about you when you are no longer there to defend yourself.

<div align="right">BARBARA KER-SEYMER</div>

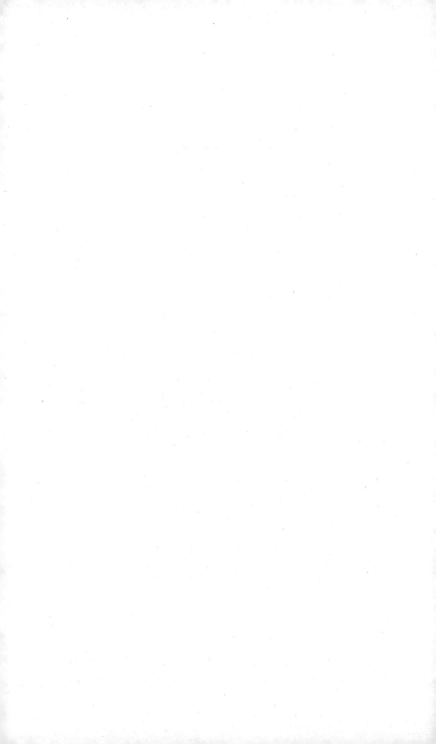

Prologue

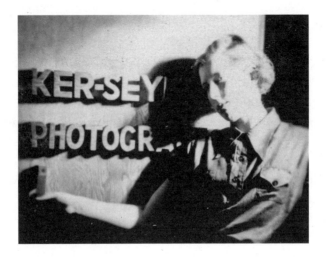

From the vantage point of 1935, Paul Nash, artist and cultural arbiter, remembered when teaching at the Royal College of Art in 1925: 'I was fortunate in being there during an outbreak of talent'. Barbara Ker-Seymer was one of the eight artists he identified who had entered the contemporary vanguard.

I first encountered Ker-Seymer in the arms of the Bloomsbury writer David Garnett, while I was writing his biography. There she felt safe, in the knowledge that he was older, married, with children, and harbouring no expectation that she would wish to marry him. I was intrigued: who was this 1930s Bond Street photographer, who rose rapidly to the peak of her profession,

evidently enjoyed sex, but had no desire for a traditional family life? How and why did she become a groundbreaking photographer at a time when the profession was dominated by men? Why did she eschew married life for independence, and at what, if any, personal cost?

Initially, Ker-Seymer proved enigmatic and difficult to pin down, apparently fun-loving and superficial, seemingly lacking self-knowledge or the capacity to engage with her emotions, and intent on a pursuit of hedonism. She and her friends exchanged witty and outrageous letters, detailing capers and high jinks, but nothing of any depth seemed to rise to the surface. She was neither a reflective nor a confessional correspondent. Or so it seemed. However, within what became the familiar tenor of her correspondence, I gradually grew aware of occasional, usually self-deprecating shifts in tone, and learnt that she communicated her emotional condition or the low points of her life in understatements, often concealed in jokes at her own expense. Apparently superficial, Ker-Seymer was of course as complex as are we all, I found, once I could penetrate the language, hear the tone and detect the murmur of her inner voice.

In 1920s and '30s England, a young woman from Ker-Seymer's upper-class background might have been expected to leave home – not to work but to marry, specifically to make a 'good' marriage to a man of the same class. According to the historian Virginia Nicholson, 'the generally held view was that a [middle- or upper-class] woman earning her living was doing so as a temporary shift while waiting for a husband to turn up'.[1] But Barbara absented herself the moment she found employment and economic freedom as a photographer's assistant, and she did so because she sought financial and personal independence. She attended three art schools, not as a bridge between school and marriage, but because she wanted as broad

an art education as possible to equip her for a future career. She disdained her mother's life which she perceived as unfulfilled: devoted to raising children, to tedious social rounds and captive boredom; a life proscribed by the mores, framing narratives and expectations of a particular stratum of society which, as Barbara came to believe, drove her mother into the stultifying clutches of Christian Science.

Ker-Seymer's life spanned most of the twentieth century and reveals much about the changing times in which she lived; however, in many respects she behaved contrary to the prevailing norms of her class and gender, simply because she was determined to live life as she chose and, unusually for a woman of her class, to work for a living to make this possible. In the 1930s, when one-third of women worked outside the home, their roles were confined largely to low-paid jobs in domestic service, in shops, offices and, as the decade progressed, in the regimented cohorts of factory workers. Those women who aspired to teach, nurse or work in the civil service were faced with a 'marriage bar', forcing them into a stark choice: to remain unmarried, and therefore in post, or to marry and resign. Thus the married, professional working woman was a rarity. Even though in 1928 all women received the vote at twenty-one, the 'Great Depression' pushed many back into unpaid work in the family home.

Ker-Seymer opted for a profession in which she was self-employed, thereby setting and in control of her own rate of pay. From that moment, she could neither be expected to be subject to family pressure to marry, nor, if she chose to marry, would she be subject to the 'marriage bar'. As a photographer and benefiting from a high level of education, Barbara was a formidable artist, but she also understood that if her practice was to prosper, it must be built upon sound business foundations. From childhood she understood the first elements of bookkeeping,

habitually maintaining meticulous ledgers in her diaries. She received no formal training but applied herself to understanding financial management, cash-flow and marketing, attracting an impressive studio clientele and commissions from the most prestigious fashion and society magazines. At a time when unmarried women were seen as second-class citizens and portrayed, in popular women's magazines, as sad 'spinsters', or, worse, as promiscuous man-eaters, and employed women were believed to be snatching bread from the hands of men, Ker-Seymer could not have cared less.

In her personal life Ker-Seymer was equally uninhibited by expectations of class or gender. She was not a blue-stocking and although as a left-leaning liberal she voted for the Labour Party for most of her adult life, she was not party political. Yet her lifestyle and beliefs were gently political and, in some respects, radical, in the way she lived life as a bisexual woman with lovers white and black, and in her hatred of racism, misogyny and homophobia in an era when the prejudices of Empire prevailed across European societies, when many of her youthful male acquaintances embarked on careers in the 'colonies', and at the height of the American Jim Crow laws.

Having turned her back upon her family, Barbara surrounded herself with a close-knit group of friends. These became a lifelong surrogate family, far more beloved and important than any blood relatives. At its core were three gay men: the artist Edward Burra, the ballet dancer and designer William Chappell, and the choreographer Frederick Ashton. Burra, whose spelling remained determinedly phonetic, liked to describe them as her 'little familly'.[2]

If I was drawn to Barbara Ker-Seymer through her association with David Garnett, my interest was further piqued by her photographs, which reveal her as one of a handful of outstanding British photographers of her generation. As well as being

championed by Paul Nash, among her peers she was admired
by Man Ray and Jean Cocteau. Ker-Seymer's work recorded and
even defined a talented, forward-looking generation of artists,
ballet dancers, writers, actors, musicians and intellectuals, who
flocked to her studio during the 1930s. Her photographs graced
the pages of newspapers and magazines in Britain and the
United States and were widely admired by editors and readers.
She disdained lucrative 'society' portraits in favour of modern,
sometimes abstract or surreal images; her portraiture broke
with convention. She was exceptionally skilful in manipulat-
ing light, bringing a sculptural quality to her subjects. While
her images as a gossip-column photojournalist for *Harper's
Bazaar* were the go-to representations of the aristocracy and
the party-going Bright Young Things at play, she stretched the
boundaries of photojournalism and artfully subordinated her
subjects through an extreme interplay with light and dark. She
wanted her photographs to speak for themselves. 'I just called
myself Ker-Seymer Photographs,' she said. 'I didn't think it was
necessary to have your sex displayed on the photographs.'

This biography of innovation, creativity and enduring
friendship locates Barbara Ker-Seymer at the centre of a close-
knit circle of talented artists at the forefront of their respective
careers. When Nash identified Ker-Seymer as one of the artists
representing 'an outbreak of talent', she was in good company,
for Burra and Chappell were fellow travellers. Nash was writ-
ing about a moment, three years after the 'birth' of modernism,
epitomised by the publication of T. S. Eliot's *The Waste Land*,
James Joyce's *Ulysses* and Virginia Woolf's *Jacob's Room* in 1922.
Though Barbara and her circle were not modernists or part of a
movement, they were thoroughly modern in embracing popu-
lar culture and raising it to a new level. Their art was informed
by cinema, revues and cabarets; theatre and ballet; film, dance
and music magazines; jazz and blues; fashion and couture.

Ker-Seymer has appeared variously as a friend, lover, background figure, and an important source in other biographies, most notably those of Frederick Ashton and Edward Burra, but she has never been centre stage or even shared the billing. In exploring her life and work for the first time, the biographical dynamic shifts from a focus on the gifted men in her circle, to a portrait of her role as a pioneering photographer and as a woman who lived resolutely on her own terms.

CHAPTER ONE

Foundations

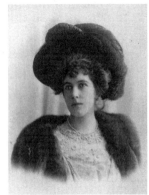

B illy spotted her scuttling along a passage at the top of Manresa Road on her way to the Chelsea College of Art. He couldn't help staring, transfixed by her clothes. Women art students in the 1920s generally fell into two dress camps: the free-flowing 'gypsy' type or the tube-style flapper dress. This young woman was an anachronism, clothed in the garb of an Edwardian matron.

In 1922 Barbara Ker-Seymer was a seventeen-year-old student at the Chelsea Polytechnic (or Chelsea College of Art, as it was also known). She had been destined to study art: as a

child she would rise at five o'clock in the morning to draw and paint before school. She was fascinated, if not a little alarmed, by the formidable and formal Holbein, Van Dyck and Kneller ancestral portraits gazing down from the walls of her maternal grandmother's Mayfair home. Barbara was regularly taken by her mother to the National Gallery, the Victoria and Albert Museum and the Tate Gallery, where, at a tender age, she fell in love with the Pre-Raphaelite artist Henry Wallis's *The Death of Chatterton*. She filled childhood sketchbooks with Mabel Lucie Attwell characters, progressing to crinolined maidens and Kate Greenaway figures. At Chelsea Poly, where neither painting nor sculpture was taught, she hoped to benefit from the vocational nature of the curriculum in which students were prepared for work involving art, rather than turning them into artists. For Diana Ker-Seymer had advised her daughter, from bitter experience, to earn her own living, and never depend on a man.[1]

Barbara was pretty, spirited, exuberantly self-confident and although privately very serious about art, out to have fun. When Billy spotted her, of course he could have no conception that she would be one of his closest lifelong friends. At fifteen, William Chappell had a pensive, diffident temperament, was very amusing, lazily impudent and – with his natural grace, heavily lidded turquoise eyes, arched eyebrows and pouting, sensuous lips – extremely beautiful. He and Barbara began to chat between classes and quickly recognising a kindred spirit, Billy introduced her to another student, his close friend Edward Burra. Burra was physically frail, small and pale, appearing younger than his seventeen years, but making up for this with the extraordinary self-possession of someone who, for most of his childhood, had been allowed to do what he wanted. What he wanted to do was paint. According to Billy, 'with no doubts, no considerations, no questions' the trio 'happily discovered

exactly kindred tastes and fell immediately into unusual communion.'[2]

'Each buttressing the others' egos', as Billy described them, they were 'quite formidably self-sufficient, and almost unsupportable: noisy, over-pleased with themselves, determined, above all, to shock. Their antics were regarded by most of the female art students with amused tolerance. Not so by the men [. . .] who were overtly suspicious and hostile: an attitude returned a hundredfold by its recipients.'[3] They were inseparable. 'We spoke the same language,' said Barbara, 'we liked the same artists, we liked the same books. We were cinema-mad and great ballet fans [. . .]. We were what you might call birds of a feather, and yet we all came from different nests.'[4]

When Billy spotted Bar (as she was known) she was garbed as an Edwardian matron because she was wearing her mother's hand-me-down clothes: her family had fallen on hard times. As a young child, Bar had been raised in a grand stuccoed house in Ovington Square, Knightsbridge, around the corner from Harrods and the Brompton Oratory. It formed part of an integrated architectural scheme constructed in the mid-nineteenth century and set around a private railed garden. The address was upmarket; the house clearly the residence of a gentleman. There Bar lived with her father, Horace Vere Ker-Seymer (known as Vere), her mother, Diana, and her sister, Manon, who was exactly two years older for they shared the same birthday. The running of the establishment, overseen by Diana, was undertaken by servants.

'The women in our family are the dominating ones', claimed Bar proudly.[5] Although there was no financial necessity for them to earn a living, both grandmothers wrote and published books. Born in 1842, her paternal grandmother, Gertrude Ker-Seymer, wrote racing novels, was a friend of Edward VII and the dedicatee of Arthur Sullivan's tune for the hymn 'Onward

Christian Soldiers', known also as 'St Gertrude'. From early childhood, Bar's maternal grandmother, Caroline Creyke, was passionate about shooting and fishing, sports in which she was encouraged by her father, Sir John Lawes, a pioneer of agricultural science who developed superphosphates at his experimental farm, Rothamsted Manor, near St Albans. Thus she was independently wealthy, and far from being a respectable Victorian matriarch she published, aged forty-six and under the name Diane Chasseresse, *Sporting Sketches*, which shocked reviewers who considered it unladylike to stalk over hills carrying a rifle, accompanied by a brace of dogs. She also wrote regular society columns, under a variety of pseudonyms, and was a published poet. Caroline married Walter Pennington Creyke, a wealthy and well-connected cleric who, having followed his father into the Church, retired aged thirty-six, suffering from a 'weak constitution'. With enormous eyes and flowing, curly locks, he was renowned as one of the most handsome men in England and was painted by the artist Frederic Leighton and the Pre-Raphaelites. Although he fathered five children, he was almost certainly homosexual, enjoying a devoted friendship with the Earl of Carlisle which lasted until death. Caroline filled any void her absent husband may have left by entertaining her circle of bohemian friends, which included the actresses Sarah Bernhardt and Mrs Patrick Campbell, the writers George and Weedon Grossmith and the artist and cartoonist George du Maurier.

Bar's father, Vere, was born in Paris in 1866, where his father Henry Ernest Clay-Ker-Seymer was the First Secretary of the British Embassy. The name Ker-Seymer, however, followed the matrilineal line, Henry Ernest Clay having acquired it from his wife, Gertrude, in compliance with her father's will when she inherited the family's Jacobean mansion, Hanford House in Dorset. There being no male heir, Henry's surname 'Clay' was

merged with his wife's name 'Ker-Seymer' by Royal Licence, thus becoming Clay-Ker-Seymer. According to Barbara, her father eventually dropped the 'Clay', considering two hyphens to be 'too much of a good thing.'[6]

The Seymer connection with Dorset stretched back to the late fifteenth century, and the family had occupied Hanford Hall for over three hundred years, although they were extensive landowners beyond Dorset. However, by the time that Bar's grandmother, Gertrude, acquired Hanford, the estate consisted only of the Hall and its farm. When she died, the Hall passed to her elder son, Vere's brother, Evelyn, but at Evelyn's death in 1918 Vere was bypassed in favour of a cousin, Vivian Thomson, who was presumably considered a safer pair of hands. He inherited Hanford on the condition that he adopted the surname Seymer.

Having expected to follow Henry Ernest into a diplomatic career, Vere's plans were thwarted when his father informed him that 'a severe financial crisis had fallen upon the family.'[7] Excessive hospitality and a string of bad bets at Newmarket were held responsible, disbarring Vere from the private income then required to enter the Foreign Office. For Henry Ernest was a spendthrift and gambler. With difficulty, he cobbled together enough money to send Vere to Argentina (at that time heavily influenced by British commercial and financial interests), where he was expected to seek his fortune, carrying with him the equivalent of £4,000 to establish himself. Having inherited his father's gambling traits, Vere squandered every penny at poker before the ship reached Lisbon. After three years working for railway companies in Buenos Aires, Vere returned to London, where he lived a down-at-heel existence in Bloomsbury, residing with a twenty-year-old actress, who in the 1901 Census is recorded as his 'wife': Mabel 'D K Seymer'. This liaison was short-lived, however, as the following year he

acquired a lawful wife in the shape of Diana Creyke. It would not be unduly cynical to note that at the age of twenty-nine and relatively 'late' to marriage, having a considerable fortune she would have been an attractive prospect to Vere.

Thereafter Vere dedicated his life to squandering his wife's riches on expensive pastimes: aviation, hot-air ballooning, motoring and gambling. He liked to loiter in aeroplane hangars with his aviator friends and was one among the small crowd assembled to witness Blériot land on the cliffs at Dover at the end of his historic cross-Channel flight. Vere enjoyed motor racing from town to town with his pal Lord Carnarvon (a sport banished in 1903 because of the collateral damage to onlookers) and was frequently summonsed and fined for speeding. He would take a hot-air balloon up for a picnic lunch, with his friend Charlie Rolls of Rolls-Royce fame, soaring above the London fog and landing in time for afternoon tea. Vere was accepted by his wealthy chums as a chap who enjoyed a bet and a good time and was entertaining to be around.

When Barbara was born in 1905, Vere described himself on her birth certificate as of 'independent means', but this independence stemmed entirely from Diana's money. Although the Married Women's Property Act of 1882 stipulated that married women could have exclusive control of their own finances and property, this did not necessarily occur in practice, and it was common for men to be in command of their wives' financial assets.

Whereas Bar's mother was markedly pretty, her father took after the Clays, who Bar described as 'a very plain lot'.[8] In his novel *Afternoon Men*, her childhood friend Anthony Powell modelled the character of Mr Nunnery upon Vere. Nunnery first appears as a moustachioed drunk in a dinner jacket, and in a subsequent passage his fictional daughter, Susan, says of her father in conversation:

'He's a curious little man with a walrus moustache.'

'What does he do?'

'He's a failure.'

'Where does he fail?'

'Oh, he doesn't any longer,' she said. 'He's a retired failure, you see.'[9]

While this may not accurately represent Barbara's feelings for her father, it does reflect the sense of purposelessness of his daily life, revolving around playing tennis, his club, gambling and motor racing. As a young child, Barbara did not question this behaviour, although she remembered: 'He used to get me up at three in the morning to play poker with him in front of the dying embers; and sometimes he'd come home and fill my bedroom with balloons, then rob my money-box to pay the taxi.'[10] Bar's youthful diaries contain impeccable accounts of income and expenditure, recording how much of her accumulated pocket money her father had 'borrowed'.

Bar's parents' marriage was not happy. She distinctly recollected the following parental interchange:

DIANA: 'I've done my painful duty for seven years!'

VERE: 'But if you go off to Italy, what am I to do?'

DIANA: 'Do what other men do. Go to clubs.'[11]

'I expect my mother married him', Barbara reflected, 'because she thought she'd never have a dull moment, but in the end he drove her to Christian Science.'[12] A music-hall song which he liked to sing, 'I'll lend you anything you like except my wife, and I'll make you a present of her', will also have grated.[13] Perhaps Diana turned to Christian Science to 'heal' the emptiness of losing her third child, Pauline, who died in 1907 aged six months, but the religion was particularly close to

home, as Vere's sister Violet Ker-Seymer was a leading expo-
nent, a member of the Board of Lectureship of the First Church
of Christ, based in Boston, USA, who travelled widely in Europe
and America proselytising on the subject. For Bar, apart from
her mother's absences travelling with Violet, the main disad-
vantage of Diana's religious beliefs was the Christine Science
doctrine not to countenance any form of medical intervention.
As Aunt Violet put it: 'Christian Science deals directly with the
fear and the mental discord expressed on the body as sickness,
and as harmony is restored in the mind of the patient, the sick-
ness which was only a physical effect or shadow of a so-called
mental cause, disappears.'[14] Thus throughout her childhood,
Bar suffered long bouts of tonsillitis, and recurrent untreated
ear abscesses, which were left to burst of their own accord,
necessitating days if not weeks of missed schooling.

But Bar had a happy childhood, shopping at Harrods with
her mother and enjoying annual summer holidays in Devon,
where her extended family of uncles, cousins and soft, smiling
aunts occupied all the cottages on the steeply wooded cliff-side
of Babbacombe Hill. These picturesque nineteenth-century
cottages, 'The Glen', 'The Grove', 'Ivy Cottage' and 'Rose
Cottage', overlooked the sweeping expanse of Babbacombe
Bay whence it was just a short walk to Oddicombe Beach, with
its women's bathing huts, where it was safe to swim. These
were idyllic days. Photographs of Barbara and Manon reveal
happy children: tots garbed in baggy knickerbockers, or aged
about seven and nine, in the sea, decked in the full panoply
of Edwardian bathing dress. As Bar, Manon and their cousins
grew older they were left to their own devices, bathing in the
sea, attending the annual funfair in Torquay and spending
their pocket money in the town's sweet shops. They visited the
cinema and played the latest rag-time tunes on the piano. The
whole affair was very relaxed: the adults enjoyed cocktails, a

new fad which Uncle Cecil Ker-Seymer had brought back from America. These leisurely gatherings were underpinned by the labour of servants, brought down from the families' town houses to work for them in Devon.

Bar and Manon were not close. They neither looked alike nor, with the exception of swimming and tennis, did they care for the same activities. As a child Barbara, who resembled their mother, was pretty, with wavy hair, a neat, straight nose and blue eyes. Manon, who resembled Vere, was taller and of a larger build, with strong features. Instead of playing with her sister, Bar enjoyed the company of her immediate contemporaries, among them the future novelist Anthony Powell (whose own mother was fascinated by Christian Science), and Brian Howard, later an archetypical Bright Young Thing. Through Grandmamma Caroline on their mother's side, and Aunt Winifred on their father's, Bar and Manon were well acquainted with Vyvyan Holland, the son of Oscar Wilde. He liked to tease them, and on one occasion when they visited him at Aunt Winifred's, they found, to their horror, that their delightful undergraduate friend had turned into a wizened old man. They were made to take out the 'magic teapot', incanting 'Abracadabra' to return Holland to his younger self. This they solemnly did in an upstairs bedroom, until Winifred announced the magic had worked, and they 'flew downstairs and there was our dear Vyvyan sitting in the chair just as we always knew him'.[15]

This carefree life came to an abrupt end in 1912 when Barbara was seven. On the ill-omened Friday 13 December Vere was declared bankrupt with debts amounting, in today's currency, to over £1 million. According to Barbara, he lost £1,500 in a single hand of poker, Diana informing her glumly: 'That was our house in Ovington Square'.[16] Diana and her daughters took up temporary residence with Grandmamma

Caroline at Seymour Place. Diana had to contend not only with the loss of her home, but also with the dramatic change of life-style which ensued. With her relatively elevated social position dramatically reduced, she was confronted by the stigma attaching to bankruptcy.

Bar was an exuberant child, eagerly demonstrative and tactile. All this had to be reined in. 'Loving, affectionate, warm hearted person that she was', Bar said of her grandmother, 'she disliked physical demonstrations. I do not ever remember her putting her arms around me, giving me a hug and a kiss other than the duty peck on the cheek on arriving and leaving. I was a very affectionate child; but I would never have dared take her hand, or hang on her arm when going for walks'.[17]

Eventually, and devoid of servants, they moved into a far less well-appointed house in Gledstanes Road, West Kensington, then a drab, down-at-heel neighbourhood. Or at least Diana and her daughters moved in, Vere preferring to reside at the Queen's Club, the famous bastion of lawn tennis, conveniently located across the road. As a young woman, Diana had not enjoyed the ritual of 'coming out' and being presented at court. She did not care for dancing, but painted, sang and was admired for her ability to amuse and her sense of style. The relative lateness of her marriage may have occurred because she preferred women to men and having done her 'painful duty' and lost a fortune in the process, she felt able to discreetly embrace her sexuality, taking up with another respectably married woman, Mrs Haworth Booth. This relationship lasted many years, and sometimes, when the two women holidayed together, Diana's younger daughter would accompany them.

When in January 1916 eleven-year-old Bar began at St Paul's girls' school, at Brook Green in nearby Hammersmith (her maternal grandmother, presumably, paying the fees) she had evidently already received some education because she could

read, write and do arithmetic. Her education seems to have been fairly relaxed: she sometimes failed to turn up to school in favour of accompanying her mother to the shops, which does not seem to have been a matter of concern. Barbara was inclined to argue with her teachers, but was good at games, an excellent swimmer, loved tennis, squash, dancing, playing the piano and craft. Outside school, she played tennis with her father at Queen's and visited the theatre and cinematograph. She was also a voracious reader, a habit which began in childhood, when she recorded every book she had read each year in her diary. Bar became a discriminating reader, as an adult consuming the latest critically acclaimed books from Harrods Lending Library.

Throughout the First World War, Barbara and Manon enjoyed annual summer schools in Ballinger, near Chesham in Buckinghamshire, or at Hindhead, in Surrey. Bar's photographs reveal a happy, carefree existence quite at variance with the strain of war. For Bar the war was at some remove: her father was too old to enlist and she had no brothers to serve. Her friend Anthony Powell remarked: 'I have quite often come across persons of my own age, even a year or two older [. . .] who say that as children they were scarcely aware of World War I taking place; beyond a dim memory of chocolate in short supply.'[18] At Seymour Place, however, Grandmamma Caroline held parties for wounded soldiers, where she would bash away at her piano playing popular songs for them to sing. Bar was roped into helping: 'I remember them well', she said, 'as I had to hand round the teas, and got my bottom well pinched in the process.'[19]

Bar spent her sixth form year at 'Mildura', an extremely liberal Christian Science boarding school in Torquay, where there was no expectation that pupils should attend lessons, although she usually did. She did not go to the Christian

Science testimonial meetings, went only once or twice to church, and for the rest of her life espoused a mild contempt for any form of organised religion. Describing itself as a 'good-class girls' school', Mildura offered a wide range of academic subjects and Barbara studied Arithmetic, Botany, History, French, Art, Geography, Scripture, Poetry, English, Literature and Parliament (the sciences then being considered inappropriate for girls).[20] The teachers appear to have been well-educated and committed to the intellectual and artistic development of the girls, of whom a handful went on to study at Oxford or Cambridge.

Writing to Barbara, Vere expressed his hope that she would always remain involved in 'the hundred-and-one interesting and instructive things available for people even as poor as we are'.[21] He had an informal arrangement to work occasionally in 'business transactions' for a friend, William Montagu, the Duke of Manchester, a notorious spendthrift who spent much of his life evading creditors. But otherwise Vere was not averse to battening on wealthy friends, or his recently acquired 'rich Egyptian friends' from whom he accepted invitations to dinners at top restaurants with tickets to the theatre afterwards.

Mildura offered a great deal of freedom, and Bar, who was sporty, played tennis and dived from a platform and swam in Babbacombe Bay. Rules were so relaxed that the girls were allowed to swim in the sea with local boys. Bar loved the school and found everything 'topping' and 'great fun'. Her school career came to an ignominious end, however, when she was stripped of her short-lived prefectship having been caught in high spirits singing the 'Mee-ow Fox-trot' before breakfast. She was reported to the headmistress, 'who rose to her feet at the end of lunch that day and said "I'm sorry to say Barbara Ker-Seymer is no longer a prefect."' Bar remembered, 'later on in the day when I had my jawing she said no nice man would ever

marry me, and I wept bitterly [...] as I felt I would never get over the disgrace.'[22] Though the school had few rules, the girls were expected to deport themselves modestly, as befitting an institution governed by Christian Science. Jazz music with its 'wild' rhythms and 'sexual' undertones was anathema, particularly on an empty stomach. Having discovered Bar's demotion, Vere wrote consolingly: 'High spirits are no crime, altho' few people are wise enough to know that they are a virtue'.[23]

In the school holidays Diana was often absent, travelling with Aunt Violet, or away in the country with Mrs HB. Vere's appearances at the dining table were so infrequent that Bar took to recording them in her diary. She spent her time with various cousins and family friends dancing to gramophone records, shopping and, best of all, attending the cinema. This same freedom (or benign neglect) spilt over into her college career, where she wasted little time in ditching her Edwardian wardrobe. She bobbed and shingled her hair, raised the hem of her skirt, lowered the waistline of her dress and swapped her heavy foundation garments – corset, chemise and petticoat – for *directoire* knickers and a brassiere. While in the Edwardian era the S-shaped hour-glass figure and mono-bosom were all, Bar's fashionably flat-chested, boyish figure perfectly embodied the flapper look.

Barbara, Ed Burra and Billy Chappell considered themselves defiantly 'modern', disdaining their more conventional middle-class counterparts – the 'drabbiest of drabbies' as Bar called them – whom they sought to shock.[24] They shared a passion for gossip (often at each other's expense) and memorised the more lurid subtitles from silent films, deploying them in conversation among fits of giggles. 'Fate, the ringmaster, had cracked his whip' was a favourite.[25] They frequented the Samovar tea rooms in St Martin's Lane and the Tea Kettle in Rupert Street, where according to Bar they would hang about 'talking

nonsense by the hour [. . .]. What we liked to do was sit in tearooms and gossip about our friends and run them down.'[26] 'We were very juvenile', she concluded, 'we didn't do very serious work and we used to cut classes and go to the cinema half the time and we'd sit for hours in tea shops [. . .] we used to sit in Lyons Corner House [. . .] till about 4 o'clock in the morning, because it's very cheap'.[27] They were terribly pleased with themselves, spilling out of cafés and rollicking along the pavement arm in arm, caring nothing for the startled looks of passers-by.

The trio specialised in innuendo, and like many coteries, their tone or manner was shaped by the most distinct personality among them, in this case that of Ed. For all his physical frailty, his mental capacity was exceptional, as evinced by a quick wit and razor-sharp tongue. His speech was delivered in a 'Mayfair cockney drawl', and, as his biographer Jane Stevenson explains, his 'gift for language was notorious in his circle [. . .]. His own particular argot [. . .] was an inspired mixture of gossip-columnist and the diction of sensational newspapers and trashy novels [. . .]. He also had a music-hall comic's gift for deflation [. . .].'[28] They liked to talk in loud, camp voices, with the objective of being overheard. Their self-consciously public larking about and loud intonations were intended for an audience: they were, in effect, performing.

CHAPTER TWO

Fooling Around

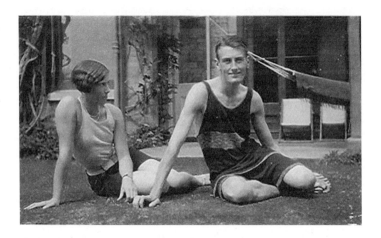

Although Vere and Diana considered themselves poor, it was nothing compared with Billy's childhood. His mother, Edith Blair-Staples, was raised in India, the daughter of a British army officer, but shed her respectable roots, taking to the stage as a repertory actress, a profession considered dubious for women at the time. Abandoned by her second husband, she struggled to raise Billy and his three sisters in a rented house in the then distinctly lower-middle-class south London suburb of Balham, scraping a living writing fashion and society columns

for a down-market weekly magazine. Billy attended Balham Grammar School, where he wasn't particularly happy, leaving at fourteen in 1921 and becoming a student at the Chelsea Polytechnic later that year, his mother having lied about his age. Although beset by financial challenges, Edith was a lovable and loving mother, and Billy relished what he called his 'matriarchal suburban background of grandmother, mother, sisters and aunts'.[1] Ed and Bar became very fond of Billy's family and were always welcome in Balham.

Meanwhile at the other end of the social scale, Edward Burra resided – while studying – with his maternal grandparents at Elvaston Place, South Kensington, but his vacations were spent in the family home, Springfield Lodge in Playden, an agreeable neighbourhood on Rye Hill, overlooking the picturesque town of Rye. The house bustled with servants, and as children, Edward and his younger sisters, Anne and Elizabeth (Betsy), were looked after by a kindly Scottish nanny whom they adored. Although his parents were not demonstrative, they loved their children dearly and provided a solid conventional background and a wealthy, upper-middle-class upbringing. Ed's father, Henry, worked briefly as a barrister, but had enough family money to retire, and to live comfortably, if not extravagantly. The house contained a library bursting with books of cartoons and caricatures, the works of the eighteenth-century satirists Gillray and Rowlandson, and those of Hogarth. It was a civilised life where Henry painted and Ed's mother, Trudy, listened to opera on the gramophone.

John Rothenstein, who taught Burra at the Royal College of Art, described him as 'a silent, pale boy, who put me in mind of a machine which had almost run down, so near did his small reserve of energy seem to exhaustion.'[2] In childhood, his joints began to distort, signs of early-onset rheumatoid arthritis. His biographer, Jane Stevenson, suggests that this, together

with anaemia and an enlarged spleen, probably signified Still's Disease, but if this wasn't enough he suffered from sphero- cytosis (a form of anaemia), which caused him to tire rapidly. Unfortunately, there was little, then, that could be given for pain relief, and he suffered from extreme pain (as well as anaemic crises, jaundice, nausea and physical collapses) all his life. Apart from a brief period, this disbarred him from formal school- ing, partly because he found it hard to stand for any length of time. But it was acknowledged that within his circle of talented friends, Edward was the 'star turn'.[3] Although Bar won third prize in a student poster competition, she and Billy recognised that Ed was the more talented artist. Barbara commented: 'Billy and I were at the stage of doing crinolined medieval ladies and knights jousting and I remember Edward doing a picture of two hideous old crones hitting each other with carpet beaters.' As Billy observed: 'you could tell from the way the masters reacted to his work that he was somebody special'.[4]

They were inseparable, united by a mutual sense of humour and a love of films, fashion, art, theatre, ballet, blues and jazz. They spent hours browsing in record stores, buying imported American jazz records from Keith Prowse in Soho or Levy's in Aldgate, and Bar soon amassed an impressive collection later embellished with records sent over from American friends. Her pride and joy was a wind-up gramophone which they lis- tened to endlessly while perfecting their Charlestons and Black Bottoms. Balletomanes, they queued for hours for tickets to the *Ballets Russes*, and they enjoyed cabarets starring the African American musical duo Layton and Johnstone or the brother- and-sister dancing phenomenon Fred and Adele Astaire. The urbane Jack Buchanan was a favourite (Bar was introduced backstage one evening), as was the jaunty female impersonator Douglas Byng, who became a personal friend, treating Bar to tickets to his shows.

They had an eye for fashion. Shoes came from Peter Yapp and Bar, particularly, liked well-cut, relatively smart clothes and looked good in them. They adored sailor suits, although the boys liked to see sailors in them, whereas Bar enjoyed the liberty of wearing them. Ed favoured expensive, quality clothes, but never looked after them. Billy was well turned out, although he couldn't often afford new clothes, and was always glad of a hand-me-down or gift from Edward. A fan of chic hats, Bar purchased hers from Adèle, a high-end millinery shop in Mayfair. They knew about couture because they read the glossy society and fashion magazines *Vogue* and *Harper's Bazaar*.

Cinema was their absolute passion. They watched films on an almost daily basis, sometimes seeing several in a single day. In the 1920s cinema was part of everyday urban life. It was cheap and as films were shown on a continuous loop one could drop in at any time – after college, after dinner, after work. Shows usually comprised a main feature, a newsreel and a selection of short films, all accompanied by music. This decade saw the rise of the Picture Palace and super-cinemas: luxurious venues which presented cinema as part of a wider experience – with cafés, powder rooms, plush seats, orchestras, exotic decor and uniformed commissionaires.

While cinemas boomed, niche entertainment could be accommodated and thus Bar and Ed were founding members of the Film Society, established in London in 1925, which screened films on otherwise quiet Sunday afternoons. A membership club, it showed the uncensored, un-commercial and 'foreign' films which the trio loved, like *Bed and Sofa* (1927), a silent Soviet film banned in the US and Europe for sexual references, or Henrik Galeen's magnum opus, *The Student of Prague* (1926), a German expressionist film using split-screen technology. Fritz Lang's pioneering science fiction film, *Metropolis* (1927), was a favourite, as was *Faust* (1926), a German film starring Gösta

Ekman and Emil Jannings, actors they particularly favoured. They also loved Conrad Veidt who acted in silent German films before fleeing Germany with his Jewish wife. The society was so successful that the venue changed from the intimate New Gallery cinema to the three-thousand-seater Tivoli.

'We were passionately interested in everything German', said Bar, 'the films and the photobooks [. . .] even though we couldn't read German, this really was no problem.'[5] She owned a copy of *Das Grosse Bilderbuch des Films* (*The Big Picture Book of Films*) which they pored over. But they enjoyed Hollywood movies too, and adored Gloria Swanson, Mae West and Lionel Barrymore, who could play 'a villain of the deepest dye'.[6] (Ed admitted that the only time he experienced an erection, 'a slight one', was during a Mae West film.[7]) They collected post-cards of actors, which Ed glued into an album or stuck on his wall, while Bar made pencil-and-ink copies of film stills in her sketchbook. They read the more high-brow film magazines like *Close Up* (Bar would become a good friend of its editor, Kenneth Macpherson) but they also enjoyed popular magazines including *Picturegoer*, *Photoplay* and *Movie Weekly*. Their letters were full of accounts of the films they saw separately or together, detailing plots and narratives, describing the actors and their costumes, quoting the dialogue and commenting on the relative merits of different films.

Their trio was soon joined by two fellow film enthusiasts and art students: Beatrice Dawson and Clover Pritchard. Clover was an extremely pretty young woman with a peek-a-boo curl on her forehead, who tried to adopt the air of a sophisticated thirty-year-old. Like Bar, she preferred to look chic, in contrast to the majority of female art students garbed as self-conscious bohemians. Raised in India, she was dispatched by her parents to board at the progressive girls' school, Roedean, whence she was expected to enter university. But although Clover was

highly intelligent, she had other intentions and an assertive
personality, insisting on studying art. She and Burra met in the
life class, where her coughing caused him to proclaim: 'She
needs some Veno's Lightening Cure' and they soon became
firm friends.[8] Beatrice Dawson, always known as Bumble (she
had been rather a round child and wore circular framed specta-
cles which made her resemble a bee), was described by Billy as
'a plump, attractive and amiable character, very short-sighted
and given to falling over a good deal'. But, he stressed, 'Bumble
[...] had a strong personality, much more positive than her
nickname implies'.[9] In fact, she had a shrewd head upon her
shoulders, a flair for entrepreneurship as well as an outstanding
ability in design. Bumble would indirectly facilitate important
developments in Barbara's professional as well as personal life.
For now, these young women fitted very neatly into the clique,
and two more lifelong friendships were established.

In 1925, when Ed completed his studies at the RCA, he
returned to Springfield Lodge, although he was always wel-
come in Balham and at Gledstanes Road. It was then that the
exchange of letters really began because Bar missed him, and as
he was unable to physically endure the hectic social round into
which she threw herself, he could at least enjoy the vicarious
entertainment her letters afforded. He was thus the conduit
through which gossip and news were conducted and the vehi-
cle for elaboration as he passed the gossip on. Although Bar's
letters to Ed are better spelt and more grammatically accurate
than his to her, there is unmistakable seepage in tone and Bar's
letters are undeniably camp. While her vocal intonation was
generally crisp and flute-like, Ed's accent was infectious, and
if camp is usually assumed to be a male preserve, it undoubt-
edly affected Bar's speech at this time. They vied with one
another in extremes of lewdness and elevated gossip to an art.
According to Bar: 'We were much less solemn than people now

are, we were very, very frivolous, or apparently very frivolous'.[10] Billy agreed: 'We were all used to hearing people sitting round and discussing art in hushed, earnest tones – it was all a question of higher values. And I think really our attitudes were a reaction'.[11] Ed remarked that whilst he was serious about his work, 'I don't spread seriousness around it's such a bore.'[12] They were in fact behaving like teenagers, although that term had yet to be coined.

At college (or when she should have been at college) Bar roistered around with her best friends, pretending to be a woman of the world while she was quite the opposite. At home she was a girl whose mother gazed anxiously at a daughter who seemed uninterested in the question of marriage and had, puzzlingly, moved on from the Poly to the Royal College of Art. Bar was obviously serious about her education (more so when Ed was out of London), but would that find her a husband? Despite Diana's advice concerning financial independence, she did not want her younger daughter languishing on the shelf. 'Never depend on a man' might have been rephrased as: 'Never put yourself in a position where you must depend on a husband, but make sure you have one.'

Since her late teens, Bar had been encouraged by her mother to meet the right sort of man. But it was her formidable grandmother, Caroline Creyke, who was really behind that impetus. Although unconventional by many standards, she had seen to it that all four of her own daughters married and was so relieved at marrying off the last one (Diana), that in celebration she took herself away on a world cruise. Bar's suitors, therefore, were young men who came from families approved by Grandmamma. But as a result of the Ker-Seymers' reduced social position, these men were not the younger sons of aristocrats, as once might have been expected, but military cadets destined for colonial work in India or Africa. Bar liked these

chaps well enough because they took her dancing or to the cinema, but she sought fun, not a marriage proposal.

Diana's unconventional lifestyle, Vere's fecklessness, Walter Pennington Creyke's homosexuality and the bohemian independence of Bar's grandmothers were all rendered possible by the polished veneer of marriage. Many homosexuals, most famously Oscar Wilde, married and fathered children because it conferred a respectable public image on what would have then been considered a disreputable private life. As Barbara grew up she began to notice that her family behaved differently to others. Later, as a young woman, she pondered the hypocrisy inherent in their Victorian haste to find her a husband despite the fact that she was educated and uninterested in the men her family deemed suitable. She could not see beyond the marriage question, perhaps failing to reflect that her parents could hardly afford to support an unmarried daughter.

Parental anxiety regarding the question of marriage was fuelled by a shortage of men. Consequent to the carnage of the First World War, there were two million more young women than men, and such was public concern that they were known as 'surplus women'. Newspapers abounded with headlines about 'our surplus girls', and any young woman who did not find a husband was perceived as a failure. It was a double-edged sword: for many the process of attracting a man was a competitive nightmare made worse by the potential stigma of spinsterhood. At the same time, 'surplus women' were viewed with suspicion, for surely they would have affairs with married men resulting in a decline in moral standards. The unmarried woman was problematical: either spinster or siren. Work was for women who had failed to find a man.

Bar was sent off with high hopes to Shaftesbury, where she was one of nearly four hundred guests attending the annual ball of the 'South and West Wilts Hunt' at Coombe House.

The male guests were almost all officers in the armed forces, with a smattering of minor aristocrats. Here there were no Charlestons or Black Bottoms, merely a decorous foxtrot. Bar did collect admirers, one of whom was so devoted that upon returning to his barracks at Woolwich, took himself off to Gledstanes Road, where, in a scene straight from *My Fair Lady* he spent an afternoon gazing enraptured at number twenty-six.

Bar also met prospective suitors during the London social season, where dances were held in the ballrooms of private houses. Her contemporary, the writer Derek Patmore described these debutante dances as 'formal, dull affairs in which ill-at-ease young girls were produced by proud mothers in the vain hope that they might attract some eligible young man.'[13] Lists of suitable men would be kept by all the hostesses, so when a man was on one list he could expect to be invited to most seasonal functions. Young women were expected to make polite conversation with the men, but in such a way as not to appear unduly intelligent, in case it put them off. That was not Bar's style: she was too forthright to simper.

Bar loved to dance and was happy to accept invitations to the Empress Rooms in the Royal Palace Hotel, Kensington, where music was provided by the Continental Five. 'It is the discriminating dancer of taste', one contemporary poster asserted, 'who goes to the Empress Rooms, there to learn dancing in such a manner that people turn in ball-rooms to say, "What a beautiful dancer – how neat and sure –". That is the "Empress" way.'[14] The most famous 'Empress' dancing teacher at the time was the future bandleader, Victor Silvester, who coined the phrase 'slow, slow; quick-quick-slow'. With a wide repertoire (the Charleston, Black Bottom, slow waltz, quickstep, tango, jogtrot and foxtrot), Bar was a popular partner and her dance cards were always full. At the magnificent *Palais de Danse* at Hammersmith, renowned as the largest dance hall in Europe,

they joined in the famous group dance, 'The Palais Stroll', dancing until midnight to American-style jazz bands.

Dance clubs flourished, despite prevailing anxieties that they gave rise to louche behaviour and polluted the minds of nice young gals. In contrast to sedate waltzes and the Edwardian custom, among the upper class, of refraining from dancing with the same partner more than once, in the 1920s couples danced together repeatedly, creating erotic and suggestive movements. The Home Secretary, Sir William Joynson-Hicks, denounced dance clubs as 'a blot on the life of London', and unsuccessfully attempted to close them down. The *Daily Mail* asserted that the Black Bottom and Charleston were 'reminiscent of Negro [*sic*] orgies'.[15] The craze for dancing was fuelled by the patronage of wealthy people and celebrities including the glamorous Edwina and Dickie Mountbatten (later Viceroy of India), who favoured the Embassy Club, where the equally glamorous Prince of Wales was to be found on Thursdays.

Grandmamma's careful introductions included two youths she particularly favoured: a Cambridge undergraduate named John Kinnersley, who became Bar's 'first best', and a military cadet named Laurence de Vic Carey, known as 'Togo', who was her 'second'. Both were a year older than Bar and hailed from Guernsey. They were friends whose families were closely connected, though a certain amount of rivalry existed between the two young men where Bar was concerned. Johnnie was the son of a doctor, whereas Togo's father was Victor Carey, a lawyer, Receiver General and later, controversially, Bailiff of Guernsey during the Nazi occupation in the Second World War.

Johnnie and Togo were both good-looking and sporty, and each devoted much free time to entertaining Bar. However, it gradually dawned on them that with Bar everything remained superficial, a matter of having fun, rather than developing into anything more serious. 'Fooled around with [name of young

man]' or 'messed around with [name of young man]' are expressions which regularly appear in Bar's diaries at this time. Both meant kissing: nothing more. As Bar noted: 'with the young men we knew, our mothers would say, "Don't you think so & so is being rather familiar?" if he took your arm. But of course we all took each other's arms and kissed each other.'[16] If Bar and her young man 'fooled around', it occurred within unstated but clearly demarcated boundaries. Occupying the same social background and coming from families who knew each other and socialised together, it wouldn't do for a Royal Engineer to get his mother's friend's daughter up the duff.

Photographs of Bar with Johnnie, Togo and other young men, taken at this time while holidaying on Guernsey, show a lithe young woman in a swimming suit at ease with her body, or reclining on a hammock, loosely draped over one or other of her suitors, evidently very relaxed in male company. She didn't look directly at the camera, but deliberately averted her gaze in an unsmiling manner, which sought, rather than deflected, attention. Perusing these holiday photographs, where Bar and her young men are dressed in an informal style widespread today, it is easy to overlook the fact that the pictures were taken a century ago. They are garbed in scanty attire. Bar is braless in a figure-hugging strappy vest and thigh-high shorts, while Togo wears a loose singlet and shorts. Thus attired, their physical proximity and un-chaperoned intimacy were daringly (or outrageously) sexy. They would have seemed practically naked to the 1920s eye.

Bar was not at all keen on what she called 'He-men' and remembered: 'They were a special brand that you don't see nowadays, unless you watch old black and white films. They had moustaches and were interested in cricket and thought it cissy to like art [. . .]. I couldn't stand any one of them.'[17] The expectation that Bar would marry within a clearly defined

stratum of society was stultifying enough, without the further problem caused by her family's fall from grace. Was that the reason why Bar was presented at court in 1927, aged twenty-two, rather than at eighteen?

Bar's friend Meraud Guinness, of the eponymous Anglo-Irish brewing family, was a fellow student, and presented at court at the same time. Ed couldn't resist a put-down: 'Well ma Cherie', he wrote to Bar, 'I suppose you and the Guiness [sic] have quite left the Slade for the courts the Royal courts not the police courts dear I mean. I do think a bunch of feathers stuck on the back will improve any face you know if you have a hair lip people notice the feathers & don't think so much of the lip'.[18] He alluded to the trio of ostrich feathers which were the compulsory head-dress of the deb, to be worn with a white gown and train and a single row of pearls. Bar might have found the whole occasion an amusing diversion if she was not so worried about the pressure placed upon her. Writing to Ed, she catalogued the grim details of the latest hopeful swains. 'You do seem to have been having a jolly time around town lately what with guardsmen and all', Ed replied, 'realy I think that kind of conversation is what a girl wants to hear to educate herself. I hope you have at least a gold bangle to show for it.'[19] The men she liked best were Billy and Ed, neither the marrying kind, at least not within the bounds of wedlock at that time. Bar's 'suitable' boyfriends took her to the cinema, but it was to see conventional American films, rather than the German films and those at the Film Society which she most enjoyed. For all her larking about with Ed and Billy, they spoke earnestly and reverentially about such films and as they pored over their German photo-books they shared a language and way of seeing which a Johnnie or Togo would never understand.

At art school, where she was most comfortable, away from the debs and toffs, Bar particularly enjoyed lithography, quickly

mastering the process and progressing to two-colour printing. She loved life drawing, producing neat, competent figures drawn with verve and confidence. From the Poly, Bar progressed to the Royal College of Art, and in January 1927, aged twenty-two, she enrolled at the Slade School of Fine Art which had been established in 1871 with the express intention of offering female and male students equal education. There she received the accolade of being admitted into the painting class of Henry Tonks, Slade Professor of Fine Art. Then in his sixties, he was a renowned, if formidable, teacher, famous for his withering manner and sarcasm. Bar escaped his acid tongue, but another student was less fortunate. As Bar reported to Ed: 'he gave one look at her canvas and said "There's nothing left for you to do but pray".'[20] Bumble was a fellow student and the two spent their breaks giggling over James Joyce's banned novel *Ulysses*, which Billy smuggled in, wrapped in brown paper.

Billy's career had taken a surprising turn. He had come to the notice of Marie Rambert, the thirty-eight-year-old choreographer and founder of what would become the Rambert Dance Company, who was then running a ballet school in Kensington. Born in Warsaw, Rambert had worked as Nijinski's assistant and as a dancer for the *Ballets Russes*, although she had little formal training in ballet. She moved to Britain at the outbreak of the First World War and married the playwright Ashley Dukes. Billy described Rambert's 'true gift' as 'her extraordinary capacity for uncovering and developing talent. As if she were some inspired and intuitive archaeologist, she would dig away at the layers of her students' minds and bodies until every atom of evidence of any latent talent was completely sifted and closely examined'.[21]

Although Billy could cut a fine Charleston, he had no ballet experience, but Rambert saw promise, especially in terms of what she considered his natural dancer's physique. When she

invited him to join her embryonic company, he reluctantly
agreed to practise early-morning *barres* in her studio in a dingy
church hall. 'It was absolutely dotty, the whole thing,' he said.
'I rushed away and didn't go near her, but she wouldn't give up.
She wouldn't leave me alone, and in the end she caught me'.[22]
Billy's initial reluctance stemmed partly from his complete lack
of experience and partly because of the reputation of male dan-
cers at this time: 'The ballet as a career for men, in England, has
long been considered rather despicable and shocking', he com-
mented. 'In this country, if a boy wishes to become a dancer, he
is fairly certain to meet opposition [. . .] the kind of opposition
which the self-conscious British character finds hardest to with-
stand. The cries of "Sissy" – "Effeminate" – the taunts and the
teasing that the average boy does not easily ignore.'[23] Although
Billy didn't face opposition from his own particular friends or
family, he had to consider whether he could withstand this
level of negative scrutiny from others.

Billy acquiesced, however, becoming Rambert's second male
dancer. It was her first male dancer, Frederick Ashton, who
inadvertently helped him to make up his mind. Fresh from
his first choreographic success, *A Tragedy of Fashion*, Ashton
appeared in a student performance one evening, in which he
twisted his ankle. Billy was in the audience, and going back-
stage to sympathise with Fred, to whom he had already been
introduced by Marie Rambert, found himself dazzled by the
vision before him, resplendent in a jewel-coloured Harlequin
costume and elaborate stage make-up: 'the matt and glowing
skin; the curving polished garnet coloured lips. This, all this,
was much more what I expected of ballet', he said.[24]

Billy trained hard to develop the physique and stamina to
practise and perform. Regarding the discipline required, he
reflected: 'No dancer can achieve greatness without it [. . .].
It does not wait on whim or inspiration, it cannot lie idle for

weeks [. . .]. There is only hard physical labour day in, day out'. 'If a dancer is not practical about his work he is eventually doomed. He has to be as practical about his life as any athlete in strict training, and must treat himself with the same considera-tion. His life should be regular, routine, and free from excess.'[25] Billy's life, however, was far from regular. Rambert described him as 'passionately lazy', and although he dutifully turned up at the studio every day, at this early stage of his career he was invariably late.[26] Fred was delighted to have a fellow male dancer in the company, although he jokingly warned Billy about the dangers awaiting him: 'Men, *old* men, will be after you and think you're to be had'.[27]

Fred and Billy soon became close friends. Inevitably, one friendship led to another and Ashton was drawn into Bar's circle. Echoing his earlier sentiments about Bar and Ed, Billy said of Fred, 'We instinctively knew that we had absolutely everything in common – the same taste and behaviour and everything else'.[28] Bar was soon able to report to Ed that she and Fred 'had such a serious talk about Billy & his future the other night, he is simply killing about Billy, really the things he says would make B turn in his grave (strictly between you & me & the gate post, though of course you will tell Billy at the first opportunity)'.[29] Ashton shared their sense of humour and glee-ful enjoyment of innuendo and gossip; he shared their interest in films, fashion, blues and jazz. Not particularly tall and very skinny as a young man, Fred never really developed the male ballet dancer's physique, and his calf muscles were notably less pronounced than those of Billy. His thick, dark, wavy hair was swept back from his forehead above a beautifully proportioned face with a long, straight, rather pointy nose. He was conven-tionally smart, more conservative than either Ed or Billy, but stylish in dress. He had a graceful, slightly theatrical demean-our, beautiful manners and was scintillating company.

Anthony Powell recollected: 'Burra, Chappell, Barbara Ker-Seymer, Bumble (Beatrice) Dawson [...] also a girl called Clover Pritchard [...]. In the late 1920s these people formed the essence of a certain sort of party, with ballet-based connotations [...] including Freddie Ashton'.[30] Bar's inner circle of lifelong friends was complete. They were notably a group, and if collectively they were not graced by the name of a district – Bloomsbury or St Ives perhaps – from the late 1920s and through the 1930s they were bound not only by friendship, but by shared tastes and artistic influences, and a drive to transform and innovate. But their frivolity and apparent inability to be serious masked something far more profound, which gradually developed over the years: a depth of affection and understanding, even tenderness, not expressed in endearments or demonstrative behaviour, but in their need to be together and to communicate. They chose one another and so remained together for more than fifty years.

CHAPTER THREE

Unsuitable Boys

Bar and Fred were fellow swimming enthusiasts and would catch the tube to Hammersmith in west London, to swim in an open-air lido where mixed swimming was permitted for three hours on Saturday mornings. 'We'd have a swim and splash each other a bit and then get the tube back', said Bar.[1] Fred gallantly accompanied her home to Gledstanes Road, where they would embark on marathon kissing sessions on the

doorstep, causing Barbara's mother anxiously to enquire, 'Are you coming up now dear?'[2] 'Freddie is my dream now', Bar told Ed.[3] In many respects he was. He was a 'safe' kisser, who made no further demands.

Fred wasn't the type Diana deemed suitable for her daughter. Although obviously well-spoken, he occupied a doubtful social position as a male dancer and was clearly far from well off. His background, however, bore some similarities to that of Bar. He too enjoyed a relatively privileged childhood but fell on harder times. A year older than Bar, Ashton was born in Ecuador, where his father was manager of the Central and South American Cable Company and later vice-consul at the British Embassy in Guayaquil. The family moved to Lima in Peru when Fred was three, but returned to Ecuador in 1914, leaving behind the now ten-year-old with a surrogate family. Five years later, he was dispatched to Dover College, an English boarding school which he detested, especially as he yearned to learn ballet, having seen the legendary Anna Pavlova perform. With a perceptible Spanish accent and a loathing for field sports, he did not fit in at school, enjoying only English Literature and the weekly ballroom-dancing class. He lived for the holidays, when, billeted in London with various dowagers of his mother's acquaintance, he filled his days with films, plays, concerts, exhibitions and ballets.

After leaving school, Fred found himself residing in an Earl's Court flat with his mother, Georgie, who had returned to England following her husband's suicide. Mother and son shared an impecunious existence, the remaining family assets having been squandered by Fred's brothers. Ballet dancers were paid by performance, and given that Rambert could only afford to stage short runs, they faced lean times between ballets. Fred and Billy both took work performing in cabarets and revues to make ends meet. But Fred was ambitious. Among his clique it

was noted that he, less able to dissimulate, could not entirely disguise his seriousness or his aspirations. Burra seized on this apparent weakness, labelling him 'La Princesse Vinaigrette' or 'Madame Megalomania'. Bar noted Fred's double standards: 'He is such a social climber [. . .], wouldn't dream of being seen speaking to us at a party'.[4]

They all had nicknames. Ed's for Bar varied between 'Bubbles', 'Babbs', 'Babikins', 'Old Tart', 'Prossie' and 'Tottie'. Bar addressed Ed with faux tenderness as 'Eddie my love', 'Eddie my dove' and 'Darlingest Eddiekins', although she sometimes stooped to 'old faggot', or the deepest irony, 'Old Sportie'. When Billy attended a Chelsea Arts Ball in a fishnet top, he inevitably received the soubriquet 'Fishnet Annie', and later became 'Mistress Chappell' or 'Nurse Chappell', for his habit of fussing over his friends.

'Why we wrote to each other as if we were middle-aged tarts is a mystery to me', Bar later wondered, 'as I was completely virginal.'[5] Her sexual education was partly obtained in the penny arcade on Oxford Street where she and Bumble watched titillating films in which 'artists' models' undressed and disported themselves on a chaise-longue to be ogled by a lecherous older man. Bar reported to Ed: 'There was one lovely looking one of the old fashioned sort about 1860 or so, of two girls in chemises clasping each other called "What Girls do when left to themselves" but we didn't dare look as there were too many people around'.[6]

Billy described the coterie 'scrambling out of adolescence' into a world where 'Sexual ambiguity was the rule. Sexual promiscuity and sexual aberration the mode [. . .]. The foursome made valiant [. . .] attempts. The outrageous talk, the sexual precocity of their mental attitudes, and their immense *theoretical* knowledge could not hide the fact that they were in *practice*, virginally innocent'.[7] They gossiped about the sex

lives of celebrities and people in their wider circle of friends. Ed wrote to Bar about their mutual friend Basil Taylor: 'as for B[asil] being a B[ugger] for years we have been wondering why he had that worn look we charitably put it down to whiskey'.[8] 'I've been hearing dreadful tales of Tallulah Bankhead and Florence Mills together', Bar wrote to Ed. 'Do you think it can be true? It's what I call a nice tasty bit of scandal'.[9] However, when Bar asked Edward, in the middle of a drawing class, what it was that caused Oscar Wilde to fall from grace, she was met with no reply, just a pointed look as he industriously continued drawing. Afterwards he said: 'You must never, ever ask that question'. Later Bar realised it was an extremely odd response coming from him. (Making the same enquiry of her mother, Diana mumbled vaguely that Wilde had been involved in a 'robbery'.) When she eventually ascertained that Wilde was homosexual, Bar considered it 'a fuss about nothing'.[10]

Billy was gay, and would soon embrace his sexuality, forming a relationship with John 'the widow' Lloyd, so named by fellow members of the Oxford Hypocrites Club after a shaving lotion, 'The Widow Lloyd's Euxesis'. (He was described by a mutual friend, Lionel Perry, as 'small, with sparkling black eyes [...] infinitely vivacious, infinitely malicious'.[11]) Edward was gay by inclination, if too physically weak and concerned to conserve his energy for painting, to be actively sexual. Fred was also homosexual, and inclined to devote time to pursuing the unobtainable, although he had several long-standing relationships and former lovers often remained devoted.

Perhaps Bar's attachment to gay men caused her parents further concern, but once her older sister Manon was successfully married to a naval lieutenant, Vere redoubled his efforts in seeking a husband for Bar, who was made to attend a dance hosted by Lieutenant-Colonel John Theodore Cuthbert Moore-Brabazon, a Conservative politician who, as an aviation

pioneer, was a close friend of her father. There she was set up with a young man in the diplomatic service, whose father was another of Vere's friends and who had attended the right school, 'so nothing could be more respectable', Bar observed, sarcastically. He was exactly the type she detested, 'a real he man', with a pencil moustache in the style of Ronald Colman, a contemporary British film star. His opening gambit was to regale Bar with lewd stories demonstrating his position as a man of the world. Failing to impress, he then announced how much he enjoyed giving women 'a good beating'. As she explained to Ed, he leapt upon her 'his tongue down my ear-hole, & one hand up me skirt & the other down me front, & my legs caught in a vice'. Although she reported the event in the style of a caricature cockney chorine, she was serious when she vowed never again to attend a society dance or to associate with a man not of her choosing. 'I got quite frightened', she told Ed, in one of her massive understatements. 'Of course', she remarked caustically, 'my mother [. . .] is still anxiously asking when I'm going to see that nice young man again'.[12]

Unbeknownst to her parents, Bar had already enjoyed an adventure with someone, who, from her family's point of view, would have been considered singularly inappropriate. He wasn't upper class or wealthy but he *was* a cavalry officer, though one of Mussolini's Blackshirts. Bar met him when in 1924, aged nineteen, she spent ten weeks in Florence enhancing her art education at the International Academy of Painting and Engraving, known as 'Savini's'. She occupied a rented studio overlooking the River Arno, in which she worked during the morning, afterwards visiting galleries, going to the cinema or attending *danze del té*. Evenings were dedicated to fox-trotting to the popular song '*Sì, non abbiamo banane, non abbiamo banane oggi*' ('Yes, we have no bananas, we have no bananas today') at the smart nightclub Raiola's, where the American actresses the

Gish sisters could be seen, and where dashing Italian *fascisti* officers milled about.

One particular officer, 'Pippo', became most attentive, wooing Bar by bringing his regiment of soldiers to her studio for 'inspection'. He invited her to watch him at the '*fascisti* parade', handsome astride his horse and garbed in the tailored fascist uniform which flattered lean bodies: black shirts beneath belted jackets with nipped-in waists and jodhpur-like breeches, exaggerated at the thigh to emphasise elegant black-booted calves. While Bar was no Miss Jean Brodie, her artist's eye could not fail to be impressed by the spectacle of mounted soldiers, designed by Mussolini to cock a snook at a city long resistant to fascism.

The parade in Florence was probably pre-election propaganda for Mussolini's National Fascist Party which, following a series of political manoeuvres, achieved a landslide victory at the election in April that year. On 9 April, while Bar was in Florence, she noted Mussolini's arrival in her diary. For Bar, the dark and violent underbelly of fascism was invisible; instead, she was dazzled by the attentions of her handsome Italian suitor.

One morning, dressed in an ankle-length coat and cloche hat, Bar rendezvoused at eight o'clock with Lieutenant Quirino Boni at Florence's Santa Maria Novella station. (She evidently trusted Boni, who liked to call her his 'little English friend'.) There they boarded a train to Pisa, where they were met by a waiting Pippo. They visited the main sites of interest, Boni photographing Bar and Pippo at the Duomo, side by side, white canes in hand like a pair of tap dancers. Pippo snapped Boni and Bar, and Bar took a slightly out-of-focus snapshot of the two uniformed men in front of the Leaning Tower.[13] This excursion must have been premeditated, but how did Bar persuade her parents, who had accompanied her to Florence, to allow her to spend time with a pair of Italian soldiers in another city? Did

she pretend that she was travelling, perhaps to take in the art and architecture, with a fellow female student?

Whatever the excuse, the events of that day were recorded cryptically in her diary as 'most eventful day in [my] life'.[14] Under the pretext of showing her the sights in Pisa, it transpired that Pippo, with the aid of his accomplice Boni, had conspired to lure Bar into a hotel bedroom. There is no sense that she was physically coerced – Boni made himself scarce and Pippo pounced – but Bar immediately drew out her hatpin and stabbed him in the hand, drawing blood. Having recovered from her initial shock, she spent the ensuing three hours with Pippo, sequestered in the room. Whatever did take place is unclear, but later events suggest they did not have sex.

The 'eventful' day concluded with Bar's late return to Florence. She apparently bore no grudge against the two young men as she carefully placed their photographs in her album, captioning them for posterity, and had a 'sad farewell' with Pippo, who waved her off on the train en route to England.[15] Her choice of language – 'most eventful day in [my] life' – is interesting because, although it reveals nothing to prying eyes, it does suggest that while she regretted Pippo's behaviour and her recourse to self-defence, the whole episode had been a bit of an adventure. Bar was already demonstrating her famous inability to be shocked.

However, Athelstan Neville, a young Englishman in whom she confided, could not disguise his astonishment at her behaviour. He advised her to tell no one else, or she would be ruined. Interestingly, when the following year Ed's sister Anne attended a finishing school in Florence to study art, she had a similar, although less alarming, experience to that of Bar. 'My sister is having such a rollicking time in Florence what with fascist officers and only the other day a perfect bruit pinched her on the—'.[16]

Bar's route to independence was partly mapped when in 1927 she received a 'legacy' from her aunt Winifred. Vere's younger sister had married 'late' at the age of forty-three, and her husband, a wealthy merchant, died ten years later. She then married her cousin, the composer Amhurst Webber. Well provided for by her deceased and current husbands, Winifred decided to distribute her 'legacies' during her lifetime, so avoiding death duties. Thus she gave her twenty-two-year-old niece £1,000, the equivalent of £41,000 today.[17] Winifred knew that Bar was sensible with money and perceived something in her: her progression through three art schools, her indifference to marriage and the disadvantage of having a bankrupt father who could provide no financial support. She hoped that Bar would use the money wisely and make her way independently in the world. It was an extraordinary gift, and one that Bar, always sensible with money, squirrelled into her bank account.

At twenty-two, the long, extended family holidays of child-hood had given way to shorter holidays with her parents, sometimes to places Bar found attractive, like Juan-les-Pins on the French Riviera. More often they occurred in Seaview, an Edwardian town on the Isle of Wight. But the holidays were now an obligation rather than a pleasure, and Bar yearned for London and her friends. She felt her mother was putting her on display in the hope that a suitable husband might be found, and despite at one point the presence of the French film star Maurice Chevalier at their hotel, Bar took matters into her own hands and returned early to London. Writing to Ed she said: 'You see I'm back, by lunch time Monday I decided I could bear it no longer, so I upped & packed & caught the 4.10 back to the dear old Metrop, leaving mother & all my luggage behind. I felt if somebody didn't do something we'd be there forever, so now I feel happy once more.'[18] It was the last holiday she took with her parents.

Back in London Bar and Ed threw a party to celebrate Billy's twentieth birthday. The invitation, requesting his presence at their 'Less than 20' party, read:

Lady Aimée Bureaux [Ed]
& the Lady Maclaren [Bar]

Request the Presence of Mr Chappell
at their 'Less than 20' party

Don't bring less than 20 (bottles)
Don't stay less than 20 (minutes)
Don't come more than 20 (times)
& don't be more than 20 (years)

C'est la jeunesse qui coûte dear guest of honour

Earlier in the year Billy had enjoyed a minor triumph in his first public performance: quite remarkable having trained with Rambert for only a single year. The work was Ashton's arranged dances for the Purcell Opera Company's revival of *The Fairy Queen* at the Rudolf Steiner Hall, in which Billy featured in the 'Monkey's Dance'. His art school training in mind, Marie Rambert encouraged him to design the sets and costumes for Ashton's new ballet, *Leda and the Swan*, which premiered the following year. Her husband, Ashley Dukes, had purchased a small, disused church hall in Notting Hill Gate, which was converted into a dance school and theatre, the Mercury Theatre. Billy's experience of dancing for this tiny space, which held an audience of only one hundred and fifty people, was fundamental to his designs, for he understood that the physical limitations of the stage dictated pared-down scenery, where anything superficial would obstruct the dancers' movements.

He had to design a set which did not rely on changes of scenery as the theatre's wings were not big enough to contain alternative scenery and the stage was only eighteen feet square. Similarly, he knew how to design costumes for movement, how to make lightweight fabrics appear heavy, how to ensure that dancers were not encumbered by what they wore.

Also that year, in December, Burra's work was shown at the New English Art Club in London. His biographer, Jane Stevenson, suggests this may have been influenced by pressure on the gallery from Burra's friend and champion, Paul Nash, who had exhibited there for nearly twenty years. The exhibition proved to be pivotal in Burra's career. Although on this occasion his work was not particularly well displayed, it caught the attention of the proprietors of the Leicester Galleries, leading to an exhibition in 1929, at which fourteen paintings sold.

Ashton's ballets and Burra's exhibitions established habits that the friends would pursue in relation to one another. Bar attended all Ed's private views, usually in the company of one or more among Clover, Bumble, Billy and Fred. She went to Fred and Billy's rehearsals, bolstering Billy's anxieties about his designs, telling him he danced marvellously and congratulating Fred on his masterful choreography. Ed accomplished only a single personal private view, being unable to bear people talking earnestly about what he called 'Fart'. Bar was working part-time as a scenery painter at the Gate Theatre Studio, beneath the arches at Charing Cross. There she attended the first night of *Orphée*, a play by Jean Cocteau, a man who would be an important figure in her future career.

In retrospect, Bar considered that Burra 'wrote most frivolously to me, he revealed himself more to Billy, and wrote more about literature to ... Clover who was cleverer than the rest of us'.[19] This is not altogether true. Although Bar and Burra were the leading humorists in the group, Burra wrote most

movingly to her. At times of crisis or sadness in his life it was to Bar that he turned. Ed would hide his feelings in a thicket of gossip rather than reveal them directly to Billy, his closest male friend. In early December he wrote to Bar, 'Dear Ba Ba, How are you getting on dear old thing? I am not getting on so well. We went to Granma's funeral on Monday [...]. My dear never do I go to another funeral I thought I should collapse at any moment. I never thought they dug graves so deep they let the coffin down with ropes'.[20] This letter, devoid of humour or camp intonation, reveals his *need* for her sympathy and understanding, an acknowledgement, perhaps, of his fondness for her. Coming from Ed, 'How are you getting on dear old thing' was almost an endearment.

On Christmas Eve Diana travelled with Aunt Violet on a mission to the United States, where she remained until the following March. Already used to a great deal of freedom, Bar grabbed every moment of every day and filled it with friends: attending private views, going to the cinema, having lunch, taking tea, visiting the theatre, perching in cafés and tea rooms. Billy, Fred, Ed, Clover and Bumble were the reliable core of what was now an extremely wide and varied social group. At a party at Great Ormond Street hosted by the artists Cedric Morris and Arthur Lett-Haines, Virginia Woolf, Vanessa Bell and other Bloomsberries were fellow guests.

Bar often dined and attended first nights with Peter Spencer, a handsome, rangy man fifteen years her senior. Urbane and kindly, he rejected the privileged world into which he was born. The only son of the First Viscount Churchill, Spencer was the godson of Queen Victoria and had been a teenage Page of Honour to King Edward VII. He distinguished himself in the First World War, spending a year at the Ypres salient where he endured gas poisoning. He was mentioned in dispatches and by the end of the war, aged twenty-eight, was a major. Spencer

was brave with strong moral values. An avowed socialist, he was disinherited by his father. Bar adored him, although she preferred not to be the object of what she termed 'interference', which she assumed was part of his gallant nature as he was bisexual with a preference, at that time, for men.

The following summer the first of their close circle moved away. Clover became engaged to Adam de Nagy, a handsome Hungarian count with a castle and large estate outside Budapest. 'She has been given a castle & estate of 600 acres 3 hrs from Budapest, he will work the farm & she will probably go into Budapest on cheap day tickets & visit the cinema', Bar speculated.[21] She could not bear the prospect of losing Clover, lamenting to Ed, 'she will be a great loss to us I'm afraid'.[22] They packed in as many films as possible before Clover's departure in late August. Afterwards Bar wrote: 'Woe is me and lack a day, Clover left for Budapest this morning. All German cinemas will close down as a token of respect'.[23]

At twenty-three Bar remained sexually inexperienced but, ever curious, she turned to Radclyffe Hall's 'lesbian' novel, *The Well of Loneliness*, which had been published at the end of July 1928 to initially favourable reviews. However, following the journalist James Douglas's excoriating *Sunday Express* editorial and his campaign to have the book banned, it was eventually condemned as obscene under the Obscene Publications Act of 1857, and ordered to be destroyed. Bar was partly interested in the book because she remembered, aged sixteen, attending a party at the Cave of Harmony cabaret club on Gower Street, where she saw two be-suited women dancing together. These, she later realised, were Radclyffe Hall and her lover, Una Troubridge.

The book was fairly tame but in the forthcoming trial which was widely publicised in the male-dominated press, same-sex desire between women was associated with 'contamination',

'degeneracy', 'pestilence', 'contagion' and so on.[24] Some years earlier, in 1921, when Vere's pal Lieutenant-Colonel Moore-Brabazon MP debated the Criminal Law Amendment Bill which proposed to criminalise sexual acts between women, he posited that lesbians had abnormal brains and should be locked up as lunatics or hanged. The bill was rejected by the House of Lords on the grounds that it would publicise same-sex desire among women who, having never heard of it, might want to give it a go.

Diana found the book lying on the piano. Bar hardly sought to hide it and was surprised at her mother's outraged lectures about the ruination of young women. She was even more surprised, aged twenty-three, to be 'sent to Coventry' and banished to the box room. Bar bitterly resented the hypocrisy of her mother's reaction. But Diana could not expect to endorse Bar's freedom when it suited her own travels, only to rein it in on her return. Bar was an adult, and life was no longer to be devoted to dull, dominating or dismissive men. With Aunt Winifred's legacy safely in the bank, she would complete her studies and make her own way in the world.

CHAPTER FOUR

Les Girls

In the final months of 1928 Bar missed not only Clover, but also Fred, Ed and Billy who were in France. Ashton was working in the Ida Rubinstein ballet company in Paris, and Burra and Chappell had repaired to Toulon for a holiday. Visiting Fred in Paris afterwards, fledgling dancer Billy allowed himself to be persuaded to join the company, where he was faced with a precipitously steep learning curve under

the formidable choreographer Bronislava Nijinska. 'She didn't like me and used to shout at me sometimes. *Terribly.* One day during a rehearsal she threw all the music at me.'[1] Tensions also surfaced between Billy and Fred, partly because they were in each other's company to the extent that being able to afford only one room, they shared a bed, carefully placing a bolster down the middle. As Ed informed Bar, 'we are all in the pink rehearsing till 12 midnight daily so you may imagine our tempers are a little off instead of Faith hope & charity its vinegar vitriol & acrimony'.[2] Billy and Fred toured Europe with the company until May the following year. In their absence Bar and Bumble saw each other on an almost daily basis and – in Diana's absences abroad – Bumble was often to be found staying at Gledstanes Road. Whether Bar and Bumble were lovers is unclear, but the two women were very close – 'bosoms' as Bar would have said.

'Well my dear', Ed began a letter to Bar from Paris in October, 'all is known in the cafes of the Boulevard Montparnasse of your charming little stay with Mr Pilkington news travels like wildfire in the gay haunts of painted sin.'[3] The friends indulged in the camp habit of swapping genders, so Billy was referred to as 'Mistress Chappell', and Fred as 'Madame'. 'Mr' Pilkington was Heather Pilkington, a round-faced, thick-set, crop-haired woman who dressed in 'mannish' clothes. She had invited Bar to a cocktail party and Bar soon found herself spending the night – the first of many – at her London home in Cromwell Mews, around the corner from the Natural History Museum. Pilkington was wealthy and often to be seen driving around London in her huge open-top car with her pet Dalmatian occupying the passenger seat. Writing to Billy, Ed reported: 'I saw dainty Bubbles Ker-Seymer last week her last remaining bonnet is over the mill my dear she's fully launched in the *demi-monde*'.[4]

Heather occupied the same milieu as Olivia Wyndham,

a thirty-two-year-old society photographer. Bumble worked as her assistant, and it was she who introduced Olivia to Bar. Olivia 'is starting up again [as a photographer]', Bar informed Ed, '& wants to photograph lots of interesting things.'[5] Olivia's pedigree was impeccable, offering her both wealth and discreet independence. Her paternal aunts were the *Three Graces* in Sargent's famous portrait, Pamela Glenconner, Mary Wemyss and Madeline Adeane. Her grandparents' house, the romantically named Clouds, was a Pre-Raphaelite and Arts & Crafts shrine, designed by Philip Webb, with decorations by Edward Burne-Jones, William Morris and Frederic Leighton. On her mother's side, Olivia was related to the Duchess of Westminster and the Princess of Pless. According to Bar's friend Neil Munro 'Bunny' Roger, Olivia ruled London lesbian society: 'She was their goddess. They were all mad about her like the girls round Sappho on Lesbos.'[6] She had untidy brown hair, a rather doughy face and a stout figure but she exhibited great kindness, a charismatic larger-than-life personality and sheer daring. She threw the most louche parties and abused alcohol and cocaine, giving rise to hilarious or outrageous behaviour, depending on how it was viewed. At one party she famously ended up exchanging punches with a male guest.

Heather and Olivia competed for Bar: whoever she was with at the end of the evening would get to take her home. (Bar now had first-hand experience of 'What Girls do when left to themselves'.) Sometimes they converged, Bar soberly witnessing their drunken antics. She told Ed that one evening Heather 'got quite drunk & fell flat on her face on the floor. I had hysterics & rushed to the bedroom, & Olivia came rushing in after me & lay on the bed & wept, Bumble got in a fury & rushed to the kitchen to make sausages, where she set the bacon on fire [. . .] really we had a most enjoyable evening.'[7]

Heather whisked Bar away for weekends at her country

home, but gradually, through sheer persistence Olivia won
the prize, and in February 1929 she took Bar for a weekend
at Tickerage Mill, near Uckfield in Sussex, the home of her
wealthy brother Captain Dick Wyndham. From there Bar
wrote to Ed: 'by the way I'm supposed to be staying with the
Nash's [sic] [. . .] I know I shouldn't be allowed to stay away
with Olivia, & the Nash's are quite safe, so whatever you do
warn him next time you see him will you? Don't forget.' Then
she added: 'Oh dear, all this intreege [sic] annoys me so much'.[8]
Paul Nash and his wife Margaret would have been deemed
respectable by Diana, while Olivia certainly would not. Bar's
mother expected to keep tabs on her daughter, but Bar had
learnt to outwit her. When a mutual friend, Lucy Norton,
fished for information about Bar's love life, commenting that
Bar and Olivia seemed very friendly, Ed replied: 'bosoms
my dear'. Probing further, Norton asked Ed if he could stand
Heather Pilkington, to which he replied: 'Well you know dear,
I can never resist a raddled baby face and a little child shall lead
them is all I can say'.[9]

 Although Bar spent much of her time at Olivia's maisonette
on the King's Road, they were hardly an exclusive couple.
According to Bar, Olivia 'had no taste at all. Sometimes a great
butch lady would arrive at the door and Olivia would send me
up to cower in the dark while she showed our empty bedroom
to the irate visitor.' Bar also commented that Olivia was a pro-
curess, 'dragging people upstairs and putting them on top of
each other'.[10] Ed made a pair of cautionary pen-and-ink draw-
ings captioned 'Ker Seymer 19 Kings Road', in which he depicts
a debauched Bar reclining, naked, a syringe and empty tumbler
discarded on the floor beside her. It was, at least in one respect,
a joke, for Bar was never interested in drugs.

 With Olivia's wide-ranging social connections, Bar found
herself at what seemed like an eternal party, although the tone

ranged from the lofty, where the celebrated thespian couple Charles Laughton and Elsa Lanchester entertained, to the decidedly low, where everyone brought a bottle and the guest list was merely notional. Bar had forsaken the rounds of dances with nice young men after she had taken Togo to a party hosted by Vyvyan Holland, to find that he bolted, offended by the ghost of Oscar Wilde. The disparity between Bar's mores and those of her old suitor could not have been more pronounced. Now occupying an entirely different arena, Bar was happy for Togo when he married that year. Had she married him, her life would have been that of a military wife in India.

Olivia's lesbian circle included Madge Garland, the brilliant and influential fashion editor of *Vogue*, renowned for her chic style and exemplary fashion sense. One evening Bar, Olivia, Bumble and Madge attended a series of parties, culminating in one to which they were taken by the singer Leslie 'Hutch' Hutchinson, where all the other guests were male. 'I've never seen anything like the clothes', Bar told Ed, 'all the fat old ones were dressed as dowagers with silver tissue [. . .], tulle scarves, tiaras or pink ostrich feather head dresses, really I've never seen anything so lovely in my life.' Then she added: 'Apparently, the police raided the party soon after we went and everybody was ordered to leave'.[11] She didn't record whether it was raided for rowdiness, or because the guests were homosexual.

Parties were the stage where the Bright Young People performed and as Bar had been absorbed into Olivia's lesbian circle, she was also accepted as one of the BYP. Hutch had his eye on Bar, escorting her to parties and taking her for intimate lunches at a fashionable new restaurant, Quo Vadis, on Dean Street. 'He's such a lovely man', Bar sighed.[12] Five years her senior, Hutch was born in Grenada, arriving in London in 1927 via Harlem and Paris. His first professional London engagement was in C. B. Cochran's London Pavilion Revue of 1927, where

he played as a member of the orchestra and also as a soloist, but from the orchestra pit, black performers being forbidden to appear on stage with white women. The Mountbattens and the Prince of Wales adored him, and so he became accepted in upper-class circles, performing in nightclubs and at private parties. Such 'acceptance', however, often meant entering through the servants' door. Hutch was handsome, had a magnetic personality, and a fine singing voice. He was rarely seen in public with his wife and had many lovers, including Tallulah Bankhead and Cole Porter. One evening at the Savoy, where Hutch had invited Bar to hear him sing, she was made to feel distinctly uncomfortable when, in the presence of a party of Hungarian diplomats and their hangers-on, she was assumed to concur with their racist comments about Hutch. 'They all started talking as loudly as possible to show their contempt for him', she reported to Ed, 'but I listened quite rapt while he sang "When will he come along, the man I love, will he be big & strong, the man I love" with melting brown eyes'.[13]

This era of parties was memorably commemorated in Evelyn Waugh's contemporaneous novel *Vile Bodies* as: 'Masked parties, Savage parties, Victorian parties, Greek parties, Wild West parties, Russian parties, Circus parties, parties where one had to dress as somebody else, almost naked parties in St John's Wood, parties in flats and studios and houses and ships and hotels and night clubs, in windmills and swimming-baths'.[14] Bar, Bumble, Olivia and the actor Hermione Baddeley went to an 'almost naked' party which started well with 'a mass of young men in tails [...] & pretty girls with nice shingles & Spanish shawls'. When the 'nice' girls and boys drifted off, the tone lowered, and the fun began. Bumble and Bar were prepared for such an eventuality, having brought their uniform of choice along: Bar changed her black diamanté-encrusted flapper dress for her Marseilles sailor suit, and Bumble donned a

boiler suit and American sailor's hat. It was the sartorial equiv-
alent of rolling up one's sleeves in readiness. Another guest,
Gordon Russell, changed out of his suit into a pair of pyjamas
which soon became detached. According to Bar (and it is worth
quoting her at length for the full flavour):

Gordon lay on the sofa in the most beautiful positions
turned himself into a girl by tucking his 'parts' (shall we
say) between his legs [. . .]. This cleared the house of the
few remaining unwanted stragglers, so then we settled
down to business. Gordon made a leap at Pip [. . .] & tore
off his clothes & they both embraced in the armchair stark
naked. Then somebody rather embarrassed put on the
gramophone, of course we were all eyes [. . .]. When the
gramophone started they suddenly got up & started the
most glorious dance you've ever seen, whereupon Brian
Howard who'd been asleep in the corner woke with a
start & rushed to the gramophone [. . .] & every time it
came to the end of a record he quickly put the needle back
to the start again for fear they should stop [. . .]. A very
startled maid came in with a tray of glasses, banged it on
the piano & fled! At last they were quite worn out so they
gave us beautiful curtsies & fled from the room, upstairs to
the bedroom.

Bar, Bumble and Hermione followed them upstairs.

People kept on coming in by mistake, & [. . .] one dreary
woman with a nice bob & fringe with green shantung pyja-
mas came in accidentally & Hermione said 'Here comes
suburbia, turn her out' whereupon the woman who was
highly embarrassed anyway said 'I won't be called subur-
bia' & tried to flounce out, but somebody barred her way

& she was made to stay in trembling all over with rage &
embarrassment. Really I haven't enjoyed a party so much for
years [. . .] when we opened the front door to find the sun
pouring in & the milkman & a policewoman with a note
book saying 'complaints from the neighbours sir' [. . .] we
fled for home.[15]

Bar identified another category of parties: the 'sick' party,
where 'every time you opened a door you caught a glimpse of
someone's head being held over a basin & the door was imme-
diately slammed in your face'. 'No one was allowed in', Bar
continued, '& white faced queens kept on hurrying silently in
and out with basins, rags & jugs of steaming water; all spare
divans were occupied by white faced girls wrapped in coats
being tended by various drunken bohemians, piles more under
the coats in the "ladies", so what with not being able to go into
any room, sit down anywhere or go to the WC or get ones bag
to leave, we really felt a little out of it'.[16]

In the late 1920s and early '30s, the Bright Young People were
the first example of an identifiable culture of youth. While
the tradition of the London Season continued, these social
rounds were now amplified by wider opportunities for leisure
and pleasure: cocktail parties, nightclubs and dancing; house
parties, themed parties and country weekend parties. The aris-
tocracy were still at play, but now they merged with bohemia,
with art students, writers, artists, composers, musicians, actors,
dancers, film stars and people merely famous for being famous.
All this was fuelled by a new type of press, where gossip or
'society' columns reported on the goings-on and lifestyle of the
'smart sets' and the most visible (or notorious) BYPs – Brenda
Dean Paul, Olivia Plunket-Greene, Stephen Tennant, Elizabeth
Ponsonby, Teresa and Zita Jungman, and Bar's childhood
friend Brian Howard.

Derek Patmore, an up-and-coming writer whom Bar
knew slightly, asked rhetorically: 'Who were these Bright
Young People, and why had they become so well known?'
He explained that 'the leaders of this set were mostly drawn
from the younger generation of the so-called upper classes,
but talent, too, was immediately a passport into this circle,
and there were no class barriers.'[17] Thus, while Olivia was
an undisputed leader of the BYP, Bar, Billy and Bumble were
welcome foot soldiers. It is true that to be accepted as a Bright
Young Person one had to have a certain allure or sparkle. But
an undeniable democracy prevailed, at least on a level above
the working classes. It isn't clear where the boundaries of what
Waugh described as 'High Bohemia' and the BYP were drawn,
if they were drawn at all. According to D. J. Taylor, 'On paper
the connection between – say – Brenda Dean Paul, Evelyn
Waugh, Diana Mitford and Ed Burra barely exists. Yet the mag-
nets that drew together the contemporary "It" girl, the aspiring
novelist, the peer's daughter and the avant-garde painter were
far stronger than the demarcations of class, wealth and tem-
perament that might have pushed them apart.'[18] The Bright
Young Person, however, was unlikely to be working class
because the lifestyle required money, time and the liberty to
stay up all night. This is underlined by an occasion when Billy
turned up as a gatecrasher. Olivia and Bar were invited to the
Great Urban Dionysia, a party hosted by Brian Howard, which
demanded Greek dress. Billy, with his flair for costume design,
had dressed both Bar and Olivia, and afterwards Bar suggested
that Olivia take him along as her electrician. According to Billy,
'we were ever so professional Olivia called me Chappell and I
said Miss Wyndham very respectfully and held all the lights
[. . .] people seemed to think it was rather twee to talk to the
electrician who wouldn't have looked at me twice if I had been
in a dainty Greek costume as a guest.'[19]

Fancy-dress parties, or freak parties as they were known, were at their peak and the press worked itself into a frenzy reporting them. One of the most elaborate was the couturier Norman Hartnell's Circus Party, where the venue, a house on Bruton Street, had been decorated to resemble a fairground. Live animals including a dancing bear were displayed and music was provided by an orchestra, a jazz band and accordion players. Olivia surpassed herself sartorially with a pair of live snakes wound around her neck. She and Heather Pilkington jointly hosted what the *Sketch* described as 'one of London's most successful parties', the 'Embarkation for Cythera' where guests were asked to wear costumes pertaining to the artist Watteau's eponymous painting.[20] Olivia wore an eighteenth-century Pierrot costume, Heather dressed up as a duellist and Bar wore a tricorn hat and a floor-length ruffled coat with an elaborate lace collar.

Bar's friend Anthony Powell commented: 'I always liked Barbara, found her attractive, and I think she liked me, but [I had] some sense of self-preservation preventing running into trouble with her [...] which could have happened in early party days.'[21] Running into trouble with her? Did Powell mean *he* needed to exercise restraint, or that Bar was renowned for a lack of it? If she had such a reputation, it would have been fuelled by association with Olivia and with Ruth Baldwin and her partner Joe Carstairs. At this time Joe (whose given name was Marion) was at the pinnacle of her career as a motor-boat racer, breaking world speed records. Five years Bar's senior, she had cropped hair and tattoos and dressed in men's suits. Although slender in later life, at this time she was muscular with a stocky build, and was usually seen with a cigarette or cigar clamped between her teeth. She had inherited a fortune from her American grandfather who made his money in the oil business. Joe drove about in a silver-grey Rolls-Royce, but

she had always been mad about vehicles, at the age of sixteen
driving ambulances in France with the American Red Cross.

Ruth Baldwin was the woman Joe loved the most, although
neither was exclusive. The same age as Bar, Ruth was a heavy
drinker, and like Olivia, a drug-taker. She was American, tall
and long-legged, plump with a beautiful face and laughing
eyes. Despite this, the word most often used to describe her
was 'wild'. Ruth and Joe lived together in a house on Mulberry
Walk, off the King's Road, not far from Olivia's flat. Joe was
very much attracted to beautiful actresses, and liked women
who were boyish and feminine, probably the attraction with
Bar. Ruth and Joe took Bar out to dinner jointly and severally,
and Bar and Olivia motored down to Joe's country retreat at
Bostwick in Hampshire, a large sprawling bungalow which
commanded a view of the sea and the Isle of Wight. Days were
spent in the pool and evenings dedicated to drinking and play-
ing games. Ruth and Joe were socially very well connected on
both sides of the Atlantic. Through them Bar met the actor,
singer and civil rights activist Paul Robeson, and Nora Holt, a
singer and important figure in the Harlem Renaissance, both of
whom entertained after dinner at Mulberry Walk.

Regardless of the imperative to marry, in the late 1920s it
was possible – even, in some quarters, considered glamorous –
to be a sexually liberated single woman, but this depended
on the social circles and platforms upon which life was
enacted. In Bar's circle no one would bat an eyelid at 'uncon-
ventional' behaviour. At the Cave of Harmony or the Café
Royal one could mingle with other eccentrics and outsiders
for here everyone was an insider whether lofty Bloomsbury,
low chorines, homosexuals, writers, artists' models, compos-
ers, musicians, dancers, actors or intellectuals. According to
Virginia Nicholson, lesbians 'had their own charmed circles
[...] and they saw themselves as the last word in modernity

and emancipation'. 'In Bohemia, "Sapphism" was just another life-enhancing eccentricity'.[22]

Despite what can only be described as a frenetic social life, Bar always made time for Ed, prioritising him above anyone else. She would travel to Rye for the day to see him and sometimes they went back to London together, talking at nineteen to the dozen on the train. In a letter to Billy, Ed, who stayed at the King's Road, provides an interesting glimpse into Bar's relationship with Ruth Baldwin. 'Babs went out with the girlies after supper so I leant out of the window & played the gramophone till about 1.30 when I staggered to Bed about ½ an hour afterwards a loud crashing was heard which was Ruth Baldwin & Babs dropping in Ruth was quite drunk & kept rushing at B and biting her however – after a bit more crashing & screams they went off'. 'Ruth Baldwin is my beau ideal', he added, 'Ive never seen anything so glorious for months I think I like them fat I cant resist anyone that goes about with an aeroplane in diamonds where there ought to be a tie shes heavenly.'[23] Ed and Bar evidently felt the same: 'I adore Ruth, don't you think she is glorious?' Bar asked Ed.[24] It's clear that Bar did adore her: she took a saucy photograph of Ruth wearing thigh-high shorts, sitting, legs splayed across the upturned hull of a boat.

For some years Bar had attended the annual Chelsea Arts Ball held on New Year's Eve or in early January, famous for its extravagance and exuberance. Conceived on a large scale and packing several thousand people into the Royal Albert Hall, it always had a central theme or 'stunt', in which art students (including on occasion Bar, Clover and Bumble) constructed intricately decorated floats which were driven directly into the Albert Hall and paraded at midnight, only to be demolished by revellers. The ball was such an integral feature of London's social calendar that it was reported in the press and in cinemas by *British Pathé News*. Everyone wore fancy dress, the more

elaborate or outrageous the better, although as the night wore on, drink and dissipation took their toll and costumes became dishevelled. The ball attracted people from many sectors of society, including gay working-class men. It sidestepped accepted social mores giving way to liberty and abandon, for the revellers were protected from prosecution thanks to a legal loophole from which the Albert Hall benefited, placing it outside the jurisdiction of the Metropolitan Police. Bar attended her first ball accompanied by Clover, and went to another with Heather and Olivia, but in January 1928 she and Billy established a tradition of going together, dressing identically and dancing only with each other. This year they were garbed as drowned sailors in net tops and matelot trousers, to which Ed contributed by collecting seaweed and shells from the beach, pointing out that the cockle shells should be strategically placed on Bar's top 'to keep the boys at bay'. 'I hope you will have a nice time at the ball', Ed wrote to Bar, 'and have no arrestations for indecency this time'.[25] They danced until five in the morning, when breakfast was served. In an arena where people competed to be noticed Bar and Billy were creating performance art: two gorgeous individuals, dancing together, dressed in inventive, sexy costume.

The Bright Young People and the flappers among them were gossip-column fodder, but they were also perceived as a destabilising force which undermined society and social 'norms'. Flappers were attacked in the press for their unmarried status and there was a certain anxiety that the flapper physique – narrow hips and flat chest – would make them unsuitable for childbearing. Moreover, newly independent middle- and upper-class young women did not expect to be 'treated' by men paying for everything and were happy to attend less conventional entertainments rather than dinners in expensive restaurants. Bar and her women friends did not need to be seen

on the arm of a man; instead they went about together, occupying their own space in the cafés, clubs and bars of London.

In April 1929 Bar took over from Bumble as Olivia's paid assistant. Her earlier work as a scenery painter at the Gate Theatre had funded her social life, but now at last she gained the financial independence to leave home, although she already spent so much time at Olivia's maisonette above the post office at 19 King's Road that Ed had taken to writing to her there. What Bar's mother made of this is not recorded, but she may have assumed (or preferred to assume) that Bar stayed over because Olivia's main work took place in the evening. 'Went home' is occasionally recorded in Bar's diary, but generally she felt a sense of ennui and couldn't summon the energy to leave. 'I'm still staggering about at no 19', she wrote to Ed, 'really I must go home, I seem to have quite lost the ability'.[26] The sense of ennui would be translated into a sense of purpose, as Bar found herself living permanently at the King's Road under unexpected circumstances.

CHAPTER FIVE

All That Jazz

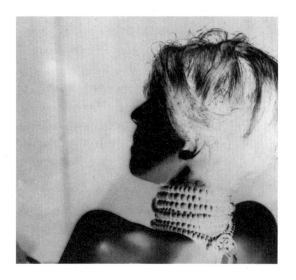

Initially Bar took on the secretarial duties carried out by Bumble, but owing to Olivia's drinking and drug-taking, she soon found herself doing more and more photographic work. In addition to her art school education which enabled her to understand composition and lighting, Bar had been a keen photographer since at least the age of eleven, when she took snapshots of her chums at summer school with what was

probably a Kodak Box, a then widely available, lightweight and portable camera which worked best outside in bright daylight because of its fixed focus and small lens aperture. Even these youthful photographs reveal an eye for composition as Bar carefully framed her friends in doorways or against appealing backgrounds.

Parties were Olivia's bread and butter, the locus of her work for newspapers and magazines. She had the social connections to be admitted everywhere. Evelyn Waugh, himself an enthusiastic party-goer, reveals the ambivalence directed at society photographers: 'Their flashes and bangs had a rather disquieting effect on the party, causing a feeling of tension, because everyone looked negligent and said what a bore the papers were, and how *too* like Archie to let the photographers come, but most of them, as a matter of fact, wanted dreadfully to be photographed and the others were frozen with unaffected terror that they might be taken unawares and then their mamas would know where they had been.'[1]

Olivia's photographic career had begun in 1925, when she and the American photographer, Curtis Moffat, established the M Studio in London. In contrast to Olivia, Moffat had studied painting in New York and Paris and it was in Paris that he began to experiment with photography and work collaboratively with Man Ray. Artistically, he was in another league from Olivia, but their professional relationship was probably symbiotic, with Olivia providing introductions to society figures and Bright Young People. Certainly, the majority of the M Studio photographs from this period are signed by Moffat alone. This is not surprising given Olivia's notorious unreliability and technical incompetence. By 1928 the partnership had fizzled out, but Bar knew Moffat and admired his work, and his influence can be seen in some of her photographs.

In a thinly disguised portrait of Olivia in his short

story 'Ursula', her younger half-brother, the writer Francis
Wyndham, referred to her technical incompetence with regard
to 'lighting, time exposure and so on which Ursula, congeni-
tally clumsy in practical matters, found beyond her.'[2] (Bar, on
the other hand, appears in the story as the more skilled pho-
tographer 'Flash Rumbold'.) Cecil Beaton, himself the subject
of a series of fine M Studio portraits, maintained that Olivia was
'completely incompetent as a photographer' and that she 'was
never mistress of her camera, a huge concertina affair [. . .] the
technical aspects were always a bafflement to her: mechanism
had a sure way of defying her.' He also commented that 'apart
from being hopelessly untechnical and accident-prone, she was
often too drunk to focus the camera'.[3] This was corroborated
by Bar, who said: 'We used to go to parties and I would have to
hold the camera because Olivia would get dead drunk. I'd help
her into a car with the cameras and get her home and put her to
bed and sit up all night developing the photographs.'[4]

Although the press was generally barred from parties, Olivia
was accepted as a friend (or relation) of the hosts. According to
Bar: 'My job was to stay up all night after the parties developing
and printing the films in order to take them round to the *Tatler*,
Sketch and *Bystander*, etc.'[5] While subordinate in the working
relationship, Bar was effectively taking responsibility for much
of Olivia's business. It was she who attended one of the society
weddings of the year, that of the BYPs Elizabeth Ponsonby and
Dennis Pelly in July 1929. It was a press sensation for which
invitations were at a premium.

In November Olivia left for Harlem, telling Bar she would be
back in a month and asking her to hold the fort. But it seemed
she had no intention of returning as she promptly moved in
with the African American actor Edna Thomas, with whom
she would live for the rest of her life. Thus having worked for
Olivia for just seven short months, Bar progressed from being

an assistant in a photographic business to potentially becoming its proprietor. She had to consider whether to take on the business or give it up. If she gave it up, what would she do?

Bar knew taking on the business was a risk, but it was one she carefully weighed up. She was relatively financially secure, with capital in the form of Aunt Winifred's legacy. Having received an apprenticeship of sorts under Olivia, she knew how to handle a camera and could develop and print photographs. While *feigning* not to take her skills seriously (a shared affectation with Ed and Billy) she approached photography logically, as an extension of her training as an artist. It was a medium to which she could apply her understanding of line, light, chiaroscuro and form, and to which she could bring her knowledge of life drawing, portraiture and art history.

It was uncommon at this time, before the influx of Jewish women photographers seeking refuge in London later in the 1930s, for women to become professional photographers with their own studios. Those young women who took a photography course at the London County Council Trade School for Girls would usually become printers or re-touchers in a photographic firm, only occasionally entering the profession as an assistant via an apprenticeship to an established photographer.

Bar was unusual in embarking on a career, and especially one which was dominated by men. She was also taking over a business shortly after the crash of the US stock market, at a time of impending financial depression. Her friend Madge Garland, another career woman, speaking about the 1920s said: 'the mass of people went on doing the same thing, but the few of us that didn't, we absolutely rejected everything our parents had and that our parents stood for.'[6] As Bar's friend Doris Langley Moore commented, 'Barbara might have spent her life defying family tradition, but she has always been very constructive – *never* an idler.'[7] When Bar was lauded, as she was

early in her career, she could not quite believe it. As a career woman – for that is what she became – Bar could not look back on similar women as examples. She could not read that history: she was making it.

What Bar lacked, however, were Olivia's contacts and social network. For the time being, Bar recognised she would need to concentrate on portraiture, and to acquire the requisite experience she roped in her friends. 'I called upon Fred and Billy and everybody I could think of. They were delighted and brought their costumes and made up their faces, and I had a very good time because they were very good models.' Realising she had never taken a fashion photograph, Fred stepped into the breach, saying: '"Oh, I'll show you." And he pulled down the black velvet curtain, draped it around himself and picked up a tatty old goatskin rug from the fireplace and draped it round his shoulders. And I said, "You haven't got a hat, Fred." So he picked up a paper bag that had had buns in it for tea and put it on his head. He looked very chic and glamorous. He really had great flair. I made it into a postcard and sent it to all my friends, captioned "Famous Beauty Series No 3", and said "Now I'm a fashion photographer."'[8] Fred was a brilliant mimic, able to conjure up another person physically as well as verbally. Over the years, Bar's photograph of him and fellow dancer Robert Helpmann in the guise of Gertrude Stein and Alice B. Toklas fooled more than one observer. Bar and her friends larked about, ostensibly having fun, but their exuberance was underpinned by a deliberate sense of support for Bar in her new occupation.

Bar had to learn on her feet because Olivia's legacy was far from perfect. Initially she found it hard to manipulate Olivia's cumbersome half-plate camera, and her mind went blank when photographing her first client, who fortunately was kind and patient, suggesting she try again. Bar was delighted when half a

dozen photographs were consequently ordered and six guineas paid. 'I thought this was a marvellous, marvellous way to earn money', she said.[9] Bar learnt quickly, utilising her knowledge of sculpture to calculate how best to light faces in order to create interesting angles and planes. She posed her subjects as she would for a painting, producing unfussy and relaxed portraits. She used backlighting, from several angles, to highlight the neckline and cheekbones, enhancing her preferred pose of the three-quarter profile. Bar also loved an extended neck, a legacy of studying sculpture and her appreciation of Modigliani.

Bar was an artist, a role she shared with Burra, Ashton and Chappell. Moreover, they were all becoming precociously successful in their respective fields despite (with the exception of Ed) coming late to their particular crafts. Speaking for himself, Fred said: 'The thing that a choreographer really needs is an eye. He has to do his training through his eye. It's not a thing you can teach, any more than you can teach people the rudiments of music and turn them into composers.'[10] This statement could equally apply to Bar, who brought a fresh vision to her photography, a new way of seeing. Like Ed, she observed others around her, and while she was not reflective regarding her own life, her ability to absorb what she saw and heard was central to her portraiture.

Whereas hitherto Bar's devotion to the cinema, jazz and blues, revues and cabaret, fashion and ballet was purely recreational, now, in common with Ashton, Burra and Chappell, she applied these interests to her art. Their youthful enthusiasms became central to their work; they were dedicated to developing a form of modernism which embraced and celebrated popular culture. They attended one another's rehearsals and performances, listened to music together, jointly viewed exhibitions, went to the cinema, theatre, ballet and cabaret. They were extremely familiar with each other's work and working

methods and shared a distinctive visual and aural aesthetic. Fred's signature motifs, for example, included jazz dance, and the quavering flicker of hands to the face derived from the melodrama of silent films. While the critical establishment largely perceived these new arts as frivolous and second-rate, Bar and her friends took them very seriously and proceeded to marshal them, with great originality, into their own particular medium.

Ashton said: 'My obsession is the classical dance, the drama latent in it & *the possibility of extending its line to contemporary rhythm & thought* without breaking the line or resorting to the grotesque'.[11] 'Contemporary rhythm and thought' is palpable throughout their work, particularly in the 1930s when, obsessed with jazz, each broke new ground. Bar had the best collection of jazz records. Ed also had a good collection, but was careless, leaving his records to languish, scratched and dusty, on the floor. Usually short of cash, Billy collected on a less lavish scale. But Fred relied on Bar's collection, and was often to be found at the King's Road flat listening intently to her records.

The jazz obsession began in May 1923 when Charles B. Cochran's production of the revue *Dover Street to Dixie* opened at the Pavilion Theatre in London. The first half, scenes set in Dover Street, London, featured a white British cast of Bright Young Things being thoroughly modern and seeking fun. The second half, set in 'Dixie' (the southern United States), was performed by African Americans including the beautiful and magnetic twenty-seven-year-old Florence Mills. *Dover Street to Dixie* was problematic in terms of the deep irony at the centre of the production in so far as the African American performers, only two generations after the abolition of slavery in America, were enacting roles of plantation stereotypes (including a 'Coal Black Mammy' according to the lyrics of one song), of an idealised and romanticised 'white' version of 'black' life and culture. Florence Mills, the show's star, was herself the daughter of

former slaves. The performers represented progress and modernism to an eager 1920s London audience, but it was an audience which did not question the 'white' values that under-pinned the show's capital, production and narrative.

Yet the second half was undoubtedly both a revelation and an inspiration to Bar and her friends. She attended the revue at least four times, perhaps coinciding with the ascendant young British composer Constant Lambert, who also went repeat-edly, though calculating when the second half would begin to avoid the stultifying first half. Lambert recounted the sheer excitement and energy of the show once it got going: 'after the hum-drum playing of the English orchestra in the first part it was an electrifying experience to hear Will Vodery's band play the Delius-like fanfare that preceded the second. It definitely opened up a whole new world of sound'.[12] This was the defining moment for Lambert which affirmed his love of jazz and from which he adopted rhythmic jazz motifs in his compositions. He would soon become the most prolific composer for Ashton's ballets, particularly those of the 1930s, and this shared apprecia-tion of jazz brought a symbiotic quality to their collaborations, a symbiosis shared with Burra and Chappell as their designers and dancer.

A second defining moment in the British taste for American jazz occurred in September 1926 when Florence Mills and the Plantation Orchestra returned to the London Pavilion with a new revue, *Blackbirds*, and an entirely African American cast. In America Mills was considered 'an ambassador of good will from the blacks to the whites'.[13] She sang 'I'm a Little Blackbird Looking for a Bluebird', an anthem for racial equality and civil rights. The popularity of the show, which ran for eight and a half months, was assured by the almost omnipresent Prince of Wales (later Edward VIII and then Duke of Windsor).

Bar and Bumble could not keep away. Nor could Constant

Lambert, who believed that: 'It is no exaggeration to say that if one wants a really perfect ensemble, whether in dancing, singing or orchestral playing, one should go to such an entertainment as *Blackbirds*, rather than to the Ballet, the Opera or the Queen's Hall'.[14] Lambert believed profoundly that jazz should be treated as serious music and it piqued him that critics generally perceived it as dance music. 'It is time people stopped talking about jazz as if it was an unvaried stream of sound', he said.[15] As with *Dover Street to Dixie*, the production, directed by the white impresario Lew Leslie, was problematic, particularly in terms of perpetuating the minstrelsy custom of 'blacking up' members of the cast. The tap-dancing 'Three Eddies', for example, were garbed in black tailcoats, white shirts, white bowler hats, white carnations in their black lapels, white gloves and white spats on their black shoes. The whole black-and-white contrast effect was heightened by oversized white circular spectacle frames and the application of white make-up to their lips. But the spectacle and energy of the show greatly appealed. 'Oh Eddie, BLACKBIRDS!!!!!!' Bar wrote to Ed:

I went to the 2nd Edition last night, and [. . .] my dear I nearly died of joy. Edith Wilson was the cabaret dancer in the most glorious frock of orange satin (skin tight, embroidered with diamonds), with a black velvet poppy on the hem, and black cotton stockings with orange satin strap shoes, it really was a triumph in costumes, when she lifted her skirt she kept on revealing black satin directoires and very full pink garters. Oh dear, the men wore the most beautiful tail suits and everybody kept on getting up and doing the most glorious black bottoms, they did the comedy black bottom, the ordinary black bottom, the tap black bottom, the society black bottom and the triumph of the evening, Edith Wilson did, that low down black bottom, it completely finished me

off [...] when she started to waggle her behind I thought I'd drop down dead with delight. [...] We were all hanging over the edge yelling & screaming after the first few minutes, the house was full, and people were standing 3 deep it was a veritable riot.[16]

The jazz obsession was further fuelled when in January 1927, and fresh from the Folies-Bergère, Josephine Baker came to town. Bar, Clover and Bumble could barely contain themselves, waiting excitedly at the London Palladium for the twenty-three-year-old sensation to ascend the stage. The show was mounted as a charity gala arranged by the composer and musician Noble Sissle in aid of victims of the Thames Flood earlier in the month. Baker arrived very late and without any music, but she more than made up for it by performing for over four hours. 'I wish you'd been', Bar wrote to Ed, 'the whole thing was so glorious'.[17] Ed, Fred and Billy were old hands where *La Joséphine* was concerned, as they had seen her in the *Revue Nègre* in Paris in December 1925. When she transferred to the Folies-Bergère thereafter, Ed went so often that he began to recognise members of the chorus in the street.

Ashton was much taken with Baker's syncopation and rhythm, which he brought to his jazz choreography of the 1930s and to his performance as the 'Dago' in *Façade* (1931) (a ballet inspired by William Walton's musical setting of Edith Sitwell's poetry, rather than by the poems themselves). In 1932 he went further, co-creating a unique fusion of classical ballet and black jazz dancing in the ballet *High Yellow* (slang, at the time, for someone of mixed heritage). His fellow choreographer was Buddy Bradley, one of the best dancers from Harlem who created many dance routines for Broadway musicals but could not officially choreograph a 'white' show and therefore earn due credit for his work. In London he worked for Cochran

and ran a dance school in the West End where he repeatedly played a record by the double-bass musician Spike Hughes, which so impressed Ashton that they decided to ask Hughes to write the music. The Camargo Society's British cast was exclusively white, with the inevitable recourse to 'darkening up' but it was a brave conception given the pervasive critical prejudice about jazz. The critics couldn't really cope with jazz dancing performed by classical dancers and suggested it should be staged as a revue, rather than as a ballet.

Jazz was the subject of one of Burra's most iconic images, *Minuit Chanson* (1931). 'My new occupation', he wrote to Paul Nash from Paris, 'is going to the Boulevard Clichy to Minuit Chanson which is glorious. You put bits in the slot and listen to gramophone records. The clientele is enough to frighten you a bit what with listening with one ear and looking at the intrigues going on everywhere [. . .]. The people are glorious. Such tarts all crumbling and all sexes and colours.'[18] The painting shows the eponymous Parisian record shop full of customers including a sailor, a woman in a mink stole, a pretty boy on the prowl, the writer James Joyce in the background and the main character, a pensive, sharply dressed black man in the foreground. The painting was snapped up by an eager Barbara Ker-Seymer, an early purchase in what would prove to be a long and astute career as a collector of art, in which respect she particularly supported Burra and her friends.

In *Minuit Chanson* Burra portrayed a multicultural society in complete variance to the racist imagery found in the media. In his ballet *Four Saints in Three Acts* (1934), performed in New York, Ashton cast exclusively black dancers, although none were trained in ballet. Moreover, at a time when British society was deeply stratified and xenophobic, Bar knew many African American people through introductions from Olivia and Edna.

These included the Harlem Renaissance cabaret singer and nightclub host, Jimmie Daniels, a sometime resident in London in the early thirties, where he accompanied Reginald Forsythe at Ciro's dance club and restaurant. Daniels was exceptionally photogenic, a characteristic Bar exploited many times. She also took a formal portrait which he sent home to his mother, in which he wore a chequered sports jacket and polka-dot tie. He was extremely handsome, with a beautiful smile and laughing eyes, rather anglicised diction, and – according to Bar – 'perfect manners'.[19] She described him as 'a very good friend, a marvellous companion'. She loved him dearly. He made her flat his London base, coming and going over the years. A wonderful cook, he did all the shopping and produced delicious meals, which he and Bar often shared with the popular cabaret singer Elisabeth Welch. Born to a Scottish mother of Irish extraction and a father of African American and Native American descent, Welch was famous for the songs 'Stormy Weather' and 'Love for Sale' and very well known in Britain for her frequent appearances on the popular BBC Radio series *Soft Lights and Sweet Music*. Bar photographed her many times professionally, backstage at the theatre, and as often informally, usually with Jimmie.

Bar was famous for her parties, which invariably included Jimmie or other temporary Harlem migrants as guests. Unfortunately, the British Union of Fascists set up shop on the King's Road close to Bar's flat, at the ironically named Black House next door to the Duke of York's Barracks. Here they trained an elite group of fascists in martial arts to protect their members in street fights and to control meetings. The gates of this establishment were manned by thugs known as 'Biff Boys', who terrified Bar's black and gay friends, hurling insults and taunting them as they emerged from her flat on their way home. Bar always regretted having taken on a

commission to photograph Oswald Mosley, but she did make him look grim.

She also took photos of Nancy Cunard – an iconic figure, famous for her idiosyncratic fashion sense, her cropped hair, cloche hats, kohl-lined eyes and the multiple African bangles ascending her arms. As a future heiress, the daughter of a shipping magnate and American socialite, she often featured in the press, which puzzled over her outspoken intolerance of racism. In 1930, when Cunard was thirty-four, her wealthy mother Maud, or Emerald as she liked to be known, heard rumours that her daughter was in a relationship with an African American man. Discovering this to be true, Maud confronted Nancy, threatening to have her lover, Henry Crowder, deported. She then embarked on a campaign to force Crowder to return to the US, hiring detectives to follow the pair. In response, Nancy wrote an article published in 1931 in the African American journal *Crisis*, entitled 'Black Man and White Ladyship', attacking her mother and her racist values. The article was also privately printed in Toulon, enabling Cunard to distribute it more widely among her friends, including Bar.

'I'll tell you what I'll do', Bar said to Nancy, 'I'll take a photograph of you and turn it into a negative and make you into a black lady'.[20] Thus Bar over-exposed the negative, reversing the light and shade: a technique discovered by Man Ray and known as solarisation. The photograph proved sensational. Bar harnessed Cunard's notoriety, and in reversing her skin tone emphasised the divide between privilege and disadvantage. It was a masterful act. The photograph was widely disseminated and immediately considered a work of innovation. It was also printed in *The Times* three years later to mark the publication of *Negro*, Cunard's massive anthology on black history and culture written by distinguished

contributors including Louis Armstrong, W. E. B. DuBois, Langston Hughes and William Carlos Williams. For someone who described herself as 'frivolous, *or apparently frivolous*', Bar had created a work which was both political and provocative.

CHAPTER SIX

A Studio of One's Own

In 1930 Bar met two American women who would be significant in her life and, despite living most of the time on another continent, would also become lifelong friends. Emily Hahn, always known as 'Mickey', breezed into the studio early in the year, a very confident woman the same age as Bar. She was Jewish American, beautiful with large pale green eyes and dark, wavy hair. She had taken a flat in Bloomsbury near the

British Library, where she was undertaking research on the life of King Charles II. Mickey was clever. She studied Mining Engineering at the University of Wisconsin, the only woman in an all-male bastion, and in 1928 took graduate studies at Columbia University in New York. The following year, aged twenty-four, she was contributing to the *New Yorker*, for which she would write prolifically throughout a long writing career. She was also unusually adventurous, later travelling solo in Africa and surviving on her wits in Hong Kong and Japan during the Second Sino-Japanese War. Mickey had a snappy sense of humour, a penchant for irony and a quick wit. She was impulsive, independent and extremely self-reliant, in many ways similar to Bar, but she was also incredibly brave and actively sought adventure.

Arriving at the studio clutching a letter of introduction to Olivia, Mickey found Bar and Fred instead. Bar was immediately drawn to her sassy humour and palpable self-confidence, considering her 'very brave to walk in and start talking to perfect strangers'.[1] Mickey soon fell into the habit of arriving at Bar's studio every day in time for tea. In an autobiographical short story entitled 'Aisle K', published in the *New Yorker*, she described the routine, fictionalising Bar as 'Julia'. 'At that hour, as I learned, there were always several people at the studio, who came in every day and brought things to help out when they happened to have the money – biscuits, or sugar, or tea itself. I liked to go there because being an American was not a bad thing at Julia's. If anything, it was good. She and her friends had such a dread of being insular that they would have made me welcome even if they disliked me personally. They didn't dislike me – they teased me, but they didn't dislike me.'[2] For Bar, who then admitted to being somewhat cliquey, it was refreshing for this 'strange', very 'normal' 'American girl' to come into their midst.[3] In time, Mickey would become Bar's

most valued woman friend and confidante, but for now they shared an enjoyment of jazz, cinema and having fun.

The other American (who Bar probably met through Joe Carstairs) was Marty Mann, another clever woman then working as a journalist for *Town & Country*, an upmarket American magazine owned by William Randolph Hearst, to which she contributed columns on British society figures and cultural life. Pretty, with short Marcel-waved hair and a figure which favoured matelot trousers and clingy thirties dresses, she was a year older than Bar. In some respects, their early paths were similar: both came from wealthy families and had bankrupt fathers and both studied art in Florence in 1924 (they missed each other by a matter of months). But in one important respect they differed: like Olivia and Ruth, Marty was a drinker while Bar was not. According to her friend Forbes Cheston, Marty was 'apt, when in her cups, to become belligerent [. . .]. When sober she was a sagacious and amusing companion, with a raffish insight into other people's foibles'.[4] It was this sagacious side which triumphed in the early days of their friendship, but the trials of a close friendship with a heavy drinker soon became apparent.

Marty, whom Bar described as 'a very sort of go-ahead, pushy character', thought Bar needed a bigger studio at a better address to attract the right type of clientele.[5] Specifically, she thought Bar should find a studio on Bond Street, the nexus of London's high-class photographic studios. Bar went along to view a property, and discovered, as a consequence of the economic slump, that a studio at 15A Grafton Street, above Asprey's the jeweller, was affordable at a rent of £90 per annum (£4,120 today) and she took on the lease. Jettisoning the connection with Olivia, Bar settled on the name 'Ker-Seymer Photographs' which was to the point and emblematic of her confidence and independence. In contrast to Olivia's rather

dishevelled and dissolute appearance, Bar was determined to present a professional and stylish front and as her business developed, she became known for wearing Schiaparelli in the studio. She looked after her clothes and when, during the Depression years, high-end fashion was less affordable, she updated her outfits with new accessories including her favourite pillbox hats from Jean Patou.

Bar's studio was surrounded by well-established competitors, many of whom enjoyed royal patronage. 'Whats this about Bond st? Muscling in on Bassano & Lafayette[?]', Ed quizzed, in his customary deflating manner.[6] It was a good point. At number 8 Grafton Street pageboys flanked photographer Hugh Cecil's door, ostentatiously opening it for his lofty clients including the Prince of Wales. Hay Wrightson, who also photographed many members of the Royal Family (including the future Queen Mother, seen in a series of portraits sharing a chair with a favourite dog), was located on Bond Street nearby. The long-standing photographic institution, Bassano Ltd, was around the corner on Dover Street. Dorothy Wilding, perhaps the most famous British woman photographer of her generation, was located across the road from Bar. Disdaining to take engagement or court presentation photographs, Bar would send any clients requesting these straight over to Wilding's studio. In a quintessentially art-deco style, Wilding produced head-and-shoulder portraits, often in profile and usually heavily retouched, set against a white background, which she lit beautifully. She took many portraits of the Royal Family, and those of Queen Elizabeth II graced two decades' worth of British postage stamps, known affectionately as 'Wildings'. In contrast, Madam Yevonde, another highly successful photographer based in Mayfair, was an early pioneer of colour photography, experimenting with the short-lived Vivex colour print process and producing a series of portraits of female society figures as

goddesses. In a field dominated by men, Wilding and Yevonde stood out as successful photographers – and were now joined by Ker-Seymer Photographs.

For Bar, the most conducive contemporary photographer was Paul Tanqueray, and it was her good fortune that he was based nearby on Dover Street. Tanqueray was an exact contemporary of Bar's, although more experienced, having opened his studio in 1925 as one of the youngest professional photographers in London. At the cutting edge, he specialised in film stars, musicians and actors, his work frequently gracing the pages of the *Sketch*, *Tatler* and *Theatre World*. A snappy dresser, Tanqueray was unassuming and kind and became a friend and something of a mentor to Bar.

In contrast to Wilding's ultra-modern art-deco gallery, Bar's studio was approached by treading a threadbare carpeted staircase. There she worked alone, without her competitors' teams of willing assistants. Her backdrops were not the ornate creations of Cecil Beaton (who used as many as six cheval mirrors to reflect a small patch of sunlight onto a sitter), but three curtains: one black, one grey and one white. Her approach to her subjects was simple: 'I don't like posing people', she said, 'I like people to sit naturally [. . .] people as they might be when you were just sitting talking to them – photographed like a loaf of bread instead of a cream cake.'[7] She often photographed clients sitting in a relaxed pose on one of the two easy chairs in her all-white studio: for instance Evelyn Waugh, with his wrists lightly resting on the arms of the chair. She also utilised a white wooden box chest, perching people on it, or leaning them against it – including the journalist and aspiring politician Randolph Churchill, sitting hunched against it, looking pensively into his future (the middle distance), one hand lying loosely on his other wrist.

Bar's studio also operated as a common room in which

her friends gathered; she called it 'a marvellous play-ground'. 'Anybody at a loose end would come in, they knew the door was always open'.[8] Between clients Bar would experiment, using her friends as models. Whoever happened to be present was fair game, and everyone enjoyed joining in. On one occasion Bar's old friend Peter Spencer arrived, only to find Freddie Ashton present. Billy came in with his friends Tony Bruce and John Goodwin, and all five were snapped, Billy off-centre, a cog around which the others seemed to revolve. The photograph has an energy and dynamism made possible by the eager participation of friends who enjoyed being part of Bar's photographic experiments and recognised she was brilliant at her trade. It was (seriously) good fun.

One such experiment saw Billy's head served up on a plate, a photograph clearly influenced by Curtis Moffat, a photographer Bar knew and admired and referenced in several works. This particular image alludes to one of Moffat's 'snapshot' series taken between c.1925 and 1930 in which an outdoor table, strewn with the debris of a meal, lies abandoned with a severed head in its midst.[9] (The title of the series is a misnomer as it is a precisely staged still life.) Bar knew Moffat through Olivia, and in June 1929 she and Fred and their mutual friend, the designer Sophie Fedorovitch, attended the opening of his new interior design gallery in Fitzroy Square. Bar's experimental work also posed friends before two enormous murals of art-deco horses and surrealist hands contributed by Sophie and another friend, the artist John Banting. She photographed Ed in the guise of his sometime alter ego, 'Dorothy Ex Bureau', grimacing while coquettishly revealing a tattooed shoulder. Bar deliberately eschewed the 'safe' and rather stereotypical studio portraiture of many of her contemporaries, utilising instead these informal sessions to experiment. She did not like creating images which were

too arranged, too perfect. It was only by breaking rules that new ways of expression could be found.

As a surrealist artist John Banting liked to occasionally 'collaborate' with Bar, although she came to regret larking around with him in the studio. Banting was a close friend of Nancy Cunard, and it was he who posed Cunard reclining uncomfortably across a sheet of corrugated metal, adorned with her signature bangles, leg-warmers encasing splayed legs. These photographs, so contrary to Bar's own portraits of Cunard, remain among her work in Tate Britain. She emphasised: 'The two photographs (which weren't even good ones) of Nancy Cunard were posed by John Banting and I merely pressed the shutter. I disowned them completely having taken much better ones myself.'[10]

Bar's friendship with Banting began inauspiciously: she was walking in the garden of an artist friend's studio when from above a sudden deluge of brandy poured over her. Bar marched into the studio and finding Banting there, slapped his face. 'Oh dear!' he said. 'What does one do to a case like this? One turns the other cheek', which he did, receiving another whack.[11] Later in life, drink overcame him, and he enjoyed regaling anyone who would listen with lurid tales of his sex life. But Bar adored him, recognising that he was, in fact, a 'dear and gentle creature'.[12] She was also an early admirer of his work, purchasing several of his surrealist paintings.

Given the peripatetic nature of their crafts, Bar was used to her friends disappearing when work took them away. But perplexingly, in the years following Clover's marriage in 1928, there had been no word from her. Bar, Ed and Billy continued to write, but received no replies. Unbeknownst to her friends, Clover was having a terrible time. She had been incarcerated by her husband on his country estate, where he intercepted her mail and prohibited her from engaging in correspondence.

She was horribly lonely while he remained absent, pursuing adulterous affairs. In the hope, perhaps, of finding a way to reach out to her friends, Clover asked her husband whether she could write a letter to the *Morning Post* in defence of surrealism. Inexplicably, he agreed. Some days later, snatching a rare opportunity to glance quickly at the mail, she found a joint letter from Bar, Ed and Billy, who had seen her piece in the paper and were making anxious and affectionate enquiries about her welfare. At that moment she decided to leave and fled to Buda. Learning of Clover's flight, her friends could only feel relief that she was safe and would return to the fold.

By now Marty and Bar had become lovers, cohabiting at the King's Road. Marty could not bear to be apart from Bar, writing on assignment from Paris to say that without her, she felt empty, that she longed for her company, and adored her. Even though Marty was 'a dead bore when she was drunk' and unpredictable, she helped to cement Bar's career in one important way: she needed photographs to illustrate her *Town & Country* articles, and so was able to commission Bar to photograph the writers and celebrities featured in the magazine.[13] (Bar's photographs reached the United States via a Fleet Street Global Syndication service.) Thus Bar acquired regular work and a prestigious platform in the United States, where she illustrated not only Marty's columns, but also those of Curtis Patterson, the magazine's literary critic. Her sitters included the writers Richard Hughes, Louis Golding, Evelyn Waugh, Richard Aldington and the ubiquitous Godfrey Winn (a newspaper columnist and writer for women's magazines known as 'Winifred God' for his popularity among women readers).

Olivia's bulky single-lens plate camera soon proved impractical. It was a lengthy process to set up a photograph and seconds could lapse between deciding to make an exposure and being ready to take it. The paraphernalia were cumbersome and the

apparatus notoriously unstable. Bar therefore decided to invest part of Aunt Winifred's legacy in a Rolleiflex, a modern, light-weight, portable and highly flexible camera, which was quick and much easier to operate. Designed by Reinhold Heidecke, the Rolleiflex was a small two-lensed camera with a roll of film running across the bottom corner to maintain tension. Its viewing and photographing lenses matched precisely in focal length, making focusing both accurate and sufficiently quick to create a bright image in the viewfinder. The camera was an instant success, because for the first time, in mass-produced form, it enabled photographers to view the subject while making the exposure. It was cheaper than a Leica, the profes-sionals' other favourite, selling originally in 1929 for sixteen pounds and seven shillings (around £850 today). According to Cecil Beaton, an advocate, 'it is an all-weather camera which can be employed on almost every occasion, and it is so simple to manipulate that the handling of it becomes automatic. It is a great advantage to be able to see the composition one is about to take'.[14] Another joy was that the negative was big enough to enlarge to almost any size. It proved to be a classic, unrivalled until the advent of digital cameras.

Bar's Rolleiflex was perfect for studio use but its portability and light weight opened doors into a more expansive world. In August 1931 it took her to Toulon where she was commissioned to photograph the cultural polymath Jean Cocteau. Playwright, poet, novelist, film-maker, designer, visual artist and critic, his elevated cultural stature together with a lean physique and handsome, sculptural physiognomy, made him attractive to the leading artists and photographers of the time. In the 1920s and '30s he was known for his addiction to opium and he did not keep his homosexuality a secret. While undoubtedly delighted to have the opportunity to photograph the iconic Cocteau, Bar was equally attracted to the prospect of visiting Toulon, the

playground of young bohemia and a destination she had long anticipated, especially as Ed and Billy had regaled her with details of their previous sojourn in the South of France.

It was no accident that many of Bar's inner and wider circle converged on Toulon that month, with a smattering of the American equivalent of her talented, carefree bohemian friends. Over a matter of days, individuals and groups arrived and merged. Fred rolled up with Sophie Fedorovitch; Ed and Billy arrived with Bumble and her brother 'Boy'; two of Bar's childhood friends, the languid, exquisite Brian Howard and Anthony Powell, turned up, the latter fresh from the publication of his first novel, *Afternoon Men*. According to Powell's biographer Hilary Spurling: 'It was as if the London cast of a contemporary *Beggar's Opera* had descended on Toulon.'[15] Having first languished in Paris, missing Bar, Marty arrived and then a contingent of up-and-coming Americans appeared: the author George Davis and wealthy art collector Arthur Jeffress among them. This disparate crowd soon became one and even the pale beauty Bunny Roger condescended to go to the beach, although he resolutely kept to the shade.

Bar found both the location and the gathering extremely conducive and was in her element snapping Fred pirouetting on the beach and Billy in the shallows making patterns with his legs in the wet sand. With her tiny Zeiss 'Baby Box' camera which cost twelve shillings and sixpence, Bar took endless snapshots: sixteen minuscule photographs to the reel, each measuring three by four centimetres. Her albums containing these images provide a unique record of this talented generation at play, revealing the sheer joy of being in a large, convivial and youthful group enjoying the freedoms Toulon offered. It was the early 1930s equivalent of attending a music festival today, where individuals converged to share a hedonistic, collective experience.

With the exception of the Americans, they were all hard up. Toulon was not a smart or glamorous place. It was a port and naval base, 'the French equivalent of Portsmouth'.[16] They congregated there because it was cheap and stayed at the basic and inexpensive Hôtel du Port et des Négociants on the Rade. According to Bar: 'We used to have supper in a brasserie where you could get a *macedoine* of vegetables for something like sixpence'.[17] 'Toulon was full of English people', she recollected, 'so was Cassis, and the whole of the S[outh] of France, but the "smart" places like Cannes & Monte Carlo [. . .] were far too expensive for us'.[18] The relative depths of their pockets was often cause for contention. Freddie liked to eat steak to preserve his strength, but Billy was always short of money and they fell out, a particular inconvenience as they were again sharing a hotel bed to save money. Although they often bickered, Billy and Fred remained devoted throughout their lives, but were never lovers.

Part of Toulon's attraction, for the homosexual men at least, was the presence of sailors – Bar took an amusing snap of Ed gazing wistfully from an upstairs window as a pair of matelots disappeared down the road. One evening at the ballet he had been so transfixed by an American sailor in the dress circle that he had barely been able to concentrate on the dancing. For Ed, the associated attractions of sailors and sex workers, or 'tarts' as he called them, were perfect source material. On a rare excursion, he and Bar took a bus to Marseilles, making a beeline for the red-light district to photograph the 'tarts' on the booth-lined streets where they plied their trade. Perhaps Bar and Ed hoped to create a daytime version of Brassaï's nocturnal views of low-life Paris. They were thwarted in their endeavours and the sex workers chased them away. However, in *The Nitpickers* (1932) Ed painted 'tarts' congregating on pavements outside their booths in a southern French seaport, a scene similar to those he and Bar hoped to capture in Marseilles.

Princess Violette Murat, an enormous woman then in her fifties, raddled by excesses of opium and alcohol, was in Toulon that summer. If Olivia had been the queen of lesbian London, Murat was the empress of the French Riviera, where she sailed along the coast, periodically coming into port to see which pretty women were about. She espied Bar, Marty and Bumble and invited them onto her yacht, where Bar photographed the scenery as it passed by.

While Burra painted all day in his room, and Anthony Powell stayed behind to write, the others travelled by paddle steamer to a beach called Les Sablettes, where, with the exception of Bunny Roger, they all sunbathed. Sunbathing was a craze and tanned skin was much admired. In both Britain (excepting Brighton) and France men were not allowed to bare their chests on the beach and were expected to wear one-piece bathing suits. They kept an eye open for the gendarme who patrolled the beach in case he caught them topless. The women wore backless one-piece swimming suits, and in town Bar and Bumble donned Chanel-influenced beach pyjamas with flared legs and backless tops or chic calf-length linen skirts, with striped tops tucked into wide belts. The male version of this ensemble consisted of striped tops or dark jerseys with handkerchiefs tied at the neck, espadrilles and bell-bottomed trousers. In a matter of just over a decade, women's clothes had transformed from Edwardian ankle-length dresses, S-shaped in profile and emphasising the bust, to liberating styles which would be familiar in the twenty-first century. In Toulon, young men were released from their stuffy three-piece suits, starched collars and frock coats into what would be considered suitable holiday-wear today. 'Billy has come out in a lovely toilette of linen trowzers bathing shoes a pull over & red kerchief and a jolly béret', commented Ed, 'oh you know old men have young ideas when they see Bill'.[19]

Bar was there to work and so putting aside the Baby Box, she took up her Rolleiflex in readiness for Cocteau. He was staying in the same hotel, often locked away in his room smoking opium with his lover and protégé Jean Desbordes, and the artist and Ballets Russes designer Christian Bérard. Bar remembered: 'We kept thinking what a delicious smell there was on the stairs and boxes kept arriving covered with Chinese lettering but we were too innocent at first to know what was going on'. Although Bar was on assignment to photograph Cocteau for *Town & Country*, he asked her to take private photographs of him smoking opium. 'He was very good and easy', Bar said, 'he loved being photographed', but when she entered his room she found them 'all lying on the floor unconscious with the blinds drawn'. Anyway, attempting to take photographs was impossible, as the room was too dark, and she had no flash. She was also assailed by Cocteau's 'very obstreperous monkey' which 'kept trying to get inside my camera'.[20] In the end she gave up and crept away. However, she did manage to take some fine photographs of Cocteau and Desbordes variously strolling along the beach, leaning over the balcony of their hotel room dandling the monkey, and displaying terracotta masks, all of which were widely published in newspapers and art magazines. There is, however, a contact sheet containing thirty images of Cocteau striking dramatic poses, seemingly in quick succession. Set against a bright, luminous background, the figure of Cocteau is inky black, and with his arms or hands aloft, he appears to move jerkily from frame to frame, resembling an animated marionette or figure in a flip-book kineograph. These photographs appear not to have been published, and it is possibly these, as well as the published photographs, to which Cocteau responded with admiration and delight.[21] Ill in hospital and unable to thank her personally, he insisted Desbordes wrote on his behalf. 'The photographs are splendid, never has

Cocteau seen such good ones and me also, naturally. They are magnificent. I congratulate you with all my heart.'[22]

For Bar the whole experience was far more than a holiday, it was an awakening in which the port of Toulon, with its sailors, stevedores, bustle, edginess, Mediterranean light and heat conferred a sense of complete artistic freedom and licence to do as she pleased. It was as if she could not stop photographing everything she saw and everyone she knew. Toulon had an immense impact on them all, in particular inspiring Fred's next ballet, *Rio Grande*, which would be designed by Burra and in which Billy danced the role of 'the Creole Boy'. The music, which can broadly be described as symphonic jazz, had been composed by Fred's close friend Constant Lambert in 1926 and widely admired by his peers including Elgar, Malcolm Arnold and a young Benjamin Britten.

The composition's title derived from a poem by Sacheverell Sitwell entitled 'A Day in a Southern Port', set in a coastal town in Brazil. Fred transposed the location to the South of France, in a town closely resembling Toulon, at the dockside with its colourful cast of sailors, tarts, stevedores, stokers and onlookers. Set and costumes were designed by Burra with utter relish, based as it was on the Place Puget's dolphin fountain, with a buxom nude added for good measure. Billy described the ballet as 'a Burra painting come to life'.[23] Premiered by the Camargo Society at the Savoy Theatre on 29 November 1931, some critics considered the backcloth too lewd and Burra's costumes were controversial, showing bare thighs and skin-tight bodices. Billy as the Creole Boy was sexually insolent in bell-bottomed trousers and a sequinned singlet. But Burra fulfilled Ashton's brief in contributing to the ballet's re-creation of the erotically charged atmosphere of Toulon. Unsurprisingly, it seemed jarring to some members of the audience, appearing in a programme alongside music by Handel and Chopin.

The principal dancers were Lydia Lopokova, miscast as the Queen of the Port; her Sailor, Walter Gore; a Creole Girl, the divine Alicia Markova; and Billy as the Creole Boy. In a 1935 reprise, the teenage Margot Fonteyn took over Markova's role, later confessing to having a crush on Billy at the time. Ashton created the role of the Sailor specifically for Walter Gore, the object of his unrequited love. Its virility and choreographic complexity suited Gore, and as Billy remarked: 'Fred put every single trick and twist and turn in it to show Wally off'.[24] It was one of Billy's favourite ballets, and he considered it 'something of an achievement' that it 'did not pander to public taste'. Burra's backdrop and costumes were guaranteed to cause 'an astonished hush among the chattering audiences when the curtain rose'.[25]

As with all ballets, *Rio Grande* was a collaboration between choreographer, composer and orchestral conductor, set and costume designer and the dancers. But in this ballet Ashton drew together some of his closest and most talented friends to create what his biographer Julie Kavanagh described as 'a masterpiece [...] as a classic of transfigured jazz'.[26] Bar was the final part of the collaboration, in front of the proscenium, wielding her Rolleiflex on assignment for a new client, *Harper's Bazaar* – she would also work for *Vogue*. Bar had progressed to working for the two most prestigious high-end magazines of the twentieth century. In their quests for pole position, *Vogue* and *Harper's* commissioned only the finest photographers. Bar's professional reputation was in the ascendant and her business flourished. Professionally she was making good, decisive choices. Her emotional preferences would, however, prove less secure.

CHAPTER SEVEN

Marty's Betrayal and a Pact with Fred

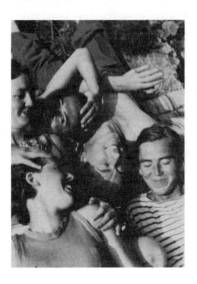

B ar did not see much of her parents. She received affection-
ate letters from her mother who was touring the States,
and occasional letters from her father, who remained bemused,
or perhaps confused, by Bar. He must have held her firmly in
mind when, in his aptly titled autobiography, *Idle but Happy*,

he mused: 'One cannot but admire the young girl of to-day, with her sturdy legs, her complete independence, and her frank *camaraderie* with all and sundry. Will this independent young thing marry? I suppose she will some day, although she is much too busy to think about that sort of thing at present.'[1] Vere echoed prevailing anxieties: 'Youth and womankind have small respect for tradition – they are, perhaps naturally, impatient of it; yet it is on tradition and patriotism that the greatness of this country was built up.'[2]

Vere and Diana had moved from Gledstanes Road to Hornton Street in leafy Kensington, and there Vere died, suddenly, on 7 January 1932. In an obituary in *The Times* his old friend Colonel J. T. C. Moore-Brabazon wrote: 'He lived to see the motor-car become universal, and the aeroplane of use rather than experiment [. . .] and all who remember the early struggles [. . .] will mourn the loss of a very dear and loyal friend.'[3] The extent to which Bar mourned the loss of her father is unknowable as there is nothing recorded in her correspondence, but it was at this time that she turned – for emotional support – to Dolly Wilde. A decade older than Bar, Dolly closely and deliberately resembled her uncle, Oscar, in dress and manner, although she was beautiful, with violet-blue eyes. She possessed a uniquely sympathetic nature, which her friend Victor Cunard described as understanding 'the joys and miseries of the human heart so well that the habit of going first to her to share happiness or find comfort in distress was quickly formed'.[4]

There are several avenues along which Bar and Dolly may have converged, Dolly's cousin Vyvyan Holland being the most obvious, although she did not get on well with him. From 1927 Dolly lived, on and off, in Paris with her lover Natalie Barney, so Bar may have met her through Marty, who sometimes attended Barney's salons. Dolly also had leanings towards Christian Science, at one time taking a serviced flat

on Queen Street, Mayfair, around the corner from the Third Christian Science Church attended by Diana Ker-Seymer. She was also a close friend of Peter Spencer. Wilde was a drug addict, although at the time of her involvement with Bar, she had taken a temporary break from heroin. She was both highly sociable and reclusive, decamping periodically from Barney's ménage to alight in various hotels or the homes of friends, in Paris and London. Her biographer, Joan Schenkar, refers to Dolly's 'emergency seductions', in which she doled out heartfelt advice while preparing to pounce.[5] Such was the nature of her relationship with Bar. 'You're still in my thoughts', Dolly wrote after one encounter, '& I'm wondering what you're really like. Sugar & spice and everything nice. All that plus something that disconcerts – is it cunning? Or hardness? [. . .] Let's meet again soon & I'll find out'.[6] It was neither cunning nor hardness. Although Bar benefited from Dolly's warm sympathy, she was less keen on the reciprocal intimacy expected by her friend. Dolly could not fail to notice what she described as Bar's 'armoured indifference to the comfort I wanted to offer you', but it was an 'indifference' Bar managed to sustain.

Bar's sadness derived from a combination of grief following the loss of her father and the deteriorating state of her relationship with Marty, whose drinking had spiralled out of control. She had resorted to stealing. In Paris, on the way back from Toulon, Marty stole Bar's Rolleiflex and was quick to sell it on. The camera had become almost an extension of Bar and she found it hard to believe that her lover, the woman who shared her home, could stoop so low. In the fickle, fast-moving world of magazine publishing, Bar needed to miss only one assignment to be passed over for another photographer waiting in the wings. Bar felt Marty's betrayal personally and professionally: a double duplicity.

Dolly advised Bar to forget Marty, 'as her attitude shows so

little imagination & kindness that I feel she is no longer the M you know'; 'decide one way or the other', she counselled.[7] But Bar could not help feeling concern for Marty's health and well-being and felt unable to cut her from her life. As her behaviour became progressively erratic, Marty moved from one social group to another, literally and metaphorically weaving in and out of Bar's life. She tried her hand at running a country pub, an enterprise doomed from the beginning, and then abruptly moved to Scotland. Ed was confused by her perambulations: 'I had a rain of postcards from Truant Mann from "auld reekie" (Edinburgh) what can she be doing[?] am daily expecting a few cards from Shanghai she seems to have got going so why should she stop[?]'[8] It was as if she was running away from herself.

Marty eventually reappeared in London where she found short-lived employment managing an opera company, before falling or jumping from a second-floor window, breaking a leg and a hip and fracturing her jaw. After six months in hospital she retreated to a rented deckchair in Hyde Park, where she sat huddled, sipping from a bottle. Bar visited her every day, to ensure that she was safe, and tried to prevail upon her to stop drinking. Then one day Marty was absent from her perch. Having borrowed money for the passage, she had departed for New York, with no goodbyes or fond farewells. After a long silence Bar discovered that Marty had sought help from Alcoholics Anonymous and begun a new life as the (now sober) Director of the National Council on Alcoholism, where she campaigned for alcoholism to be recognised as a disease, rather than as a social choice. Despite their fractured history, she and Bar remained friends and occasionally saw each other when Marty's mission brought her to London.

It was Aunt Winifred who resolved the problem of replacing the stolen Rolleiflex with the timely payment of the second half

of her legacy. Bar told her aunt the camera had gone missing in Paris. 'I do hope that when you get a new camera, you will be careful ALWAYS to lock your door when you go out', Winifred remonstrated, 'in every hotel, in any country, and ALWAYS to lock your door at night'. The legacy was a substantial gift, in the form of shares valued in 1931 at £2,300, the equivalent of over £100,000 today, with the added advantage of an annual income of £90 (£23,000). Aunt Winifred exacted a promise, however, that Bar would not part with more than £500 of the capital during her lifetime (Winifred died in 1958). Given that Vere died intestate, this was a very welcome gift, which Winifred bestowed because her niece had proved herself 'capable of handling your money matters satisfactorily.' There was a little sting in the tail: while Winifred approved of Bar's independence (having come late to marriage herself), she disapproved of her style, or rather, the lifestyle it signified. 'I can't say I like the Pyjama and Matelot costume Stunt. Evening dresses are so VERY pretty now-a-days, it seems a pity to be eccentric, and not wear them.'[9]

Despite his physical frailty, Ed was overseas for much of 1933 and Bar missed his semi-regular visits to the King's Road flat. He omitted to alert his parents to his travel plans, at the time of departure merely mentioning to his mother that he was going out to the garden. He spent spring in Paris and Spain, and early autumn in Marseilles, setting off afterwards, accompanied by Sophie Fedorovitch, for New York. There he stayed in Harlem with Olivia, Edna Thomas and Edna's husband, Lloyd (who lived amicably with his wife and Olivia). While there, Ed had a surprise encounter with Bar's old flame Ruth Baldwin. 'There was a jolly cocktail party the other day', he reported, 'at which Dame Baldwin appeared and did she get a turn when she saw me walk in if the empire state building had crept in on all fours she couldn't have had a worse shock.'[10] Still addicted to

drugs and alcohol, Baldwin died a few years later, following an overdose.

Harlem was a revelation to Ed and he was taken around by Olivia, who knew everyone and all the best speakeasies and nightclubs, drag-clubs and drag balls and clubs catering for gay or lesbian clienteles. 'Theres so much talent at the partys here that its more like non stop Variety', he wrote with his usual careless punctuation and spelling. 'We went to the Savoy dance Hall the other night', he told Bar, 'you would go mad Ive never in my life seen such a display an enormous floor half dark [. . .] Ive never seen such wonderful dancing'.[11] He wrote regularly to Bar who loved his colourful letters and longed to go to Harlem herself. Harlem was another country and Ed's ensuing paintings were quite unlike those of any other British artist at the time. The famous *Harlem* of 1934 with its brownstone tenements, elevated tramlines and people going about their business and gossiping – and the more edgy *Harlem Scene* (1934–5) – were painted after his return to Britain, every detail etched in his memory. Cool dudes on street corners; young revellers at play in nightclubs; women returning home with laden shopping bags; people emerging from basement flats or gossiping on the steps above. Bar adored these paintings, which brought her as close to Harlem as she could get, at the time, while work commitments confined her to London. It was all the more galling, therefore, when Fred, too, returned from New York, full of his success from collaborating with Virgil Thomson on his opera *Four Saints in Three Acts*.

Arriving in New York by ship, Fred had been overwhelmed by its famous skyline. He thought the city '*marvellous* – Harlem, the parties, all the jazz'.[12] He too had gravitated to Olivia and Edna's apartment, where he found Bar's close friend Jimmie Daniels, host and entertainer at one of Ed's favourite Harlem clubs, the Hot-Cha, 'a dive but an elegant dive.'[13] Daniels

accompanied Ashton to the Savoy Ballroom in order to identify potential dancers for the *Four Saints* opera. There were few ballet schools and even fewer black ballet dancers, so those selected were untrained, but chosen for their potential. And it worked. Ed and Sophie were in the audience the first night, witnessing the opera's immediate success.

Bar enjoyed a vicarious taste of Harlem in June 1933, with the eagerly anticipated arrival in London of Duke Ellington, the band leader of the famous Cotton Club in Harlem. While appealing to a largely African American audience in America at this time, in Britain he was a superstar, appearing for two weeks at the London Palladium at the beginning of a forty-six-day concert tour. Of course, Bar was in the audience that first night, with a large group of jazz-mad friends who had taken the first two rows of the stalls from where they showered the musicians with flowers. Ellington received a fifteen-minute standing ovation the moment he appeared onstage. Afterwards, in hired cars, they followed the charabancs conveying the band to play a late set in a Brighton nightclub, returning at dawn singing the Duke's numbers all the way. Bar was in the audience a third time when Ellington played the Astoria dance hall. Constant Lambert, a fellow devotee, celebrated Ellington's musicality and orchestral dexterity in his *Sunday Referee* music column: 'The orchestration of nearly all the numbers show an intensely musical instinct, and after hearing what Ellington can do with fourteen players in pieces like "Jive Stomp" and "Mood Indigo", the average composer who splashes about with eighty players in the Respighi manner must feel a little chastened'.[14]

Bar's stamina for late nights remained undiminished, although there was less pressure in the studio because in the autumn of 1932 she had taken on Julia Strachey as a part-time personal assistant, at a salary of £1.00 per week. Though Julia had studied commercial art at the Slade School, she was

notorious for her tardiness and her intense dislike of matters practical – attributes hardly recommended for employment – but Bar, who was capable of generous but discreet acts of kindness, had taken pity on her as her tempestuous marriage to the sculptor Stephen 'Tommy' Tomlin was coming to an end. Julia had experienced an unhappy and disjointed childhood, spending her first six years in India until her parents divorced and she was sent to live in England with an aunt she did not know. She was subsequently parcelled about between various aunts and sent to boarding school at Bedales. She had recently enjoyed success with her first novel, *Cheerful Weather for the Wedding*, published in 1932 by the Hogarth Press to critical acclaim.

Bar and Julia were good friends, and Julia was equally at home with her Bloomsbury relations and associates as with Bar and her circle. Julia's husband Tommy was a fixture in Bloomsbury. While the denizens of Bloomsbury were a couple of decades older than Bar and her friends, the two groups overlapped. Both Fred and Billy were regular guests of the ballerina Lydia Lopokova and her husband, the economist John Maynard Keynes, despite the latter's tendency to pounce upon the younger men. Through Julia, Bar would become friendly with Frances and Ralph Partridge and it was possibly also through Julia that she found herself at a party hosted by the Bloomsbury artist Duncan Grant. There she met the writer David 'Bunny' Garnett. A self-confessed and enthusiastic libertine, Bunny acknowledged that his main ambition at a party was to 'get the young woman whose eyes answered one's own downstairs in an empty room among the hats and coats'.[15] Evidently his eyes locked with Bar's.

She and Ashton had recently conversed about sex. She said to him: 'I really think it's time you had an affair with a woman', and he replied: 'Well, I think it's high time you had an affair with

a man', so a pact was made. While Fred's aberration occurred with a chorus girl, Bar's man was probably Humphrey Pease, who she had known since the 1920s when they were fellow students at the Slade. When she called Fred the following morning to see how things had gone, he said it had been 'terrible'. On his asking Bar how she had fared, she replied: 'Wonderful, I'm never going back'.[16] Pease was untypical of her friends. A country-loving six-foot-four-inch amateur ornithologist and lepidopterist of independent means, he enjoyed attending race meetings and having a flutter on the horses. He was an obvious choice as he was evidently eager and, in contrast to most of her male friends, he wasn't gay.

While Pease served a purpose, Bar found Bunny far more attractive. He was extremely confident in the bedroom and, perhaps unusually at the time, understood the mutuality of pleasure between male and female sexual partners. Forty-one to Bar's twenty-eight, he was tall, athletically built, blond-haired and blue-eyed. He had defective eye muscles which prevented him from looking out of the corners of his eyes. Instead, he would turn his head sideways, bestowing the full focus of his blue gaze on whoever he was with. 'Many people', remarked his son Richard, 'found his candid gaze most attractive.'[17]

Bunny's latest book, *Pocahontas*, had been published in January 1933, and he had recently taken on the literary editorship of the *New Statesman*, a role he approached with some reluctance. He welcomed the salary and enjoyed writing his editorial essays but was less keen on being tied to a desk, taking on responsibility and working full-time. Although he loved the city, he was happiest in the country, at his Cambridgeshire home, Hilton Hall. Bunny relished contrast: he liked to be able to escape from one place to another. One day he would enjoy physical labour digging his country garden, feeling the earth in his fingers and the sun on his skin, and the next he would be

in London, at his club, or dining with friends. Unfortunately
for his long-suffering wife, Ray, he also required contrast and
novelty in his personal life. For this reason, she insisted that
if he took on the *New Statesman* role, she would move with
him to London. And so they took a flat on Endsleigh Street in
Bloomsbury, around the corner from Gordon Square. Bunny
lost little time in arranging a second meeting with Bar, in April
1933 booking an appointment to have his photograph taken at
her studio. According to Bar, Bunny 'didn't pull any punches
and I thought to myself after one or two outings, "Well, I shall
have to give in, otherwise he won't take me out any more."'[18]
Thereafter Wednesday evening became a regular arrangement.

Bar provided Julia not only with employment, but also with
a roof, as she took refuge at the King's Road, attempting to
leave Tommy and his threats of suicide. Julia had great charm
and wit, and Bar 'doted on her'. 'Julia is a god send really', she
wrote to a mutual friend, 'there's nothing she won't do & if I say
rather reluctantly "I think we'd better write a letter to so & so"
she's up & sitting at the writing desk with pen poised in hand
almost before the words are out of my mouth. It's marvellous.'[19]
'She came to stay with me one of the times she left Tommy,' Bar
recounted, 'and he was forever hammering on the front door
and ringing the bell of 19 King's Road to see Julia. We wouldn't
answer [. . .]. Julia and I used to barricade ourselves in with a
bottle of gin'. 'The joke', Bar added, '(if you can call it that) was,
that when he was living with Julia he was liable to hammer on
the door to visit me.'[20]

Bar was inclined to double standards when it suited her. She
could be very kind, as she was to Julia, but remain oblivious to
the fact that sleeping with her friend's husband was unkind.
Bar remarked that 'Us girls were always getting pounced on
by married men', which 'really put me off marriage, quite
seriously' while cheerfully jumping into bed with Tommy or

Bunny Garnett.[21] But such views were rooted in the fact that Bar did not believe in the institution of marriage. She had seen her mother trapped in a loveless marriage in which she had little respect for her husband. In the same way that Bar's attitude to sexuality was fluid, she considered the boundaries around other people's spouses porous. Or, as someone commented about this period in her life, 'Bar had some blind and rather hard spots when it came to other women. I suppose you have to if you're having affairs with their stupid husbands.'[22]

Tomlin was four years older than Bar, educated at Harrow and at New College, Oxford, where he read Law, although he did not complete his degree, deciding instead to train as a sculptor under Frank Dobson. As a result, he produced some fine heads of Duncan Grant, Lytton Strachey and Virginia Woolf. Tommy was bisexual, and according to Julia his 'daemon insisted that not only with their souls but definitely with their *bodies* everyone must him worship'.[23] He and Bunny Garnett were close friends and had once been lovers (such were the convolutions of Bloomsbury where recycling relationships was almost de rigueur). Tommy was short and stocky, with fair hair and a high forehead, not conventionally attractive, but magnetic. He was also highly intelligent but dogged by black moods which he sought to brighten with alcohol. 'Tommy was a great charmer but fiendish to be married to', said Bar. 'He had to seduce every girl he met and so did Ralph (or tried to).'[24]

The *'or tried to'* is significant. After a weekend at Ham Spray, the Wiltshire home of Frances and Ralph Partridge, the latter became obsessed with Bar. In the summer of 1933, he bombarded her with letters, berating her for rejecting his advances, while his wife was in a nursing home trying to retain a pregnancy which did not endure. Speaking of Frances Partridge later, Bar commented: 'what she had to put up with from Ralph is almost unbelievable'.[25] Bar did everything to

keep him at arms' length. Two years younger than Bunny, he appeared older and Bar couldn't stand him. He was not physically her type and she disliked his innuendo, delivered with a seemingly permanent sneering grin. She repeatedly rejected his invitations to dine and when she eventually capitulated, he complained that she was cruel and berated her for her lack of seriousness. He behaved like a hound pursuing a fox while blaming the fox for its instinct to flee.

Ralph did not disabuse his wife Frances of her assumption that he was having an affair with Bar. In that quarter, at least, his *armour propre* remained intact. Frustrated, he turned first to Alix Strachey for advice, only to be informed that Bar got on best with gay men. Seeking support from Rosamond Lehmann he learnt only that Bar wrote very good letters. He even attempted a man-to-man talk with Bunny, who was determinedly non-committal, knowing he had the upper hand. Ralph's letters arrived in a torrent. Then they stopped. Bar did her best not to dislike him, but in her opinion, he would never be anything more than a poor imitation of Bunny.

In a few short months Bar's love life had become rather complicated. To compound matters, Humphrey Pease decided to propose and invited her to the South of France where he planned to pop the question. Meanwhile Bunny was on a camping holiday in Ireland with his wife and children from where he wrote: 'Darling – I think about you frequently not a fruitful form of spending one's time', ending: 'Many kisses & hugs & much love from your devoted Bunny'.[26] The allure of Antibes proved too much for Bar to resist, and anyway she had a commission from *Town & Country* to photograph George Davis there, a handsome American writer she had first met in Toulon in 1931. She worried about the question of what she termed 'obligations' where Pease was concerned, knowing they would be sharing a sleeper and assuming they would also share a hotel

room. She and Pease travelled via Paris but – to Bar's relief – they were not alone as Freddie Ashton decided to join them. 'Fred was at a loose end, so he came too', Bar remembered. 'He knew that once he got there he'd find plenty of people he knew, which he did.'[27] Tucking himself up on the floor of their sleeper, it did not occur to Fred that he might be intruding.

Antibes, an ancient city on the Côte d'Azur, with winding cobbled streets overlooking miles of sandy beach, was more upmarket than Toulon. In many ways it was a repetition of the Toulon holiday. As Bar predicted, Antibes was full of people they knew, including Billy Chappell, Peter Spencer and Paul Tanqueray, and they quickly became friends with those they didn't. It was a safe playground for gay men who could sunbathe topless without fear of patrolling gendarmes, and in Bar's numerous snaps of bronzed young men and women there is an evident sense of freedom and abandon. But she took very few photographs of Pease, who despite a predilection for ornithology, was not a very outdoors type in the context of a hot Mediterranean summer. While many of the young men went topless, as did Bar, Pease's concession was to discard his jacket and roll up his shirtsleeves. He was anyway more at home in a bar than on the beach. It must have been a huge disappointment for him to find Bar disappearing into a crowd of hedonists. If Pease did follow through his plan to propose, Bar evidently turned him down, just as she had earlier rebuffed John Goodwin, a handsome young friend of Peter Spencer and Billy Chappell.

On an excursion from Antibes in the back of Arthur Jeffress's Rolls, Fred and Bar had a terrible argument when Fred accused Bar of behaving badly to Pease, to whom she derisively referred as the 'Trembling Stick' (he did tremble and was socially very nervous). Fred threatened to get out of the car: 'He had his hand on the handle of the door', Bar recollected, 'and I told Arthur to

stop the car at once because I was afraid that he was going to jump out while it was moving. But Fred then *had* to get out so as not to lose face. We drove off and Fred claimed later that he had to walk all the way back to Antibes because I'd thrown him out of the car.' Bar and Jeffress saw him later in the evening in a club, sitting alone, and sent the waiter over to ask if he would like to join them for a drink. According to Bar: 'The waiter came back and told us, "The gentleman says thank you, but he's not thirsty." '[28]

In Antibes, Bar received a postcard from Man Ray stating he would arrive on Thursday and was very excited at the prospect of seeing her. We might speculate that they had previously met, perhaps during arrangements for an exhibition at London's Wertheim Gallery in which they had both exhibited the previous year, for the tone of his postcard, although cryptic, suggests a degree of familiarity: 'Can dispense with the pyjamas! Very excited.'[29]

An Outbreak of Talent

When interviewed in later life, Bar was inclined to be self-deprecating about her work, even disparaging. While she looked upon her friends' artistic achievements with admiration, she appeared not to value her own skills. It was as if she viewed photography as a second-rate art form. Bar persisted in believing that her practice had been handed to her, and consequently, that she was undeserving. She did not recognise

the gaping chasm between Olivia's ability with a camera and her own. Such self-denigration was part of Bar's tendency and that of her circle to appear frivolous or flippant, but there was a clear dichotomy between what she said about her work and her inherent talent. Her remark 'the "gays" came to me because I made them look so beautiful' may have been made jokily, but Ashton stated, seriously, that Bar's photographs were the most becoming ever taken of him.[1] Her immediate circle obviously valued her talent and she took several portraits of Ed and many of Billy and Fred. If Bar was ever in any danger of taking herself seriously, she could always rely on Ed for a put-down. Referring to the success of the solarised Cunard portrait, he quipped: 'White Ladyship is a great success in Rye nobody knows what it is about'.[2] But this remark was made in the context of a meteoric professional and artistic ascendancy which even Ed could not fail to perceive.

People came to Ker-Seymer Photographs because her images were bold, modern, original and experimental. In contrast to the heavily retouched perfections of Dorothy Wilding, or the dramatically embellished goddesses of Madame Yevonde, Bar produced portraits which were honest and unfussy, and which often communicated something of the sitter's inner life. These were the 'straight' portraits. But she also produced highly contrived, even surreal portraits, with the delighted cooperation of some of her more outrageous friends. The writer and critic Raymond Mortimer, who would soon take over the role of literary editor of the *New Statesman* from Bunny Garnett, was photographed apparently in bondage, while the Freudian psychoanalyst Alix Strachey was portrayed – in a visual pun alluding to Freud's so-called 'iceberg' theory – chained to a block of ice.

Only two years after taking over Wyndham's studio in late 1929, Bar's work was receiving widespread exposure. In March

1931 the *Bystander* carried what would become another iconic Ker-Seymer image, captioned: 'Miss Nancy Cunard [. . .] is a great follower of the Surrealist Movement'. This photograph encapsulated Nancy's reputation as an exponent of surrealism and embodiment of the Jazz Age. It is one of a series in which Bar has Cunard wearing a leopard-print fur collar and tightly wound turban-like cloche hat, posed against a tiger-skin background. These photographs were among those which cemented Bar's reputation. In the most arresting, we see Cunard's head and shoulders, facing forward, her chin tilted very slightly downwards, her penetrating gaze only slightly softened by a thin gauze veil. The tiger skin occupies the top third of the image, the stripes emerging from her back like a pair of closely bound wings. Half a century later these images were misattributed to Cecil Beaton – it was assumed that no other British photographer of the 1930s could attain such heights of artistry, glamour and sophistication.

To be the chosen photographer of a woman of Cunard's fame, whose trademark was her own image, was an accolade. (Cunard even appeared unannounced at Bar's flat on one occasion, requesting a humble passport photograph.) Bar's earlier solarised portrait of Cunard was widely viewed as daring and original. In consequence, she was singled out as an exponent of an exciting 'new' photographic technique and was probably the first London photographer to adopt solarisation.[3] In 1931 the photograph appeared in a 'special autumn number' of the *Studio* magazine, dedicated to 'Modern Photography'. This upmarket international art magazine, published in London and New York, was designed to break down cultural boundaries. Special numbers were produced three times a year as substantial art books, destined for the library shelf or for coffee-table display.

Bar gained more prominence the following year when in

April 1932 she was one of eleven international photographers featured by the artist and critic Oswell Blakeston in the scholarly and influential international journal, the *Architectural Review*. In 'The Still Camera Today' he discussed the importance of photography and its influence on architecture and design. He identified a new type of photographer, who elevated the profession into an art form, in contrast to the 'star photographer of yesterday, with his flowing tie and gently disorganised hair', who 'lingers on only to be found on the beaches of more obscure holiday resorts'. The article was illustrated by a solarised version of one of Bar's 'turban-and-veil' Cunard portraits, which Blakeston hailed as a 'form of modern creative photography [. . .] flooded with the cold light of purity'.[4] Only two other women were featured: Aenne Biermann and Germaine Krull, the latter a photographer Bar particularly admired.

In July Paul Nash took up the baton in an article called 'Photography and Modern Art' published in the *Listener*, to which he contributed a regular column as the magazine's art critic. The importance of Nash to artists and designers of Bar's generation cannot be overstated. Sixteen years older than Ed and Bar, he taught, briefly, at the RCA while Burra was a student and recognised his artistic precocity and unique talent. In the First World War Nash had been an official war artist, famous for his painting *The Menin Road* (1919). He was exceptionally kind and generous, akin to Marie Rambert in his ability to identify and draw out the innate strengths of his protégés. He treated younger artists as equals, never resorting, like Bar's Slade professor Henry Tonks, to sarcasm, but befriending them and finding commissions or markets for them. Significantly he was not hierarchical in his views, believing all the arts were equal.

In this article, Nash urged photographers 'within or outside the film industry, to extend the limits of their experiments.

Stunt arrangements and chic portraiture is not enough.' Then he added: 'Fortunately, this has occurred to at least two talented people – John Havinden and Barbara Ker-Seymer, who are beginning to make individual reputations'.[5] Nash went as far as suggesting, implicitly, that Bar's photography influenced Burra's paintings. Three years later Nash would go further, explaining that when teaching at the Royal College of Art he was 'fortunate in being there during an outbreak of talent, and can remember at least eight men and women who have made names for themselves since then in a variety of different directions; in Painting, Edward Burra; Applied Design, Edward Bawden, Barnett Freedman, and Eric Ravilious; Textiles, Enid Marx; Pottery, Bradon [sic], also William Chappel [sic] in Stage Design and Barbara Ker-Seymer in Photography'.[6] It must have been very satisfying for the three friends to find themselves united in praise, and in such illustrious company.

Bar's reputation was further enhanced when she was selected as one of the British artists to exhibit at the prestigious Wertheim Gallery in Burlington Gardens, London, in an international exhibition, 'Twenty-Seven Photographers', which ran for six weeks, and included works by Herbert Bayer, László Moholy-Nagy, Man Ray, Albert Renger-Patzsch, Howard Coster and Edward Steichen. If the exhibition was accompanied by a catalogue or itemised list of contents, it hasn't survived, but it is possible to make an educated guess regarding the identity of Bar's subject in terms of the unusual amount of time and detailed attention she devoted to one particular portrait. She explained that she did 'as little retouching as possible', although she sometimes had to retouch because 'no society lady would *dream* of letting her skin texture show'.[7] A feature in *Photography London* magazine stated: 'Miss Ker-Seymer [. . .] dislikes retouching of any kind'.[8] However, there is a series of seven photographs of a young Kyra Nijinsky, the daughter of

Vaslav Nijinsky and a ballet dancer herself, over which Bar took exceptional care in retouching. Kyra Nijinsky was eighteen in 1932, the age she appears to be in these photographs, and given the extraordinary level of thought Bar applied to their execution, it seems likely that they were prepared for the exhibition.

Although her studio had a darkroom, Bar rarely involved herself in what Cecil Beaton called the 'drudge work' of photography – developing films, retouching prints with pencil and paint.[9] Paul Tanqueray introduced Beaton to Messrs Jeffery & Boarder (photographers) who processed his film and printed his negatives. Given that Tanqueray was a friend of Bar's and they occasionally collaborated on commissions for *Harper's*, he may well have introduced her to Jeffery & Boarder as well, because her studio work was retouched and printed elsewhere. Her work for *Harper's* and other magazines would be retouched in-house, Bar sending over a print with instructions marked on the back, typically: 'ONLY remove line from nose to mouth. Lighten a little under the eye. NOTHING ELSE.'[10]

Bar's retouching directions for the Nijinsky portraits were unusually detailed and prolix: 'Tidy hair at parting, remove lines and spots indicated, can you darken in shadow right side of nose where indicated; exact'.[11] Furthermore, Bar's marks on the images are more deliberate than usual, with sweeping lines indicating shadows to be removed, ink marks peppering over blemishes, and heavy cropping. From these photographs, where Nijinsky adopts a variety of poses, the single chosen image is stunning: Barbara has cropped it heavily to focus in on Nijinsky's face, her chin resting on her hands. The face is a perfect oval, framed by the sitter's chin-length bob, revealing the beauty of her famous grey-green eyes. Thus, from a lengthy technical process of retouching, cropping, selection and rejection, Bar achieved a seemingly naturally posed and relaxed portrait of a dazzling beauty. Of course Bar had easy access to

the world of ballet through Billy and Fred. She often attended rehearsals and was familiar to the dancers and a natural choice as their photographer. Bar took a tender photograph of the young Margot Fonteyn, emphasising her delicate and tiny frame beneath a puffed-out tutu and exaggerated cap sleeves.

Bar's art was informed by a wide range of influences from Florentine Art of the Renaissance period to the German Post-Expressionists George Grosz and Otto Dix. Ed shared her interest in Grosz's work. According to Bar: 'We liked the earlier drawings best, particularly the one of bloated plutocrats with cigars in their mouths, gambling at tables covered with money and diamonds being watched by starving children and mutilated war victims [probably *Toads of Property* (1920)]. We also loved the terrible brothel themes. These drawings were very like German films we went to, for instance "Joyless Street" in which Greta Garbo was reduced to going to a brothel and becoming a prostitute.'[12] Well-grounded in her knowledge of drawing, painting and sculpture from her extensive art education, Bar also knew the collections of the major London galleries intimately. From her mid-twenties she had begun to collect art and she was invited to commercial galleries' private views. She was versed in contemporary art as well as art history. Her life-drawing skills were superb (as evinced by being a chosen student of Tonks) and she brought an exceptional spatial awareness to the posing and lighting of her sitters which had the effect of making them appear three-dimensional. Her professional work was almost exclusively portraiture or photojournalism, and as she photographed in black-and-white Bar was, in effect, an artisan of light, sculpting three-dimensional portraits through the manipulation of light and shade. Her knowledge and understanding of sculpture, not as a practitioner, but as an educated connoisseur, translated directly into her portraits. That of the novelist and music critic Eddy

Sackville-West, published in *Harper's* in February 1933, shows him posed against a huge mural of stylised art-deco horses, his long, oval face illuminated, heavily lidded eyes gazing downwards. The expression Bar captured is not unlike that of a Renaissance Madonna, perhaps Michelangelo's bas relief, *Tondo Pitti* (1504–5) in Florence's Bargello museum.

Bar's art was also influenced by popular culture, including the silent German films shown at the London Film Society. Her inventive use of extreme chiaroscuro – the interplay of light and dark – for *Harper's Bazaar*, and her tendency to take portrait shots at close range in profile or three-quarter profile, was a reflection of what she saw in these films. Writing to Ed in 1928 she rhapsodised about *Der letzte Walzer* (1927) a German silent romance: 'The Last Waltz is one dream of close ups of Willy Flitch very plump and rather pimply in the most passionate embraces [. . .] the entire screen is taken up by his profile'.[13] At art school, Bar had made pencil-and-ink copies of film stills in her sketchbook. For her creative generation, the importance of film, including mainstream American movies, cannot be overestimated. The writer and biographer D. J. Taylor has commented on the impact of cinema on Bar's friends and contemporaries Evelyn Waugh, Henry Green and Anthony Powell, whose novels at that time were 'composed in a kind of filmic shorthand, cutting sharply from scene to scene and put together out of ricocheting one-liner dialogue'.[14] Bar and her coterie indulged in the one-liner dialogue themselves, but her close-up portraits reflect this filmic shorthand, in which the sitter's profile occupies the entire frame.

Bar and her friends were passionate about German films and photography, and although they couldn't read German, they pored over the photographs in *Der Querschnitt* (The Cross-Section). They loved the film *Berlin: the Symphony of a Great City* (1927), which began at dawn and took the audience through the

hours until dawn of the next day. 'We thought it marvellous', said Bar wistfully, 'and longed to go to Berlin, but never went.'[15] She particularly admired the work of Germaine Krull who was experimenting with photomontage, shadow and perspective, and in 1928 had published a portfolio of images entitled *Métal*. In Marseilles and Toulon, Bar and Ed took photographs by what they described as 'the Germaine Krull method'.[16] Krull was fascinated by hands, as seen in her series of portraits of Jean Cocteau (1929) in which she focused entirely on his folded hands or portrayed him at very close range, one hand covering his face, a palimpsest where the hand replaces the face as the subject of the portrait. When Bar photographed Burra's seemingly incorporeal gnarled hands for Unit 1 in 1934, she might have had these in mind, together with Krull's remarkable photomontage of the illustrator Pol Rab (1930) seated atop a cascade of disembodied hands. Bar may also have been familiar with the American photographer Berenice Abbott's *Hands of Jean Cocteau* (1927), which has the same disembodied quality as *Burra's Hands*. Abbott had trained under Man Ray, and was someone Bar also admired.

If Man Ray influenced Ker-Seymer's solarised prints, Bar was, of course, more than familiar with the work of other contemporary photographers, and particularly admired the work of Edward Steichen (with whom she exhibited at the Wertheim show), famously employed as Condé Nast's chief photographer for *Vogue* and *Vanity Fair* between 1923 and 1938. Her multi-textured Cunard photographs nod towards Steichen's *Portrait of Gloria Swanson* (1924) in which the actor is depicted with her head tightly encased in a turban, her direct gaze shot through a layer of lace upon which appliquéd flowers are drawn taut across her face.

Many of her studio portraits referenced Helmar Lerski's 1931 photo-book *Köpfe des Alltags* (Heads of Everyday Life),

faces of working-class people in intense close-ups. Bar obtained
this book through her friendship with Kenneth Macpherson,
photographer, film-maker and founder and editor of the jour-
nal *Close Up* in which he reviewed Lerski's work. Bar recalled:
'After Lerski, we began oiling people quite a lot and John
(Banting) got people to cover their faces with egg white'.[17] Bar's
monumental close-ups of heads, in homage to Lerski, were
unlike anything produced in Britain at the time. In her *Portrait
of Nancy Morris* (1932), the subject is viewed head and neck in
profile, completely filling the frame, skin and hair oiled, reveal-
ing every pore and strand in startlingly close proximity to the
viewer, a marked contrast to the society portraits of the time,
in which photographers went out of their way to represent
a smooth 'airbrushed' visage. Morris's head has a sculptural
quality, appearing almost three-dimensional, bringing to mind
Rodin's sculptured heads. With Morris's cropped hair slicked
back and her upturned profile emphasising the muscularity
of her head and neck, this is also an essay in androgyny. In
another sculptural portrait, of the actress Beatrix Lehmann
(1933), the entire frame is occupied by Lehmann's head, one eye
covered by unruly hair. She appears confrontational, almost
wild. Bar engaged with most of the modernist photographic
techniques: negative printing, solarisation and multiple expo-
sures. She made double-exposure portraits of Jean and Cyril
Connolly (1936), the double-couple seen through the window
of their apartment in the King's Road, Chelsea, as if they are
reflected in – rather than seen through – the glass.

In her personal photographs Bar was even freer to
experiment, and in Marseilles and Toulon she and Ed took
photographs with their 'Baby Box' cameras in the style of the
French photographer Eugène Atget (1857–1927), famous for his
representations of the streets and architecture of Paris, record-
ing physical changes to the city. 'We tried to take photographs

like Atget,' Bar remembered, 'and reflections in shop windows like the Avant Garde photographers.'[18] They ensured they were up-to-date in their reading, purchasing *Varietés*, a Belgian photo magazine covering the arts, from Zwemmer's on the Charing Cross Road, where they would browse what Bar described as 'all the best art books and mags.'[19]

What Ashton, Burra, Chappell and Ker-Seymer had in common was what Fred described as the 'eye'. Ed could observe a scene and retain both the essence and the detail in a later painting. He didn't sit in a bar and paint, or even sketch, but absorbed every detail by looking. Similarly, Bar set up a portrait photograph quickly; she did not mess about with the theatre of cumbersome props but kept everything simple. Her knowledge of art history, understanding of form and masterful use of light, together with a rapidly acquired expertise as a photographer, enabled her to pose her subjects to heightened effect. A contemporary described Bar's strong visual acuity: 'She had a sharp, almost microscopic painter's eye and was continually making me see things which otherwise I would have missed, so that when one was with her, in the park, in the streets, in the Zoo, one always came home with a collection of *choses vues*, like the hard brightly coloured objects which a magpie picks up for his nest.'[20]

What Bar captured, in many of her subjects, was a sexual fluidity: Alix Strachey in a leather bomber jacket with her severe Eton crop; Billy Chappell indolently sexy as the Creole Boy; Eddie Sackville-West simultaneously *triste* and camp; Nancy Morris, androgynous. While her photojournalism for *Harper's* inevitably focused on the rich and famous, her studio portraits of her own circle of friends are particularly alive because she knew them for whom and what they were and could capture this on film. She had their *permission* to do so.

In one portrait, Ashton is posed informally, chin cupped in

hand, elbow on knee, seated. Bar's lighting puts the left side of his face in semi-shade, while the right is illuminated, giving his head the sculptural quality of a Greek or Roman bust. It makes him seem somehow magnificent, physically much more powerful than he was. Bar also photographed Ashton dressed in Stuart period costume, eyelids heavily Vaselined, posed against a tapestry background. It was in images like these, where she experimented with textures – tapestries, corrugated iron, chains, tiger skins or massive blocks of ice – that her originality was most profound.

Radio magazine's Christmas 1936 number featured Bar's portrait of Sidonie Goossens, a distinguished harpist and founder member of the BBC Symphony Orchestra. Here, Bar's surreal representation of Goossens's bodyless head appears suspended in mid-air, 'supported' by her fist clasped under her chin, head and hand brightly illuminated against an all-black background. She wears an oversized ring which appears to shed a beam of light onto a glass paperweight. The image is informed by an art-deco elegance, unusual in Bar's work, which serves to alleviate a portrait which may otherwise have been considered too stylistically *outré* for a popular magazine. Another experimental photograph finds John Goodwin at Grafton Street, posed against a black background with an enormous painted thumb and two fingers outlined in white to the left of his head as if emerging from his shoulder. In common with Ed, Fred and Billy, Bar brought a unique experimentalism to an established form and made it her own: she had the courage to conceive her portraits as art.

In August 1934 Bar was the subject of *Photography London*'s feature 'People of the Camera', which carried the strapline 'HORIZONTAL PHOTOGRAPHY', alluding to a short-lived fashion for photographing people lying down. The piece was illustrated by Bar's portrait of the strikingly beautiful actress

Florence Lambert (*c.*1931–2), lying on her back on a tiger skin. It is skilfully illuminated, emphasising the planes of Lambert's face, and has a softness absent from portraits of the same subject by Bassano or Madame Yevonde. Bar may have adopted this pose having seen Curtis Moffat's *Mrs Greville* (*c.*1925–30), in which the subject reclines on her back on a chaise longue, her head in the foreground facing upwards towards the viewer. Bar used the reclining pose to very different effect in a series of four portraits of the Ghanaian-born British actor Harry Quashie, reclining against a tiger skin, naked, on his back, viewed from above. For a while, the reclining pose proved popular with customers – usually, in Bar's opinion, to their detriment. 'I do *not* photograph people on the ground nor on the sofa', she commented, huffily, 'unless they are of a very unusual type specially lending themselves to that pose.'[21]

Bar's experimentation with light, texture and pose were important and distinguishing factors if she was to survive as a professional photographer at a time when the market for portrait photography was contracting. Individual studios were in decline, giving way to mass-produced and inexpensive portraiture offered by department stores which employed new automatic photographic techniques whereby multiple shots could be quickly and cheaply taken. In the *British Journal of Photography* in 1936 Madame Yevonde cautioned: 'be original or die'.[22] Bar was fortunate, as her studio market was that of the artists, writers, dancers and actors who required high-quality press photographs widely circulated for publicity purposes. Thus she produced portraits of Louis Golding, author of *Magnolia Street* (1932); of Rosamond Lehmann (1932); Richard Hughes, author of *A High Wind in Jamaica* (1932); Elizabeth Bowen (early 1930s); Stephen Spender (1933); David Garnett (1933); and Vita Sackville-West and her husband Harold Nicolson (1932). For the latter, unusually Bar travelled to their

home, Sissinghurst Castle in Kent, rather than photographing them in her studio. She described the couple as 'like royalty' although she found them most agreeable. They gave her lunch and cooperated gladly with the various poses in which she placed them. The ensuing images have a comfortable informality, as if the subjects enjoyed being photographed at home. 'I learned one thing about my trade at the time', Bar was amused to note, 'the grander the people, the better they treated you.'[23] When she went to the *Harper's* offices, however, she had to enter through the servants' door and was escorted upstairs by the butler in the staff lift.

As a relative newcomer, Bar was working for some of the most prestigious magazines of the period. She obtained occasional work from *Vogue* and continued to work for the American magazine *Town & Country*, although Marty was no longer involved. But Bar's greatest coup was to work as a photographer for British *Harper's Bazaar*, contracted by the magazine's owner, Condé Nast, in December 1931. For *Harper's* Bar took the occasional society portrait, but she was also responsible for a series of portraits, entitled 'Footprints in the Sand', of up-and-coming writers, including the young Evelyn Waugh. She was also largely responsible for the gossip-column photography, taking over from Howard Coster, a highly successful and well-respected photographer renowned for his portraits of writers, including the famous image of A. A. Milne with his son Christopher and Pooh Bear. She was competing for and securing work that had previously largely been given to men. Moreover, Bar made the photojournalism gossip-column format her own. With great originality she combined society portraits, fashion shots *and* gossip-column photojournalism – an amalgam of all three genres. She also illustrated a column by Derek Patmore, entitled 'London Conversations', with photographs of aristocrats wearing couture clothes in apparently

uncontrived 'social' situations, or celebrities looking relaxed and informal in groups, going about their business or at play.

Harper's described Bar's photographs as 'snapped informally', and they were, compared to the magazine's portraits of aristocrats and young women presented at court. Nevertheless, they were carefully constructed, particularly with regard to contrast and tone. Sometimes Bar could not resist letting her sense of the absurd intrude: commissioned to photograph various extravagantly attired aristocratic tots for *Vogue*, she deliberately snapped the moment when little Noël Cunningham-Reid looked as if he would kill his brother Michael, who was busy demolishing a toy bus. She also photographed the infant John Julius Norwich conducting an imaginary 'children's' orchestra. In an article by Mrs James Rodney about modern aristocratic mothers condescending to be seen with their offspring, illustrated with photographs of women in haute couture gazing doubtfully at their infants in perambulators, Bar included a portrait of Mrs Rodney's Airedale terrier, Boodles, peeping through the tiny rectangular rear window of her car.

Up until now magazine illustration and text layout had consisted of rows of columns of text beside a centred box containing the picture. As the 1930s progressed, this format changed and photographs became more prominent because new cylindrical printing presses using wraparound printing plates could hold whole pages, allowing entire pages and double-page spreads to be laid out. Pictorial magazines such as *Picture Post* entered the market and made the text subservient to the photographs. In the glossy magazine world the art editors had sway and Bar was subject to assignment directives and aesthetic conventions, but despite these regulations she continued to bring a striking originality to her work, often looking to film photography for inspiration. As a result, she used unusually bold shadowing which made her figures appear to both stand out from

and recede into the shadows. She pored over the film stills
in Kenneth Macpherson's magazine, *Close Up*, where highly
luminous figures emerge from an inky background. Despite a
relatively short lifespan (1927–33) the magazine was immensely
influential, generally disdaining English and American films
in favour of avant-garde productions from Germany and the
Soviet Union. The August 1929 issue was devoted to black
cinema: 'Not black films passing for white and not please white
passing for black'.[24] 'Have you seen the May number', Bar
enquired of Ed, explaining, sarcastically, that 'foreign' films
could not find buyers in Britain 'on account of crude close ups
showing the head of an old artist & a young male lead far too
effeminate to please the land of pale ale and football'.[25]

In her work her figures were often dwarfed by artful lighting
which threw huge looming shadows, giving them a surreal
quality. Bar captured the artist and designer Oliver Messel
standing, in profile, beneath a huge bas-relief, in the process
of making a model for a set design. Messel appears dimin-
ished beneath his own towering shadow on the wall behind.
Distorted shadows were a device Bar frequently employed
in both portraiture and photojournalism. According to the
photographic historian Val Williams: 'it is evident that the
great wave of German cinema and photography which had
dominated the consciousness of the new avant-garde since the
beginning of the decade was leading Barbara Ker-Seymer into
experiments with posing and lighting quite new to British pho-
tography.'[26] Williams's comment that Bar's 'experiments with
bold shadowing' made 'her subjects appear as creatures from
the *demi-monde*' is apposite: in so doing she cleverly turned the
haute-monde figures she was photographing on their heads.[27]
But her 'bold shadowing' also nods towards Edward Steichen's
portraits of film stars for *Vogue*. Loretta Young (1931) and a
jaunty Maurice Chevalier (1930) composed with strikingly

alternating inky black and silvery white tones; a large shadow looms on the wall behind Young.

Bar was working for the magazine at an exciting time when new printing methods produced more scope for photography. It was beginning to move away from a rather dated reliance on illustration, where fashion plates enormously outnumbered photographs. But while in many respects *Harper's* was modernising, the captions accompanying Ker-Seymer's photographs in Patmore's society pages were contrastingly banal. 'I'm sure we look awfully dissipated' (woman with wine glass in hand), 'No you look far too charming'. In a portrait of Beverley Nichols, William Gerhardie and Mrs Gerard d'Erlanger the three figures form an inverted triangle, with 'Mrs Gerard' at the bottom, her face so highly illuminated as to obliterate the features. In contrast the two men appear in semi-darkness, with blackened faces as if they have emerged from a coal mine. All three seem almost ghostly. 'I hate being photographed', runs the inane caption, followed by 'I think it's such fun'.[28] It is as if Bar's modernism was at variance with the contrived modishness of the text.

As Aunt Winifred had observed, Bar had a sound business head: she was canny. In addition to studio portraiture, photojournalism for *Harper's* and regular work for *Town & Country*, her photographs were published in other print media including the *Bystander, Sketch, Tatler, Modern Home* and *Good Housekeeping*. She was not averse to taking advantage of friends and contacts, photographing Anthony Powell and Lady Violet Pakenham's 'December Wedding' for the *Bystander* in 1934, and Olivia's sister-in-law 'Mrs Richard Wyndham' for *Tatler* in 1933.

As usual Bar was adept at hiding her seriousness, keeping to the Burra–Chappell–Ker-Seymer creed of being 'very, very frivolous, or *apparently* very frivolous'.[29] 'Apparently' is an important caveat: she earned her reputation as a pioneering

photographer because she was both immensely talented and determined to be financially independent. She had not forgotten her mother's advice. Always be independent. Never depend on a man.

CHAPTER NINE

Loving in Triangles

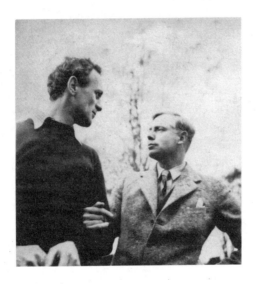

Bar was invited to join luminaries at the Mount Royal on Oxford Street, at what she described as 'a little party', celebrating the forthcoming International Surrealist Exhibition at the New Burlington Galleries. Burra and the British surrealist John Banting exhibited in the show, alongside Salvador Dalí, Marcel Duchamp and Pablo Picasso, amongst other famous artists. Bar enjoyed the party, and was transfixed by the spectacle

of a fainting Brâncuşi, who was subsequently carried off to his room. She was sceptical, though, about what she considered to be Burra's spurious association with the surrealists, despite the elements of fantasy in his work. Ed was not a natural joiner-in, and for this reason, Bar was wryly amused when his inertia caused him to fail to turn down an invitation to participate in Paul Nash's worthy, but short-lived, art movement, Unit 1. Unit 1 was a group of artists, architects and sculptors whose combined work united abstract art with surrealism and stood for 'the expression of a truly contemporary spirit'. Nash sought to create an identifiable English art movement, and explained in a letter to *The Times*: 'though as persons, each artist is a *unit*, in the social structure, they must, to the extent of their common interests, be *one*.'[1] At the moment when Burra was busy painting his famous Harlem street scenes, much admired by Bar, he was expected to contribute surrealist paintings to what turned out to be Unit 1's only exhibition, held in April 1934 at the Mayor Gallery, on London's Cork Street.

Bar was also involved, in a small way, in supplying photographs of Burra for a book accompanying the exhibition, subtitled 'The Modern Movement in English Architecture, Painting and Sculpture'. Edited by Herbert Read, it presented statements by and photographs of the artists and their work. Ed either failed to or refused to provide a statement as he hated having to rationalise his art. Bar liked to quote his most profound, if un-illuminating, comment about his work: 'I like painting [pause] I like to paint'.[2] She supplied three photographs representing Ed: a close-up head of the artist, a view inside his studio, and a study of his hands. The first is very straightforward; it reveals little beyond the artist's youth. The studio image, however, expresses a great deal more about Burra. It depicts an untidy room, records strewn on the floor; there are no Burra paintings, but instead the walls are festooned with

postcards of film stars. The obvious artist's attribute is missing – there is no easel (Burra liked to work on the flat surface of a table) – but a gramophone is positioned prominently, as if in its place. Burra was irritated by being represented in this way, but Bar captured his natural habitat perfectly. Her third photograph spoke volumes, representing Burra's cruelly deformed hands, surreally disembodied, like a pair of crawling tarantulas.

Bar's relationship with Bunny was going well. It suited her to have an affair with a married man who did not expect commitment and she felt perversely free in the knowledge that he would not leave his wife and children for her. Regular, midweek sex appealed, and she could otherwise continue to live life as she pleased, though she often accompanied Bunny when he socialised with his literary friends. She was vivacious and amusing and fitted in and even if she did not go in for Bloomsbury's narcissistic intellectual conversation, she could hold her own with Vanessa Bell or Duncan Grant.

Bar and Bunny missed each other during the summer of 1933 and looked forward to meeting up again following a prolonged absence, Bar's Antibes break having coincided with Bunny's family holiday. Finding a letter waiting for him when he arrived home the second week in September, he wrote back: 'I was delighted to get your letter the moment I got home [. . .] especially as you voiced my feelings exactly for you [. . .]. I love you very much'.[3]

During that long summer while Bunny was away, Bar whiled away some of her time with Tommy, Julia's estranged husband. The Bunny–Bar–Tommy triangle meant that a harmonious balance was sometimes difficult to maintain. Bar could be exercised about Bunny's relationship with Tommy and sometimes felt excluded. Bunny magnanimously accepted that Tommy and Bar were lovers, although at times through gritted teeth. Tommy was a little jealous of Bunny, realising

that Bar prioritised him. He scribbled a verse on a scrap of paper
and either gave it to Bar or, more likely, left it lying around at
the flat for her to see:

> *I want to kiss you*
> *But I won't*
> *It'll all be over in 6 months*
> *I wouldn't even mind lying near you*
> *Without any clothes*
> *But what's the use*
> *We've both been through it before*
> *so*
> *Let it be sufficient to say that*
> *I love you very very much*
> *And know that B[unny] won't one day*
> *(perhaps).*[4]

Bar and Bunny were united in their concern for Tommy's
well-being. Julia Strachey had 'puzzled greatly as to how people
could be so taken in by what one of the few who comprehended
him had described as the "inspired charade of normality" that
Tommy managed to assume'.[5] He was up and down, unpre-
dictable. When he visited Bunny at Hilton the latter wrote,
reassuring Bar: 'Tommy was very lovable & seemed in good
form'.[6] But when Bar sent an anxious letter to Tommy enquir-
ing about his health, he proffered a disappointingly succinct
reply: 'It was very kind of you to write. I'm gradually rising
to the surface, I think. I look forward to seeing you again.
Love, T'.[7]

Tommy was excellent company, but his dark moods were
difficult to lift and he inclined to drink, causing himself more
despair. Bar felt the responsibility keenly. She knew Tommy
had recently experienced a catalogue of sadness attendant

upon the death of his beloved brother, Garrow, in a flying accident, followed closely by the death of his confidant Lytton Strachey and by the ensuing suicide of Strachey's companion, Dora Carrington. To compound matters, Ralph Partridge had expected Tommy to stay with Carrington after Lytton's death, effectively placing him on suicide watch. Bar found buoying up Tommy's spirits exhausting. He would arrive at her studio in a depressed state, seeking a drink or two to feel better. Then he would want to go on somewhere, to the Palladium perhaps, where more drink would be consumed. Afterwards, he insisted on going to the Café Royal and when that closed Bar was dragged off to a nightclub. According to Bar, he 'did some wonderful Tangoes & rumbas & got entangled with a "dance hostess" but managed to escape'.[8] By this stage Tommy was pickled in alcohol and Bar could only march him to the nearest Lyons Corner House to mop it up with food. It was therefore some relief when Bunny eventually returned from Ireland and into Bar's arms. He wrote beforehand: 'I am feeling very happy & fit & on Wednesday [. . .] I shall shout very loud in your ear [. . .] Darling I love you.'[9]

Although Bar rarely shared personal confidences, many people confided in her, knowing she was both sympathetic and unshockable. 'You must talk to no one with the same *kind* of freedom that you talk to Barbara', Brian Howard advised a mutual friend.[10] One such confidante was the writer Rosamond Lehmann, whom Bar had known since 1932, introduced by Julia Strachey. Rosamond was extremely beautiful with a pale complexion and striking height. According to her biographer, Selina Hastings: 'Rosamond frequently found herself in the uncommon position of having her looks reviewed in tandem with her work. Although by the standards of today such treatment might be considered an affront, Rosamond accepted it as entirely appropriate.'[11] But she wasn't vain, suffered from

low self-esteem and rarely found the happiness with men that she craved.

Her marriage was far from perfect. Her husband, Wogan Philipps, was presently trying to extricate himself from an affair with Julia Strachey. Charming and good-looking, he combined an excitable, ebullient character with a tendency to over-analyse his own feelings and those of everybody else. He was accident prone and, as Selina Hastings put it, 'by no means remarkable for intelligence'.[12] The son of Laurence Philipps, 1st Baron Milford, a self-made millionaire, Wogan was sent to Eton and Oxford, although he left university after two years as his father considered it a waste of time. Subsequently Wogan was placed in his father's insurance business in the City, which he loathed. Then he went to Newcastle to 'learn' the shipping business, but had no head for it. Thereafter he tried – unsuccessfully – to establish himself as an artist.

Bar spent many happy weekends with Rosamond and Wogan at Ipsden House, their seventeenth-century home in the Chiltern Hills in South Oxfordshire. According to Selina Hastings, 'the bohemian Barbara appealed to Rosamond, who thought her comic and original and commissioned her to take portraits of herself and Wogan.'[13] In the resulting widely published image of Lehmann, Bar placed her against a background of chain links, positioning her dramatically angled head in sculptural three-quarter profile.

Rosamond loved Bar's colourful letters. 'Darling', she wrote, 'I think your last letter the best yet. I intend to make a collection of them & publish them as my original work in a few years.'[14] Her tongue was only half in cheek, for her novel *The Weather in the Streets* (1936) contains a passage which is very close to Bar's description of her escape from a particularly louche party. Bar's passage reads: 'I left John Strachey making a bonfire in the middle of the floor with all the paper decorations pulled

down from the wall with Tommy gallantly trying to put out the fire with an empty soda water siphon.'[15] Lehmann's novel reads: 'The last I saw was Billy with a broom sweeping the rubbish, pulling down the paper decorations and making a heap of them in the middle of the floor and putting a match to them, and Colin with an efficient level-headed expression squirting at them with an empty soda-water siphon'.[16] Bar was also the inspiration for one of the book's characters, the photographer Anna Cory. It was not the only occasion Lehmann borrowed from her. 'I've been wanting to write to you for ages to say I've borrowed without permission a paragraph out of an old letter of yours from S of France for my work. It's quite external – about [. . .] Juan Les Pins – I haven't quoted it word for word, but the gist! It conveys the "atmosphere" much better than I could. It was a wonderful letter: I was tempted to quote all of it, but I didn't. I hope you don't mind.'[17] Over the years many people, including professional writers, suggested Bar should write fiction. Like Fred she had an 'eye' and was often extremely amusing. She had a pleasing facility with language and a brilliant command of the absurd. Bar always protested, however, that she could not spell and lacked grammar.

At Easter 1934 Bar travelled down to Rosamond and Wogan at Ipsden by train, accompanied by fellow guest John Banting. He photographed her in the carriage, stylish as always in a fur-collared coat and pillbox hat; she photographed him, dapper in an overcoat, trilby and tie. The next day Bunny arrived in a rather less conventional conveyance. He had purchased, jointly with his friend the publisher Hamish Hamilton, a German Klemm aeroplane. It was an odd-looking machine built of wood, with huge wings, a tiny propeller and wheels, and controls marked in German. Allegedly just second-hand, in fact it had a long series of previous owners. Bunny flew it the way he drove his car: with verve rather than precision. While

motoring, he had the habit of accelerating as he approached a crossroads, eyes fixed ahead as he enquired of his passenger whether anything was coming from either direction and sped across.

Garbed in his great leather flying coat, silk under-gloves and gauntlets, Bunny cut a dashing figure. Approaching Ipsden he made a bumpy landing some distance away, having overshot the field in which he had intended to land. Rosamond arrived in her car to convey him to the house for lunch. Afterwards, according to Bunny, everyone wanted a ride in the plane, so he took each up individually, including Bar who found the experience so terrifying that she vowed never to repeat it.

Bunny really enjoyed the day – 'sitting in the sun, talking to Rosamond, Barbara Ker-Seymer's shining eyes, Banting and Wogan competing in craziness'.[18] Afterwards he wrote to Bar: 'It was a dream the whole time at Ipsden: it only seemed a moment that I was there: five hours passed like five minutes and I don't think I have ever wanted to hug you more [. . .]. I am 365 times more in love with you than I was a year ago & I was crazy about you then.'[19]

A year into their relationship, Bunny's single weekly night with Bar had long since multiplied. 'Darling, you were angelic on Thursday & on Wednesday & on Tuesday. I love you a lot', he enthused.[20] However, on one occasion Bar was furious when she learnt that having left her bed, he had gone on to a party of Tommy's at the Eiffel Tower restaurant and she accused him of being deceitful and lying. Bunny explained that he had been at the party for only an hour and needed a temporal divide between leaving her and returning home to a wakeful and angry wife, Ray. 'I have often walked round & round Gordon Square', he added, 'after dashing back in a taxi – post haste – trying to make myself think of something else & not you'.[21] Bunny was particularly concerned that he had scuppered his

holiday plans with Bar, as they had arranged that she would stay with him at his Yorkshire cottage. During the holiday, part one, he would spend ten days there with Ray and his father, the literary reader Edward Garnett; when they both left it would be Bar's turn to share the holiday, part two.

Bar and Bunny were happiest during weekends in the country. In Norfolk they stayed at the Red Lion, Needham, where Bar photographed their tousled bed and what passed for an en-suite: a washstand, ewer and 'his and her' chamber pots in a corner of the bedroom. They visited Sophie Fedorovitch at her converted barn on the North Norfolk coast near Brancaster, where she photographed Bar and Bunny on the beach, Bunny bundled into a three-piece tweed suit, Bar in an elegant matching skirt and jacket, her blouse emblazoned with bold art-deco buttons. They picnicked in the sand dunes, hunks of bread and cheese washed down with wine, followed by nips of whisky from Bunny's hipflask.

'I shan't soon forget how pretty you were looking last time I saw you. As pretty, for a moment, as the steel blue swallow turning its red cheek to me', Bunny wrote to Bar.[22] A photograph of him, taken in September 1934, in hot weather on the beach at Abbotsbury, in Dorset, reveals just how beautiful she found him too. It is a sensual close-up of his naked upper body which celebrates the texture of his skin, his strength, his fair hair and handsome features. She makes him appear sculptural, as if carved in alabaster or marble. According to the art historian Graham Clarke, the nude photograph 'makes the private space of the body open to the public eye and, overwhelmingly, that eye has traditionally been male'.[23] Here Bar subverts that gaze within the format of the informal snapshot, although it is carefully composed. Bunny is lying on sloping shingle, at an angle to the viewer, head in profile, arms raised above his head, emphasising the muscularity of his chest and upper arms. She

took many photographs of the men in her life, but none share the sensual quality of this.

From Ray Garnett's perspective, taking a flat in London to keep an eye on Bunny had not been a success. She assumed that living with him in London would – at least to some extent – curtail his wanderings, but he informed her that he wanted to spend half his time with Bar. He wanted each woman in a neat compartment, and when Ray moved back to Hilton Hall, he persuaded Bar, against her better judgement, that during the week he should reside with her. He now spent longer in London with Bar than he did at Hilton with Ray.

Partly under the influence of Tommy, Bar and Bunny began drinking too much. 'I felt frightfully sick', Bar wrote to Rosamond Lehmann, '& went to the office in a taxi with a sponge bag (which luckily wasn't needed) having had a night out with Bunny.'[24] Their jaunts often revolved around cocktails, and Bunny's letters contained increasing references to his tendency towards bad temper when inebriated. 'I was so furious with you & with myself I never wanted to see either of us again', Bunny wrote, 'then I began to think I was the only fool – but what a pair of fools we are'.[25] Despite protestations that he was on the wagon 'where I belong', Bunny continued to drink and to apologise, in a roundabout way, for his behaviour. 'Well – not a word you'll have noticed of repentance or crawling in the mud for forgiveness, so far – Darling. I suffered quite as much as you: if I wounded your feelings, I wounded myself too. I hate doing that sort of thing, I hate it. And I wouldn't treat you so when I'm sober. So darling, if you'll forget & I'll reform we'll drink pints and pints of water whenever we meet – and Nothing shall ever come between us. No more cocktail parties'.[26]

Bunny's drinking was also a reaction to being what he called 'a tired businessman'. He wrote brilliantly for the *New*

Statesman but did not enjoy the administrative side of work in his position as literary editor. To compound matters, he had to confront the impending death of his dearest friend, Francis Birrell, who had been struck with an incurable brain tumour. In the late summer of 1934 Bunny's drinking began to cause friction between him and Bar.

Leaving her flat for his office one morning, Bunny announced, in a manner which brooked no disagreement, that he would take her to London Zoo that afternoon, followed by dinner and a revue in the evening. Feeling irked at his overbearing behaviour, Bar was delighted when Rosamond's husband, Wogan Philipps, arrived unannounced at the King's Road, and suggested a pre-lunch drink. One drink led to several and Bar invited Wogan to join her and Bunny at the theatre that evening. Leaving Wogan at the flat, she made for Bunny's office, where she tipsily demanded he order another ticket, only to learn that the performance had been cancelled. Then Bar announced, provocatively, that she planned to join Wogan on a forthcoming trip to Dieppe.

Later in the evening, after a visit to his ailing friend, Bunny was so upset that he drowned his sorrows, arriving at Bar's flat drunk. Over dinner he became progressively inebriated, aided by Wogan who plied him with drink in an attempt to cheer him up. When Bunny became garrulous, ignoring Bar and directing his conversation exclusively at Wogan, she felt hurt and uncomprehending and left the room in tears. Trying to salvage the evening and to mask her unhappiness, Bar breezily suggested they should go out to watch a newsreel, which they did, Bunny by then so drunk that he talked throughout at the top of his voice. He suddenly bolted from the cinema, with Wogan and Bar in pursuit. Unable to find him, they returned to the flat, where Bunny appeared in the middle of the night and was violently sick. The next morning, finding him white and

shaking, Bar was so distressed that she left for work without saying a word.

Both men wrote to her afterwards with some contrition. 'I do hope things are better now', Wogan said, 'I'm afraid my being there did make things worse, & I ought not to have let him talk on like that at dinner.'[27] Writing from Truro, where he was on holiday with his family, Bunny said: 'I have thought a good deal about you & me: the last week seems to me so horrible really that I can't bear it or face a repetition'. 'I am sorry for you & Wogan that night', he continued, 'but must say the drink did serve its turn.'[28]

A fortnight later, Bunny arrived back in London as if nothing had happened. 'I think we were too pleased to see each other to have any explanations or anything', Bar wrote to Rosamond.[29] They made one another happy and miserable by turns but Bar realised they could no longer remain living together. She was now effectively occupying the position of wife, a role she wished neither to accept nor to fulfil. When she informed Bunny that the arrangement had to end he retorted by stating that staying with her every week was a mistake, 'a sort of make believe marriage with the bad features of marriage rather than the good'.[30] Bar railed furiously at his double standards, because he came to her flat and into her bed when it suited him. 'He could be very cruel', she recollected, 'taking me out to lunch and then to bed, only to get up without a word, and catch the train when he'd finished'.[31]

Then Bar found herself with another married suitor. It wasn't that she had a penchant for married men, merely that she was open to having relationships with anyone to whom she was attracted, and most of the men she knew were either gay or married. In contrast to Ray Garnett, who Bar barely knew, this man was the husband of her close friend Rosamond Lehmann. In August 1934, when Wogan Philipps languished at

Ipsden nursing two broken ribs and a bad cut to the head (injuries sustained from diving onto a submerged rock in a river), he wrote to Bar to say that Rosamond was away on holiday with the children, and he was lonely, and would she like to visit? 'I long & long to see somebody from outside. If you haven't gone off somewhere do pop down'.[32]

CHAPTER TEN

Parallel Lovers

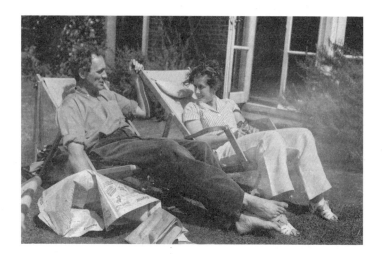

When *Harper's* commissioned Bar to photograph the recently formed Ballets Russes de Monte Carlo (a less successful successor to the original Ballets Russes) at the Alhambra Theatre, Leicester Square, she decided to share the commission with a photographer who later described her as one of his 'best and dearest friends'.[1] As Humphrey Spender and Bar were in the habit of speaking on the telephone, rather than corresponding, little evidence exists of this particular

friendship, although a handful of letters survive in Spender's
archive. His habit of reading a letter and then casually drop-
ping it into the bin may also have contributed to this paucity.
Humphrey was a shrewd judge of character: 'It seemed to me
that "Bar" always stood outside the events of her life (and the
lives of her friends) and observed things with marvellous wit
and sympathy and perception, and sometimes just a touch of
very enjoyable malice. For me this was a calming influence
during difficult times in my own life'.[2] He alluded to Bar's sup-
port when his wife of eight years died from Hodgkin's disease
on Christmas Day 1945. Bar knew the value of practical help in
times of grief.

Spender was five years Bar's junior and like her an avid
member of the London Film Society. He studied Art History at
Freiberg and qualified as an architect in 1933, after four years
at the Architectural Association in London. 'Having never
been able properly to understand a sectional drawing of a sash
window', he mused, 'I was alarmed at the idea that any work-
ing drawing of mine might be translated into actual buildings.'[3]
He had been mad about photography since childhood, and
established a photographic studio on the Strand in partnership
with his lover Bill Edmiston, a fellow architectural student.
Later, Spender would be known for his poignant photographs
of the housing conditions of London's East End, for his work
as 'Lensman' with the *Daily Mirror*, as a Mass Observation pho-
tographer, and for his work for *Picture Post*. Commenting on
the early days of his career he noted: 'With minimal, mostly
second-hand equipment, large format camera, tripod, spotlights
and masses of what we thought to be very original and modern
background materials (corrugated cardboard, Army Surplus
medical gauze, Air Force Surplus airship silk) we exploited
friends and relatives and commissions came in.'[4] One of the
first was from Bar, of whom he took the portrait (now in the

National Portrait Gallery) beside a tripod with her Rolleiflex. It was probably through Humphrey that Bar received a commission to photograph his brother, the poet Stephen Spender.

The *Harper's* commission occurred at the very outset of Spender's career and it came about as a result of Bar's twofold desire to help him obtain work, and to receive professional assistance on what she considered too large a project for a single photographer. The fact that Spender's camera was a Leica, with an exchangeable lens system (including both a wide-angle and telephoto lens) may also have been a factor, as they would be working from the theatre's wings, to capture a Degas-like intimacy.

They arrived at the Alhambra Theatre accompanied by Paul Tanqueray, clutching his cine camera, intent on filming them photographing the dancers. But the whole thing was a fiasco and hardly professional. Used to undertaking commissions solo, each relied upon the other to take the key images, and as a result Bar managed to take only one photograph which could be successfully developed. Spender spent the evening photographing male dancers, and between them they failed to capture any ballerinas, a spectacular omission in a programme comprising Massine's *Jeux d'enfants*, featuring the fourteen-year-old sensation Irina Baranova, and *Swan Lake*, in which Alexandra Danilova danced Odette.

Tails firmly between their legs they returned a second night, but then still larked about, wasting precious time photographing each other. During the performance they were convulsed with giggles watching a swan on a trolley being pulled across the stage by stagehands. When they eventually set to work, Humphrey's film got stuck in the camera and having attempted to prise it open, they decided to tear the film in half and hope that the remaining pictures could be developed. In the event, mercifully there were sufficient photographs to grace a single

page in *Harper's*, unfortunately credited to Ker-Seymer and 'Spencer'. Somehow they received another joint commission and collaborated more professionally in photographing Elisabeth Welch and Roy Atkins, stars of the *Dark Doings* revue at the Leicester Square Theatre.

Outside Bar's studio a policeman had taken up regular point duty in order to direct the traffic on Bond Street. He sequestered some of his equipment in the space behind Bar's studio display board and soon began to beckon her over whenever she emerged and, to her delight, held up the traffic for her to cross the road. She and Harry Daley quickly struck up a friendship, holding long conversations in the middle of the road. He enquired about a photograph of a particular beauty displayed on Bar's board, and when she told him it was Florence Lambert, Daley rejoined that he was a balletomane and knew her husband, Constant, very well. One day he called out to her: 'Do you know Joe Ackerley?' Bar replied in the affirmative and said: 'Do you?' 'Known him for years', he said, '& wots more, there's a lot of people you know that I know too'.[5] There were indeed. Daley was a friend of Duncan Grant and was E. M. Forster's erstwhile lover. It was typical of Bar's charm and curiosity – she always attracted people and was fascinated by them.

While Bar's career was a great success, in the world of British ballet, Fred was undoubtedly the star choreographer, responsible for creating a home-grown ballet for the first time. When Ashton and Chappell embarked on their ballet careers, the notion of 'British Ballet' was unimaginable. The Ballets Russes had dominated European ballet for two decades until Diaghilev's untimely death in 1929. It seemed impossible, even for British dancers who had worked under the impresario, to carve careers and establish practices in such an uncertain landscape. Yet Fred's ascent was so rapid that within a few years a signature step would be recognised as indisputably his. The

Fred Step (actually a short sequence of steps) first appeared in his ballet *Les Masques* (1933), and would thereafter feature in all his ballets, as both leitmotif and talisman.

Having attended Freddie's triumphal first night of *Le Baiser de la fée*, Bar wrote to Ed afterwards gossiping that 'Madame [Fred] had to take about 10 calls & was the best piece of mime in the show, she had to make a speech in the end, it really finished me off!!' In contrast, the modest and retiring designer Sophie Fedorovitch 'took about 3 calls, white as a sheet, bobbing nervously to right and left & trying to escape, nothing like Madame's sweeping bowings & scrapings & kissings of the hand'.[6] Bar, Billy and Ed liked to gossip about Fred's airs and graces. Dining at Rules following a performance, Bar and Billy's order of Welsh rarebit and coffee was overruled by Fred who demanded champagne & caviar. But Ashton's star was in the ascendant. His ballet *Apparitions* (1936) cemented his position at the helm of British choreography, a triumphal success which launched sixteen-year-old Peggy Hookham – transformed into Margot Fonteyn – as a leading ballet dancer, and one who would become his muse.

Billy designed for Fred throughout the 1930s (and also for Ninette de Valois's Vic-Wells Company) and the two friends and collaborators complemented each other perfectly. By now Billy had developed an extreme work ethic, far removed from his lazy early days as a dancer. He had to take all the ballet and design work offered, because unlike Fred who became resident choreographer of the Vic-Wells Ballet in September 1935, thereafter earning a regular salary, Billy was an un-salaried dancer, earning according to the number of ballets danced or designed. 'The rewards are, in worldly and material value, poor', Billy complained. 'Financially, although a dancer works one hundred per cent harder than most other theatrical artists, the gains are microscopic compared to what may be earned

in many forms of entertainment.'⁷ Bar always worried about Billy, knowing he worked too hard and that he never had any money to save.

Rambert's decision to encourage Billy to design sets and costumes paid off: he was an expert designer for theatre because he understood design from the perspective of performance. This provided a useful second string, even if it did make him a workaholic. Throughout the 1930s Billy created more than forty dancing roles and designed for the same number of ballets, often performing and designing for the same ballet. With his art-school training and knowledge of art, he was an inspired designer for Ashton's *Foyer de Danse* (1932) after paintings by Edgar Degas and de Valois's *Bar aux Folies-Bergère* (1934) after Manet's eponymous painting. His set and costume designs for Ashton's *Les Patineurs* (1937) remain in repertoire today.

While Bar, Freddie and Billy's professional lives were carried out in the public arena, Burra's work was a solitary affair even though he exhibited most years and designed for theatre and ballet. Working from the family home, he had a considerable financial cushion of parental support, but was, according to Bar, 'in a constant state of fear of calamity and impending doom'.⁸ In the mid-thirties he acquired an agent, Gerald Corcoran, a handsome Irish-Hungarian who met and married Bumble, and who began to deal in art privately from their London home, selling Burra's paintings. After war service, Corcoran was invited to join the Lefevre Gallery and in the early 1950s he began to hold regular exhibitions of Burra's work. But despite his reluctance to blow his own trumpet in any way, in the 1930s Ed felt keenly the lack of recognition.

Bar accepted Wogan Philipps's invitation to visit him, and writing afterwards to Rosamond, deliberately let slip that she had been to Ipsden. 'I'm so glad he's better [...] he seemed almost fully recovered. I stayed the night (I hope you don't

mind!) as Bunny said he would fly over the next day & take me for a picnic. Which he did'. Bar glossed over the fact that she had not only stayed the night but had spent it with Wogan. Panicking, Wogan wrote afterwards to Bar: 'I did enjoy your visit [. . .]. But I think perhaps you are wise not to write to me much for a bit. No harm is done yet, I promise you, but Ros is a person who got badly caught once, you see.'[9] Bar did see, as Rosamond had confided in her during the Julia affair.

Having invited Bar into his bed, Wogan then endeavoured to keep her out of it, explaining variously that he was still in love with Julia but also that he couldn't visit Bar at her flat because of doctors' orders. 'I underwent a rather unpleasant stiff examination from the doctor this morning. He hasn't been able really to do it before because I couldn't allow him to do what he wanted. I wish I could have for your sake, instead of kept you dangling like this. But now all the X ray plates are printed he can see, & feel by pummelling me, that it is not quite a simple fracture in my rib. One of them has got pushed out of place & he says it will take a long time to come back & join up again. He says I couldn't travel until the end of the month. Isn't it too dreary & sad & I can't tell you how sorry I am, darling. I've led you up & down the path.'[10] It was a long path, and one up and down which Wogan would continue to lead Bar for some time.

In December, for the *Bystander*, Bar photographed one of the society events of the year, the wedding of Anthony Powell and Lady Violet Pakenham, at All Saints in London's Ennismore Gardens. She was taken aback at the prenuptial party when the artist Henry Lamb approached her in 'a most threatening manner', stating: '"You girls! You reduce us to ashes. Then we go home & sleep with our backs to our wives"!!'[11] Was this a barbed comment about Bar's involvement with married men, or just male anxiety about an attractive single woman in their midst?

While Bunny remained her 'first best' and Tommy was 'second', Bar was very drawn to Wogan and expected him to keep his promise to see her the moment he recovered from his injuries. However, he avoided her, preferring to gallivant around Europe with a wealthy friend. When Rosamond invited Bar to Ipsden for Christmas, she accepted the invitation eagerly, although with Tommy as a fellow guest it cannot have been easy to dissimulate in the company of two lovers, in front of Rosamond who remained in the dark. Bar wrote afterwards to thank her hostess for 'the most lovely Christmas [. . .] the nicest Christmas I've ever had.'

Five months elapsed before Wogan condescended to spend a second night with Bar. He wrote, clumsily, afterwards: 'the old cabbage Wog finds it all a bit difficult. He got planted out in a new kind of bed last week!'[12] The old cabbage evidently found his new bed most agreeable because he began to use Bar's flat as his London base, although his visits were less frequent than Bunny's. In the spring of 1935, however, Bar confided to Tommy that she had a crisis with her 'monthly' – news which Tommy duly reported to Wogan. Wogan wrote to Bar referring to her 'accident', enquiring subsequently: 'Barbara Darling: how are you settling down now? I did see how awful it would be for you & you sounded so despairing on the telephone. I'm so glad we had the evening after we got back. It would have been horrid not to have seen you again after you were ushered into the torture chamber'.[13] Wogan refers to her sounding 'defeated' and depressed. It seems that Bar had been pregnant and had undergone an abortion, a procedure then illegal in Britain unless pregnancy placed a woman's life at risk.

Though back-street abortionists proliferated, Bar would most likely have visited a Harley Street specialist or booked into one of the private London nursing homes where terminations could be had for a hefty fee. The pregnancy was

probably the result of failed contraception, which a woman of Bar's class and level of independence would have used. Family Planning clinics increased in the 1930s, and while these were aimed at married women, it wasn't difficult to fake a wedding ring. Women could take charge of birth control, assuming they could afford to buy 'Volpar' (a contraction of 'Voluntary Parenthood'), a spermicidal gel, pessary or paste which could be used alone, although it was safer to adopt a belt-and-braces approach and combine it with a condom.

The question is, which of Bar's concurrent lovers – Wogan, Tommy or Bunny – was the father? The answer seems to be Wogan, as sympathetic words poured forth in his letters. It was out of the question for Bar to have a child at this time. Who would look after it when she was working? She could hardly cart a baby to a society assignment or have an infant wailing in the corner of her studio. Julia had ceased working for Bar by the autumn of 1934, so she could hold neither the baby nor the fort. Bar was evidently very distraught by the termination, and this would naturally have been compounded by hormonal changes during and after pregnancy and potential post-partum depression. The distress was all the more profound as having entered into a light-hearted affair, Bar had fallen for Wogan.

What did she see in him? It is odd that Bar should fall for someone who in some respects resembled her father. While Vere was feckless in a carefree manner, intent on enjoying life at almost any cost, Wogan's fecklessness was rooted in ennui – a complete lack of direction or motivation. He was handsome but tweedy, with a pipe clamped permanently between his teeth. He could be fun, of course, and sparkled in company, but one to one he was needy and self-absorbed. He was unreliable, often cancelling assignations at short notice. As he admitted himself, he kept Bar 'dangling', spending most of his time at Ipsden,

while Bar waited for him in London. Perhaps he was good in bed, although he referred to sex in an infantile manner as 'cuddles'. He treated Bar like a plaything, something to be taken up or discarded as the mood took him. 'You are a wonderful addition to my far too lucky life', he wrote half-heartedly. 'I love our friendship & cuddles, & it is all very valuable to me indeed. But I can't really give you anything worth much. I can join you to my life, but can't join my life to yours [. . .]. I can't give lasting pleasure; I can only hurt you if I get too close to you, yet I long to get close, close, close.'14

Bar's uncharacteristic unhappiness was partly the fallout from the abortion, but it also centred on the three men with whom she was involved. While on the surface these relationships suited the independent, freewheeling Bar, in practice they proved challenging, because she was never put first. Although Bunny was genial and affectionate, he was also grumpy and selfish. Tommy was enormous fun but equally, he could be morose and self-absorbed, and the switch would be flicked in a moment. Wogan was selfish, and tortured in his continual prevarications and constant obsession with his own psyche. 'You do know I'm an awfully moody person don't You? – added to which I am in rather a special defensive state', he informed Bar. 'I'm very fond of you, feel I want to expand & be absolutely free with you, but am frightened of consequences to myself, to you. I seem to have made such a mess of things, & to have been made a mess of too, & can't shake myself clear, & am now frightened when I feel really warm. But I can't help feeling warm.'15 He was undergoing Freudian psychoanalysis with James Strachey, which only served to intensify his self-obsession. 'One feels so charged with introspection feeling', he told Bar, 'that if any one came here one feels one would burst, give completely false values – in other words creep to a mother for comfort!!' 'Well', he added, 'apparently this old bugger was

plunging with joy back into his mother when to his horror he found his father's penis there already'.[16]

In the midst of all this emotional uncertainty, Bar moved in March 1935 from the King's Road, to a flat at number 4 Church Street (later renamed Romilly Street) in the heart of Soho, opposite Kettner's, the famous French restaurant. Billy and Fred's friend and colleague, the ballerina Sally Gilmour, resided in the same building, and Bar was overjoyed to discover African American members of the cast of Cochran's latest revue occupying the floor beneath hers. Writing to Billy, Ed enquired: 'Have you seen Mdlle Ker-Seymers new *"cocottes bonbonieres"* in the heart of the demi monde? It really is lovely [. . .] so convenient for Rosin's Jewish Bakery'.[17]

At this time Soho (situated between Leicester Square and Oxford Street) was home to French and Italian communities. The butchers, bakers, greengrocers and grocers were largely French while the restaurants and bars were mostly Italian. Chinatown was then focused around Limehouse, and it wasn't until after the Second World War that it transferred to Soho. For once Ed was not exaggerating when he referred to the 'heart of the demi monde', for the area had long been associated with sex workers and had an edgy atmosphere which appealed to Bar. Soho was full of nightclubs, private drinking clubs, pubs and bars, and was unusual in that the pubs welcomed female clientele. At night it came alive with men looking for sex with women or other men. 'In those days', Bar reminisced, 'there were jolly motherly looking tarts on every corner.'[18] She loved it. She relished what she called 'all the little foreign shops' and felt the whole ambience resembled a village. She was a regular at the French House (as the York Minster pub was usually known), run by the formidable Belgian Victor Berlemont, which attracted artists and writers: Dylan Thomas accidentally left the manuscript of *Under Milk Wood* beneath his chair. Later

it drew in such reprobates as Jeffrey Bernard, Francis Bacon and Daniel Farson. Of course Ed was a regular when he stayed with Bar. It was dangerous too: four sex workers were strangled in Soho between November 1935 and May 1936. Bar and John Banting inadvertently walked into a crime scene where crowds were gaping at a dirty window behind which the latest murder had taken place. 'The latest victim was one of the Church St girls', Bar explained, 'her beat was outside the oriental pub, opp: me, so it seems they are closing in'.[19] Bar was on first-name terms with these women and saddened that they should fear for their lives.

In the summer of 1935 Bunny blew hot and cold, one moment insisting that Bar should 'accept me as a friend & lover as you do Tommy', the next declaring his devotion.[20] He knew about Wogan and didn't feel unduly threatened. But Bar's relationship with Wogan was confined to sailing the River Fal in Cornwall with a jolly crowd, including Rosamond, providing little scope for intimacy; otherwise, Wogan remained at Ipsden with his wife, hosting the Connollys and Nancy Mitford among a stream of guests. In the circumstances Bar jumped at an invitation from Kenneth Macpherson and Jimmie Daniels to join them at a rented villa at Juan-les-Pins in the South of France. 'Kenneth is wonderful', Bar wrote to Ed, 'pays for everything & sent me £25 to get out here so I'm enjoying myself like one o'clock what with Picon grenadines on the Terrace most of the morning, cocktails & bal musette all the evening.'[21] They went to Cannes to buy jazz records, to the precipitous Gorges du Loup, and visited Sainte-Maxime and Toulon. 'I'm having a jolly time at Margate', Bar joked to Ed, at the 'villa which is right on the sea & the terrace overlooks the cocktail bar of the Provençal so there is plenty to do what with hanging over the edge of the Terrace listening to the conversation, & swimming slowly about in the drains, carefully avoiding the skins

of salami sausage, shit, old rolls, French letters etc'.[22] They spent their evenings on the terrace looking towards the casino, watching the exotic American dancer Joan Warner execute a fan dance in the nude. The holiday was an act of kindness on Kenneth's part. He and Bar were good friends and he had photographed her in her studio for publicity purposes. She had planned to holiday in August, when her workload decreased as many people were away and Wogan promised to accompany her, assuming his wife would be absent on her annual holiday with her sister Beatrix. However, Rosamond informed Tommy that she would be vacationing earlier that summer, and he passed this news to Bar, who was terribly upset and glad to be rescued by Kenneth and Jimmie.

Bar kept her lovers in compartments quite separate from her best friends. Bunny, Tommy and Wogan occupied different spheres to her coterie, but anyway, Bar did not want her relationships scrutinised by Ed with his sharp tongue, nor did she wish them to be the subject of continual gossip. Bar did confide in Mickey Hahn, who had arrived in London on the arm of the Hollywood screenwriter Eddie Mayer. Bar could not understand what Mickey saw in him, as he was married, running to fat, bespectacled and with a lazy, drooping left eye. Mickey flashed her silk underwear at Bar and showed her the diamond-studded watch she had been given and invited Bar to dinner at Boulestin's. Bar left the house 'looking very posh & neat, seen off by Clover, Ed and Fred' and was 'brought back some hours later bent absolutely double, & speechless, with indigestion' having consumed two glasses of gin, one dozen oysters, a bottle of white wine, a whole grouse, peaches, brandy and champagne. Afterwards, at the Café de Paris, Bar caved in during the cabaret, and had to be escorted to the powder room upstairs.[23] Bar always loved her food and could not resist gorging on delicacies when someone rich paid the bill.

Perhaps perversely, Bar continued to socialise with Wogan and Rosamond at Ipsden and, ironically, Rosamond began to feel that her marriage had improved: 'Everything is much peacefuller and happier', she remarked. 'The unending process of adaptation which is marriage goes on successfully, I dare hope'.[24] However, when Bar telephoned Wogan one morning, Rosamond answered, and having put Bar through to the studio extension, she stayed on the line, hoping to cut in with some chat herself. Bar asked Wogan: 'Did you mean what you said', to which Wogan made what Rosamond described as 'a tremulous reply'.[25] Drawing the obvious conclusion, Rosamond was very upset: she felt Bar was first and foremost *her* friend, just as Julia had been. Afterwards, Wogan confessed the affair, although he described it as a 'cuddly friendship', attempting to soften the blow by depicting it as a return to the nursery.

Bar evidently wrote to Rosamond afterwards, as the latter replied: 'I do so want to see you but I feel it's got difficult, & am so miserable. I never meant to eavesdrop'. 'The sad thing for me', she continued, 'is he will choose people I'm fondest of, which means they're lost to me'. 'He is so terribly important to me in every way but one – & because of that one not working properly, I am no use at all to him, it seems.'[26] (She alluded to her lack of interest in sex following the difficult birth of their second child.) Rosamond concluded the letter by asking Bar to burn it so Wogan wouldn't see it. 'Don't answer, either', she said. 'Too awkward'.[27]

What Bar decided she needed was fun, and she found it in the shape of Len Lye, an avant-garde artist and animator from New Zealand, then based in London. Bar had admired his films since she was twenty-five and had marvelled at his 'really strange batixs [*sic*] & "constructions"' at 1928's Seven and Five Society exhibition.[28] The following year she found his first film, *Tusalava* (1929) – shown at the Film Society – fascinating. In

1935 Lye joined the GPO Film Unit in London, where he made the film *A Colour Box* that year. Bar met him in 1936 at a party at Roland Penrose's house in Hampstead. Lye was making a film (*Rainbow Dance*) requiring a male dancer and of course Bar knew many dancers. She and Len had much in common. They both loved jazz, and as Len was too poor to buy records, like Fred, he mined Bar's extensive collection which included American records and rarities presented by Jimmie Daniels and other friends. They also shared an enjoyment of and curiosity about other cultures. In his early career Lye studied the 'ethnographical' collection in the Canterbury Museum in Christchurch, New Zealand, where he made detailed drawings of Aboriginal art from Australia, masks from what was then called Papua and New Guinea, and Māori art. In contrast to prevailing notions about so-called 'primitive art', he concluded it was all an outcome of intellectual engagement, talent and aesthetics. Lye and Bar had mutual friends, including John Banting, and Len also designed the covers for Nancy Cunard's Hours Press. Bar and Len saw a lot of each other as the GPO Film Unit was based in Soho. 'We were both rather hard up', Bar remembered, 'so he was in and out of my flat, and my photographic studio [...] sharing our rather frugal meals, & playing records on my radiogram'.[29]

Within the groundbreaking range of GPO Unit films, produced or directed by the brilliant John Grierson and Alberto Cavalcanti, Lye's films stand out for their originality and experimentation. His techniques included painting directly onto celluloid and overlaying documentary footage with 'dancing' colour abstractions. In *Rainbow Dance* (1936) – an advertisement for the General Post Office – Lye's shot footage is overlaid with abstract colour effects, so that the dancer Rupert Doone appears as both a real and an abstract figure – sometimes in silhouette, at other times streaked with colour. As Bar later commented,

Rainbow Dance 'made you sit up as if you had suddenly drunk a very strong cocktail'. Comparing it to what she considered the more 'worthy' GPO films, she said 'it was as though there had been a mix up in the projection room and an extract from a contemporary [i.e. late twentieth-century] avant-garde film had got in by mistake'.[30]

According to Lye's biographer Roger Horrocks, Len admired Bar's 'experimental approach to photography and to life in general'.[31] Len and Bar shared many aesthetic interests. They both loved the German film *Berlin: the Symphony of a Great City* (1927), and admired Lerski's *Köpfe des Alltags*, which seems to have influenced Lye's film *N or NW* (1937), which begins with a sequence of extreme close-ups. Alternatively, it may have been Ker-Seymer's *Portrait of Nancy Morris* (1932), which Lye had in mind. The film's remit was to caution the public about the importance of addressing letters with correct postal districts, but Lye undermined the seriousness of this message with an inventive and humorous narrative in which a letter is followed, travelling in a dancing post-box superimposed upon a map. The film was accompanied by a soundtrack chosen by Bar from her record collection, including Fats Waller's 'I'm Gonna Sit Right Down and Write Myself a Letter'.

Bar considered Len 'the most remarkable man', 'the only person I've ever met, who appeared to be so completely happy.'[32] He had little formal education, attending school for only a couple of years before leaving altogether aged thirteen. Nevertheless, he had an insatiable curiosity and appetite for learning. Museums, art galleries and libraries were his classrooms. 'When I was a kid, a lot of disturbing things happened to me', Len reflected. 'But ... happiness became my whole theory of life. Not hedonism, but happiness of a lasting kind, like art.'[33] Four years Bar's senior, Lye had gone bald in his twenties and taken to wearing unusual hats. He was stylish in

an idiosyncratic way and had an unusual verbal delivery – talkative but in a monotone, and in both spoken and written speech, he rarely finished a sentence. He communicated in highly colloquial language with a lot of slang and snippets of jazz, like scat-singing, or what Horrocks calls 'word doodling'.[34] The way he moved resembled the jerky scratching of his animations; he proceeded in a skipping and dancing manner.

In May 1936 Len and Bar photographed each other in the studio. Her photographs of him are arty, experimenting with light and shadow against a completely black background. Lye's photographs of Bar are more relaxed: there is a voluptuous quality in the way he sees her, as if he is celebrating the physical side of their friendship, for they soon became lovers. Bar considered him 'a wonderful person to have an affair with'.[35] Although self-absorbed, he was not selfish and could be very sensitive. Bar said she 'took Len as he was and enjoyed him very much as he was'.[36] Thereafter, he remained one of her dearest friends. From a Jewish friend he acquired the cod-Yiddish expression *'Ich gebibble'* (I should worry!) which rather summed up his attitude to life.[37] He was the complete opposite of Wogan and a wonderful balm. He was, of course, married.

Hopes and Fears

I n 1935 Bar reunited with Clover. She had been working in
Madrid, teaching English at the British Institute where she
had met and fallen in love with Antonio Pertinez, a Republican
politician from a landowning family with estates in the Spanish
province of Granada: a fitting profession for the son of a landed
and patrician family, 'at the liberal-reformist rather than the
Communist end of Republican opinion'.[1] Ed liked him: 'Mdms

[Clover's] man is charming and very respectable,' he said.[2] Bar approved too: 'Well, Madame has just left, having scavenged thoroughly every dept at Barkers, eaten all the kippers at Berwick St, & left a trail 6 ins deep of make up & French papers all over Church St. I think her man is madly attract: to look at.'[3] Clover and Antonio stayed with Bar at Church Street, the latter inevitably receiving the moniker 'Oh Oh' from the then popular song, 'Oh! Oh! Antonio'.

Bar's love life lacked the tranquillity of Clover's. She was still involved with Wogan, Tommy and Bunny, but she saw that Bunny was withdrawing. 'I loved you and love you a great deal', he said, 'but the framework of my life is set. I have a wife & sons whom I must support & spend a lot of my time with & consider.'[4] Ray Garnett was completely worn down by Bunny's behaviour, particularly in the context of being treated twice for breast cancer and recently enduring another scare. She wrote Bunny a scathing and heartfelt letter, to which he responded with protestations of love, disingenuously explaining that 'Barbara originally fell in love with me & is still, I'm afraid in love far too much. She is affectionate, warm with a single-hearted warmth [. . .]. I do not at all want to hurt her, but for some time I have realised that I do not love her enough [. . .]. I can't break with her violently'.[5] Then a month later, he did break with her.

In the summer of 1936, at a loose end in London with Wogan away, Bar embarked on a relationship with yet another man, Goronwy Rees, assistant editor of the *Spectator*. Rees was twenty-seven, charismatic and devastatingly handsome, and also feeling rather adrift. Bar was a good listener and as usual one thing led to another. In his autobiography, Rees wrote: 'I fell in love with a girl with whom, all that summer, I was very happy'. He didn't mention Bar by name, perhaps because they remained friends long after their summer of love and he

didn't wish to betray their friendship. At this time he was a close friend of Guy Burgess. Many years later it was alleged that Rees, who was sympathetic to communism in the 1930s (as were many people) was an agent or even a double agent. While his daughter Jenny Rees has countered that his involvement with communism was a brief dalliance, others believed otherwise.

'It is terribly difficult to tell you how happy it makes me to be with you', he told Bar. 'Perhaps you will think it absurd if I say that when I get up in the morning I feel happy because of you: but it is so'.[6] Bar later confessed that she 'adored' Goronwy, but was wary of his intensity, that she had 'seen the red light' the first time they met.[7] Rees had many admirers, including Elizabeth Bowen who invited him to stay at her home, Bowen's Court in County Cork, apparently believing they were on the brink of an affair. Rosamond Lehmann was a fellow guest and Bar jokingly warned Rees that he would 'fall instantly in love' with her.[8] Bar helped him pack and accompanied him to the station, in an apparent rush to bundle him off. At Bowen's Court, while penning love letters to Bar, he had eyes only for Rosamond and they spent most of the night together, talking in her room.

Rosamond quickly made it clear to Wogan that he was in no position to castigate her about the affair. Whether she knew about Goronwy's relationship with Bar is uncertain. If she did, perhaps she enjoyed a sense of retribution, but in their circles it was the norm for relational re-assortments to occur. Bar does not seem to have been unduly concerned at the loss of Rees; she may even have been relieved to be free from his puppy-like devotion. Later, she rather cattily described him as 'the world's worse [sic] lover', but they remained friends and occasional lovers for many years.[9] Rees's affair with Rosamond gave Bar licence, if any was needed, to continue

her relationship with Wogan. But political storm clouds were beginning to gather in Europe and to shed a dark shadow over everything.

Ed – a confirmed Hispanophile – was in Madrid with Clover during the spring of 1936, and they witnessed the political situation becoming progressively bleak. Clover felt that Ed's study of Goya's paintings at the Prado coincided with a darkening in his work and a premonition about the forthcoming Spanish Civil War. According to his biographer: 'Spain in the months before it slid into civil war was a revelation of the inherent horror of life, which, for Burra, was a glimpse into the abyss. It had suddenly become a place where people were dragged from their homes in the small hours, and when the corpses were found the following morning, nobody dared claim or identify them'. To Burra 'it suggested a kind of collective insanity which shocked him to the core'.[10]

That July Ed was in Granada with Clover and Antonio when the Spanish Civil War was declared. He managed to secure a passage to Britain, much to Bar's relief. But Clover and Antonio were stranded in Madrid for a time. Clover's mother telephoned, terribly concerned for her daughter's safety, and Bar did her best to reassure her. But she could have no conception of the extent to which events in Spain would indirectly impact upon her own life and well-being.

Bar was vaguely left-wing and voted Labour for most of her life, but within her circle politics were rarely discussed. It came as a terrible shock, therefore, when Wogan decided to go to Spain in support of the Republican cause. His political allegiances had taken a sharp turn to the left during the General Strike in 1926, and holidaying with the Partridges in Spain in 1936, he became fascinated by the country and fearful for its political fragility. In February that year a Popular Front coalition was narrowly elected. The socialists refused to join

the new government and the resulting instability erupted in violence, murder, strikes and the destruction of religious buildings. In July the monarchist opposition leader was murdered. The exiled General Franco, beloved of the Spanish middle class, was flown to Spanish Morocco where he launched a *coup d'état* to overthrow the Republican government. The British government's attitude to the crisis was one of non-intervention. But the fault lines of European disintegration were opening as the Soviet and Nazi German governments hastened to exploit the situation in Spain.

Many outside forces took up the cause, fearing that fascism was threatening Western civilisation. Wogan threw his support behind the Republican cause, loyal to the Popular Front government of the Second Spanish Republic, which had joined forces with anarchists and communists against the Nationalists led by Franco, who was supported by Falangists, monarchists and conservatives. It was a war which focused many overlapping conflicts: class struggle; religion; dictatorship versus democracy; fascism versus communism.

With some trepidation Bar wondered what form Wogan's support might take, but she was distracted by an alarming turn in Tommy's fortunes. He had a tooth extracted a few days before Christmas 1936, and falling ill, was rushed to a nursing home where he developed septicaemia and was diagnosed with a rare blood condition associated with cocaine abuse. He died in January aged only thirty-six. His biographers, Michael Bloch and Susan Fox, believe that the underlying cause of death was a constitution substantially weakened by alcohol and drugs. His friends tried to keep an eye on him but it was impossible to change his behaviour. Bar's albums contain many photographs of Tommy, sitting in an armchair in her flat reading a newspaper, or standing in his bathing shorts, preparing to dive into the Ham Spray pool. After his death, she pasted into her album an

obituary written by Bunny, published in *The Times*. It begins: 'There are in all circles figures universally beloved'.[11]

Only a month later, in early February 1937, Wogan volunteered his services to the Spanish Medical Aid office in London, joining a convoy ferrying medical supplies south through France to Barcelona. The Medical Aid Committee, established for the purpose of collecting money for these supplies, had been established by Bar's friend Peter Spencer. He had personally accompanied the first convoy to Spain in August 1936, and so successful was his fundraising, that he created five fully equipped and staffed base hospitals behind the lines. His work was exhausting, and during his rare intervals in London, he took refuge in Bar's flat. He was hardly reassuring about the conditions which confronted the volunteers.

Bar was devastated by Wogan's departure. For all her dalliances with Bunny, Rees and Lye, she realised it was Wogan she loved. She needed him to be safe, so she could at least hope he would leave Rosamond and commit to her. The very best outcome, which Bar could barely allow herself to contemplate, was that Wogan would marry her. Then she could legitimately have his child. But he departed for Spain leaving her desperately anxious that he might never return.

Writing to Bar, Wogan was hardly reassuring. With no medical training, he initially tended the injured in hospitals. 'You have never seen such a butcher's shop', he wrote alarmingly. 'Amputations, eyes blown out etc!' He steeled himself not to faint, and soon realised that, if he was to cope, he must remain as detached as possible. While hitherto his behaviour showed all his weaknesses – failing to confront the problems in his marriage, blowing hot and cold over Bar, dabbling in painting and enjoying a life of leisure – Spain transformed him. 'Barbie, dear', he wrote, 'I am here, caught by my interests, beliefs, & urge to be doing something for those beliefs. If I have lost you

and your wonderful love through this, it is because of my char-
acter, my fate, & I can't help it.' 'This is very cruel for you', he
acknowledged. 'I have never not realised that'.[12] Wogan's letters
to Bar from Spain are notably more ardent than those scribbled
at Ipsden, making everything worse, because she believed him
when he wrote: 'I love you frantically & miss you till I can't
bear it', and: 'Darling I love you love you love you'.[13]

Redeployed as an ambulance driver, Wogan was put in
command of a vehicle allegedly emblazoned with the motto
'Fuck Franco', which was smaller than the usual conveyances
so it could approach the front lines. Having survived the
fiercely fought battle of Jarama, one night in June Wogan was
driving of necessity, without lights, positioned at the back of a
long convoy of vehicles. They ascended a steep road into the
Guadarrama Mountains, stopping briefly at the front-line hos-
pital, before descending into a valley through dense dark pine
forest, in order to reach a roadside dressing station just before
dawn. It was Wogan's job to convey the wounded, those who
had received preliminary dressings, to the hospital back up the
mountain, and during the journey his vehicle was often strafed
by enemy planes. He also worried, with every bump in the
road, that it would end the life of a wounded passenger. It was
while waiting in his empty ambulance in readiness to leave the
hospital that a shell landed beside the vehicle, shattering one
side. Alighting to examine the damage, he felt his 'brain went
loose, in pieces in my head. At the same time something red hot
hit my arm with smashing force'.[14]

Constantly fearful of receiving a dire telegram, instead Bar
took delivery of a hastily typed note torn off immediately below
the text as though the same message had been repeatedly typed
for different recipients. 'Have been slightly wounded. Am very
well. Must be as I am typing this myself. Will come home end
of month. Love ONLY IN THE RIGHT ARM. ONE SMALL

HOLE'.[15] The note was accompanied by two jaunty photo-graphs of Wogan beaming from ear to ear (obviously happy to be alive) and wearing an open shirt to accommodate a heavily bandaged arm. If he sent one of these missals to Rosamond, she did not receive it: she first heard of her husband's injury at the end of the month, apprised by a journalist. Bar affixed the two photographs, annotated 'Wogan in Hospital Spain, June 1937' to her album, beside the last shot she had taken before his departure.

Though preoccupied by Wogan's predicament, hoping to lighten the burden of worry, Bar accepted an invitation from Arthur Jeffress to join him and a group of friends at the glorious Villa Malcontenta near Venice. Bar had known Jeffress for some time – he was an exact contemporary, one of the Americans who had earlier assembled in Toulon and Antibes, and she spent occasional weekends at his English country retreat, Marwell House in Hampshire. She was accompanied to Venice by Humphrey Pease, who remained in love with her, escorting her about town in Wogan's absence. His tender gaze is evident in photographs of Bar posing at the Lido, looking gorgeous in a figure-hugging floral maxi dress.

The party included Jeffress's partner, John Deakin, a working-class former shop-window dresser and aspiring artist, who was interested in photography and asked Bar to teach him how to take photographs. Bar showed him how to use a Rolleiflex, finding him 'a very apt pupil'. 'He was a very good photographer and painter too but too much of a drunk and a dilettante' she concluded.[16] Post-war he established himself as a photographer for *Harper's*, *Picture Post* and British *Vogue* (which sacked him, twice). A fixture of Soho, Deakin was generally disliked, but Bar was sympathetic and encouraging, and glad to see his career taking off during the Second World War. She took the publicity photograph for his first exhibition. They

remained friends into the 1940s, until, as she put it, 'he became too impossible'.[17]

Bar continued to work and during this period she briefly shared her studio with Gerti Deutsch, a twenty-nine-year-old Jewish photographer, who had left Austria for London the previous year, to escape the escalating anti-Semitic climate. By the summer of 1937 Gerti described her occupation as 'Partner (Photographic Business)': her business card was inscribed 'Gerti Deutsch of Vienna', giving her studio address as 15A Grafton Street. Bar had undertaken one of her acts of kindness, as she did when she took on Julia Strachey as her assistant or provided Humphrey Spender with an early magazine commission. She later referred to responding to 'an emergency' where Gerti was concerned: perhaps the need for a studio and a fixed and established business address to achieve the requisite status to gain a work permit, which was granted in June. Gerti would soon marry Tom Hopkinson, the deputy editor of *Picture Post*, for which Humphrey Spender also worked. Perhaps Spender intervened on Hopkinson's behalf and asked Bar for this favour. Possibly Gerti would have introduced herself to other Jewish refugee women running photo studios in and around Bond Street, especially those with a Viennese connection, and so may have met Bar through one of them.

The upshot was that the Under Secretary of State of the 'Aliens Department' of the British government's Home Office extended Gerti's permission to remain in the United Kingdom until May 1938, on the express condition that she enter into 'partnership' with Bar.[18] Bar's business remained resolutely 'Ker-Seymer Photographs': the 'partnership' extended only as far as the symbolic business card, an informal means to an end. Deutsch's daughter, Amanda Hopkinson, later commented that the whole idea of a partnership was 'a bit of a joke really, since Mummy always said she was useless at business'.[19] Gerti's

residence in the UK was consolidated when in 1938 she married
Hopkinson, and started to work for *Picture Post*.

During the short period in which Bar shared her studio,
Wogan returned from Spain to recuperate. He issued
Rosamond with a brutal and unrealistic ultimatum: she must
leave the children and return to Spain with him, or he and
she would have a trial separation. On her categorical refusal
to leave her children, Wogan suggested she should live with
Goronwy and he with Bar, and if that failed, he and Rosamond
could try again. This he communicated to Bar, whose hopes
were raised only to be dashed as Wogan continued to prevari-
cate over the question of his marriage. Having failed to resolve
the issue, he returned to Spain, as Bar put it, sardonically, or
perhaps bitterly, to 'complicate the Spanish situation further'.[20]

Wogan's dedication to the Republican cause and Bar's devo-
tion to him imposed a serious strain upon her friendship with
Clover. It was evident to Bar that Clover and her husband
Antonio Pertinez did not agree with Wogan's position, and by
implication, with hers. They considered him an idealist with
little understanding of Spanish politics. Some Spanish intellec-
tuals considered Franco to be the 'least-bad Spanish solution',
and 'Pertinez's politics were pragmatic rather than strongly
ideological, and were arrived at as the result of intimate knowl-
edge of his country and its inner life'.[21] Ed made a glaring error
of judgement when he showed Bar a letter from Clover, in
which she disparaged Wogan's stance on the political situation.

Remonstrating with Clover for her 'sneering & mockery',
Bar wrote Ed a very strongly worded letter. Clover's behav-
iour wounded Bar, as she tried to explain to Ed: 'It has upset
me very much, as God knows I hate Wogan being there, and
did everything I could to stop him. I never have a minutes [*sic*]
peace when he's there [...]. I feel very touchy on the subject,
particularly as the last night, Wogan was in tears, saying he

felt that everybody was mocking him & sneering at him for going. But he says having seen all the ghastly suffering [...] he feels he's got to do something to help'. 'If he wasn't there', Bar continued, 'I wouldn't care a fuck what anybody says or does, but when he is, I'm in such a state of worry & nerves I just can't take it'. 'We may have rhino's hides as you said', she added, 'but we all have our heel of Achilles, & the Spanish war & Wogan's being there are mine'.[22] Although the habit of being 'very frivolous, or apparently very frivolous' was ingrained, Bar could not maintain her guard. Caught between Wogan's idealism and Clover's loyalty to her husband, Bar felt unsupported and misunderstood. Ed's tactlessness simply made a bad situation worse.

Bar was also wrangling with Asprey's about renewing her studio lease. The initial lease with the jewellers, taken on at the time of the slump, had been inexpensive, but they now demanded a higher rent and shorter tenancy. Bar renewed, accepting her landlord's maximum period of two years. At this juncture she expanded her portfolio to advertising and fashion photography, recognising, pragmatically, that should her lease fail to be further renewed, without a studio she would be unable to undertake portrait commissions. Bar needed to diversify and work was obtained from the advertising agency Colman Prentis & Varley, perhaps as an outcome of her acquaintanceship with Arthur Varley, who had recently married an old art-school friend. The agency was formed in 1934 and based in Mayfair, at number 34 Grosvenor Street, a grand neo-classical building with an elegant staircase. According to Varley, 'When we began we weren't concerned with doing art-rate advertising or with telling industrialists how to run their business. Nor, quite honestly, did we want to make a fortune. We were interested solely in the creation of extremely good advertisements.'[23] An extremely good photographer was therefore a prerequisite.

Bar worked mainly for CPV's Jaeger and Elizabeth Arden portfolios. Advertising photography was markedly different to photojournalism and portraiture, taking place in Bar's studio or in a studio in CPV's offices, often against a rudimentary backdrop, for instance sand and buckets for modelling swimwear. Bar's work was not the glamorous high-end fashion photography featured in glossy magazines, but more mundane, aimed at middle-class and middle-aged readers of women's weekly magazines. She always asked the models which was their favourite sandwich and when they invariably answered 'cheese' they appeared to smile and she pressed the shutter release.

At a Jaeger commission to photograph men's underwear, the model turned up without a jockstrap and Bar had to send him out to obtain one. She found 'Jaeger underwear' 'most unbecoming', and was 'terribly embarrassed' when required to pin the combinations tightly around the model, as if fastening a towelling nappy on an oversized and unfamiliar baby.[24] It was imperative that the outfits appeared completely wrinkle-free, thus clothes were often clamped from behind, sometimes to the extent that the models were unable to move in them, yet the photographer had to make the models appear natural and relaxed. Ed remained singularly unimpressed with this development: 'Miss Ker-S seems very busy photographing Miss Modern washing her panties in Trex'.[25] Fashion photography helped to pay the rent, but it was uninspiring for the innovative Bar.

Wogan's final and vital work in Spain was organising the evacuation to Mexico of around 2,000 refugees on the SS *Sinaia*. Then, towards the end of 1937, he returned to Ipsden and found everything a struggle: he couldn't concentrate on painting and felt depressed, which he called 'a reaction'. He described his 'centre' as 'heavy & numb' and could summon up no energy to do anything. He probably suffered from what

is today known as post-traumatic stress disorder. But Bar was overjoyed to see him, taking Byronic photographs of him, and he maintained that she brought the only happiness he experienced since returning. But beneath this patina of contentment there remained a worrying truth: she and Wogan had been together for three turbulent years and the relationship still seemed to be going nowhere.

When it eventually dawned on both Wogan and Rosamond that they could not afford to maintain separate establishments, the status quo was precariously maintained. Wogan seemed to have no conception of the distress Bar experienced while he was in Spain, or of her immense loyalty towards him. She told him she did not want to be his mistress. He grudgingly admitted his 'terrible disappointment & cruelty' to her but shrugged off any responsibility by explaining that the putative divorce was merely a means of exacting revenge upon Rosamond. In a curious repetition of Bunny's remark, he uttered: 'My greatest responsibility is to my children', all the more curious because he had always seen them as Rosamond's department, taking very little personal interest in them.[26]

In an effort to absolve himself of guilt, Wogan tried another ruse: 'For the last eighteen months', he said, 'several people have become very fond of you & you of them [. . .]. They are in a position to do everything for you – devote their lives completely to you. You are very fond of them, & I always imagine could become much fonder if I wasn't in the way.'[27]

CHAPTER TWELVE

War and Pease

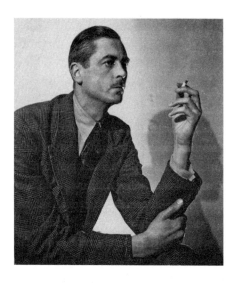

B ar fled to Antibes, where Kenneth Macpherson and
Jimmie Daniels had taken a villa, again inviting her to
join them. Ken's wife Bryher (born Annie Winifred Ellerman)
was there too, although it was a lavender marriage as he
was gay, and she was in a lesbian relationship with the poet
Hilda Doolittle, known as H. D. Bryher and H. D. were
involved in Macpherson's magazine *Close Up*. It was, like Bar's

unconventional 'little family', an unusual set-up, with H. D.'s young daughter Perdita, from an earlier alliance, sometimes in attendance. The Villa Marina, where they stayed, was, like its inhabitants, slightly incongruous, resembling a Victorian vicarage. Delicious food was provided by a resident cook, and meals were taken outside, under a canopy of sycamore trees with concealed lights among the leaves. A beautiful, partly tropical garden ran down to the sea.

Everyone seemed to be in Antibes: Bar narrowly missed Cecil Beaton and the playwright Terence Rattigan; the American society hostess Elsa Maxwell was in town, as were the Duke and Duchess of Windsor, who according to Bar 'every one stares at until Marlene Dietrich arrives, then they all turn their backs to stare at her'.[1] They spent the evenings in 'boiling boites [nightclubs] packed with sweating queens in fancy costumes.' '"Doing the Lambeth Walk" is the rage', Bar lamented, 'nothing else is danced, it drives me quite mad with rage every time I hear it struck-up [. . .]! Even the [. . .] accordionists play it away & sing the chorus'.[2]

It was a playground for the rich and famous but such enjoyment as there was to be had was set against progressively unsettling times. British tensions with Germany were heightened by its withdrawal from the League of Nations and disarmament negotiations. In 1938 the seeming inevitability of war was on everyone's mind, following the reoccupation of the Rhineland in 1936, the Italian invasion of Abyssinia, the occupation of Sudetenland and the crisis over Czechoslovakia. 'One realised', remembered Bar, 'that at any moment now as far as we were concerned it would be the end of the world and it wasn't possible to think of anything past the thirties or making any plans for the future because one just didn't know what was going to happen – we probably thought we'd be killed'.[3]

Bar's studio lease came to an end in 1938 and could not be

renewed. So she decided the only option was to concentrate on work for Colman Prentis & Varley. In the census that year she described herself as a 'fashion photographer' based at 4 Romilly Street (Church Street having been renamed). Whereas hitherto Bar had been able to offset the drudgery of fashion photography with invigorating studio work, now with no studio, and with war on the horizon, she had little option beyond the pragmatic.

In the summer of 1939 Bar took a holiday, a final one before the declaration of war, at Sainte-Maxime in the Gulf of St Tropez, between Provence and the French Riviera. It was a strange amalgamation of the two strands of her social life: Billy, Bumble and the fashion historian Doris Langley Moore on one side, and Wogan on the other. Bar perched somewhat precariously in between. Wogan was not part of her set and the gap does not appear to have been bridged, as Bar spent time either with Wogan *or* with her old friends. With Bumble, Billy and Doris she visited St Tropez, leaving Wogan behind. To Ed she wrote: 'First there is a mixture of minestrone & drains, then a layer of yachts packed like sardines then two layers of cars, after that about 20 deep café tables crowded with screeching smarties in cork soles, & shell flowers. Mrs Chappell & I secretly liked it'.[4] Then Bar and Wogan paid a separate visit to St Tropez, where they encountered Jean Cocteau and ended up in a brothel with him, watching an Edwardian film of *Madame Butterfly*. This surreal conjuncture would surely have been in keeping with Bar, Ed and Billy's tastes, rather than Wogan's.

Back in London there were visible signs of preparation for war. Sandbags were stacked around buildings, trenches dug in parks and anti-aircraft batteries were established on the Embankment and at Horse Guards Parade. Gas masks were issued, and leaflets dropped through letterboxes which emphasised the need to prepare 'refuge rooms' in homes. Neville Chamberlain ineffectually trotted back and forth between

England and Germany, finally returning on 30 September bear-
ing the Munich Agreement, the infamous piece of paper which
claimed to rule out war and brought palpable relief. Then on
9 November 1938 the Nazis ordered a sustained and devastat-
ing attack directed at Jewish people throughout Germany and
Austria: Kristallnacht, an apparently beautiful name for a night
of heinous brutality and destruction.

Against the gloom of Bar's faltering relationship with
Wogan, war drew palpably closer. Notices were pasted up with
information about air-raid warnings and gas attacks; leaflets
were distributed advising 'What to Do in an Air-Raid'; mas-
terpieces were evacuated from museums and sticky tape was
applied to windows in criss-cross formation to protect against
bomb blasts; street lighting was turned off, leaving taxis driving
in the dark with dim blue headlights while other vehicles' head-
lights were entirely masked. Bar's pal Humphrey Pease drove
his car into a stationary lorry at Epsom and crossing Piccadilly
from the Ritz on foot one evening, with what he described as 'a
blonde on my arm', was knocked down by a taxi, which turned
around and transported them to hospital.[5]

With the introduction of petrol rationing, London was
almost devoid of cars; the Oval cricket ground was turned
into a preparatory POW camp, shelters were springing up and
statues taken down. Soon the city's street names would also be
removed. Silver-coloured barrage balloons bobbed reassuringly
above London's spires. On 3 September Chamberlain declared
war with Germany. Blackout was introduced, the government
stipulating that no light should be visible from any building.
When call-up was launched for ARP (Air Raid Precautions)
wardens Ed wrote jokily to Billy: 'Mdm Ker-S couldn't keep
away from her *infame Reduit*. Ive just heard from her she flashes
her torch in the Blackout and surprises the strangest things
going in.'[6]

Bar's relationship with Wogan limped on. He threw her crumbs from his table, telling her she was 'the most faithful, loyal person in the world', as if she were a pet dog. In the same breath he accused her of never bridging the gaps between their meetings, surely a description of his behaviour, rather than hers.[7] In July 1939 she received a rambling and incoherent letter from him, written in rapid and careless script as if under the influence of great emotion, or perhaps alcohol. 'Barbara', it begins, 'I am very very sorry & ask for your full forgiveness'. 'Let me go.' He continued: 'I will give up / I am not living with Rosamond, / What's the use.' He ends: 'I know with all my heart that I did love you [. . .]. Goodbye. I AM SO unutterably SORRY. FORGET'.[8] Wogan's psychoanalytical entanglement with James Strachey was now ratcheted up to an hour each weekday. Bar could see the escalating detrimental effect it had on him and particularly resented Strachey's apparent insistence that his patient should stay away from her. 'It is just the closest intimacy which is the most dangerous at present', Wogan pleaded, unconvincingly.[9] In the end, it all seemed to boil down to his mother: 'My mother having caused me some ghastly experience of which I can remember nothing just because it was so bad, has made me into a being who longs for love & happiness, but who cannot trust it'.[10] Bar replied bitterly that he had ruined her life and there was nothing left for him to destroy.

When war was declared Bar repaired to the country, avoiding the capital as much as she could. 'I am now cowering in Cornwall', she told Ed, 'which is full of hearty English folk with purple noses & knees, & crumpled grey flannel shorts (to the knee) & tin specs. It makes a nice change from St Maximes, not a cork sole in sight, plimsolls is the mode here'.[11] She procrastinated about where she should live, finding it difficult to choose between the apparent safety of the country and the reassuring familiarity of the city. In October she settled on alternating one

week on and one week off, billeting herself with various rurally located friends. She sent her radiogram to be stored, placed her jewellery in a bank and awaited developments.

The war ruined Bar's business. Although CPV had an impressive array of clients, photographic supplies were hard to find and paper was rationed, removing the basic medium of advertising. There was anyway little scope or appetite for fashion advertising, particularly after clothes rationing was introduced in 1941. Distribution was problematic as railways were prioritised for the movement of troops and munitions; road transport was no solution because of petrol rationing. Colman and Varley joined up (the latter rising to the rank of colonel and being twice mentioned in dispatches); the company survived on a skeleton workforce (and had to be substantially rebuilt after the war). Bar's main means of livelihood disappeared overnight.

When later asked what she did when war broke out, Bar replied: 'Well I just went back to my little flat and lived as frugally as I could'.[12] She found short-lived employment interviewing applicants for a musical show designed by Sophie Fedorovitch, but this fell through when the star pulled out. Bar wrote to Bunny, who had metamorphosed into Flight Lieutenant Garnett of the Air Ministry, Whitehall, asking, tongue only half in cheek, if she could be his char. 'I'm looking for a job, mine went smash the moment the war started', she said, adding, rather dejectedly: 'I don't really know what to do for the best'. 'Please ask me out immediately,' she demanded, 'I long to be taken out by a man in uniform, and you're my only chance.' She ended on a sad note, saying she was 'thoroughly depressed and lonely and dying to see an old friendly face again'.[13] Desperate, Bar turned to Wogan for help, hoping he might bolster her a little financially. 'I know that losing your job has put you in a ghastly position', he answered, tartly. 'I do

help other people, but they ask for direct help, free from emotions & other demands'.[14] Bar might have been reminded of her mother's advice: never depend on a man.

In common with other householders, Bar received a booklet outlining employment opportunities for women, which included vehicle construction, engineering utilities, ship-building and metal and chemical production. Although desperate for paid employment, she was not desperate enough to take advantage of these. Neither, during the course of the war, did she enlist in any of the women's auxiliary services: the ATS, the FANY, the WRNS or the WAAF. Many women were liberated by war work, able for the first time to earn their own living and be free from the tedium of homemaking. But it seems that against the odds Bar was holding out for something more creative, preferably involving photography.

Bar was seeing something of Humphrey Pease, a kindly, reliable friend who doted on her and observed, ruefully, that 'living alone in London, having lost her job must be very depressing, and I'm afraid if the bombs do fall, she will leave London for good.'[15] A pacifist, Pease was in the capital hoping to obtain non-essential war work. When war with Germany was declared, he wrote: 'am frightened and depressed: I don't think I should ever be able to stand out against public opinion for any length of time'.[16] He had offered the authorities the use of his car with himself as chauffeur, but it was a two-seater. He was therefore relieved to be informed he would be employed by the Ministry of Information as a Mass Observer, a role he had previously undertaken in Bolton in 1938.

Meanwhile, despite his refusal to help Bar, Wogan lost little time in seeking her help when he misguidedly offered Ipsden as a refuge for children evacuated from London's East End – a strange decision, particularly as Rosamond was in a nursing home, recovering from a miscarriage. Was it another act of

spite towards Rosamond whose miscarried child was presumably fathered by Rees? According to her biographer, Selina Hastings: 'Returning to Ipsden, she was confronted with a scene of indescribable confusion: Wogan assisted by Barbara Ker-Seymer ineffectually attempting to cope with eleven evacuee children'. '"They were so miserable," said Barbara. "They slept on the floor, and they peed everywhere and were sick, and they'd never cleaned their teeth in their lives. Rosamond got lovely meals for them, which they wouldn't eat because they wanted fish and chips."'[17] Then Rosamond noticed that two of the children had scarlet fever. Concerned for her own children's health, and despite her fragile condition, she arranged to have the evacuees removed and the sick children taken to hospital.

'I look forward and love my time in London with you', Wogan told Bar, limply, in February 1940.[18] But his recourse to psychoanalysis progressively infuriated her. She saw the damage it caused him, the constant prevarication and questioning of every personal decision or motivation. When he turned the tables, scrutinising Bar's feelings and motives through the prism of patriarchal Freudianism, she found it impossible. They spoke different languages. His visits diminished and then creaked to a halt. Cristina Hastings, the estranged wife of the Earl of Huntingdon and daughter of the Marchesa Casati, had moved into the picture and would become Wogan's second wife in 1944. He had known her a while. From Spain in 1937, he had written to Bar casually mentioning that Cristina was a fellow volunteer. As Ed wrote to Billy, with an unusual degree of empathy: 'Wogan has gone off with Hastings I hear not that I didn't know so I suppose that upsets poor B as well as everything else'.[19] Wogan wounded Bar brutally, and it was on the rebound that she would make a surprising relationship choice.

The winter of 1939–40 was so cold that water pipes froze, the

Thames iced over, coal supplies ran out and vegetables could not be prised from the ground. At the end of January, as a result of the freezing conditions, the pipes burst in Bar's flat. Ration books were introduced that month, and butter was rationed to four ounces per person per week, sugar to twelve ounces and bacon and ham to four ounces. In March meat in general was also rationed and by May it would be cheese. Shortages were aggravated by the rising cost of living. On 10 May 1940 Germany invaded Belgium and Holland. Ten days later the Germans were on the French coast, across the English Channel. On 10 June Italy entered the war in support of Germany and in a minor act of misguided aggression the Italian shops in Soho had their windows smashed. (When Bar told Grandmamma Caroline that the Italians had entered the war and were thus enemies, she replied: 'They can't have, dear. I just bought a Guardi this morning'.[20]) Paris surrendered on 14 June. Around that time a pamphlet was issued to British households entitled *If the Invader Comes*. According to the historian Juliet Gardiner: 'It seemed to most people that now the Germans had overrun Holland, Belgium and France, their next logical step must be an airborne assault on Britain.'[21] It was a terrifying time.

Commenting on the transition of the Bright Young People's generation to political awareness in the late 1930s, Curtis Moffat's son, Ivan, said: 'It was a problem the 'thirties must have imposed on many people who'd started on one thing, and then had to stop.'[22] This was certainly the experience of Bar, Billy and Fred, and to a lesser extent, Ed. The war changed everything. It was a watershed which disconnected them from, or irrevocably altered, their pre-war careers. It distanced them geographically and, if the collaborative nature of their work and shared creative values diminished as the thirties came to an end, the war represented a bridge between the collective aestheticism of the 1930s and the individuality of their post-war

Barbara Ker-Seymer, Studio, October 1935

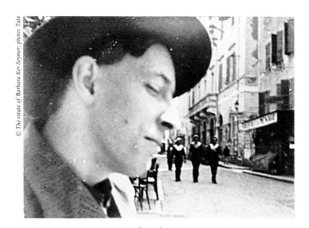

Edward Burra

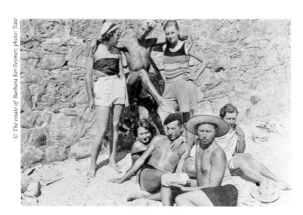

Toulon 1931
From left, back row: Barbara, Billy, Marty
Front: Bumble, Freddie, John (? Lloyd), Sophie Fedorovitch

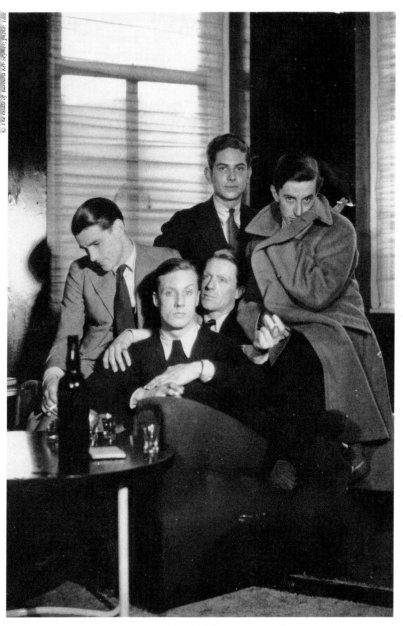

Studio 1932
From left: Tony Bruce, Billy Chappell, Peter Spencer,
John Goodwin, Frederick Ashton

William Chappell as
the Creole Boy

Frederick Ashton

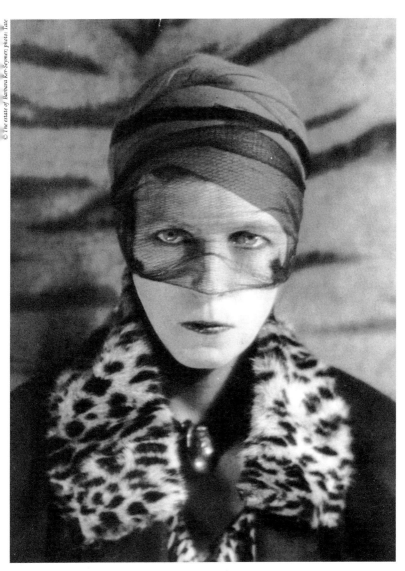

Nancy Cunard

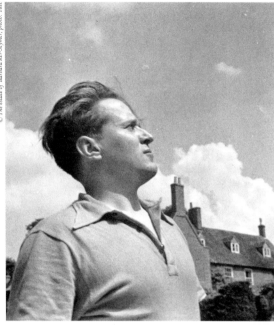

Tommy Tomlin

Len Lye, Studio,
May 1936

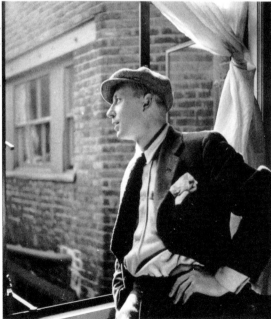

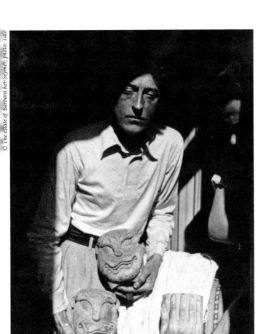

Jean Cocteau and
Jean Desbordes

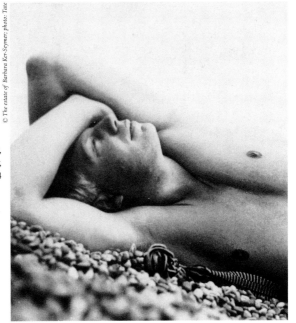

Bunny Garnett,
Abbotsbury,
September 1934

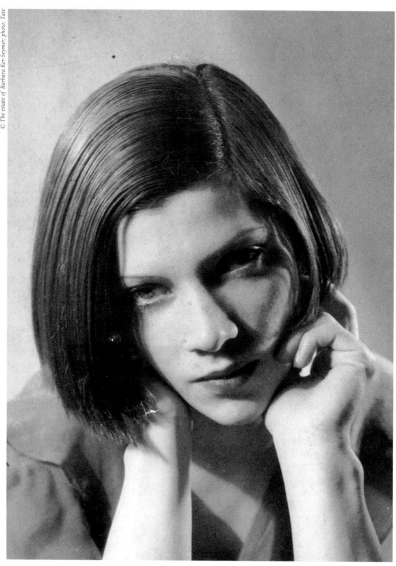

Kyra Nijinsky

careers. The war and its aftermath stopped the swinging thirties in its tracks, arresting many of the cultural and personal freedoms gained in that decade which would not reappear until the 1960s.

When war was declared, Fred, Billy and Robert Helpmann were touring with Sadler's Wells Company, which continued to tour. Performing in Holland the company made an alarmingly narrow escape at the time of the German invasion. In June 1941 Fred was called up and inducted into the RAF, where, hopeless at maths, he failed to make the grade at photographic interpretation which required at least a basic ability in algebra to calculate scale. Instead, he received a commission as an intelligence officer attached to various squadrons dotted around the country. Although he found it difficult to issue commands, he was popular with his colleagues because he was so entertaining. He hated this life and spent much of the war petitioning various influential friends to intercede on his behalf to leave the forces. It wasn't until October 1944 that he finally achieved a posting in London as a civil servant 'Air Advisor'.

While Fred's war avoided active duty and he occasionally gained leave to return to choreography, for Billy it was a different matter. He enlisted for active service in the Royal Artillery and undertook five months' cadet training in Yorkshire. On a short leave, he returned to London and dined with Ed, who found him 'scarlet in the face & swollen from the weather on the plain and with feet burned corn beef hash full of fissures & cracks'.[23] 'For a while', Billy wrote, 'on sporadic and hysterical leaves, any lost dancer such as myself hurried like a homing pigeon to the New Theatre where the company had taken up its wartime residence. I sometimes pushed my way back into the family group and I popped up unexpectedly in *Façade*, in *Job* or *The Rake's Progress*'.[24] Performing in *Façade* when he and fellow dancer Richard Ellis were on leave, he heard Constant

Lambert announce that their particular roles would be danced by 'Ordinary Seaman Ellis and Gunner Chappell'.

As Ed put it, Billy was being ground 'to red pottage with idiot officers & 35 mile route marches etc toughening process they call it'.[25] Billy had an essay published in John Lehmann's *Penguin New Writing*, entitled 'The Sky Makes Me Hate It', an angry and despairing reflection on sixteen months of army life. He paints a very different picture to the stereotype of *Blighty* pulling together during the war. 'War, as it welds the people of a nation together, makes every life an isolated life. Everyone is lonely [...]. We have all become strangers.'[26] He wrote poignantly of the peacetime luxuries he had taken for granted: chocolate, long hours lying in bed, hot baths; delicious and varied food; being surrounded by his possessions; reading; talking; visiting the cinema.

Billy was given leave from his military training to visit his mother in hospital. She had moved from Balham to her daughter's house in Amersham in Buckinghamshire to escape the bombs, only to be wounded when one landed on the house. He returned briefly to London on leave again in the summer of 1942, where Bar photographed him and Ed sitting together on a bench under a tree in Fitzroy Square, Billy's arm draped behind Ed and his other arm on his lap almost touching his friend's hand. Another photograph has Billy playfully placing his military cap on the head of a laughing Ed.

But Billy had a miserable war. Serving in North Africa and later in Italy, everything he held dear was removed from him: his mother and sisters, his friends and that all-important familial world which he referred to as 'the enclosed kingdom of ballet'.[27] While George Bernard Shaw campaigned for male ballet dancers to be exempted from conscription, on the grounds that British ballet's now high-standing reputation would be lost if male dancers disappeared, Arnold Haskell, an

influential critic, argued that male dancers should enlist and thus prove their manliness and distance themselves from their effeminate image. Billy found his army career pointless. Not mathematical, Gunner Chappell W.E.979498 failed to master gunnery; however, his organisational capability was soon recognised and he was made responsible for entertainment, putting on amateur revues. But the war destroyed his dancing career. While marching and drilling made many former civilians healthier, it damaged the muscle-memory of his dancer's body, which required regular practice on the stage and at the barre. Billy was so traumatised by his army career that he went over and over it in articles published in *New Writing*. He was still referring to army life four years after demobilisation, in his published monograph of Margot Fonteyn.

Too sickly and physically frail to be called up, Ed spent most of the war confined to Rye, or 'Tinkerbelle Towne' as he disparagingly called it. Paradoxically, he saw more fighting than either Billy or Fred, for Rye was beneath the enemy flight path towards London, and from July until October 1940 the Battle of Britain roared in the sky above. Vapour trails, the sound of machine guns, air-raid warnings, the clatter of spent cartridges and the hum of aircraft engines were constant. 'All we have are air battles overhead with machine gunning swooping roaring and carrying on', Ed wrote.[28] He couldn't do much for the war effort but regularly pilfered asparagus and other delicacies from his parents' garden, carefully parcelling them up to send to his friends.

In September 1940 London experienced persistent bombing. The Battle of Britain raged overhead and on 'Black Saturday', 7 September, bombs fell on the London Docks. It was the beginning of the Blitz, and there was no respite for nearly sixty days. According to the historian Juliet Gardiner: 'That was how life would be for many months. There were piles of rubble where

houses had stood, while some still standing were a grim cross-section of their former lives, the protection of their outer walls peeled away as if a giant tin-opener had ripped them open'.[29] By the end of September 5,730 people had been killed and 10,000 seriously injured. Oxford Street, bordering Soho, was badly bombed on 17 September. 'Barbara "carries on" in Soho,' Pease told his diary that month, 'without any work congenial for her to do. I see her much less than formerly, but we still drink at Berlemonts [the French Pub], eat at Victors [*Chez Victor*], and go to the Leicester Square Cinemas about once or twice a week.'[30] At the end of a miserable month, when all the news seemed to be bad, Bar learnt that her uncle, Launcelot Creyke, had died, hit by an underground train.

Alone in her flat during this period, Bar experienced over-whelming claustrophobia, believing it was probably only a matter of time before the flat received a hit. When a bomb landed on the church at the end of her street, Bar fled London. To Bunny, John Banting commented that 'Barbara has taken to the country by now and also digs away & (I'm told) produces very special vegetables & really enjoys it – with the aid of the good old "radio-gram" of course'. 'Her part of Soho', he continued, 'looks very bad & its [*sic*] a good thing she left before it got like that – she would certainly have been wounded I think. Her address in case you don't know it is Diamond Cottage – Aldworth, Nr Reading, Berks. There is a true honey and an unfading one!'[31] More acerbically, Ed commented to Billy: 'Little Miss KS is of course as snug as anything always on the right side that girl isn't it wonderful.'[32]

Diamond Cottage belonged to Rosamond, who bought it in 1939 hoping it would provide a base for herself and Goronwy while he underwent military training at Sandhurst, but their relationship was grinding to a close and the accommodation remained empty. Rosamond may have been glad of a tenant and

the rent, and perhaps she had some sympathy for Bar given that Cristina Casati had taken Wogan from them both. Aldworth is a small village on the Berkshire Downs within easy distance of London and about twelve miles from Reading. Initially Bar took on the cottage with other women friends, each contributing one pound a week. The cottage was relatively humble, with whitewashed walls and a tiled roof, a garden and a road at the back which led downhill to the village. Although Bar claimed to 'never having so much as stuck a trowel into the earth all my life', she was now indeed cultivating vegetables, having first cleared the garden of nettles and weeds.[33]

She was nothing if not resourceful, buying a sixpenny book entitled *Make Your Garden Feed You* and setting about sowing seed. By the summer they had a glut of lettuces, beans, peas, onions and spinach. They were rigorous about adhering to 'working hours', but it was a huge change of lifestyle for Bar. She also began voluntary work which she thoroughly enjoyed, driving a YMCA-sponsored mobile canteen to the military camps and aerodromes 'selling everything from chocolate doughnuts to hair oil'.[34] Bar's women friends dispersed, leaving her alone in the cottage, which she then resourcefully made available to the Defence Workers Rest Scheme. Thus she was able to earn income from people billeted there, gaining respite from their labours as ARP wardens or from other forms of defence work.

In 1941 the British army aimed to recruit nearly two million men, thus denuding factories of their workers while the supply of munitions required an additional one and a half million pairs of hands. Consequently in March it became mandatory for all women aged between nineteen and forty to register at employment exchanges so that those considered suitable could be directed into 'essential work' in manufacturing or the auxiliary services. There was no question of choice; you were simply sent

to where you were needed. At thirty-six, Bar fell within this age bracket and as a single woman without dependants, she could have been sent anywhere in the country. Such considerations may have been the catalyst for her to act completely out of character, apparently jettisoning her belief in financial and personal independence. But war created an uncertain world, bringing long-held values into question, for nothing was reliable or normal.

The social historian Virginia Nicholson commented that 'war often favoured romance in the most unexpected quarters'.[35] One such quarter was Epsom Register Office in Surrey where, on 7 May 1941, Bar married Humphrey Pease in a quick ceremony. Bar considered him 'very handsome (in the Anthony Eden style)' and described him as 'a very gentle man with beautiful manners'.[36] Her affection for him can be seen in a series of carefully contrived portraits in which he is depicted mostly in profile, and made to resemble a dashing film star.[37] These photographs were for neither publication nor publicity; after all, Pease was a Mass Observer and as such was required to remain beneath the radar. It was as if Bar was trying to polish up this charming, shambolic man in an attempt to persuade herself that he was marriage material. She had known him for over a decade and often turned to him for company when Wogan disappeared. She considered Humph a safe harbour.

Pease was gallant and considerate and believed 'ladies first' to be the rule.[38] He was a man of routine, reading the *New Statesman* with his morning coffee and enjoying a beer in a pub at lunchtime. He chain-smoked du Maurier cigarettes, deeming them less harmful than other brands. He worried about such considerations, and he worried a lot. Judging from his diary charting the months from July 1939 until April 1941, Bar was his chief preoccupation, and he often expressed concern for her happiness and well-being, although such concerns

were squeezed between paragraphs bemoaning his alcohol consumption, gambling habit and recourse to what he referred to as 'tarts'.

As a Mass Observer in London, based at Ladbroke Road, his special subjects were art, theatre and cinema, which suited him down to the ground. His role was to scrutinise the degree to which these were affected by war, a process which might involve determining the number of paintings which referenced the war in an exhibition, or counting the number of gallery visitors carrying gas masks. Pubs and bars were a particular speciality, although he could not always decipher his notes the following morning. 'I think I smoke far more than is good for me', he reflected, 'in company, especially when drinking, accurate observation & record become almost impossible'.[39] Only a week before the wedding, Humph confessed to his diary: 'Continue to live at rather unnatural pressure, more nights than not spent drinking and visiting the Boogy-Woogy: the tarts are my chief companions'.[40]

After the ceremony, the newly-weds parted company, she to spend her honeymoon in London with her sometime lover, Len Lye, while Humph went to the races. Bar wrote to Aunt Winifred about this latest development, jokily mentioning that if she couldn't find the rent at least Humphrey would cover it. Winifred retorted with a ten-pound note and a furious letter accusing her of 'utter callousness and selfishness'. 'I think that during your whole life, you have never given a thought to anyone but yourself', she spluttered. 'No doubt you will have a rude awakening someday and, you will deserve it.'[41]

CHAPTER THIRTEEN

Larkins, London and Love

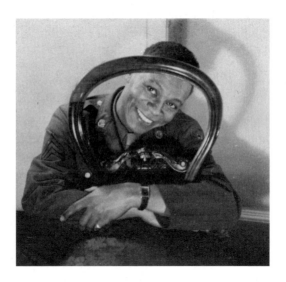

I f Bar did not exactly experience a rude awakening, she did have a shock when she and Humphrey eventually consummated their marriage. Pease had become dependent on a 'lady who had a flat in Pitts Head Mews who catered for all his needs', which centred on scenarios in which he would dress up in a beaded 1920s evening dress, or receive 'chastisement' from the woman garbed as a prison warder. 'It seems such a

harmless way of giving pleasure', Bar mused, but at the time
her sense of humour deserted her, as she did not expect to gain
sexual satisfaction by dressing up as a nanny and instructing
'Master Humphrey' that it was time for his bath.[1]

Humphrey was not a very confident man as evinced by his
diary reflections couched in self-doubt. He spent weekdays
working in London, living in a dank, furnished flat, rented by
the month, returning to the cottage at weekends. Occasionally
Bar came up to London to be with him, which he celebrated in
his diary as 'a treat'. The same entry records him getting very
drunk and behaving 'badly' at a wedding reception, 'loudly
trying to seduce' a colleague's wife 'among other things'. He
commented on how he missed various haunts which had been
closed down, noting wryly, 'some help in saving me from
penury, d.t., V.D., etc'.[2]

Though their affection was manifest, Bar and Humphrey
soon realised that marriage had been a step too far and amica-
bly agreed to divorce. The question remains: was it a marriage
of convenience to enable Bar to escape essential war work?
The unusual honeymoon arrangements together with what
was then a quick divorce suggest it had been. But it was more
than that. It was also an act of desperation on Bar's part, as she
could not find convivial work to maintain her independence.
However, she was fond of Pease and long after the war he was
often to be found, shirtsleeves rolled up, at her kitchen table.
Perhaps the marriage was a combination of pragmatism and
the mistaken assumption that affectionate friendship would
be enough to make it work. Pease loved Bar for the rest of his
life and she remained very fond of him, but Humphrey's sexual
requirements were too specific for her taste and the decision
to divorce was a relief for them both. The marriage officially
lasted a year and a week, ending on 14 May 1942, although
they separated earlier. The reason cited on the papers was

non-consummation, then the quickest way to dissolve a marriage and the closest to a no-fault divorce.

That same month Humphrey faced the challenge of gaining military exemption as a Conscientious Objector, and on the 18th his collection of rare printed books and letters, 'the property of Humphrey Pease Esq', was auctioned at Sotheby's. Earning only a pittance for his MO work, Pease could not fund his lifestyle from his earnings alone, particularly as he gambled – perhaps another contribution to the failure of the marriage, as Bar knew the destruction that could cause. She made a point of ensuring Humph took all his belongings, not wanting to face 'a pair of bedroom slippers or an abandoned pipe', but when she found some of his suits hanging in the wardrobe, she entertained no qualms about having them converted into suits for herself as clothes were now rationed and prices had soared.[3]

For a time Bar remained at Aldworth, but when Rosamond decided to reside there herself, Bar moved to Amners Farm at Burghfield, a village four miles south-west of Reading and within easy reach of London – a necessity as she had finally found photographic work, albeit of a very different nature to anything she had done previously. She gained employment with the Larkins Studio, a film unit making stop-motion animation films for purposes of military training and public information. Based at 51 Charles Street, in London's Mayfair, it was a relatively new company, founded in 1940 by William Larkins, a former art director of the J. Walter Thompson advertising agency. When Bar joined, the company was under the leadership of the German-Jewish émigré Peter Sachs, an innovative, experimentally brilliant animator who had trained in the studios of Weimar Berlin.

Stop-motion involves physically manipulating objects in tiny increments between photographed frames so that they

appear to move when the frames are played back. (Aardman Animations' *Wallace and Gromit* films are perhaps the best-known examples today.) The work was arduous: Bar had to photograph frame after frame, and while recognising that they made excellent films, she found the amount of work required 'horrendous'. Even so, her capability in this respect underlines her technical skill, ability to maintain light levels, timing and focus, her facility for teamwork and interpretation. Films made during the war included *Summer Travelling* (1945) which promoted the benefits of walking rather than taking overcrowded public transport. As it did not make entertainment films, the Larkins Studio remains relatively obscure today, but it had a huge influence on British animation and established the career of Bob Godfrey, of *Roobarb* and *Henry's Cat* fame.

Although Bar wasn't lonely, she missed seeing Ed, and she missed Freddie and Billy who had disappeared into the forces. Trying to entice Ed to visit for the weekend, Bar wrote: 'If by any chance you get a few too many windows broken or want a rest, why not come to Reading for a bit? I sometimes go down in the evening after work & the trains are quite empty then'. Bar leapt at the rare occasions when either Billy or Fred was granted leave. On one happy occasion their leave coincided; Bar and Ed rushed to meet them at the French House, and they lunched at a restaurant afterwards. It was a glimpse of the past, as Ed commented: 'I had an old time chat at the firewater Inn (Bergamot) [the French House] with Fred Billy & Mrs Pease a witches Sabbath as you might say we had lunch at a "little restaurant" called Sava not bad very cheap too & a bottle of Lachrima [*sic*] Christi if you please'.[4] For Billy, leave was a mixed blessing. 'When I go on leave there is an air of strangeness about everything and everybody,' he commented ruefully, 'and I cannot fully enjoy the companionship of my friends and my family, for our lives no longer mix'.[5]

For a while Bar commuted between London and Burghfield by train, but this proved tiresome after a long day in the studio, so in 1942 she moved back to London, to a top floor and attic flat at 11 Fitzroy Square. Below was the Cresset Press, which Bar's friend Dennis Cohen founded in 1927, and it was probably through his kindness that she obtained the flat, at a pepper-corn rent. The elegant square was partly designed in the late eighteenth century by Robert Adam but Bar's flat occupied the northern side, built c.1827–8, and backed by the Euston Road. It was approached through a graceful door at the side of the building on Fitzroy Street, and then by flights of inter-minable stairs to the fourth floor which contained a drawing room, dining room, small kitchen and bathroom. A further staircase led to two attic bedrooms and another bathroom. It was relatively well appointed with both a bath and shower, and the kitchen contained an 'Ice Box', or early refrigerator. The spare bedroom was important because it was reserved for Ed's visits and fortunately, he thoroughly approved of the location: 'I rather like Fitzroy Square a very pretty garden in the middle surrounded by some lovely Palladian fronts and ruins'.[6] The neighbourhood was part of the attraction: during the war Fitzrovia flourished as a centre of bohemia and was sometimes referred to as 'North Soho'. The Fitzroy Tavern, a notorious hang-out for homosexuals, was an establishment Ed particularly enjoyed.

In addition to her professional work, Bar volunteered at a smart club for American officers, making waffles ('to rhyme with baffles', she explained), behind the snack bar at the Jules Hotel. The first GI entered Britain in January 1942 and by May 1944 there were one and a half million American troops in the country. With their smart, crisp and beautifully tailored uniforms, it was as if Hollywood had come to town. Given the privations of rationing, Bar felt nauseated by the amount

of food they were served, 'plates piled high with meat & 3 veg & large portions of apple pie loaded with cream'.[7] While most of the other helpers were 'bright faced ladies with pearl button earrings, & diamond regimental badges pinned on to their plaid gingham overalls', Bar found a kindred spirit in Adelaide Yorke, known as 'Dig', the wife of Tony Powell's close friend Henry Yorke, who wrote under the pseudonym Henry Green. 'We hide behind the coffee urn', recounted Bar, 'like two "nippies" gossiping about "New Writing" or some such topic'.[8]

With the influx of GIs, Bar's flat became a popular locus for the Harlem contingent, Jimmie Daniels first among them. He brought along fellow African American GIs, including James 'Stump' Cross, one half of the then legendary entertainers 'Stump and Stumpy'. Bar pulled out her camera to snap the photogenic Daniels, and she photographed Cross on the floor, garbed only in the pages of *Variety*, and naked in her bath. While both Daniels and Cross were internationally known and respected performers, as African American GIs they were segregated from their white counterparts and given menial roles. Segregation was so extreme that 'black' and 'white' GIs took alternating days' leave so they wouldn't risk frequenting the same pub or café. So overt was racism in the American forces that the British government tried to distance itself by urging the British police not to discriminate against black personnel. In some quarters white American officers carried out a public-relations exercise by discouraging English women from inviting black GIs into their homes. This reflected a covert fear that black soldiers would fraternise with and impregnate white women.

Bar certainly fraternised with Stump Cross, but there was another African American in London who would occupy a special place in her heart, as well as her bed. At twenty-eight, Allan Morrison was eleven years younger than Bar,

handsome, principled and extremely intelligent. He was a reporter with *Stars and Stripes*, the only black journalist working on that publication at the time. His military rank was that of army sergeant. After the war he would go on to become the New York editor of *Ebony*, the foundational American magazine about black life, culture and politics. He was also an influential advocate of civil rights. Above all he and Bar shared a love of jazz, and Morrison was even more knowledgeable than she on the subject.

As a war reporter, Morrison's presence or lack thereof was a litmus test of whether critical events were about to unfold. In March 1944 Rye became a restricted military area because of fears of invasion via Normandy. Residents were expected to remain put, which made Ed want to flee, but Bar replied to a letter from him in late May saying: 'No! I don't advise any travelling at the moment as I suspect something will take place during the week or very shortly.' She explained that her 'intellectual friend' and correspondent for *Stars and Stripes* 'has just had his injections, and to-day has gone to deposit his luggage' and she expected him to set sail with an advance guard of journalists, presumably to cover the Normandy landings of 6 June.[9]

Pleased to be back in London, Bar snatched at any semblance of normality, so was glad when Fred too began working in the capital, where they enjoyed what she called 'high life' together, although it was really 'low life' as they would spend the evening in the Marquis of Granby pub on Rathbone Street, notorious for being a haunt of gay men, where 'queer bashing' was a regular spectacle. If the enormous guardsmen could find no homosexuals to beat up, they would set about each other. 'I've never seen anything like the peroxide & painted male tarts,' Bar told Ed, 'mincing & bridling, the female counterparts are all 45 or over, enormously fat [. . .] when we finally dragged

ourselves away an enormous old balloon [. . .] came out after us, and without a word opened her legs over the gutter and let out a stream of boiling pee. Fred was transfixed'.[10]

Ed's visits to the capital were less frequent and as Billy remained overseas, for Bar the only pattern of life revolved around the routine of going to work. Nothing was predictable. The weekend of 16 June was particularly bleak as the first V-1s or 'Doodlebugs' reached London, damaging St Mary Abbots Hospital in Kensington, and killing many in the congregation at the Guards' Chapel, Wellington Barracks. Within the first few days of the V-1s' arrival, more than two thousand people were seriously injured and nearly five hundred killed. Hearing the bombs coming overhead was agonising, a whining tone which grew louder on approach but went silent when the engine cut out, before plummeting to earth and exploding. Morale was low and disruption high. Everyone was on edge, waiting for the petulant sound of the next flying bomb. 'Weve had some very odd noises down here', Ed wrote to Bar from Rye, 'including V1 which simply wont stop & flies on & on over hill & dale'.[11]

Since their divorce, Bar and Humphrey's relationship had relaxed into affectionate friendship. He often turned up at Fitzroy Square for dinner or a drink. Bar continued to worry about him as he had failed to obtain complete exemption from military work. He had gone before the notoriously unsympathetic London tribunal in Fulham to have his application for conscientious objector status considered, but had fallen into category 'C', meaning he was liable to be called up for non-combatant duties. He thus transformed into Private H. Pease of the Non-Combatant Labour Corps, who would not handle any military material of an aggressive nature, but would be expected to drill without arms, and to be deployed in the heaviest and harshest forms of work, including construction,

quarrying, filling trenches and felling timber. 'Life could be galling for the non-combatant with endless kit inspections, the absolute minimum of leave, pedantic enforcement of every pettifogging regulation and sometimes outright hostility.'[12] Writing to Julia Strachey, Bar explained that 'Poor Humphrey is living in Monmouth House, the workhouse in Tisbury, & spends his days repairing the Wiltshire roads, breaking the stones & turning the handle of the concrete mixer'. It was work entirely unsuited to a man who was neither physically nor emotionally strong. Being a 'conchie', he found no one would partner him at the local dances, for the WAAFs took one look at the letters NCC on his shoulder bands and turned their backs. 'It is very sad', Bar reflected.[13]

One evening in early 1944, when Barbara was out drinking with Goronwy Rees, she beckoned over a young woman of her acquaintance, Marie-Jacqueline Hope-Nicholson, who was with her boyfriend, John Rhodes. Marie-Jacqueline found Bar 'intimidating in the way she summed up the young with that amusing look which signalled every likelihood that he or she would be found wanting'. She was also 'anxious as to whether Barbara would like John', but could not resist sitting beside 'the devastatingly attractive Goronwy.' 'As the night wore on I became aware of our foursome having turned into distinct entities – Barbara and John on one side of the table, Goronwy and myself on the other.'[14]

John Rhodes was a six-foot-tall, blond-haired and brown-eyed twenty-three-year-old, or as Bar described him: 'a slim, handsome aspiring writer'. The second of three brothers, he spent his infancy in India, where his father, Colonel George Rhodes CBE, served in the Royal Engineers. The colonel enjoyed a distinguished career and was decorated in the First World War; on his retirement from the army, he became an engineering inspector for the Ministry of Health, and resided,

with his wife Dorothy, in a house overlooking a golf course in Kingston-upon-Thames.

Rhodes was educated at Rugby, where he excelled at sport. Having abandoned his Cambridge law degree to enlist, he was undergoing training in the Intelligence Corps. He hoped, after the war, to make his way in the world free from the control which his parents sought to exert over him. On the rare occasion when his mother came up to London, she would expect all three sons, if available, to meet her at Waterloo station and accompany her on her errands. Aged twenty-one Rhodes sowed his wild oats in a relationship with the flamboyant homosexual poet Brian Howard. Rhodes hoped to be a writer or journalist, and he found Bar's circle of writers, artists and intellectuals extremely conducive. He was attracted to her bohemian world of cocktail parties and jazz records and slightly dazzled that this very attractive sexually liberated older woman should be interested in him.

'I got married to young John Rhodes', Bar wrote nonchalantly to Ed, 'who recently came back from Holland, he is very nice, very domesticated, and a wonderful character'.[15] They married on 31 March 1945 at St Pancras register office. With John twenty-four to Bar's forty, it was a considerable age difference. For John's part, the marriage was a continuation of his liberation, or put another way, an act of escape. In marrying an older woman, it was perhaps an act of defiance towards his domineering parents, for surely they would have expected him to marry a woman of his own age and social background rather than a jazz-loving bohemian with an odd assortment of mostly gay friends.

It is ironic that Bar spent her youth evading proposals from junior officers only to marry, in middle age, a young man with a pukka military background. Why did she marry? Could they not have simply embarked on an affair? Having already been

stung by marrying the wrong man, why would she try again, and with someone so much younger, whose background was clearly at variance to her own? Was it the impetus of war when lives could be lost and time was of the essence? Was Bar on a mission to save John from his parents? All this is perhaps to deny that they were in love, but her language: 'young John Rhodes', 'very nice', 'a wonderful character' seems rather lame, as if she is relaying the merits of a puppy or small child rather than a husband and lover. Perhaps the marriage was driven by Bar's desire to have a child, and despite her generally relaxed attitudes, she knew a child born outside of marriage would carry a stigma. She had desperately wanted a child with Wogan, but his prevarication had taken away the years when that might have been achieved. Possibly, she married Humph with a child in mind, unaware that his sexual proclivities had taken an unfortunate turn. Now she was married to a strapping, healthy young man almost as an insurance that at least on his side there would be no obstacle to conception.

They had known each other for a year when they married, but were apart much of the time, with John stationed at Maidstone in Kent. At the time of their marriage, he had not even met Ed. When Billy heard the news of the wedding he let off a stream of invective, but then, since entering the army, he had often been touchy in his correspondence with Bar, making her feel she was not doing her bit. Bar suggested to Ed that if she visited him in Rye, John could come over from Maidstone and pay them both a call. She was very careful to ensure Ed felt he remained a priority in her life, and he was. She saw him more often than her husband.

Bar's London life carried on much as it had done before. She attended 'a very smart cocktail party' given by Major Anthony Powell and his wife, Lady Violet Pakenham. 'I have never seen so many smart officers of every known nationality', Bar

reported to Ed. 'Needless to say a small huddle was formed
in the corner consisting of Bum, Constant [Lambert], Margot
[Fonteyn] and Tony and me, where we remained until nearly
12am. Tony recklessly emptying bottle after bottle of pure
whiskey into a huge jug with lemon peel [...], so you can
imagine the state everybody was in'.[16] Bar hosted a show of
Len Lye's films for friends, and attended the cinema, theatre
and ballet. Her overseas friends dispatched largesse, but not in
the form of chocolate or nylons, as might have been expected.
Len Lye sent the *Esquire Book of Jazz* and Allan Morrison mailed
American magazines and jazz records. Mickey Hahn regularly
posted the *New Yorker*, but even the laid-back Bar was shocked
to receive her irreverent autobiography, *China to Me* (1944),
which candidly charted her love life and adventures in the Far
East, where she became the self-proclaimed 'concubine' of a
charismatic, opium-addicted Chinese writer and bore another
man's child out of wedlock.

On Tuesday 8 May 1945, VE Day, Churchill addressed the
nation and most of the world from Downing Street, announc-
ing that hostilities with Germany would officially cease at one
minute past midnight. Billy, based in Naples, awaited demobili-
sation, but the army failed to inform him for a whole year that
he was free to go. He complained bitterly in letters to friends
and family, but Ed, who was travel-starved and had been ill for
much of the war, could only retort, unusually honestly for him:
'I realy feel like DEATH and cant go on'.[17] After Japan's surren-
der on 14 August and a two-day public holiday in celebration,
any euphoria Bar felt was subdued by the death of her mother
on 19 September. Diana died at Hawthorne House, Hampstead
Heath, the first Christian Science Nursing Home in Britain. She
was seventy-one years old, and survived by her own mother,
Caroline Creyke, who died a year later aged one hundred and
two. 'I had a letter from Billy,' Bar reported to Ed, 'who has

quite changed his tune on hearing of my mother's death, a little tribulation wins him round in no time'.[18] Probate from their mother's estate was granted to Manon and Bar, who shared the equivalent of around £40,000 today. As Grandmamma Caroline outlived Diana, her estate, valued at the equivalent of over £3 million, went to her two surviving daughters and neither Bar nor Manon were beneficiaries.

Once demobbed, Billy returned to Balham to find his mother's house obliterated and he had nowhere to live. Post-war there was a huge shortage of housing, but thankfully, a fortuitous encounter with an old acquaintance, Lord Ritchie, the brother-in-law of Ed's sister Anne, resulted in a tenancy of the top two floors of his house in Thurloe Square, near the V&A. However, the happy-go-lucky days of ballet were behind Billy. 'Of course, before the war, I did not know how to despair', he wrote, 'My life being free, I did not have to think at all'.[19] It was ironic that Billy had enlisted in the first place, because there was a lot of work for dancers during the Second World War when ballet was viewed as an art form which could feed the nation's hunger for entertainment and escapism. The government began to subsidise the arts, and as a result dance companies old and new entertained in London and toured the provinces, performing for theatre audiences, munitions and other factory workers and the troops. As a male dancer, Billy would have been in particularly high demand.

Initially he tried his luck as a theatrical costumier, but extended too much credit to customers, and had to give up the shop after a couple of years. Of course, Bar was a patron, commissioning a beautiful coat. Work slowly began to accumulate. Billy designed the costumes for the film of Terence Rattigan's play *The Winslow Boy* (1948), directed by Anthony Asquith, and starring Robert Donat. He then choreographed the BBC revue *Oranges and Lemons* (1949) starring Bar's old

friend Elisabeth Welch, and was given a role in a farce called *The Little Hut* (1950), directed by Peter Brook, which ran for over 1,200 performances at the Lyric, Hammersmith, thankfully restoring his personal finances. Thereafter Billy took any work available, and gradually he became in much demand as a director, producer, choreographer and designer for revues, theatre, film and television. He directed Sheridan's *The Rivals* at the Saville Theatre, London (with a cast including Laurence Harvey) and Noël Coward's *South Sea Bubble* for the BBC; he was dance director for John Huston's film *Moulin Rouge* (1952) and arranged dances for Laurence Olivier's *The Prince and the Showgirl* (1957), starring Olivier opposite Marilyn Monroe. For Billy, the war was a watershed between his hard-working but carefree years as a ballet dancer, and the world-weary workaholic director and producer he would become. He also turned his hand to writing, with some success. During the war he had three pieces published in John Lehmann's *New Writing*, a journal sympathetic to working-class voices, and in 1948 Lehmann published Billy's first book, *Studies in Ballet*. In the early 1950s Chappell wrote a monograph on Margot Fonteyn, *Impressions of a Ballerina*. It was quite something for a working-class boy from Balham who hated school and left aged fourteen.

For Ed the end of the war meant freedom to travel and he visited first the Lake District and Ireland before venturing to New York and New England in 1948. He designed for ballet, opera, film and theatre, as well as illustrating books, and in June 1947 held a one-man exhibition at the Leicester Galleries. The end of war also relieved him of the strain of being confined to Rye and coping with the war playing out across the nearby Channel and overhead. The strain proved physical as well as emotional. He was anaemic, had an enlarged spleen, and suffered from nausea and jaundice. Ed seriously missed having fun.

Fred's war ended better than it had begun, when in 1944 he left the RAF and was posted in London as a civil servant 'Air Advisor'. Afterwards he returned as principal choreographer of the Royal Ballet (formerly the Vic-Wells) which in February 1946 celebrated its move to the Royal Opera House at Covent Garden with a gala-night production of *The Sleeping Beauty*, attended by the Royal Family and Cabinet. Ashton was able to exploit the much larger stage at Covent Garden and produce a ballet celebrating dance purely for its own sake rather than that of narrative or characterisation. The result was *Symphonic Variations* (1946), a masterpiece and landmark of British ballet. With Sophie Fedorovitch as his designer, there was overall harmony between choreography and design. The set was inspired by a sunlit glade the pair encountered when out cycling together near Sophie's Norfolk cottage. Billy commented: 'Ashton's ballet has shown a contemporary romanticism, based only on movement [. . .] [which] expresses, in some inexplicable abstract way, as much, or even more, of the human heart, as any ballet with a definite plot or obvious theme.'[20] Ashton had made a triumphant return.

Bar continued to work full-time for the Larkins Studio. It was evident that her happy and fulfilled professional life as a photographer was irrevocably behind her. Bar always maintained that at this point she lost her negatives, having left them at Larkins, and that when she returned to retrieve them, they were not there. Yet today the Tate Archive contains several boxes of negatives, which clearly match photographs in her albums, while others are studio portrait negatives. Bar had kept the boxes tucked away at home and they were given to the Tate after her death. This begs the questions: did she mislay her negatives and forget where she had put them, or did she insist that they were irretrievably lost to deflect interest in her work? Perhaps it was simply too painful to contemplate a

decade's worth of pioneering photography to which she could not return?

Bar had not practised as a portrait photographer for seven or eight years. In some respects, her photography and the market for her work were of their time, deeply embedded in the 1930s and the gossipy, fashion-rich, glossy magazine world. Other photographers, for example Humphrey Spender and Gerti Deutsch, had moved with the times towards reportage and worked for *Picture Post*. Bar didn't stop taking photographs but she directed her camera now only towards those in her orbit, not in a professional role. As Virginia Nicholson observed: 'Whatever their wartime experiences, few had emerged unscathed – but many felt that they were entering the next period of peace as, essentially, different individuals from the ones they had been when the last peace came to an end in 1939.'[21] This could not have been truer of Bar.

CHAPTER FOURTEEN

Life-changing Events

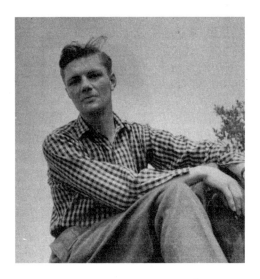

Post-war, the clique's friendship and mutual affection endured: Bar and Billy looked out for Ed who spent even more time at Bar's; Fred still dropped in, uninvited, for supper. But they were all six years older, and the pressures – variously of work, responsibility and ill health – made themselves felt. While Billy and Fred were demobbed from their respective war duties, the end of war did not bring John Rhodes home

to Bar. Instead, he continued in the military, as a captain in the Intelligence Corps stationed in Berlin, where he remained, except for short periods of leave, until late 1946. While she saw little of her husband, Bar took his younger brother Richard under her wing, introducing him to French films and opening his eyes to her version of bohemia. 'Barbara was very kind to me and introduced me to friends in London', he remembered, 'at luncheon with her in 1946, I met the novelist Henry Green'.[1]

Bar led her life much as she had before marriage. At the Larkins Studio, they now made films which combined animation and stop-start motion, in the form of short instructive documentaries for commercial concerns or government information about rationing. Ever a balletomane, Bar made a new friend in Donald Saddler, a twenty-eight-year-old American dancer and original member of the American Ballet Theatre, who went on to become a distinguished choreographer and theatre director. It was a continuation of the current that brought American artistes to Bar. Saddler was performing at the Royal Opera House with New York's Ballet Theatre, dancing in Ashton's *Les Patineurs*. Naturally, Bar and Billy were among the first night's audience and afterwards they accompanied Saddler to the Caribbean Club in Soho, where the resident trio were jazz experimentalists. According to the bass player Coleridge Goode, who arrived in London from Jamaica in 1934, 'The Caribbean Club was a kind of "ideal" of how people could mix without tensions and trouble. As the War ended we were looking ahead to the way things might be better . . . it was a genuinely mixed club in terms of race and class.'[2] It was an 'ideal' very much sanctioned by Bar and her friends.

Initially Bar wrote carefully to Ed about the dates when her husband would be home on leave, reassuring him that the spare room would be available any time thereafter. She was perhaps anticipating trouble as she later wrote rather cryptically to Ed:

'When he is settled in, you must come and stay and meet him and we must try not to get too hostile together!'[3] John was evidently home by Christmas 1946, because Ed wrote to Billy: 'I gather Mrs Rhodes is busy with her nose at the gas stove cooking lovely fresh food & nothing out of a can'.[4] Although it was a typically caustic remark, it alluded to the fact that Bar was expecting.

It was not a good time to be pregnant. Rationing remained in force and in some respects was more stringent than during the war. Continual rain during the summer of 1946 had ruined Britain's wheat crop, causing bread to be rationed for the first time. The exceptionally hard winter of 1947 destroyed over-wintered potatoes, leading to potato rationing. Notwithstanding some leniency where pregnant women were concerned, the fat ration had been reduced and the 'Make Do and Mend' mentality was difficult to apply when sewing materials like Sylko were in short supply. Having altered and re-altered clothing for most of the duration, threadbare remnants could scarcely be let out and transformed into maternity wear. When Bar resigned from her job at Larkins in early 1947, the whole country was frozen solid, battered by a biting north-easterly wind. Water froze in washstand jugs, from top to bottom. The weather caused havoc in transport, fuel and food supply. Frozen pitheads affected coal provision and to save fuel, electricity was cut off for five hours in every twenty-four.

For all these reasons, and having been confined to Blighty for the best part of eight years, at five months pregnant Bar rejoiced in the prospect of travelling to Rome with John to visit his younger brother, Richard. The allure of the Eternal City was such that Bar ignored her better judgement, agreeing to share the holiday with her mother-in-law, Dorothy Rhodes. They journeyed by train, stopping for a few hours in Paris and

other cities en route. As Bar told Ed: 'I leapt out of the train at every station causing mother dear to have heart failure'.[5] John was still in thrall to his mother and despite marriage and impending fatherhood, too much of a son. They stayed at a *pensione* at the Villa Borghese, where Bar was surprised to encounter two Italians carrying a single bed up to the double room allocated for her and John. This had been arranged by 'mother dear', apparently unable to countenance the fact that her son shared a bed with his wife.

Bar found it difficult to avoid Dorothy's hawk-like gaze and to escape into the city by herself. Dorothy was sixteen years older than Bar, the same span of years as between her son and his wife, and she did not approve of the union. She was over-protective of both her son and future grandchild, forbidding Bar to go to the cinema or wander far from the *pensione*. Bar was astonished. No one spoke to her like that. Standing her ground she informed Dorothy that it was *her* child and she intended to do exactly as *she* wanted. As a compromise, the younger brother, kindly Richard, showed Bar the sights, taking her to the Forum, the Palatine Hill and the Sistine Chapel, as well as San Pietro in Vincoli to see Michelangelo's *Moses*, where he noted that she greatly admired the artist as both a painter and sculptor. Deeply manipulative, Dorothy took to her bed suffering from 'water on the knee'. John remained dutifully in attendance.

Despite the presence of her mother-in-law, Bar fell in love with Rome, rhapsodising about it as 'the most wonderful place I've ever been in, it is so beautiful, and combines all the chic of Paris with wonderful buildings and blaring sun & blue skies, and everything looks so clean and sun-drenched'.[6] Bar could not get over the food, a veritable cornucopia compared to rationed Britain, where the only eggs she managed to consume were those dispatched from Mickey's Dorset hens. Like Mole

in *The Wind in the Willows*, the sheer range and volume over-
whelmed her.

> Spaghetti, rice, cannelloni, gnocchi, every sort of pasta
> to start (loaded with butter, tomato sauce and parmesan),
> though I rather favour anti pasta [*sic*] which consists of a
> plate lapping over, with real ham, smoked ham, salami,
> anchovy, olives, baby onions [. . .]. After that there is a
> choice of at least 6 dishes, two or three consist of real eggs
> [. . .]. Most of the veg are served cold on side plates covered
> in oil with a slice of lemon, really delicious, I'm particularly
> fond of the little baby marrows. After that fruit, cherries,
> apricots, peaches, oranges, apples, or cheeses or if room
> [. . .] dolces [*sic*], which generally consist of an enormous
> oblong of homemade cake, about 6 ins by 3 high & 2 across,
> covered in cream and chocolate & soaked in marsalla [*sic*],
> which simply melts away in your mouth![7]

In London Bar had experienced fainting fits and stomach
cramps, but with this rich and nutritious diet, she felt quite well
again. It was lucky they holidayed when they did, for in August
Attlee's government returned the country to a wartime econ-
omy: tea and meat rations would be reduced and foreign travel
was suspended.

Bar prepared for motherhood by reading an *Advice to a
Mother* manual, but she did not let her pregnancy slow down
her socialising. In August, at eight and a half months pregnant,
she went down to Dorset, solo, to stay with Mickey and her
husband, the brilliant linguist and historian Charles Boxer,
whom Bar met for the first time. Fortunately, she approved of
the union, and, anticipating her own child, was particularly
interested in their young daughter Carola (born in Hong Kong
during the Second Sino-Japanese War), declaring her 'one of the

most beautiful children I have ever seen'.[8] Together with Billy, Bar occupied her favourite seat in the front row of the London Casino, to see the tap-dancing Nicholas Brothers, 'quite like the old days'. She asked Ed to squeeze in a visit before the baby's arrival in early September. On the evening of 6 September Bar attended a concert performed by famous American vocal group the Ink Spots, during which she felt the baby 'dancing about like mad inside me'.[9]

The following day, she went into a nursing home. 'There is a lot to be said for Caesareans', she quipped, 'when the day of birth can be chosen to fit in with social engagements'.[10] Max Humphrey Lionel Ewart Rhodes was born on 8 September. His first name was for Max Beerbohm (the essayist, writer and caricaturist, of whom Bar was a long-standing admirer), his second for Humphrey Pease and his third for Lionel Perry, a charming Irish friend of Bar's, whom she had known since the days of Billy's involvement with John 'the Widow' Lloyd, a mutual friend. Ewart was a Rhodes family name, but Max's forenames were weighted in Bar's favour, as if she was trying to make up for the loss of her double-barrelled surname. It was not then a convention for fathers to be present at the birth, and Bar would have remained in the nursing home for a couple of weeks afterwards. She received an affectionate letter from Donald Saddler, referring to her baby as 'a lucky child'.[11] From Len, Bar received a typically oblique and animated congratulatory message: 'Now you prong into the future has an umbilical in the hope of Max plus as well your own haze of hope.'[12]

To Ed, who was not interested in the finer points of motherhood, Bar wrote, 'Max is getting on splendidly and is madly busy during his waking hours snorting and mumbling, kicking his legs out and boxing with his arms, he seems very happy and contented thank goodness, he is putting on weight like mad.'[13] While Bar was engaged with the baby, John was looking for

work. Unable to obtain experience as a journalist, he returned to university, this time to read German. Bar was alarmed, however, when three months after Max's birth, her husband spent Christmas with his parents in Kingston-upon-Thames, leaving her holding the baby in Fitzroy Square. It was as if a silent battle was being fought over John between Bar and Dorothy Rhodes, and it was clear who was winning.

It didn't get better. In the summer of 1949, when Max was nearly two, they went *en famille* to the South of France with Ed in tow. John found himself on holiday with his wife and toddler and a middle-aged man who liked nothing better than sitting in dingy bars drinking Amer Picon. It was Bar and Ed's old stamping ground, where eighteen years before they had tried to photograph prostitutes. She and Ed viewed the world through the same lens, and it was not a world which John recognised or wanted. He felt trapped by parenthood and the fact that his 'youthful' wife was actually middle-aged and so were her friends. His response was simply to walk away. In the middle of the holiday he left. Bar was devastated.

She had not seen it coming, and considered him to be a good father: 'John and Max were wonderful together I loved watching them play.'[14] Whether or not it was premeditated, the abandonment was brisk and determined. Writing to Ed, their mutual friend Betty Keen said: 'Barbara told me the whole business in a letter and I was so horrified I've not known what to say [. . .]. It was so awful happening on your holiday like that and such a shock for Bar. Oh dear, oh dear. She said you had helped such a lot and if you hadn't been along she'd probably have jumped into the Channel.'[15] It was an interesting turn of the tables for Ed to be the one to lend support.

John's brother, Richard, had a theory about John's reaction to life with Bar and baby. He believed that when John returned to Berlin in the period after the war, he and Bar shared a similar

left-leaning outlook, but that in divided Berlin he saw the after-
math of the shocking and devastating behaviour of Russian
communists at first hand – they had carried out systematic
looting, and raped an estimated 130,000 women. Meanwhile
starving German children scavenged for food. These horrors
may well have caused John to change not only his political per-
spective but also his outlook on life generally, in which respect
Ed's sarcastic quips and Bar's joyful banter may have seemed
irritatingly trivial. Crucially, he was twenty-eight to Bar's
forty-four and the age gap had not narrowed. As a boy he had
been controlled by his domineering parents; he had dedicated
the first half of his twenties to military service, and despite his
short-lived affair with Brian Howard, had experienced little of
the freedom of youth. From the army he had moved straight
into marriage and fatherhood. Perhaps he discovered that he
didn't really know Bar and that they had little in common.
Taking into account his absence during the war and afterwards
in Berlin, their time living together amounted to about one
and a half years. The marriage was not a success, and Bar later
commented that John sometimes behaved badly towards her,
although she did not elaborate on how this manifested itself.

Once back in Britain, Bar made straight for Mickey Hahn's
Dorset home where she received sympathetic and practical
support. It was fortuitous that Mickey was in the country as,
living mostly in New York, she was only permitted residence
in Britain for ninety days annually for tax reasons. She and
Charles spent many months apart, residing on different conti-
nents. They now had a second daughter, Amanda, born a year
after Bar's Max. Bar grieved for her marriage, unable to con-
template life without John. She could not fail to see the irony of
finding herself a single mother after all.

Bar also felt guiltily unable to cope with Max's needs and he
seemed to symbolise her failed marriage. Having plucked up

the courage to return to Fitzroy Square, she was confronted by an infestation of rats. Feeling desperate and in a distraught state, she prevailed upon her mother's former cook, Lillian Gutteridge. 'Thank God Lily took Max off my hands,' Bar wrote to Mickey, 'otherwise there might have been murder. He seems to sense that something is wrong and clung to my legs all the time looking pleadingly up into my face.'[16] Bar had to confront the facts. 'I know now that John will never come back. He has said quite coldly and without anger that he would rather live alone in a back bedroom eating at snack bars and washing his own socks, but free to live his own life. After that, there is nothing more one can say'. Then she stated: 'I really feel I would like to die right now, except that my will is made out in his favour, so that I must get altered first'.[17]

Bar spent an afternoon with Anne Hill at her Heywood Hill bookshop in Mayfair, perusing books on child psychology to research the effects of having separated parents. 'I suppose', she remarked, 'I shall have to find a father substitute among my many queer friends'. John returned to his parents' house, where Bar assumed he would be miserable. 'At meal times Father says, "pass the fruit Dorothy" and she being slightly deaf doesn't hear, and he says in a very loud voice "I said pass the fruit, F.R.U.I.T." I think John has a lot in common with his father really', Bar concluded.[18] To add insult to her husband's desertion, John's parents were intent on taking Max from her, believing she was an unfit mother and he should be raised by them. Many years later, Bar wrote to Max, recognising that his father was 'dominated by that awful mother and fiendish father.'[19] She had to battle to keep her son and she fought fiercely for him. But she did not find single parenthood easy. She had experienced self-reliance and freedom for so many years that it was difficult to accept that life had changed and she must change with it. When Goronwy Rees turned up one evening with a bottle of gin it

was tempting just to have a good time. Settling down to read Truman Capote in the park one day, she looked up to find Max bashing other children with his spade. 'I suppose that one day things will straighten themselves out', she sighed.[20]

Despite – or perhaps because of – Dorothy's desire to take custody of the boy, John refused to contribute to Max's keep, and angered Bar by neglecting to respond to her letters enquiring about his work. To help make ends meet she acquired a succession of lodgers, vacating her bedroom for Max, and moving her bed to a corner in the drawing room so that the lodger could occupy the remaining bedroom. Bar paid £6 per week rent against an income of around £5 a week from investments, but was determined to remain in her flat rather than move to somewhere cheaper in the suburbs. John did not want a divorce, which remained highly stigmatised, usually requiring 'proof' of adultery in the form of (usually) the husband being 'caught' in a hotel room with someone hired for the purpose. As there was no legal requirement for John to provide for his son, Bar needed to earn a living. John's desertion also served to eradicate any hopes she may have harboured regarding a return to working as an artist. But what would she do?

CHAPTER FIFTEEN

A Question of Priorities

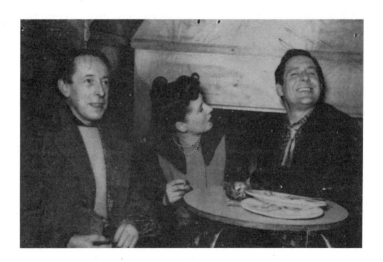

While struggling with the responsibilities of mother-hood, Bar desperately clung to a former life: she could not resolve the dichotomy between her role as mother and her long-held identity as a hedonist. Freedom and fun were habits she found hard to relinquish, and in October 1950, when Max was three, she eagerly accepted an invitation from her old flame Stump Cross, to join him for eight days at a smart hotel on the Champs-Élysées in Paris. He and his professional

partner Stumpy were performing at the Cirque Medrano and Stump offered to foot the bill. Bar left Max in the capable hands of a woman friend and set off with high hopes for the holiday, arriving in an 'unbelievably lovely' Paris, where she felt relaxed for the first time in ages.

However, arriving at the hotel she discovered that she was expected to share a double room with Stump, a surprise rendered more unwelcome when, on entering the room, she was confronted by him and Stumpy shrouded in a fog of cannabis smoke. This set a precedent for subsequent evenings, when Bar was unable to retire as Stump and his cronies caroused into the night. Bar eventually resorted to bolting the door to prevent them from bursting in, only to be awoken at dawn by Stump climbing in through the window. Their room was on the seventh floor.

Bar was treated with contempt by the hotel staff as a white woman consorting with a black man, and was mistreated by Stump, whose generally friendly and fun-loving demeanour had changed under the influence of drugs. He locked her in the hotel room; he locked her out. The hotel porter deliberately refused to acknowledge that she was registered at the hotel and would not let her in. To Mickey, Bar reported mildly that 'the visit was not without its ups and downs', but the experience brought home just how irresponsibly she had behaved. It marked a defining moment. Many years later, when asked about parenthood, she said: 'it completely changed my life because it took away my attention from myself [. . .] before I felt I had no responsibilities to anybody at all and I felt now I must look after this child and see that he grows up in the way he wants to be and he is a happy person'.[1] Now in her mid-forties, although still svelte, stylish and youthful in appearance and outlook, she could no longer afford to take risks because she was responsible for Max.

Bar's resolve was, however, only up to a point. The time she spent in Soho was 'rather cramped in the '50s as Max was three by then but he spent many hours in his pram throwing all the shopping out on the pavement outside the French Pub'.[2] She couldn't resist drinking with Humphrey Pease, leaving Max in his attic bedroom, on occasions, to repair to the 'pub below', where Humph regaled her with stories of his encounters with his woman friend in Pitts Head Mews. Bar thought it hilarious when he complained that this woman's standards had slipped: as a result of continuing privations, she issued stockings full of holes, and a petticoat too short for Humph to wear. Humphrey's picaresque accounts of his sexual adventures cheered Bar up. Sometimes she said 'to hell with it', locking the door to her flat with Max tucked up inside, while she and Humph retired to a restaurant to drink champagne and dine on duck and oysters.

But Bar was off on a new mission. Although Len Lye had moved to the United States in 1944 and was living in New York City, he was often in touch and once commented on the pro-liferation of Laundromats in the US. At this time, there were relatively few launderettes in London, and not many house-holds had a washing machine. Laundry was labour intensive and was almost always carried out by women, usually on a Monday leaving the remainder of the week for drying and ironing. Len's observation sparked an idea. Bar spent weeks tramping the London streets, Max in tow, visiting all the launderettes she could find. She asked customers about their experience doing laundry away from home, and without fail they commented that they could not understand how they had managed before. Recognising that demand for launderettes exceeded supply, Bar decided to open her own.

At that time the American company Bendix (a subsidiary of Philco, in turn a subsidiary of the Ford Motor Company) had the monopoly on launderettes in London, having opened

the first self-service launderette in 1949 in Bayswater. The Bendix concession came in three sizes; the larger the number of machines, the greater the boiler capacity required, and also the larger the premises. Bar set her sights on the smaller model, a twelve-washer unit costing £4,500 (around £140,500 today). Of course there were additional capital costs in terms of investment in frontage, in lease or rental agreements and in boiler equipment, pumping paraphernalia and hot water tanks. Bendix preferred to identify sites and then franchise them to prospective clients, but Bar made her own decisions. She called her business Westminster Launderettes.

Bar found a suitable property at 21 Tachbrook Street, Westminster, and later, in 1954 or '55, she opened a second launderette in Regency Place, also in Westminster. Bar's former help, Lily, was by then on National Assistance, a post-war Welfare State benefit, so Bar invited her to work in the launderette. Lily replied: 'I know nothing about being a laundress, mam', to which Bar countered: 'you'll have to learn and so will I'.[3] They carried out service washes for local customers themselves; it was hard work and initially Bar had to farm Max out to women friends, which she regretted, but she was delighted when her lodger, James Cummins, commented on her transformation into 'a hard-headed and shrewd businesswoman'.[4] Bar was proud that the business was an immediate success, and she found the enterprise 'very amusing because I met so many people – I thoroughly enjoyed being a launderess'.[5] Ed, who reliably deflated any notions of grandeur, referred to her as the 'laundry princess' or the 'launderette girl'.

As a businesswoman, Bar was pioneering, courageous, resourceful and extremely unusual as in the 1950s very few women were entrepreneurs. Bar had the same chutzpah as Margery Hurst, another single mother who took control of her career, opening a one-woman typing agency which rapidly

grew into the stock-market listed employment agency, the Brook Street Bureau. While Hurst borrowed from her father, Bar secured a loan from Coutts, the private bank which generally catered for a wealthy clientele. Her bank manager recognised that she was shrewd and reliable with money, that she had previously run a successful photographic business, and that she had been careful to preserve and invest Aunt Winifred's legacy. Furthermore he (bank managers were all men until 1958 when Hilda Harding was appointed a manager at Barclays after twenty-four years of service) had faith in Bar's careful market research and in her considered opinion that there was capacity for additional launderettes to thrive. Ultimately, the business was so successful that it took only four years to repay the loan. Once again, Bar operated in a largely male domain although as front of house, as well as CEO, she worked for and among clients, gaining valuable market insight and experience. According to Rachel Cooke, whose book *Her Brilliant Career* examines the lives of ten women who bucked the trend, a 1950s businesswoman needed to be 'thick-skinned: immune to slights and knock-backs, resolute in the face of tremendous social expectation'.[6] The dictum to remain independent and never rely on a man had never been more relevant, especially at this stage in Bar's life when a very small man was reliant upon her.

Bar was still in touch with John Rhodes's former girlfriend, Marie-Jacqueline Hope-Nicholson, now married, with the surname 'Lancaster' and a mother herself. She provides a delightful vignette of Bar's maternal style: 'One day Barbara brought Max to nursery tea, humping his pushchair in and out of buses from one end of London to the other. The occasion was not a success as Max would keep launching himself like a missile against the nursery window while my two girls cowered under the tea-table. How odd it was to see Barbara totally content with

late motherhood and sublimely unruffled at what I feared were going to be Max's last hours on this earth.'[7] Bar was hardly supremely content, as she worried about Max's health, but at the same time maintained a rather cavalier attitude towards it, perhaps a legacy of her mother's Christian Science approach. She paid no attention when his tuberculosis test proved positive or when a doctor instructed her to keep him out of the sun. At one point when she discovered Max had been whisked off to hospital from school, she marched into the ward and yanked him out of bed, ignoring the protesting matron.

Max was a lively little boy. Staff at the Cresset Press, which occupied the lower storeys of 11 Fitzroy Square, discovered one morning that there had been no post, only to find it shoved down the lavatory. Max was brought in, 'very shamefaced to apologise and promise he wouldn't do it again'.[8] He had been a pupil at the Francis Holland School in Sloane Square for about a year, conveniently close, perhaps, but it was a girls' school and he was teased relentlessly. Bar also insisted on sending him to ballet lessons on Saturdays which he loathed; he was the only boy in the class. Eventually, he was expelled from Francis Holland for getting into a fight, afterwards attending Burdett Coutts, a London County Council school conveniently located at Rochester Street, behind his mother's launderette. In the Easter holidays Bar also had responsibility for Clover's teenage son, Edward, who attended boarding school in England while his mother resided in Spain.

Bar's flat in Fitzroy Square remained an important locus for her friends, but they had become more dispersed. Billy seemed to be constantly on the move between productions in the capital and the provinces. Fred also travelled for work and Ed for pleasure. Much to his dissatisfaction, while he was on a prolonged visit to the United States his parents moved from Springfield to Chapel House in Rye, a smaller and more

manageable residence. Its convenient location near the shops
proved inconvenient for Ed, as it was built at the town's apex,
requiring a walk up- or downhill over cobbles, an ordeal for his
feet. In the summer of 1952, Bar was able to accompany him
on holiday to Barcelona, where they sat in cafés and flamenco
bars and Ed enjoyed tapas, which he found very satisfying, to
Bar's chagrin as she considered sitting down to an extended
meal an essential component of a holiday. One of their daily
routines involved Bar leaving Ed in what she described as 'the
back regions of the darkest bar' drinking Amer Picon, while
she took a tram to the beach and indulged in one of her greatest
pleasures: swimming in the sea.[9]

Allan Morrison was in London during the summer of 1953
and he and Bar rekindled the relationship they had enjoyed
when he worked for *Stars and Stripes* during the war. This time
it was serious on both parts, and Allan asked Bar to return to
New York with him, promising to marry her after divorcing his
estranged wife. Bar faced a terrible dilemma. She desperately
wanted to marry Allan, but if she took Max to New York he
would be removed from his friends and all that was familiar
and would not receive the education she envisaged for him.
She wondered how she would earn a living, launderettes being
old news in the US. She also questioned why she would have
invested financially and personally to build a successful busi-
ness only to abandon it.

When Allan returned to New York, he wrote to Bar saying
he found leaving her in London almost unbearable. He told
her how much he loved and needed her and that she could
make him completely happy. He wanted to spend the rest
of his life with her, but how could they breach the distance
between them? Each hoped the other would make the deci-
sion; each felt unable to shoulder the burden. Perhaps they
were both unwilling to accept the glaring fact that a long

distance love-affair was hardly sustainable, particularly as Bar had to consider Max.

There was an additional complication. At forty-eight, Bar thought she was pregnant again. Allan desperately wanted children, but neither he nor Bar were divorced, and he pondered whether the stigma would be too much for Bar. The fact that the child would be of mixed heritage was not raised: perhaps that mattered to neither of them, although in either London or New York it would be brought up in a largely segregated world. What Bar really wanted was for him to relieve her of her conflicted feelings by making the decision for both of them. Bar asked him whether he would give up his life and move to London. This he categorically refused to do. He loved New York, relished his job, felt impelled to campaign for civil rights and to continue his charitable work for the children of Harlem. He could not envisage living anywhere else. Ultimately, this was an issue that could not be resolved satisfactorily on either side. The logistics of a transatlantic relationship were insurmountable.

Allan offered to pay for an abortion, although he emphasised his discomfort in addressing the subject by means of correspondence rather than face-to-face. Did Bar have a second abortion, or was it a false alarm? There is no evidence either way. Having taken the decision to remain in Britain, the question of whether it was the *correct* decision would continue to fester at the back of her mind.

With a business to run and a young son to care for, Bar's life was busy enough, but it became further complicated by Ed's friendship with David Paltenghi, a handsome and enigmatic Anglo-Swiss former ballet dancer. Ed was devoted: it was one of the intense platonic relationships he enjoyed throughout his life. When Burra was in London staying at Bar's, Paltenghi was now inevitably in tow. He was a very heavy drinker, leading

him to develop gout in his early thirties, which prematurely ended his dancing career. Unfortunately Ed increasingly devoted his London weekends to drinking with Paltenghi, causing Bar grave concern for his health and a certain amount of frustration. 'Ed has been staying, with disastrous effect on my peace of mind', Bar commented, 'however Carmen [the au pair] has become very adept at finding new hiding places for the drink.'[10] It wasn't that Bar disliked Paltenghi. On the contrary, she liked him very much and enjoyed his company. But what she did not enjoy was the disastrous effect he had on Ed, who tried to keep pace with Paltenghi's drinking, but admitted that '3 days was my limit, by that time if the gin was brought within 1 ft of me I gagged'.[11]

While the inner circle of friends had been long established, two new people entered the fold that year. Ed first encountered Barbara Roett and Geoffrey Dove at a fancy-dress party, which, disliking parties, he attended only because he was accompanying Paltenghi. Barbara Roett was drawn to Ed because of his 'marvellous face, especially his nose, very attractive and sensible and amused', but as she was shy, she encouraged Geoffrey to approach him and introduce himself.[12] In consequence, Barbara and Geoffrey, who were lovers, invited Ed to dinner, and as he was as usual staying with Bar, he brought her along.

Dove was of mixed heritage, with a Sierra Leonean father and English mother. He was tall, handsome, charming and highly intelligent. A former athlete, he narrowly missed selection for the 1948 Olympic Games. His first degree was in Geology, and he bravely applied for, and successfully won, the post of Mining Engineer in a South African mine at the height of apartheid. Unfortunately, he fell (or was pushed) down a mine shaft, leaving him with a permanent limp. When he met Bar he was retraining as a GP, and both she and Ed abandoned their respective practices for his. Dove was extremely affable

and knew all his patients by name. According to Stevenson, there was more to Ed's relationship with Dove than a friendly doctor–patient rapport. As with Paltenghi, 'Burra loved him. Dove was one of the splendid, genial, attractive men that Burra fell periodically for throughout his life'.[13] They enjoyed an adoring friendship and intense pleasure in each other's company.

Barbara Roett was twenty-six, and around five feet four in height with a slender athletic figure, very short dark hair and intense and vivacious dark brown eyes. She was born in Brooklyn in New York, but her ancestors hailed from what was then British Guiana, now Guyana, in the Caribbean. Although white, her maternal relatives all spoke with what Barbara's friend Madeleine Harmsworth describes as a 'delightful West Indian lilt'.[14] Barbara's father died when she was six months old and in consequence she had a traumatic early childhood, moving between foster parents, while her mother, Gwen, endeavoured to earn enough money to support them both in New York. When Barbara was about nine, Gwen decided to take her 'home' to Georgetown in British Guiana. There she enjoyed an idyllic childhood until her mother moved to England, where Barbara studied sculpture at the Royal College of Art. When she first met Bar she was working as a sculptor, but soon opted for less rarefied work, describing herself as a 'carpenter'.

Despite a twenty-two-year age difference, Bar and Barbara were drawn to each other. In contrast to Bar's outgoing, highly sociable and demonstrably affectionate style, Barbara Roett was painfully shy, a workaholic who often put in unnecessarily long hours, prone to pursuits in which she would immerse herself for months or years before abruptly discarding them. She was physically very active and enjoyed cycling vast distances; she was also immensely practical, with a prowess in joinery and building work. Unlike Bar, who had no interest in matters

spiritual or religious, Barbara seemed to be on a permanent, though evolving, voyage of spiritual truth and self-discovery. They were also sartorially different: Bar always chic and feminine, whereas Barbara favoured waistcoats, trousers and shirts.

Barbara had an original mind and a sharp, dry wit, and according to Madeleine Harmsworth 'she often had her audience in stitches with her off-the-cuff comments and humorous interpretations of stories and events.'[15] Within the household, for that is what it soon became, Max was very much his mother's son, but occasionally Barbara would take what he described as a more 'fatherly' interest in him. The decision for Barbara to move in was not taken lightly. Bar found her emotionally inscrutable, impossible to gauge unless she was actually angry. 'The only recognizable expression I have ever seen on your face is rage and annoyance, apart from that no indication of any emotion is ever seen, nor do your actions give any clue as to what is going on behind the mask,' she informed Barbara.[16] When she received a letter from Barbara, she couldn't stop herself from writing back, only partly in jest: 'I suppose it would be too much to expect you to start off with a 7 letter prefix ['darling' Bar].'[17] But when Barbara departed for a holiday visiting relatives in New York, Bar imagined, rather dejectedly, that she would find a younger suitor there, and realised that the relationship was worth pursuing.

In May 1955 Bar inspected Port Regis School, a preparatory boarding school at Motcombe Park near Shaftesbury in Dorset, with a view to sending Max there in the autumn. She may have also visited Bryanston School as well, to which she hoped he would progress after prep school. Max's father objected, as it was considered progressive, what he called a 'crank school'. 'Any place suggested by me obviously would be!' Bar observed, sarcastically.[18] Port Regis evidently met her expectations as Max was dispatched there on 20 September, twelve days after

his eighth birthday. He knew he was going to a new school, but Bar did not discuss it with him, and he was apprehensive about boarding. Garbed in his new uniform, he was delivered to Waterloo station, where – inexplicably to Max – without further ado his mother left him on the platform to take the school train. He found his new environment perplexing, having no idea what a dormitory was. He had never seen a Bible, although he was expected to read from it every day. Barbara Roett, who objected to Max being sent away, could do little about it. He remarked: 'I was a wonderful delightful little boy until I went off to boarding school; when I came back, I wasn't the same.'[19] John Rhodes finally began making proper financial contributions having at last consented to a divorce because he wanted to remarry. The divorce was granted on the grounds of desertion for a period of three years or more. Rhodes paid Bar maintenance to the princely sum of one shilling a year together with her legal costs. For Max's keep he contributed £300 per annum until the age of twenty-one and also paid the school fees. While Bar missed having Max around, his absence meant she could begin to explore wider horizons.

CHAPTER SIXTEEN

Harlem at Last

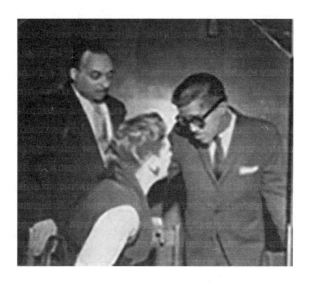

Bar's new-found freedom came at a juncture when she experienced a crisis of identity. So much had changed in her life: she had gained a child, lost a husband, become a single parent and created a successful business. She was in the early stages of what she worried was an uncertain relationship with Barbara, and she remained conflicted about Allan Morrison.

Bar needed to rediscover herself, or at least discover if she

had changed significantly, and the place to do this was New York. Writing retrospectively to Barbara, she explained: 'I had felt for some time that you were trying to make me into something I wasn't (I don't mean sexually) that you wouldn't accept me as I am. I haven't been able to be myself for months, that is why I had to go away. Naturally I wanted to see New York, but what I really wanted to do, and needed to do, was to see my old friends again, just to see if I had changed'.[1] She omitted to mention that the New York trip was partly an opportunity to resolve, once and for all, whether she wanted to be with Allan. Usually, when Bar made a decision she stayed with it, and was able to metaphorically place it in a box with the lid on. But the possibility of a life with Allan persisted in her mind.

The launderettes were ticking over nicely and in January 1956 Bar embarked, tourist class, on the luxury liner RMS *Queen Elizabeth*, then the largest cruise ship in the world, where she found waiting in her cabin a beautiful box of flowers from her affectionate and capable staff. She dreaded the journey as she suffered from seasickness and found her cabin claustrophobic. Writing to Barbara she said: 'I can't tell you how I missed you last night, and longed to be back safe and sound in my own bed with you.'[2]

When the liner docked in New York, Bar was met by an old friend, the Anglo-Irish writer and literary critic James Stern, who informed her that they would be dining with W. H. Auden and his partner Chester Kallman. Arriving at their apartment in St Mark's Place, Bar could only feel disappointment, as it resembled so closely every flat she knew in Bloomsbury and Fitzrovia. Although she enjoyed the evening, she would have preferred her first taste of New York to be Bloomingdale's department store or the famous jazz club Birdland.

But in New York Bar was in her element, surrounded by close friends. Based with Len Lye and his American wife Anne,

she was escorted to jazz clubs by Allan Morrison and dined with Jimmie Daniels and Donald Saddler. She and Mickey were invited to a pre-production party given for the cast of *Mr Wonderful*, a musical which was mostly a vehicle for Sammy Davis Jr. Bar informed him that he was very popular on the BBC radio show *Housewives' Choice*. She wondered why the actors and musicians at the party made a beeline for her, concluding that they thought she was a British theatrical agent. 'I am not sleeping with Allan', she wrote disingenuously to Barbara, 'I came here to hear some jazz, and I can tell you by about 5am when I get home after an evening of jazz, all I want to do is to crawl into my bed'.³

Bar loved Harlem. In a particularly atmospheric bar, she concluded it was 'the most terrible place really but pure Ed, it is exactly like his early paintings [. . .] of Harlem, I was struck immediately I went there, and knew it was just the sort of place he would love'.⁴ She spent an amusing afternoon with Olivia Wyndham and a bottle of vodka in a dark hotel bedroom, where they were joined by Edna Thomas between performances of *A Streetcar Named Desire*. Jimmy Stern threw a party at which Bar was the guest of honour and Marty Mann was surprised and delighted to see her again. Marty also threw a party, although, as it was entirely teetotal, Bar found it rather trying. Afterwards, in a letter full of affection, Marty explained that she still preferred Bar to anyone else, and that her affection remained undiminished, despite the passing years.

When Bar and Jimmy Stern were the worse for wear at a cocktail party at the Plaza Hotel, he insisted they went to the famous Oak Room for another drink, but she felt nervous at the prospect, certain it was the kind of place John Rhodes would frequent, as he was living not only in New York, but on the same street as Allan Morrison. Bar was terrified she would encounter him and his wife in the neighbourhood bar,

but then concluded it was probably too low a dive for their patronage.

Allan was most attentive, taking Bar to see Tennessee Williams's play *Cat on a Hot Tin Roof* at the famous Morosco Theatre. Directed by Elia Kazan, its stellar cast included Barbara Bel Geddes and Burl Ives. Afterwards, Allan treated Bar to a memorable meal of *filet mignon*, asparagus and salad, washed down with gin and Coca Cola. Meanwhile the trumpet-player Jonah Jones serenaded them with the 'St. James Infirmary Blues'. Allan also took Bar to the Brooklyn Paramount, to meet the stars of Birdland, where to her delight she found herself conversing with the jazz legends Lester Young and Bud Powell. She was disconcerted, however, when Powell suddenly gripped her hand and pushed her into a lift, afterwards dragging her down a series of dark subterranean passages. To her relief they arrived beneath the stage where there was an enormous buffet and a well-stocked bar. He silently handed her a drink but by then she was shaking so much she could barely hold it. Allan escorted Bar to all the jazz clubs and he knew all the musicians, but the usually unshockable Bar was 'horrified that all the jazz people were stoned out of their minds'.[5]

She came to see that she could not settle with Allan in New York after all, partly because of his sheer pace of life. He was a workaholic and never stopped working or playing, seemingly able to burn the candle at both ends. Although they adored each other, she found him touchy and argumentative, concluding that his justified anger regarding civil rights placed considerable strain on his mental health. Their increasingly fraught rows were fuelled by the poignant fact that they realised this would be their last time together. Bar finally accepted the responsibilities of single parenthood and conceded that this trip to Harlem would be her last big adventure until Max was old enough to fend for himself. It was hard to avoid the glaring irony that John

Rhodes had chosen to live and work in New York. Without parental responsibility, he could do as he pleased.

Bar used her temporal and physical distance from Barbara to reflect on their relationship. In 1956 she was fifty-one to Barbara's twenty-nine. They were at completely different stages of their lives. Bar was a mother and had a business to run. 'You have no idea how lucky you are to be free, with no ties', she told Barbara.[6] She worried whether 'as nothing lasts it is better not to let anything start up in the first place'.[7] She had been mistreated and abandoned by Philipps and Rhodes, who, between them, had corroded her ability to trust. If there was one thing Bar knew she had to hold on to, it was her independence.

Bar's concerns that she had changed – that Barbara had changed her – evaporated in the company of old friends. They reflected back something vital to her: that, as Bar acknowledged with great relief, 'I haven't altered'.[8] Len reassured her that 'you are more you than ever'.[9] Bar spent almost the whole of Max's spring school term in New York, and was especially sorry to part from Len, who she told Barbara was 'full of joie de vivre which is most infectious. I don't know when I have laughed so much as I have this last six weeks. He is the most stimulating person I have ever known and has long been my dearest and most intimate friend.'[10] Len composed a poem for her:

> Shine Eye Bar – bar the love lamp lamb
> 1st the nice things said about you
> 2nd the nice things thought about you
> 3rd the nice things wished about you.[11]

Bar sailed from New York on the *Queen Mary* on 14 March, concluding that she would give her relationship with Barbara the benefit of the doubt. 'What I want to say', she informed her, 'is that I do love you as much as I am capable of loving anyone,

except, of course, Max. I want us to continue together, but a woman of my age doesn't have the feelings of a woman of 28, in a way, I wish I did [. . .]. I am not withholding anything from you', she continued, 'that belongs to anyone else. I suppose the root of it is, that I am emotionally worn out [. . .] [and] I have learnt from long experience, how to protect myself from being hurt'.[12]

CHAPTER SEVENTEEN

A Woman of Property

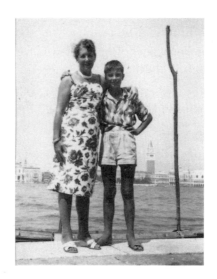

Bar was happy living in Fitzroy Square and would have remained there if it hadn't been for Barbara, who was appalled that a woman in her early fifties with a child should still be living in rented accommodation. In early 1957 Bar duly purchased number 37 Homer Street, in London's Marylebone, a pretty Georgian, three-storey, red-brick terraced house with a basement below and a fanlight above the front door. The

move from rented to purchased property may also have been precipitated by the controversial Rent Act of 1957, which was aimed at providing an adequate return to landlords after years of rent control. Ministers believed it would redress the balance of supply and demand and alleviate the serious housing crisis. It caused a different crisis: unscrupulous landlords doubled rents, forcing tenants onto the street.

The house was purchased with a bank loan, rather than a mortgage, as, astonishingly, in Britain women could not secure mortgages by themselves until the 1970s, the rationale being that few were in continuous employment. Until then, a mortgage could only be secured by a woman with the signature of a male guarantor. Fortunately, Coutts allowed Bar to pay off the loan when she could, rather than on a monthly basis. As with her business loan, she repaid with alacrity, causing her bank manager to comment that if everyone paid their loans off as quickly, he would be out of business.

Bar was delighted with her 'little house' and enjoyed the street's atmosphere and what she described as its 'twitching net curtains'. The spare bedroom, useful for friends and reserved for Ed, was sometimes put to use as an income stream from paying guests. Bunny Garnett was the first incumbent. His wife Ray had died in 1940, and he then married Angelica Bell, the daughter of Vanessa Bell and his former lover, Duncan Grant, but the marriage was under duress. With four young daughters Angelica resented being tied to the stove, but she had also embarked on an affair. Bunny was in a despairing mood when he viewed the spare bedroom and took it on as a part-time London bolt-hole.

Bar relished Bunny's company, and was not averse to his advances, although she declared that he was 'a great charmer and a marvellous entertainer but obsessed with one thing'.[1] She teased him by placing a book entitled *Sexual Difficulties in*

the Male outside his bedroom door, perhaps a gentle dig at his attempts to seduce Barbara. At sixty-five Bunny prided himself on his libido, but Barbara, now thirty, avoided being alone with him, and if she heard his key in the lock when Bar was out, she hid in the wardrobe. As Bar put it: 'as David got older, his girls got younger, I think he started off as a father figure, and then – the pounce'.[2] But she remained fond of him, viewing his foibles with wry detachment.

Having encouraged Bar to buy a home, Barbara now suggested that the business might achieve a more solid footing if she owned the buildings which housed the launderettes. The first such investment was on Vauxhall Bridge Road, at the time a tatty and seedy bed-and-breakfast-type hotel, with a down-at-heel coffee bar on the ground floor. As Bar said drily: 'The hotel at the moment is a "one night walk up no questions asked" type of place. We do all their washing so there is nothing we don't know about it. Lillie threatened to report the owner to the police the other day when a miscarriage was brought in in the washing [. . .]. Lillie told him firmly that she wouldn't have any more miscarriages in her machines.'[3]

While the two Barbaras did not actually become business partners, they had a symbiotic relationship in which Bar provided the capital and paid Barbara to project-manage the refurbishments, while also undertaking the joinery, decorating and interior design. Bar made Barbara a promise, early in their relationship, that 'as long as you are with me, you must never be ruled by money. I will look after you'.[4] But Barbara worked hard and was conscientious in all her endeavours. What had at first appeared to Bar as a problematic disparity between their interests proved to be a strength. Thus 246 Vauxhall Bridge Road was transformed into flats above and ground-floor shops below, all tenanted and let through an agency. Bar went on to purchase the freehold of 13 Regency Place, where

her second launderette was located, planning to sell the lease of her Tachbrook Street launderette to a new landlord. The whole enterprise continued under the umbrella of Westminster Launderettes. If Bar's mother had conveyed the message about independence, and Aunt Winifred provided the wherewithal, then Barbara supplied Bar with a practical means of achieving long-standing financial security. But it was Bar who had the business acumen.

While Bar made light of her latest business venture, she was again taking a calculated risk. At a time when working women were paid around half of male earnings, she remained in control of her income and career. It was, anyway, time to diversify. The launderette trade was undergoing rapid change. In 1960 Bendix's virtual monopoly in Britain changed with the removal of the nation's embargo on importing machinery. This resulted in a deluge of competitive equipment entering the country, especially from the United States. Bendix had failed to modernise, and the business's franchisees were confronted by increased competition from owners with multiple launderettes forming cartels, together with the introduction of increasingly automated laundrettes. After nearly a decade in the industry, Bar could see that Bendix launderettes would soon be relics. The American-owned Automatic Wash & Dry Limited wanted to open a twenty-four-hour seven-day-a-week coin-operated launderette in the street adjacent to one of Bar's premises. She commented, pragmatically: 'There is no sentiment in business, so it is no good complaining of them taking away our trade'.[5] Bar sold all her launderettes, retaining and developing the properties which housed them. She was able to announce, with some satisfaction: 'All is well now and I can sit back and wait for the rents to roll in'.[6]

In January 1961 fourteen-year-old Max started at Bryanston School in Dorset. Bar noticed that he was developing a 'deep

croaking voice' and was 'quite the young man now'. He did not enjoy his studies and Bar was called in, on one occasion, to an audience with his headmaster, housemaster and tutor who complained that Max evinced an interest only in pop music, that he had been caught smoking, and had cribbed Latin from another pupil. Bar sometimes pondered, given Max's disinclination towards academia, whether it was worth sending him to such an expensive public school, but then, she reasoned, it was his *father* who paid the fees.

Teenage Max was something of an enigma to Ed, who periodically tut-tutted about his smoking and drinking, although he grudgingly acknowledged that as a guitarist he was rather good. Occasionally Max's father arrived in London, when he would take his son and Bar to dine at the Savoy Grill. He saw Max perhaps once or twice a year and it irked Bar that on these rare occasions, which should have been enjoyable treats, John was inclined to fuss about the length of Max's hair, or whether he was wearing a tie. But in September 1966 Max did something rather noble which gratified Bar enormously: he changed his surname by deed poll from Rhodes to Ker-Seymer, thus continuing the tradition of matrilineal nomenclature. Bar had resumed using her maiden name soon after her divorce, although Ed still referred to her, annoyingly, or perhaps ironically, as 'Mrs Rhodes'.

Burra was as happy at Homer Street as in Fitzroy Square, but with the passing of the years his health issues increased, and he often had to choose between painting and being sociable. 'Each of the series of major illnesses he suffered in the course of his life did damage, from which he soldiered on without ever quite making a full recovery. As time went by, his friends, led by his sister Anne, Bar and Billy Chappell, entered upon the most benign of conspiracies, to keep Ed on the road, happy and productive, without ever forcing him to admit, to himself

or anybody else, how frail and dependent he was becoming.'[7]
There was one recurrent thorn: Ed's drinking. Some years
earlier, John Banting had moved to Rye, and they became
comrades in arms in the local pubs. Bar wrote to Banting cau-
tioning him not to lead Ed astray: 'I get a bit alarmed when I
hear that you have been on the bash together as he is not in the
best health, to say the least of it, and drink in large quantities
is fatal'.[8] Ed blotted his copybook more than once with Bar
by getting blind drunk at lunchtime and failing to turn up as
arranged to meet her. She wrote after another bout of anae-
mia, mildly chastising him: 'Needless to say you do nothing
about these impending attacks, such as having B.12 injections
or taking iron or something.'[9] Whereas Ed had been the life
and soul of Bar's circle in the late twenties and early thirties,
his poor health had incrementally reduced his vigour, if not his
talent for sharp observation and a deflating aperçu.

As the sixties began to swing in London, Bar watched with
some amusement, from the vantage point of having partic-
ipated wholeheartedly in the swinging thirties. She was not
exclusive in her relationship with Barbara and had no expec-
tation of exclusivity on her side, although they had developed
a deep devotion to one another. Though when Goronwy Rees
came to stay, Barbara was infuriated to find he had climbed
into bed with Bar as if he belonged there. Heterosexual male
friends, especially, were used to viewing Bar as a heterosexual
woman and some former lovers assumed they could simply
pick up the reins. Max described Bar and Barbara as 'always
inseparable', with a tendency to tease one another, yet he pon-
dered why he never saw any display of closeness between them.
'My mother was so very affectionate', he said, 'she would kiss
anybody very affectionately, but the affection between the two
of them, I never even noticed it.'[10] Possibly Barbara was simply
more reserved.

In 1964 the ménage moved to Charlton Place in Islington. Nestling behind Camden Passage, it was a pretty Georgian terrace in a dilapidated state in what was then a scruffy corner of London. The house was configured on the same lines as Homer Street, with two bedrooms on the top floor, a bedroom and bathroom on the first floor, drawing room on the ground floor and kitchen-diner in the basement. It also had the benefit of a small back garden. Barbara carried out the renovations, alongside a pair of brothers who undertook the building and plumbing work. Despite the move, on the domestic front nothing changed. Bar continued to cook and dispense drinks for what Ed still called her 'little familly', variously, Billy, Fred, John Banting, Bumble, Clover and Burra himself. Bunny simply transferred from the spare room at Homer Street to that at Charlton Place.

Bar informed John Banting: 'We enjoy living in Islington, there is a lovely market, open on Sundays with proper cockney ladies dispensing winkles and shrimps, and Soho is only a few minutes away in the bus if one wants a few delicacies'.[11] It quickly became Ed's favourite place in London, although he worried that it would soon be gentrified like other parts of the city: 'It will probably be ruined & made terribly quainty dainty wee before you can say knife at present its strictly Non U & working & pubs full of ladies pickled in years of Guiness & gin'.[12] It was quite a rough area, which Bar enjoyed, although she advised Ed to avoid certain pubs where innocent bystanders had been stabbed. His routine was to stay the weekend and spend Sunday morning in Chapel Market, sifting through boxes of junk, and then visit one or more of the surrounding bars.

Ed's description of Bar's circle as a 'little familly' was perhaps more serious than his usual throw-away remarks, for in some respects she had become the group's matriarch. They were indeed her family, and they had been unusually close-knit

for almost forty years. Fred had no family, except for his sister Edith, for his mother had died in 1939, before the outbreak of war. Billy's mother died in 1952, having resided with him since shortly after the war. Bar and her 'little familly' had grown up together, and despite Fred and Billy's inclination to bicker, or Ed's caustic remarks, there was an admirable degree of tolerance, understanding and affection between them.

But they were growing older and Bar had begun to notice slight hearing loss in 1959, which gradually worsened over the years. Geoffrey insisted that she should be seen by the head consultant at the Royal National Throat, Nose and Ear Hospital, who concluded that she had severe bilateral perceptive deafness and tinnitus, and that nothing could be done. This was a serious blow to Bar, a highly sociable person who gained so much pleasure from the cinema, although she could still watch subtitled 'foreign' films. When she asked the consultant whether the loud rushing and roaring noises of tinnitus would make her go mad, he replied, quite cheerfully: 'If you let it get you down, it will get you down, on the other hand, if you don't let it get you down, it won't!'[13] Bar decided to take the latter course, but as a belt-and-braces measure, she enrolled in lip-reading classes.

Ed's physical decline was obvious to his friends, but if strangers remarked upon his health it was another matter entirely. Bar, Geoffrey, Fred and Clover joined forces in May that year, composing a letter to the editor of *The Times* to refute an unusually grousing review of Ed's latest London exhibition, in which it was insinuated that he was disabled and reclusive. His verdict was that the criticism was 'a cloud of puke', but they weren't going to leave it at that. The letter, indignant in tone, read: 'As fellow art students and life long friends of Edward Burra [...] we consider that your art critic draws too much attention to the "ill health" of the artist. Edward Burra is not a "foot" or "mouth" painter for whom allowances must be made,

nor were water colours "forced on him" by "physical weak-
ness" [. . .]. In conclusion, far from being a recluse Edward
Burra has a first hand knowledge of low life in many countries,
besides the other aspects of his very varied work. He is a reg-
ular in many London pubs and places of entertainment.'[14] Bar
made sure that they each had their due title; Geoffrey's being
'Dr' and Fred's 'Sir', having been knighted in 1962.

Although Bar paid Barbara for her renovation work, it
worried her, nevertheless, that Barbara had no property, and
therefore capital, of her own. Bar was also conscious of the
financial disparity in their relationship, and of the age differ-
ence, which would, she assumed, mean she would predecease
Barbara. Bolstered by the sale of the launderettes, Bar decided
to sell £10,000 worth of shares (£176,000 today) and give the
money to Barbara so that she could buy what Bar described as
a 'slum house' in Islington; however, it was a major restoration
project with much financial potential.

Bar also worried about Billy, whose finances were always
precarious; this forced him to take any job on offer, to an
often-exhausting degree. Some jobs were more appealing than
others: he worked twice for Orson Welles, notably as the dance
and movement arranger in his masterpiece, *Chimes at Midnight*
(1965). In London, Billy continued to rent Thurloe Square, but
he also took another of Kenneth Ritchie's properties, Pump
Cottage in Rye, as part of the conspiracy to keep an eye on Ed,
although Billy enjoyed being nearby. Unlike Billy, Ed was very
well off, though hopeless with money, preferring cash in the
hand rather than savings in the bank. He could not understand
why, having paid income tax amounting to £500, he received
another demand for £1,300. 'It is no good lecturing Ed or trying
to explain anything to him', Bar observed, 'as he has resolutely
no money sense at all. He never puts in any claims against his
tax to reduce it. He doesn't know how to. The fact is, that he

is so ill that he can only keep going if he has no worries at all [...]. Every other week-end he crawls up here [to Charlton Place] to get away for a couple of days.'[15]

One reason Ed needed to get away was his ailing mother, Trudy. His father had died in 1957, but Ed was closer to his mother, and experienced high levels of stress attendant upon her long and slow decline. When she eventually died, in May 1968, he wrote to Billy: 'She realy was in such a state of misery & discomfort & half doped. Im glad shes dead and its all over.'[16] Bar wrote immediately: 'Needless to say your friends are all most concerned about your future. What is to be done about the house, where will you live etc[?]. I expect Ann[e] will arrange everything, but do count on Bar[bara] and I if there are any unpleasant removal or transport jobs to be done. We feel that you must be spared as much as it is possible [...].' She invited him to Charlton Place: 'See how you feel, you have the front door key so all you have to do is just walk in'.[17]

When Ed decided to purchase a house for Frederick, his mother's faithful retainer, Bar used this uncustomary act of altruism as a lever to encourage him to do something similar for Billy. 'As for poor Billy', she said, 'he is in a constant state of worry about his overdraft as he has no capital to fall back on. You could give him an annuity and never notice the difference, as what is going to happen is the government is going to claim nearly all the money when you die. The money could be used to give happiness and a little security to someone when they are still alive.'[18] Ed did nothing, but Bar continually nagged him to help.

Bar was not judgemental; she viewed people not by their perceived inadequacies but only by their merits. She did not bat an eyelid when David Paltenghi collapsed in a drunken heap on her floor, nor when Ed collected a cushion and settled himself down to sleep beside him. When Geoffrey Dove turned up in

the middle of the night complaining about the state of his mar-
riage, Bar simply put him in the spare bedroom, although she
did suggest he should self-medicate less, as he was rather wild.

It was because of this tolerance that Bar was able to sus-
tain a long friendship with the notoriously difficult American
writer, Patricia Highsmith. The Bars met Highsmith through
a mutual friend while on holiday in France in 1966. Highsmith
was forty-five to Bar's sixty-one and Barbara's thirty-nine. Bar,
who was extremely well read, had been an admirer of her writ-
ing having seen the film *Plein Soleil* (1960), directed by René
Clément, which was loosely based on Highsmith's 1955 novel
The Talented Mr Ripley, which Bar subsequently read. Although
Pat, as both an alcoholic and a misanthrope, was short on
empathy, she came to regard Bar and Barbara as 'two of her
closest friends'.[19] According to Barbara: 'Pat was best at friend-
ship at a distance.' 'I got the feeling from her', she continued,
'that she could not sustain relationships, she didn't even try.
She was strange with me, she used to talk to me as if I were
another man [*sic*], and she had no idea what other women were
feeling and thinking'.[20] When the Bars first met Pat, they found
her vulnerability appealing but their sympathies were soon
depleted by her heavy drinking and challenging, aggressive
behaviour. 'I saw what a monster she could be in any relation-
ship so I quickly changed that view.' But she added: 'Having
said that, I still liked her a great deal'.[21] Bar, who realised that
'quarrelling with Pat ... would be like quarrelling with a dog
with rabies. You could get bitten', decided it was wise to avoid
confrontation.[22]

Pat's friendships generally ended badly, but she and the Bars
remained friends for years. It is interesting that in her published
Diaries and Notebooks, she does not have a bad word to say about
them.[23] This may simply reflect editorial choices, but Bar was
famously un-shockable, finding humour in most situations, so

there was little point in Pat trying to shock her. Pat was given a key to Charlton Place so, when in London, she could come and go as she pleased. When she stayed with the Bars in the spring of 1968, she introduced them to the twenty-seven-year-old British journalist Madeleine Harmsworth, who met Pat while interviewing her for the *Guardian* and for *Queen* magazine. The result was a long-distance, short-lived dalliance, which Harmsworth soon regretted. Madeleine subsequently became a good friend of the Bars, although she was closer to Barbara. Pat treated her appallingly. At a dinner party at Charlton Place the Bars were astonished to witness Pat brazenly trying to make Madeleine jealous by dialling a random sequence of telephone numbers and conversing with the dial tone, pretending it was another lover. Madeleine soon became disillusioned, perspicaciously recognising that Pat 'was an extremely unbalanced person, extremely hostile and misanthropic and totally incapable of any kind of relationship, not just intimate ones.'[24] When Bar protested about Pat's treatment of Madeleine, Pat replied that she was so lonely at the time she would have had a dead cat. As Bar commented in a massive understatement: 'the even tenure of our existence underwent a slight upheaval recently when Pat Highsmith came to stay'.[25] Bar dealt with her by leaving a tray by her bed with a bottle of whisky, two glasses, a large jug of water and a pint of milk, which she said 'seem to be her only form of sustenance.'

On one occasion Highsmith wrote to Bar saying she would arrive Sunday evening and could Bar arrange for her to see a doctor Monday? Bar duly made an appointment for her to see Geoffrey Dove, but was anxious about Pat's attitude to being examined by a black doctor. 'I hope I have done the right thing', she said to Barbara. 'Presumably Pat, being very "left wing" doesn't operate a colour bar?'[26] In fact, Pat had abandoned the United States for Europe precisely because she was a racist and

objected to African American demands for civil rights. She was also fiercely anti-Semitic.

When Pat was around, Ed kept away; he disliked her, particularly as she was aggressive when drunk. He delighted, however, in reminding Bar that Pat's behaviour was even worse than his own. Horrified by her drinking, Barbara took her to Geoffrey for liver tests, hoping that hard facts would encourage her to reduce her intake, but the results came back normal. Bar also tried to tackle Pat's drinking. After a lengthy preamble in a letter, she wrote: 'Now, to change the subject, and to risk bringing our correspondence to an end by what I have to say which is this. You really should go to a Doctor and have a proper medical check-up. No Doctor can prescribe for you until he has seen the results. It is obvious that you can't stop drinking, any more than you can start eating like a normal person, but what the Doctor can do once he has all your particulars is to prescribe something for you to take, to maintain your balance and keep you going'.[27] Fortunately Bar's rather outspoken advice did not bring an end to their friendship.

Pat's only salvation was her work. 'She knew that it stood between her and, I would say, insanity,' said Madeleine. 'If she hadn't had her work she would have been sent to an insane asylum or an alcoholics' home. If you look at the characters she writes about, they are her. It took a little while for me to figure this out, but all those strange characters haunting other people, and thinking and fantasising about them – they were her. She *was* her writing'.[28] Pat knew her sanity was precarious, confiding in Bar: 'I feel the madness in me, quite near the surface'.[29]

Later, when the Bars stayed with Highsmith in her cottage at Montcourt-Fromonville, near Fontainebleau, she pretended to be the perfect host, telling them that she would take them to a market to buy produce for the delicious ratatouille she planned to cook for dinner, but then she disappeared into a bar, leaving

her guests to do the shopping. Barbara believed that Pat, who ate very little and at odd times of day, had an issue with food. According to Bar: 'The worst ordeal is going to Simpsons with Pat Highsmith as she allows her plate to be piled high with rare roast beef and all the trimmings and does not eat one mouthful causing embarrassment all round'.[30] While Bar and Barbara had clean plates, their knives and forks neatly aligned to signify they had finished, the waiters received no such signal from Pat, so the longed-for pudding was delayed.

The Montcourt stay was surreal. Bar and Barbara were subjected to the distressing display of Pat placing her pet cat in a hessian sack and swinging it around and around so that she could afterwards enjoy the spectacle of the poor creature staggering about the room. When Barbara and Bar were chattering in the bedroom, they suddenly heard a thump and saw a dead rat on the floor. Pat had lobbed it into the room by its tail. 'She probably liked Barbara the best of all her friends,' Barbara Roett observed, 'and I thought if this is how she treats her, God knows how she behaves with other people.'[31]

CHAPTER EIGHTEEN

Keeping an Eye on Ed

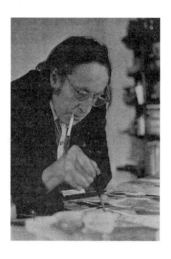

From New York during the summer of 1968 Mickey Hahn wrote to say Allan Morrison had died. 'How sad about Allan', Bar replied, 'I knew this sort of end was inevitable for him but not quite yet, he was only 50. The trouble was that he drove himself too hard and life for him was one long battleground [. . .]. He never was at peace with himself or anyone else. He never stopped fighting or quarrelling with me and really I am a most peace loving person'.[1] While mourning this

husband who might have been, her real ex turned up. Bar was surprised to find John Rhodes in an unusually genial mood. To her amusement he 'spent the evening telling me how right I always was, and how well I had organised my life, and how badly he had treated me, to which I replied that he had done me the best service I ever had.' Then she reflected: 'Aren't people strange? He was terrible to me when we were married.'[2] She noted that he was 'not a very good advertisement for a successful businessman as he looks so frightfully disagreeable and disgruntled now and all his good looks have disappeared beneath mounds of purple flesh'. Bar did not think Max would turn into his father, 'as he has always been a very happy character'. She observed: 'He and John get on very well together now, though not in the least like father and son'.[3]

When Pat wasn't around Ed continued to spend alternate weekends at Charlton Place, where Barbara answered the door one day to find him standing between two policemen who suspected him of trying to break in. It may have been drunkenness, or simply that his gnarled hands found it difficult to unite lock with key. His drinking sprees were of constant concern, causing Bar to reflect that he was 'terrified of not keeping going, and yet courts disaster by drinking himself to death.'[4] Following his mother's demise, Ed moved from Chapel House in Rye back to Playden, to a staff cottage attached to Springfield, his former parental home. His sister Anne and her husband Colin had also moved nearby. Visiting Ed, Bar found the cottage in chaos, so she took it upon herself to sort through hundreds of his early drawings, and in the process discovered a large suitcase crammed with all her early letters to him. She was fascinated to discover this younger version of herself. 'I related in detail the plot of every film and play that I saw', she exclaimed, 'and a full description of every party with everything that went on, who said what to who, and who got off with who [. . .]. I was quite

cheered up as I had forgotten what a gay spark I was in the days
when I was a virgin and didn't drink!'[5]

When Max left Bryanston, aged eighteen, Bar was pleas-
antly surprised to discover that he was hard-working with a
good head for business. He always found work and was entre-
preneurial; in some respects a chip off the maternal block.
While Max was doing the rounds of State Fairs in the United
States, his father called Bar in high dudgeon complaining that
he had repeatedly invited Max to stay but received no replies.
'You'd think he would write to his own father', John protested.
Bar pointed out 'very gently that as his "own father" had never
written to him once or sent him a birthday or Christmas card
when he was a child, it was just conceivably possible that Max
might be the tiniest bit cynical on the subject'. With impec-
cable timing, she casually dropped into the conversation the
fact that Max had married his girlfriend, Jean De Ru, which
elicited another 'Good God! You'd think he would let his own
father know'. As far as Bar was concerned, Max had come of
age when he was eighteen and was free to do as he pleased.
She told John that he should be proud of his son, who was 'a
hard working steady young man instead of a long haired drug
taking hippy'.[6]

Bar's relationship with her other ex-husband was entirely dif-
ferent. She remained very fond of Pease and loved to see him on
his occasional London jaunts. On one occasion, when Max was
small, he had turned to Barbara and said: 'Look at Humphrey
kissing Mummy!'[7] Sometimes Bar and Barbara would visit
him at his Suffolk home, Cedar House, an unprepossessing
building which offered wonderful views of Orford Ness. But
Humphrey's London visits gradually became less frequent.
He wrote to Bar announcing that he would make one final
visit to London, expressly to take his leave of her. It was a very
sad letter: Humphrey explained that after years of drinking,

alcohol had, at last, defeated him. He was physically debilitated and mentally depleted.

Bar received another gloomy letter in which Humphrey reminisced about a leopard-print coat and red beret which she wore in the years before and during their short marriage. Fifteen months later she was plunged into gloom when she received a telephone call from his nephew to say Humphrey had died. Humph had a difficult final month, scalding himself and ending up in hospital where he died from a heart attack. 'I'm amazed really that he lasted as long as he did after nearly 60 years of solid drinking and chain smoking'. 'Thank goodness he died of a sudden heart attack', Bar added, having visualised a long and painful demise.[8] His probate amounted to £10,787, around £62,000 today, not a great deal considering that he had recently sold his large house in Suffolk and downsized to a two-up-two-down. As Bar ruefully commented: 'He has left nothing for posterity and is just another name crossed out of my address book'.

Billy resided at Charlton Place for several months in 1970, following two operations for blocked arteries in his legs. While he recuperated, meetings were held there to organise a gala tribute to Freddie Ashton on his retirement as director of the Royal Ballet, a position he had held since Ninette de Valois's retirement in 1963. The gala would include excerpts from Ashton's ballets performed by friends and colleagues, with linking commentary written by Billy and delivered by Robert Helpmann. Although Fred always said he would retire in 1970 at the age of sixty-six, privately he hoped to stay on for a couple more years and his ego would have been satisfactorily massaged had he been asked to stay. But he was presented with a fait accompli and informed that Kenneth MacMillan had already been appointed as his successor and would take up the post that year. Afterwards Fred harboured a grudge against

MacMillan, and repeatedly turned down invitations to return
as a guest choreographer.

The tribute had to be kept secret from Fred; he could not
understand why, on several occasions when he phoned to invite
himself to dinner at Charlton Place, he was turned down. The
gala took place on the evening of 24 July, and Bar found it 'really
wonderful, an experience I shall never forget.' When Ashton
mounted the stage to take his bow the whole house rose to its
feet, cheering loudly. Flowers were thrown onto the stage and
Margot Fonteyn knelt at his feet clutching an enormous bou-
quet of crimson roses. Bar observed: 'He looked quite stricken
and broke down finally when he tried to make a speech'.[9] She
considered Billy's organisation superb, concluding that it was 'a
marvellous gala', and she enjoyed seeing what she described as
'lots of old ghosts from the past' 'who turned up to pay homage
& drink free champagne'.[10] Ashton continued to work thereaf-
ter, choreographing short ballets and gala performances, and
choreographing and directing a full-length ballet film, *The Tales
of Beatrix Potter* (1970), in which he memorably played the role
of Mrs Tiggy-Winkle.

Unlike Fred, Ed remained notoriously private and twitchy
when it came to publicity. When the Arts Council commis-
sioned Peter and Carole Smith to make a film about him, Anne
Balfour-Fraser, the film's producer, approached Bar to act as an
intermediary, hoping she would be able to coax Ed into agree-
ing to the project. Bar was very much in support of the film,
which she felt could only enhance Ed's reputation, although
she recognised that he would be reluctant to accept any 'fuss'.
She cautiously encouraged him to allow the project to proceed,
stressing that the focus would be on his paintings rather than
himself. He agreed, reluctantly, although predictably he sabo-
taged the film. Ed liked getting high, but never smoked dope
when working. So he used the opportunity of *not* working

while being filmed to get high, and was painfully uncooper-
ative and reticent; when he did answer a question, it was a
monosyllabic 'yes' or 'no'. 'I don't know what all this personal-
ity has to do with it', he mused. 'Some people don't like being
pried *on* [pause] do they? [pause] *No.*'

During the filming, which took place at Burra's cottage at
Playden, Bar was there to lend moral support and to liaise with
the Smiths. Cooking sausages for lunch, Ed couldn't under-
stand why he was expected to be filmed while eating them.
Later, when the film (*Edward Burra: The Complete Interview*)
was edited, Bar persuaded him to go to the cutting room to
watch it, Peter Smith having thoughtfully provided a bottle
of whisky for the occasion. 'Ed was absolutely fascinated, as
though it was nothing to do with him. He kept on pointing at
the figure on the screen and going off into peals of laughter.'[11]
He commented, dispassionately, on his appearance, which he
thought resembled 'a derelict meths drinker [. . .]. On the way
to the crypt'.[12]

Sadly, it was not much of an exaggeration. Ill health, fatigue
and alcohol had taken their toll, not helped by grubby and
unkempt clothes. Bar tried to encourage him to bring spare
clothes on his visits to Charlton Place, so that she could laun-
der them, but that was hit and miss. Unfortunately, friends
who should have known better indulged him, and it was often
Bar who had to pick up the pieces, although Billy's assistance
could be relied upon when in town. Following a bender with,
of all people, Geoffrey Dove, Ed arrived at Charlton Place
unconscious in a taxi. 'I suppose I must have put away a great
deal of gin to become quite unconscious', he wrote pensively,
'I thought it was lovely driving back from Putney laying on
my back & looking at the sky & waving my arms about'.[13] He
remembered nothing after that, until he found himself being
put to bed by Billy.

Bar was furious. She tried to discourage him from drinking by threatening to no longer have him to stay, but of course she didn't mean it. Ed wrote to Bar by way of apology, saying: 'Im sorry your [sic] upset, you always did tell me I had an instinct for self preservation'.[14] Concerned that the state of Ed's feet combined with his drinking habits would cause him to have a fall, Bar and Billy contrived to meet him from the train when he came up to London, but he was intentionally unreliable about train times. He joked provocatively: 'I shall probably get drunk & have a black out & be found "laying" in the St & taken to Marlborough St [police] station'.[15] Ed used alcohol as a fuel to numb his constant pain and energise his tired body. He could either paint or socialise but could not manage both. Unfortunately his socialisation mainly took place in London, often in pubs, and Bar continued to shoulder the strain.

Despite their living on different continents, Len Lye remained one of Bar's closest friends and there was palpable affection between them. His missives tended to be short, but to the point. 'I must say of all the sharp keen warm witted discerning human stuff art stuff pals I've got you're the most, so I thought I'd say it right to your face, bham! Like that: OK?'[16] When he wrote saying that he and Ann would be in France in June 1975 judging an animation festival, Bar replied: 'You MUST come to London for a few days. You can have the run of the house and the whole of the top floor to yourselves'.[17] They had a splendid visit, as Len put it: 'to make sure we are alive together snooking & snorking & at close proximity of what we feel who we are you be me'.[18]

Ed was gearing up for a major retrospective at the Tate which opened in May 1973, where 143 of his works were exhibited, including his iconic painting, *Minuit Chanson*, owned by Bar. 'I dread all the terrible horrors being brewd up over this Tate affair', he moaned to Billy.[19] Of course Ed

avoided the private view, but Bar went and thought the paint-
ings looked marvellous. Francis Bacon was a fellow guest,
who, she noted, was 'beginning to look like one of his paint-
ings'.[20] The following evening there was another preview of
Ed's work, at a commercial exhibition at the Lefevre Gallery,
where Bar was surprised to encounter Wogan Philipps after
so many years, remarking, rather unkindly, that he 'looked
very odd, very haggard.' More forgivingly, she commented:
'I think he was a bit nervous at being confronted by all these
figures from the past.'[21] It transpired, however, that Wogan
had earlier enquired at the Lefevre about the possibility of
obtaining a ticket and of course he would have known exactly
who would be at the preview.

'The exhibitions are a terrific success', Bar noted. 'The Tate
crammed, and all the pictures at the Lefevre sold.' Of Ed she
lamented: 'He is not interested. It is sad to have all this success
and not be able to appreciate it, however his friends are wallow-
ing in it on his behalf'.[22] After much persuasion, Bar managed
to get him to visit the Tate exhibition, but when they arrived
he started to fumble in his pocket for the admission charge.
Bar explained he didn't need to pay, and he turned on her in
an unusually hostile manner, shouting: 'I HAVEN'T GOT MY
TICKET'. Bar explained again there was no need to pay to see
his own exhibition, which he then sped around before bolting
back out through the exit. 'I think his only interest is in sur-
vival', she reflected, ruefully. 'He can only just keep going by
a will of iron. It was like taking a child to the dentist. I had to
chatter gaily all the way there in the car to distract his atten-
tion, and walk behind him into the Tate in case he gave me the
slip.'[23] Ed relied on Bar's warm hospitality but never recipro-
cated, believing her to be wealthy. She wasn't hard up, but she
had generously given large sums of capital to Barbara and to
Max, having purchased a house for him near Islington. 'Ed can

get his hand into his pocket', Bar would comment, 'but he can't get it out again'.[24]

Bar was also concerned about Barbara who as usual was working extremely hard and had too many commitments, including responsibility for her mother who had become very dependent. According to Madeleine, one of Barbara's 'most striking characteristics was the ability she had to bring stability, security and constancy into people's lives, despite having experienced [. . .] such a disruptive childhood'.[25] Barbara was playing hard too, announcing that she was making up for lost time, on the premise that Bar and her friends had all 'lived', while she had not. 'Quite true of course,' concluded Bar, 'as we are all about 20 years older than her, and you can do quite a lot of "living" in 20 years, particularly if you have no ties and a hedonistic nature!'[26] But Bar recognised the weight of the years between them and that Barbara needed a certain amount of latitude to enjoy life.

Whenever Ed left to return to Playden, Bar implored him not to get drunk between Charlton Place and the railway station. An accident seemed inevitable, so in October 1974, when Anne phoned Bar in a state of anxiety as Ed had failed to emerge from the five o'clock train and two subsequent trains, Bar feared the worst. She then received a call from St Thomas' Hospital reporting that Ed was in casualty. Bar called Billy and Geoffrey Dove, and Geoffrey rang the hospital instructing them not to touch the patient, concerned they would remove his spleen and that he would not survive the operation. The three rushed to the hospital, where they found Ed very pale, with a large lump over one eye and covered with blood from a gash on his arm. He had either fallen over or been knocked down by a car. 'I must say', Bar commented, 'they are marvellous in the hospitals as they thought he was some old meths drinker in his stained and dirty clothes [. . .]. They had his trousers off and

three nurses and two Doctors were going through his pockets in horror drawing out one £20 note after another, the total sum coming to £1200 not to mention a few hundred French francs.'[27] When Billy asked Ed what he had been doing and why he hadn't asked the hospital staff to call them earlier, 'His reply was not only a flat statement of fact. It was delivered with deliberate complacency. "I was dead *drunk*", he said.'[28]

Ed's injuries were superficial, but he was badly bruised and in pain. He was kept in hospital overnight and the following day released to Charlton Place, where he spent two days. After the accident, Billy noticed that 'his face seemed smaller – paler [...]. The visits to London became fewer and far less energetic. He seemed relieved rather than resentful [...] at the close watch his friends kept on his comings and goings. He was met at the station and taken to the homeward train again at the end of the visit. I would catch sight of him when I went to meet him and see him moving (as slowly and deliberately as a snail) among the trailing figures of the last passengers to alight'.[29] Ed confided to Clover that he found London a strain and could only move very slowly for fear of falling. Although Bar was devoted to him, she was beginning to find it stressful having him to stay, as she had to keep a close watch on his drinking while respecting his strong will to remain at least superficially independent. 'I don't go out further than Chapel Market & the Duke of Pisspot when Im in Islington', he told a friend, '& never get up till 11! It is a rest from washing cooking shopping'.[30] A rest for him, perhaps, but not for Bar.

While working around the clock to produce Gluck's opera *Alceste*, Billy had to vacate both his residences after Anne's brother-in-law, Kenneth Ritchie, died and Pump Cottage and Thurloe Square were to be sold. Bar and Anne had long nagged Ed to buy him somewhere to live, and he finally capitulated. In London Billy moved to a flat belonging to Alexander Grant,

a principal dancer with the Royal Ballet and one of Fred's old flames, while in Rye Ed purchased a pretty terraced house with bow windows on Rope Walk. Billy moved there in 1976, completely unaware that Ed had bought the house outright, believing that he was simply covering the rent. Although Billy often worked away from home, his presence in Rye was comforting for both Bar and Ed. She knew she could rely on him to keep an eye on Ed, whereas Burra had the simple pleasure of spending time with his dearest male friend.

In May Ed tripped over on some worn steps in Rye, fracturing his hip, necessitating a week in Hastings Hospital and three weeks in a nursing home, or 'The Institution', as he called it. The usual communication line was activated, with Anne calling Billy, who called Bar, who rang Geoffrey. The three of them made their separate ways to Hastings, where they were amazed that Ed had survived a hip operation. Afterwards he recuperated at his sister's house, and at Charlton Place preparations were made for his arrival by moving the spare bed to the ground floor of the small studio across the road in which Barbara worked.

Bar was relieved that she could leave Ed in the capable hands of 'Nurse Chappell'. But she worried that between keeping an eye on Ed and coping with mounting work projects, Billy would be permanently exhausted. She wrote pointedly to Ed stating that she hoped Billy 'will be able to have a bit of a rest before setting off for Vienna'.[31] Ed, who seemed to have improved slightly, had tentatively returned to painting. But at the end of September while Billy was staying with him, he became very ill, vomiting throughout the night. The next morning, when Anne arrived, Billy returned to work in London with a heavy heart. Ed was taken to Hastings Hospital where he died on 22 October 1976.

The same day Geoffrey sent Bar a brief note: 'Though I love

Ed – I'm sure my feelings are insignificant in comparison to the tremendous grief that you must feel [...] but there it is our friend and sweet love is dead and with him goes part of us.'[32] Geoffrey described Bar's feelings perfectly. The loss of Ed was the greatest loss of her life, far more momentous than the deaths of her parents. Bar and Ed had been close friends for half a century and he was a vital and central force in her life.

Anne wrote detailing the lengths to which she had gone while preventing the surgeons from operating. She knew that Ed would not fully recover either with or without the operation and that he would rather die than contend with surgery and be even more physically compromised. She also vetoed a post-mortem. 'I must truly say', she admitted, echoing Ed's words following their mother's death, 'I was thankful when he finally gave in & died'.[33] She thanked Bar for all her help and kindness. Bar and Billy had spent so many years savouring Ed's sharp humour, admiring his paintings and discreetly supporting him in his progressively proscribed way of life, that his death left not only an emotional vacuum but a practical one. The bed, occupying the ground floor of the studio at Charlton Place, was now redundant. There were no more arrivals or departures to be overseen.

CHAPTER NINETEEN

Ancient Monuments

As Bar predicted, Ed died intestate having never bothered to make a will. His residual estate was inherited by Anne, and it was only at this point that Billy realised the house he occupied on Rope Walk had been purchased by Ed, rather than rented by him. Of course, Anne acted with kindness and generosity, giving the house to Billy as her brother had intended. Why Ed had kept the matter from Billy is uncertain, perhaps

because he wanted to spare him embarrassment, or because he thought it might affect the tenor of their friendship.

Ed's death coincided with Max spending much of his time working in the United States. He was gravitating towards moving there permanently, though his wife, Jean, was less keen. Bar seemed sanguine enough at the prospect, despite the distance which would separate them, as she had raised Max to be independent and trusted his judgement. In this respect she showed remarkable stoicism. Barbara also – though intermittently – disappeared to the States, where she had taken to cycling vast distances on lengthy annual holidays with Madeleine Harmsworth. According to Madeleine, Barbara adopted cycling with 'a ferocious intensity'. 'When we started our marathon cycling trips across America', Madeleine recalled, 'she threw herself into the project [. . .], devoting hours on end to planning our routes and where and when we would arrive each day, almost to the minute.'[1] Always rigorous and practical, Barbara taught herself bicycle mechanics and purchased spares and tools to equip them for their journey. Among Bar's friends, Barbara became known as 'Handle Bar', to distinguish the two women.[2]

The failure of her second marriage had caused Bar to retain a certain and necessary degree of detachment in her relationship with Barbara. Responding to a letter from Pat Highsmith seeking relationship advice, Bar commented: 'I have been in these situations and have been able to argue myself out of them and it is almost as if one had come out of a restricting garment and can move freely again, the aura surrounding the other person has dissolved and one can continue the affair without any of the pain or agony'. Sagely, at the end of the letter, Bar added: 'A relationship of this sort can't stand still. It has to move on in one direction or another. Only friendships can remain stationary'.[3] Bar recognised that while relationships develop and change

over time such eventualities did not necessarily diminish their value. She accepted that Barbara was much younger and had her own interests and friends. Madeleine was perceptive: 'I never believed that Barbara would ever desert Bar, and sensed that once Bar felt fully reassured on this score, she wisely gave Barbara considerable leeway.'[4]

Bar was, anyway, now suddenly kept busy by a plethora of biographers, art historians and academics eager to mine her extensive knowledge of famous contemporaries, living or dead. She found this amusing and puzzling by turns as she never expected to be a keeper of flames. When approached about Banting's work, which the Arts Council hoped to include in a 1978 exhibition at the Hayward Gallery entitled 'Dada and Surrealism Reviewed', Bar mischievously produced an oddly shaped bone Banting had found, in which he had stuck two pieces of glass for eyes and as a joke called it Edith Sitwell. She was surprised subsequently to receive a form requesting *Portrait of Edith Sitwell* as an exhibit. When the curator tentatively asked if she had heard of someone called Len Lye, Bar showered her with press cuttings, magazine articles, photographs and exhibition catalogues. She also, reluctantly, lent her copy of Lye's *No Trouble* to the exhibition, a limited edition of autobiographical fragments and musings on art, and a precious gift from the author. 'I didn't know you were a Surrealist did you?' she asked Len.[5] She also received a communication from the *Observer*'s art critic, William Feaver, enquiring about the *nature* of her connection with Len Lye. 'He may well ask!' Bar quipped to Len. 'Us 30s characters are becoming Ancient Monuments'.[6]

Bar was interviewed by David Mellor, an art historian from the University of Sussex who was undertaking research for a seminal exhibition and accompanying catalogue, entitled *Modern British Photography 1919–39*. This was the first major

re-evaluation of the social and aesthetic importance of that pio-neering period of photography; it would tour between July 1980 and April 1981, taking in venues including Oxford's Museum of Modern Art, the University of East Anglia in Norwich, Bolton Museum and Art Gallery, and the Gardner Arts Centre at the University of Sussex. Bar was surprised to be interviewed about her own work. Nearly forty years after her decade as a pho-tographer, she could not comprehend that she was more than an adjunct to the celebrated people she knew and was being evaluated as a notable talent in her own right. For the exhi-bition Mellor selected the solarised portrait of *Nancy Cunard* (1930), *Portrait of Julia Strachey* (1930) and *Portrait of Sandy Baird* (*c*.1931). To Len, Bar mentioned, somewhat indignantly, that she had suddenly become an 'avant garde' photographer. She put it down to being 'the only survivor'.[7]

Bar was proud of her property business and of having what she described as 'a very special relationship with my tenants', who were generally very obliging, although she occasion-ally had to intervene if they failed to honour rental reviews.[8] Although she managed her business single-handedly, deafness made it difficult to take business calls. Usually Barbara dealt with the telephone, so Bar was relieved when Max – now a resident of the United States – timed his visits to coincide with Barbara's cycling tours. 'Hullo there! Good morning to you!' she heard him say to a tenant and glowed with pride. Madeleine described Bar as being 'magnificent' about her deafness, 'man-aging to follow and partake in conversations round the dinner table, using lip reading and intuition as well as whatever help hearing aids provided.'[9]

After he had moved to America, Max noted that he and his mother 'started having a very good relationship'. He loved to treat her on his London visits. 'I would take her to the cinema,' he recollected, 'to a film she wanted to see, and sometimes I

would take her to somewhere she had never been before'.[10] If
Mickey was in the country Max would drive Bar down to Little
Gaddesden in Hertfordshire, where she and Charles now lived.
The spare room at Charlton Place was kept ready for Mickey's
visits and it amused Max that Bar and Mickey 'would just
chat away and talk and talk' as if they had never been apart.[11]
He liked to invite his mother to dinner at a restaurant of her
choice, usually L'Etoile, insisting she ordered whatever she
liked, typically lobster mayonnaise and fruit salad. Bar con-
sidered her son a 'very good host', 'Very considerate and very
polite to the waiters'.[12]

In 1976 Fred finally laid down the cudgel, agreeing to return
to the Royal Ballet as guest choreographer, where his rendi-
tion of Turgenev's *A Month in the Country* was the triumphant
result. He was a frequent guest of the Queen Mother at Royal
Lodge, Windsor and at Sandringham House in Norfolk, where
they would often perform a sedate tango. Whereas Bar or Billy
were always glad to entertain Fred to dinner when he turned
up, he never accepted invitations from them in advance in
case he had a better offer elsewhere. He adored hob-nobbing
with royalty, and while Bar was amused by his airs and graces,
Billy found Fred's self-interest galling: 'It's so ingrained', he
complained, 'He's like one of those Restoration characters, Mr
Self-Absorbed'.[13] Billy began to refer to himself as 'Last-Resort-
Chappell', declaring that Ashton saw him only when there was
no one 'superior' to see. As time went on, however, the ageing
Ashton found the royal rounds something of an ordeal. He had
to amuse while also be on best behaviour; he was expected to
perform all the time, and while part of his character enjoyed
lofty social connections, another part was happier relaxing
with old friends who did not expect him to mind his language.
Despite Fred's social climbing, he and Billy remained devoted,
speaking on the telephone every evening. Billy always kept a

tin of salmon in the cupboard in case Fred turned up for a fish-cake supper.

Watching Melvyn Bragg's long-running television pro-gramme, *The South Bank Show*, one evening, Bar was taken with its subject, the British artist Beryl Cook, and was pleased when Cook mentioned her admiration for Burra. Bar immedi-ately dashed off a fan letter explaining that she had long been a close friend of Burra and declaring how much she enjoyed Cook's work. 'I simply love your paintings', she wrote. 'They are absolutely fresh and straightforward and quite unique, and, what is more, they can be wildly funny'.[14]

To Bar's delight she received a reply, and so began an impor-tant friendship for them both. Beryl was one of the people with whom Bar most enjoyed corresponding, letters becoming increasingly important as her deafness worsened. 'You are a godsend to me', she told Beryl, 'because after Ed died I had no one to write letters to in the way I wrote to him as you both have the same interests'. She continued: 'What you don't know is how very alike you are to Ed in many ways [. . .]. You are both observers rather than participators, in other words you prefer to sit in pubs and watch the people around you'.[15] While Cook and Burra shared a love of low-life, Cook's paintings res-olutely brought out the joyful side. Beryl and her husband John were often the models for the disparate characters she por-trayed, often joking at her own expense. For all the jollity and ribaldry in Cook's paintings, the women in her painted world are empowered, whether they are performing a striptease or pulling a pint.

Beryl had come late to art, but success was swift. In her youth she worked as a showgirl and model and after her marriage to John in 1948, they tried their hands at various enterprises, including running a country pub and a stint in South Africa. In the late 1960s they moved to Plymouth Hoe where she ran a

guest house while John worked in the motor trade. There Beryl
began to paint. By 1975 she was exhibiting at the Plymouth
Art Centre, and the following year her work graced the cover
of the *Sunday Times* colour supplement. At the same time, she
was taken up by the Portal Gallery, where her first London
exhibition was shown in 1977. Thus, Bar and Beryl's friendship
was formed early in the latter's painting career. 'I must tell you',
Beryl wrote to Bar, 'how very reassuring your letters, and now
being able to talk to you, have been to me over the past year.
I'm forever troubled by lack of confidence and somehow you
have put it all into perspective for me.'[16]

Beryl's friendship was just what Bar needed. It came at a
time when Ed's loss remained a gaping hole, when Max was
not often around and when Barbara, although devoted, was
pursuing her own interests. Bar and Beryl shared a similar
sense of humour, and while Bar was now stouter in appear-
ance, she wore her clothes with aplomb, sharing Beryl's
penchant for slightly outlandish charity-shop finds, outfits
far removed from the then stereotypical elderly-lady look.
They also delighted in the risqué and absurd, and while Beryl
was twenty-one years younger than Bar, they had children
of around the same age. It was uncharacteristic of Bar to be
particularly interested in other people's children or grand-
children, but with Beryl it was different, and the two women
shared family interests and advice. Bar was something of a
muse to Beryl, appearing in several of her paintings, includ-
ing *Bar and Barbara* (1984) and *Bermondsey Market* (1987). Bar
and Barbara, and Beryl and her husband, John, soon met: Bar
had a palpable talent for friendship and was not afraid to accel-
erate the process of befriending someone interesting. Over
the years she was welcomed many times by the Cooks in their
Plymouth home.

At seventy-five, Bar decided that notwithstanding a reluctance

to fly, she should travel to Atlanta to visit Max and Jean. Her
anxiety about flying was alleviated by a belt-and-braces cock-
tail of champagne, brandy and Valium, the latter prescribed by
Geoffrey Dove. It was only the beginning: she became a sea-
soned traveller, visiting Max every summer. She travelled first
class, enjoying the airline food, the champagne and the fuss
from the air hostesses. 'I simply love it here, and Max and Jean
are making a great effort to give me a good time,' she wrote
from Atlanta to Barbara. Max and Jean took her to a lobster bar
where they sat on wooden benches and the waiter tied a bib
around each of their necks. 'I never thought,' Bar joked, 'when
I had a dear little baby to feed, that one day I would be wearing
the bib & the dear little baby would be cracking lobster claws
& feeding me!'[17]

In New York they attended the landmark Picasso retrospec-
tive at the Museum of Modern Art, where for the first time the
entire museum was dedicated to the work of a single artist.
'I've never seen such a marvellous exhibition', Bar enthused.
'The Cubist paintings were superb. I was absolutely riveted to
them, they were quite amazing, then the paintings became less
"Cubic" & brighter coloured, & he got on to his next stage.'[18]
Max drove them all the way to New Orleans where he had
booked them into a smart hotel. 'Max was so loving and affec-
tionate', Bar told Barbara. 'Fortunately he has my taste exactly
"foodwise" and every restaurant we went to served the most
delicious food'. Then: 'I ate everything in sight swimming in
butter and rich sauces [. . .] and have never felt better', she
informed Barbara, somewhat provocatively as the latter had
become vegetarian, partial to nut cutlets and 'health food'.
Bar delighted in relating her experiences: 'morning at the
Fleamarket just outside Atlanta with Max. Afternoon in ice
cold movie seeing "Urban Cowboy". Cooling off in the pool
on my return then sipping Jack Daniels "poolside" whilst Max

barbequed a side of beef. An ideal life.'[19] It did rather under-
line the differences between her and Barbara, who preferred
roughing it.

These differences multiplied when Barbara embraced the
movement founded by George Ivanovitch Gurdjieff which
pursued the questions: 'Who am I? Why am I here? What is the
purpose of life, and of human life in particular?'[20] For Barbara,
whom Max describes as a 'seeker', the movement became all-
consuming. Madeleine believes that Barbara 'fell prey' to the
teachings of Gurdjieff and his followers: 'What seemed to me
her slavish adoption of his philosophy saddened, disturbed
and disappointed me. It was almost like a brainwashing that
crushed the wonderful uniqueness of her'.[21] Bar initially looked
on with amused detachment, but soon concluded that it was a
'very suitable cult for masochists'.[22]

While Barbara was on a cycling tour from Dakota to New
York, Bar wrote only half in jest, expressing the frustration she
experienced in their relationship: 'I must say I feel far closer to
you when there are thousands of miles between us as you write
daily giving the most vivid descriptions of what you are doing
in full detail, whereas when you are here, you disappear out of
the house and it would kill you to tell me where you had been
or what you had been doing! Information has to be dragged
from you like drawing blood from a stone, and when you are
here most of the time is spent with your nose in a book, or "in
a position" with your eyes tightly closed "meditating" so that I
daren't speak to you!'[23] Barbara would return from her cycling
marathons only to depart, almost immediately, to a Gurdjieff
summer camp in Provence, where she was delegated to cook-
ing or carpentry. From there she would arrive home thin and
exhausted. 'The Gurdjieffs are supposed to help with stress
and give you "inner peace"', Bar said to Beryl. 'I find a nip of
Jack Daniels Tennessee Sour Mash Whiskey gives me "inner

peace" with much less trouble as I don't have to move from my armchair'.[24]

David Mellor's exhibition, *Modern British Photography 1919–39*, opened in July 1980 at the Museum of Modern Art in Oxford, before commencing a national tour. Placing Bar's professional photography before the public for the first time in forty years, it began a process of re-evaluation and rediscovery. Here she was positioned in the context of well-known photographers who, with a few exceptions, continued to pursue post-war photographic careers: Cecil Beaton, Curtis Moffat, Howard Coster, Paul Tanqueray, Shaw Wildman, Norman Parkinson, Angus McBean and Humphrey Spender. Only four other women were featured: Rosalind Maingot, Edith Tudor-Hart, Dorothy Wilding and Madame Yevonde.

Despite her new-found recognition, the publisher Penguin had used one of Bar's black-and-white photographs on the front cover of the paperback edition of Anne Chisholm's biography of Nancy Cunard, which annoyed Bar as it had been 'tinted [. . .] in very crude colours like old French postcards'.[25] It was also credited to Cecil Beaton. Bar was anyway cynical about biographers. She had earlier written to Len admonishing him to put his papers in order 'and have your views on every subject expressed for posterity, otherwise, after you are dead, people will start writing the most frightful rubbish and nonsense about you.'[26] 'I have turned against Biographies,' she announced, 'as they always end up in the most ghastly death bed scenes'.[27] Learning of Bunny Garnett's death in early 1981, Bar was very sad. 'He seemed indestructible. I suppose the biographers will be on to him next'.[28] (It took thirty-four years.) Bar found it frustrating, however, that during what would prove to be the heyday of British literary biography, her portraits appeared unacknowledged in books, prints having been made from originals which remained in the possession of the subjects' families,

descendants or archives. In consequence Bar's photographs began to appear in literary reviews and obituaries. When someone remarked that they had seen her shots of Cyril Connolly in the *Sunday Times*, Bar wrote demanding payment and received a cheque for £90. In the *Observer* she noticed a photograph of David Garnett and extracted another fee. But it was vexing that her work was turning up in print with neither acknowledgement nor remuneration.

Edward Burra's reputation remained high and Robert Littman, director of New York University's Grey Art Gallery, was organising a major exhibition, 'Edward Burra and Paul Nash: A Sense of Place', to be shown at the gallery between February and April 1982. At the same time, British art historian Andrew Causey was compiling a complete catalogue of Burra's work. Both converged on Bar in June 1981, Littman hoping to persuade her to lend *Minuit Chanson* and two other paintings to the exhibition, and Causey wanting to catalogue the Burras in her collection. Bar was reluctant to lend the paintings. 'I tried to explain to him that Ed Burra to him was a commodity, to me he was a very dear friend and that painting was, to me, a reminder of the good times we had together. It is part of my life.'[29] In the end she acquiesced, as usual putting Ed's needs before her own.

Naturally, Bar was invited to the private view but now aged seventy-seven she was in two minds about travelling to New York. 'When I have had a few "Wild Turkeys" @ 101% proof, I am all agog and ready to go', she said, but was less keen on the prospect when sober.[30] Wary of travelling alone, Anne Burra asked Bar to accompany her, generously paying both fares; they opted for a package tour, departing in February 1982 for one week. Bar was concerned about spending a whole week with Anne, of whom she was fond but whom she considered rather conventional and set in her ways, but they had a wonderful

time. Bar very much approved of the exhibition, marvelling at
how well the paintings were lit and displayed. The curator, Bob
Littman, threw a protective arm each around Bar and Anne,
giving them seventy-five cents apiece before putting them
on a bus to the Frick Collection. Bar loved New York: 'I can
thoroughly recommend this neighbourhood', she remarked to
Beryl. 'It is very seedy, and as usual in NY, half the buildings
are being demolished'. One such was the famous Morosco
Theatre, where Allan Morrison had taken Bar to see *Cat on a
Hot Tin Roof* all those years before. Along with Liza Minnelli
and Lena Horne, Bar joined the throng demonstrating to save
it. She described the view from her hotel window with glee:
'Down below is a building with a large electronic sign saying
"Church of Scientology" on the roof of the opposite building is
a large placard in lights announcing "WHOREHOUSE" in 3 ft
high letters [. . .]. We can see huge skyscrapers every window
ablaze and on all night, and huge flashing neon signs [. . .]. It's
lovely, like being in a movie.' Max arrived 'in very good form'
and took charge as the two elderly women were a bit bewil-
dered and fearful of being mugged. He took them to dine in
Chinatown. 'It was marvellous', Bar said. 'We clung to him and
clutched our bags to our bosoms'.[31]

CHAPTER TWENTY

Resurrection

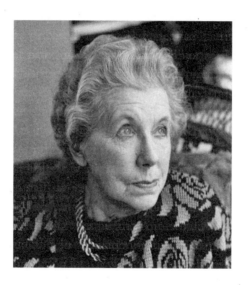

B ar and Billy dealt with the loss of Ed in different ways. Bar
was always happy to talk about Burra's art, feeling that as
he 'hated any form of publicity and talk about "ART"' she could
speak seriously about him and rectify any false impressions.
'As one of his friends,' she said, 'I am only too glad to try and
give a true picture of him.'[1] But she was less sanguine when the
BBC invited her to be interviewed about Burra by the genial

jazz singer, critic and entertainer George Melly, for a radio pro-
gramme appropriately entitled *Don't Fuss*. But it went well and
she was consequently more relaxed when again interviewed by
Melly, this time for BBC Television. On this occasion she was
joined by Beryl Cook, whose approach to being interviewed
was the opposite of Bar's. Beryl couldn't bear to rehearse, want-
ing to receive the questions 'fresh', whereas Bar, being deaf,
preferred to know the questions in advance. In the event all
went well and by the end of the programme both women were
convulsed with laughter. Afterwards interviewer and inter-
viewees repaired to an Islington pub.

Billy sought to keep Ed's memory alive by memorialising
him, and proposed doing so with the publication of two books.
Bar was reluctantly involved in these projects, as she did not
really approve of Billy's biographical approach, particularly as
Ed had been such a private person. The first book, and the least
to her liking, was entitled *Edward Burra: A painter remembered
by his friends*, edited by Billy with a foreword by George Melly.
It comprised essays by Ed's sister Anne and friends including
Fred, Clover and Billy. Bar contributed what amounted to a
single page describing Ed's reaction to his retrospective at the
Tate. 'I didn't want to write anything but was made to & to my
annoyance even that was "doctored".' She concluded that the
whole thing was 'a bit too careful so as not to upset Anne'.[2] The
book was published by Andre Deutsch but heavily subsidised
by Anne and the Lefevre Gallery.

The second, and oddly slightly less contentious, project –
from Bar's perspective – was a collection of Ed's letters. She
thought readers would find them difficult to decipher, replete
as they are with in-jokes, phonetic spelling, innuendo and
camp language. 'With reviewers in mind I shall be very careful
what I produce as there has to be a lot of explaining to be done
about them', she said.[3] Bar and Billy almost fell out over the

letters which Gordon Fraser, the greetings card company, was to publish. 'The carry-on about those letters', Bar exclaimed. 'I get urgent communications from Anne begging me not to release certain things and get blown up by Billy for being un-cooperative which I am not'.[4] When the volume of letters, entitled *Well, Dearie!*, was eventually published in 1985, Bar was pleasantly surprised to see favourable reviews in the *Guardian* and *Telegraph*. While Bar and Billy did not altogether agree over the books, it did give them a lot of time together, at Billy's house in Rye, or at Charlton Place. They enjoyed doing ordinary things – watching television, talking about Ed, reminiscing about the past. They dined together often, though Bar was alarmed by Billy's culinary frugality, which saw three-day-old roast lamb turned into a stew supplemented with five-day-old cooked sausages.

Interest in Bar's artistic and literary generation was gaining momentum. Other old friends had books published about them and Bar's portrait of Julia Strachey graced the cover of Frances Partridge's memoir *Julia*, published in 1983. Frances seemed to have buried the hatchet regarding Bar's supposed relationship with her husband Ralph, as the two women met up, and Frances wrote afterwards to say how grateful she was. Bar wrote to congratulate her on the book, although she considered it impossible to convey Julia's unique charm and wit. As an art student Bar had been adept at sharp renditions of 1920s characters in pen and ink. Six decades later she was surprised to be persuaded, by Anthony Powell, to design the cover of his forthcoming novel. He explained that she was the only person who could create a drawing with a genuine twenties feel. *O, How the Wheel Becomes It!* was consequently adorned with an image of a stylised flapper, in profile, cigarette in a long holder in one hand, a cocktail in the other. Powell also asked Bar whether she could advise him about work as a professional photographer,

for he intended to have such a character in his next book. *The Fisher King* (1986) was to be his final novel, and it contained a character – a photographic assistant – called 'Barberina': a private joke and gentle tribute to a long friendship.

The two people with whom Bar had most fun were Beryl and John Cook. Beryl was a celebrity in Plymouth, so unable to go to the local venues she enjoyed, but in London she was anonymous. She accompanied Bar to a tea dance, theoretically to observe, but they both ended up dancing with 'the old codgers'. Bar then introduced the Cooks to a strip show in a Docklands pub, and Beryl and John took both Bars to Madame Jojo's, a cabaret club in Soho with burlesque entertainment. Bar always felt confident with the Cooks, who coped well with her hearing loss. When Donald Saddler took her out to dinner in London, he noted, sadly, how deaf she had become. It was a cruel disability for someone as sociable as Bar, who began to eschew parties, gatherings and noisy restaurants.

In January 1983 Bar received a letter from Max with the bluntly delivered news that his marriage was over. That same evening he arrived at Charlton Place, unannounced. Bar assumed Jean had become weary of his constant business trips, but it transpired that Max had fallen in love with a twenty-six-year-old fashion designer in New York. Max explained that Jean would receive half his assets and the house. 'But thousands of dollars and an empty house are no compensation when the bottom has dropped out of your world', Bar said. 'I feel almost as bad as if it had happened to me'.[5]

Six months later Max visited again, this time as expected, and with his girlfriend, Susan Garside. 'I don't know what she will make of the Charlton Place ménage', Bar mused.[6] But she was immediately taken with Susan. 'She is a lovely girl', she told Beryl, 'very stylish. Quite tall and slim with black cropped hair with a quaff [*sic*] over her eyes which constantly has to be tossed

back! She comes out in wonderful "get-ups". I felt an immediate "rapport" with her, and felt closer to her after only a couple of meetings than I did with Jean after 10 years [. . .]. It makes me feel very sad about Jean. I hope she will find someone more suited to her than Max'.[7] It was Susan's first trip to Europe, and Donald Saddler had reserved four tickets to the first night of the musical *On Your Toes* for Max, Susan, Bar and Billy. They sat in the front row of the dress circle among what appeared to be most of the Royal Ballet Company, including Wayne Sleep and dear Freddie Ashton.

In January 1985 and with little fanfare Bar turned eighty. She was as usual depressed over her birthday, always fearing it would be her last. By way of a birthday gift the two Bars were given Beryl Cook's print *Bar and Barbara*, a witty and imaginary portrait of the two women approaching the Algonquin Hotel in New York. Both are decked in huge fur coats and Cook used artistic licence in making them resemble each other physically. 'You really have the art of being very funny indeed without being in the least malicious', Bar wrote. 'Bar[bara] is delighted at having a bit more weight put on her.'[8] The painting referenced a prospective trip to New York to scatter the ashes of Barbara's aunt Nita, who died the previous year, and to deliver the fur coats she had bequeathed to an American friend. The Bars had joked with Beryl that they would have to wear them as they would otherwise take up all their luggage allowance.

That year Andrew Causey's complete Burra catalogue was published to coincide with a retrospective at the Hayward Gallery. The exhibition was a great success, located upstairs, while David Hockney exhibited downstairs. Bar thought the juxtaposition appropriate, as Ed particularly admired Hockney's work, and had hoped to meet him one day. Burra's reputation continued to soar, and Bar complained to Humphrey Spender: 'It is rather depressing the way people

come and interrogate one about one's dead "contemporaries"! I have no less than 6 people interrogating me about Ed Burra amongst other people'.[9] In fact she rather enjoyed the attention.

Bar was particularly charmed by the former ballerina Julie Kavanagh, who was writing the authorised life of Frederick Ashton. But when Kavanagh expressed a wish to write an article about Bar's life and work as a photographer, Bar panicked. Now used to the business of sharing information or memories of friends, she was less willing to be in the limelight herself. So it was particularly daunting when she learnt that a television company wanted to make a programme exclusively about her.

The programme was one of a series proposed by the Broadside Production Company for Channel 4 entitled *Five Women Photographers*. 'Some dotty people on Channel 4 said they wanted to do a programme on 5 women photographers', Bar declared. 'I had to rake in my past as Olivia's dogsbody. Olivia had a most imposing clientele, the Queen of Spain, Lady Carisbrooke [. . .]. When I took over the class of clientele took a plunge to Billy Chappell and Freddie Ashton'.[10] On a hastily scribbled postcard to Beryl she wrote: 'The whole thing is worrying me to death. I do hope they think better of doing me.'[11]

Bar was surprised that a television company would be interested in what she called 'geriatrics' and believed that the audience would switch off. Her initial response to the questions put to her was to adopt Ed's approach of being unhelpful and slightly facetious. Asked what she was thinking when she took particular photographs for *Harper's*, she replied: 'I hoped they would come out all right and that I would be paid and given another assignment.'[12]

'The thing is', she reasoned, 'there were plenty of very successful photographers in the '30s but they are all dead, they are reduced to the dregs! The other 4 photographers are all very worthy and have been all over the place photographing

deprived miners in the Rhonda Valley [sic] [. . .]. What I'm doing on that programme I don't know [. . .]. I am an elderly nobody with barely a dozen perfectly ordinary photographs of other nobodys.'[13] She decided not to be involved and wrote a letter to that effect in February, but by March she had reluctantly changed her mind, although she dreaded the interview and worried about her physical appearance. 'I was looking in a shop window recently', she told Beryl, 'and I saw a terrible old crone glaring at me from a TV screen, and to my horror I realised it was me'.[14] Bar had been out of the limelight since the beginning of the Second World War. She had to steel herself for the interview and then, much to her surprise, she enjoyed it.

'Well! The house is clear at last and I must say I had a thoroughly enjoyable and highly amusing week ending up by being toasted in Pink Champagne! It is rather nice', she conceded, 'at my age to be the centre of attention for 5 days on end!' And: 'They could not have been nicer', she said, 'and with the assistance of Valium I really enjoyed myself, though I dread to see the results'.[15] Of course Bar was perfectly lucid and dignified throughout, and did not appear at all nervous, although she pretended to be indignant, when watching the film, to find she was twice filmed unscrewing her bottle of vivid red Campari, pouring herself a drink and lighting a cigarette. ('A bit early for drinking', she giggled at the end.[16]) In contrast Helen Muspratt was filmed carefully measuring out instant coffee for the crew.

Bar's friends were quick to congratulate her on her television appearance. Anthony Powell sent a congratulatory postcard and, in his diary, commented that Bar 'is quite unchanged, the TV programme bringing back vividly not only her own diction, demeanour, but that of the 1920s, of which she was so typical a specimen'.[17] Doris Langley Moore, however, stated more baldly that it was awful seeing one's old friends on the TV as elderly ladies. Bar was amused to see what she called 'a

terrible photo of us 5 old bags in the Observer' taken by the inimitable Jane Bown.

Channel 4's publicity press release claimed: 'In this documentary series, each woman presents a lively account of her work and life – with a large selection of her photographs'.[18] With the exception of Ursula Powys-Lybbe, who worked briefly for *Harper's* at the beginning of her career, the other subjects – Helen Muspratt, Grace Robertson and Margaret Monck – were documentary photographers. Bar was very differently represented, as a fun-loving jazz fan, against a soundtrack of vintage jazz records and a focus on photographs of her friends disporting themselves in Toulon. It was nevertheless a serious documentary which did justice to her work.

Julie Kavanagh achieved her ambition to write about Bar, and the resulting article, in her column 'Queen's Counsel' was published in the October issue of *Harpers & Queen* (*Harper's Bazaar* and *Queen* having merged in 1970; the magazine was later restyled in the UK as *Harper's Bazaar*). It was, of course, fitting that Bar's work in the thirties was celebrated in the pages of the magazine for which she had worked. 'Today, even in her eighties, Ker-Seymer has not lost her Twenties wit, originality and relish for life's vagaries', Kavanagh's article reads.[19] But the strapline says it all: 'Barbara Ker-Seymer, unshockable friend of Edward Burra and Nancy Cunard, has *chosen to be neglected*: she is violently self-effacing and most of her photographs are lost somewhere in Charles Street. But this month her avant-garde work is brought to light in a television programme, an exhibition and a book.'[20] Kavanagh brilliantly extracted details of Bar's professional and social life from a reluctant subject, and it was a testament to the burgeoning friendship and affection between the two women that Bar felt able to reveal so much. (Alongside Fred and Billy, Bar was a godparent to Kavanagh's first child.) The article is illustrated with many of her professional works,

photographs from her private albums, and with a picture of
the eighty-one-year-old Ker-Seymer, sitting on the stairs at
Charlton Place, still elegant in a leopard-print dress.

The book to which Kavanagh referred was Val Williams's
Women Photographers: The Other Observers 1900 to the Present
(published by Virago in 1986); the exhibition was 'Women
Photographers in Britain 1900–1950', shown at Bradford's
National Museum of Photography. Bar was being celebrated
in a dual context: as a photographer and as a *woman* photogra-
pher. Williams attests: 'Ker-Seymer's most successful work,
photographs which have a wit and style difficult to find in such
concentrated form elsewhere in British photography, were
those which were inspired by an entirely personal experimenta-
tion [. . .] and in the photographs of her friends Nancy Cunard,
Frederick Ashton, David Garnett and Eddie [*sic*] Sackville-West
the strength and individuality of her experimentalism is at its
height [. . .]. Here was the new, post-Bloomsbury generation in
a setting of industrial metal and soft embroidery, encompassing
the modernists' interest in industrial forms with the aesthete's
love of luxuriant surface. It was the quintessential new British
photography.'[21]

Bar could neither understand what all the fuss was about,
nor could she position herself in a historical context, even from
the vantage point of eighty-one years. She could not see herself
as an important or successful photographer, partly because she
felt she didn't have to strive to be one. Perhaps it was simply
too painful to contemplate her lost career. Bar, who never
quite believed what she read about herself, or saw on film, was
amused at all the carry-on and remained convinced that she was
being placed on a pedestal simply because she had survived. To
Pat she wrote: 'It is very odd being dug up after all these years
of obscurity, with good reason as I have never done anything
worthy of all this publicity.'[22] However, Bar was always the first

to compliment her friends' achievements, and she very much admired Humphrey Spender's Mass Observation photographs which in recent years had also been 'rediscovered', published and exhibited. 'You're always writing me marvellous "fan" letters', he commented, 'so now it's my turn'.[23]

But Bar had perhaps forgotten, or chosen to forget, the calibre of her work as a portraitist and photojournalist, the high esteem in which she was regarded by her peers, the fact that she worked for the most prestigious magazines in the business. Bar had forgotten, or chosen to forget, where her box of prints and negatives was tucked away, so that she would not have to look at them and recollect the regret she felt at the end of an exciting and brilliant career. With impunity she had re-read her youthful letters to Ed, capturing her whirlwind life as a Bright Young Thing, but she could not, would not, look back at her photographic oeuvre.

In the New Year of 1988, Bar was overjoyed when Susan called from Atlanta to announce that she was pregnant. Bar wondered whether Max and Susan would marry, although she had no moral expectation that they should do so. However, they did marry, on 23 June at Chelsea Town Hall, a considerable kindness on their part, for they could have married in the US. Afterwards Bar was most indignant to find that Max's father had arranged for the vintners Berry Bros. & Rudd to deliver a jeroboam of champagne to Charlton Place. It must be sent back, she announced, it was too ostentatious. Very practically, Susan suggested they should drink and enjoy it, which they did. In the evening, Max hosted a dinner for eight at Simpsons, and they all sported white carnations to acknowledge the special nature of the occasion.

Ian Clay Ker-Seymer was born in October. Bar was glad that 'Clay' had been restored to the family name and delighted that Barbara was a chosen godmother. But Bar's happiness was

overshadowed that year by a very sad event: Freddie Ashton's death. The only comfort was that despite his acknowledged obsession with death and how he would die, he died peacefully at home, in his sleep, while his dear friend Alexander Grant was there.

For Bar it was a question of who among their 'little familly' would be next. Poor Billy was ill with emphysema. Confined to Rope Walk, he wrote to Bar, complaining of enforced tedium. She sent him the latest books, with which, laid low and with increasing difficulty breathing, he could at least be entertained. He spent much time living in the past, and lamented that Bar, whom he loved dearly, was his only surviving friend from the halcyon days of Chelsea Poly. He told her that he remembered their first encounter in Manresa Road as clearly as yesterday, but questioned whether, in the exhilaration and freedom of youth, they could have envisaged or shouldered the prospect of old age.

For Bar the weight of the future was easier to bear as she had her family. To Susan she said: 'I absolutely despised families and didn't want to have anything to do with mine. I understand about your having a family now. I now feel I have a family for the first time, I had to wait years for it! Max never really had a family before and I can see he makes a very good "family man".'[24] Impressed with the way Max treated Susan and other women as equals, Bar acknowledged that his lack of a conventional background had some positive outcomes. 'I think', she surmised, 'this is the result, and a very good one, of being brought up by women and gay men without a father to inhibit him'.[25]

Bar now spent Christmas as well as part of the summer with Max and his family and was delighted when baby Tess arrived in February 1992. Although Bar and Barbara were not noticeably demonstrative, Bar felt the need to communicate

her affection. It was easier to make such statements from a dis-
tance, and so, from Atlanta, she wrote to Barbara: 'I wanted to
thank you for being such a wonderful friend'.[26] It was as if Bar
had had some intimation of mortality, for the sentiment was
prescient. She was diagnosed with heart failure, from which
she died in London on 25 May 1993, aged eighty-eight.

The life of this most unassuming of photographers was
celebrated in obituaries in the *Daily Telegraph*, *The Times*,
the *Independent* and the *Guardian* (a heartfelt tribute by Julie
Kavanagh). The *Oldie*, a magazine to which Bar subscribed,
paid tribute to 'an innovative but always unpretentious por-
traitist who held her own artistry in such little regard that she
succeeded in losing most of her negatives.'[27]

The word 'artistry' applies not only to Bar's photography,
but also to her capacity to live a full and (mostly) grounded life.
If Bar's shift was from the limelight into relative obscurity, it
did not diminish her as a person. She was a remarkable busi-
nesswoman from the 1950s to the 1970s, at a time when career
women were rarities.

Throughout Bar's long life, her capacity to find joy remained
undimmed, as did her facility for love and friendship. Born in
the Edwardian era, Bar had many chapters to her life: ebullient
schoolgirl; archetypical twenties flapper; Bright Young Thing;
bohemian; sophisticated artist and photographer; sensual and
sexual woman; mother; businesswoman; keeper of Ed's flame;
and towards the end of her life, proud mother-in-law and
grandmother. What direction might Bar's life have taken if she
had not met John Rhodes in that subterranean nightclub – if she
and Goronwy had opted for a different bar in which to drink
that evening? Would she have married Morrison and moved
to the United States? Without the impetus to provide for Max,
would she, perhaps, have returned to photography, or moved
into a new photojournalism? Would Humphrey Spender, or

Gerti Deutsch's husband, Tom Hopkinson, have found work for her at *Picture Post*? After the interruption of the war, would the second half of Bar's life have counterbalanced more equally the first, allowing her to continue to pursue her career as a photographer?

It is the quality of her surviving photographs which salvaged Barbara Ker-Seymer from obscurity. Without this body of remarkable work, she would have remained invisible. Moreover, her personal photograph albums provide a unique record of a generation who came together in Toulon and Antibes at a particular moment in history. It is a portrait of a group of young people who, as individuals, would go on to achieve recognition for their important contributions to twentieth-century British and American culture, but who, collectively at this conjuncture, were an early example of the culture of youth. It was Woodstock or Glastonbury transposed to Mediterranean France in the early 1930s. In her personal albums as in her studio work, Bar left a haunting record of a short-lived, talented and carefree bohemia which would disperse and disappear with the war. 'I was very serious [about my photography]', Bar acknowledged, towards the end of her life. 'We were serious, underneath'.[28]

Acknowledgements

I am indebted to Barbara Ker-Seymer's son, Max Ker-Seymer, for his tireless help, enthusiasm for and encouragement towards this biography. I also thank him, and Susan Ker-Seymer, for their warm hospitality. I was very lucky to be able to visit Bar's home at Charlton Place before it was renovated, which remained almost unchanged from when she lived there.

I am extremely grateful to the Society of Authors and the Authors' Foundation for their generous research grant.

This book has benefited enormously from the scholarship of others, particularly Jane Stevenson and Julie Kavanagh whose biographies, respectively, of Edward Burra and Frederick Ashton, bring Barbara's coterie of intimate friends to life. They knew Bar and interviewed her at length and their outstanding biographies have provided a wealth of invaluable material and insight.

I am not a photographer and have been very aware of the pitfalls this might present. However, I have benefited hugely from the expertise of Rachel Spender and Amanda Hopkinson and am grateful to them both for their knowledge, time and hospitality.

John and Theresa Cook generously allowed me to photograph the extensive correspondence between Beryl Cook and Bar (both sides, as Beryl made copies of her own letters), and I thank them for their kindness and hospitality.

I thank Len Lye's biographer, Roger Horrocks, for allowing me to read his correspondence with Bar, and for putting me in touch with the Len Lye Foundation, where Paul Brobbel and Emma Glucina very kindly sought out and made available uncatalogued material.

I am most grateful to Madeleine Harmsworth who provided vital information concerning Barbara Roett. Christopher Knowles, who interviewed and corresponded with Bar, kindly shared his material. I also thank Andrew Stephenson for making available his correspondence with Bar.

Susan Fox, friend to many biographers and now a biographer herself, very kindly transcribed material in the Berg Collection, New York Public Library. I am also grateful to her and to Michael Bloch for information about Stephen Tomlin.

I extend grateful thanks to the following: Howard Bailes (St Paul's Girls' School), Matthew Butson (Getty Images, Hulton Archive), Caroline Denyer, Eva-Maria Deutsch, Devon Heritage Centre archivists, Tim Evenden (East Sussex Record Office), Guillaume Fournié, Jennifer Goller (Lilly Library), Lucy Hughes and Elizabeth Abusleme (Corpus Christ College, Cambridge), Susie Johnston, Melanie Llewellyn (Getty Images), Rose Lock (Special Collections, University of Sussex), Patricia McGuire (Archivist, King's College, Cambridge), Philip Neale, Patrick Perry, Cristina Podavitte (Queen's Gate School), the late Richard Rhodes, Virginia Richter (University of Bern), Clare Risoe, Rafael C. Siodor (UCL Special Collections), John Stockton (Cary Arms Hotel, Babbacombe), Ulrich Weber (Swiss National Archives). If I have forgotten any names, or missed anyone out, my thanks and apologies.

Special thanks to the staff of the Manuscript Room, British Library, and extra special thanks to Adrian Glew and his team at the Tate Archives.

At Virago/Little Brown I thank my stellar editor, Lennie

Goodings, and her brilliant team Zoe Carroll, Mary Chamberlain, Jill Cole, Katya Ellis, Marie Hrynczak, Marie Lorimer, Linda Silverman and Nico Taylor.

This book would not exist without the support of my wonderful agent, Maggie Hanbury.

Finally, thanks to my son, Rafael Barnett-Knights and to my husband, Tony Barnett.

Credits

Joan Schenkar, *Truly Wilde: The Unsettling Story of Dorothy Wilde, Oscar's Unusual Niece* (London: Virago Press, 2000; paperback edition 2001) p. 414

Laura Cumming, *On Chapel Sands* (London: Chatto & Windus, 2019; Vintage 2020) p. 296

Geoff Dyer, *See/Saw: Looking at Photographs* (Edinburgh: Canongate Books, 2021) p. 20

Max Ker-Seymer for permission to quote Barbara Ker-Seymer and Winifred Ker-Seymer/Webber and himself

Lefevre Fine Art and Mr Alexander Corcoran for permission to quote Edward Burra

John Cook for permission to quote Beryl Cook

Laura Cumming for permission to quote from *On Chapel Sands*

Oliver Garnett for permission to quote David Garnett

The Society of Authors as the Literary Representative of the Estate of Rosamond Lehmann

The Len Lye Foundation for permission to quote Len Lye

Roland Philipps for permission to quote Wogan Philipps

Sarah Rhodes-Woollard for permission to quote Richard Rhodes

Rachel Spender for permission to quote Humphrey Spender

For permission to quote themselves: Madeleine Harmsworth and Amanda Hopkinson

Abbreviations

AS	Andrew Stephenson
BC	Beryl Cook
BC & JC	Beryl Cook and John Cook
BCA	Beryl Cook Archive, private collection
Berg	Berg Collection, New York Public Library
BKS	Barbara Ker-Seymer
BL	British Library
BR	Barbara Roett
DG	David Garnett
EB	Edward Burra
EH	Emily Hahn
HP	Humphrey Pease
HS	Humphrey Spender
HSA	Humphrey Spender Archive, private collection
JS	James Stern

KCC	King's College, Cambridge, Archives
KS	Ker-Seymer
LL	Len Lye
LLF	Len Lye Foundation
LL, HP	Lilly Library, Hahn Papers
MH	Madeleine Harmsworth
MOA	Mass Observation Archive, University of Sussex
MKS	Max Ker-Seymer
n.d.	not dated
Northwestern	Northwestern University Library
NS&N	*New Statesman & Nation*
p.c.	postcard
PH	Patricia Highsmith
pmk	postmark
RH	Roger Horrocks
RL	Rosamond Lehmann
SLA, PHP	Swiss Literary Archives, Patricia Highsmith Papers
TGA	Tate Gallery Archives
VKS	Vere Ker-Seymer
WC	William Chappell
WD	*Well, Dearie!*
WP	Wogan Philipps

Notes

Prologue

1. Virginia Nicholson, *Singled Out*, p. 107
2. EB / WC, Chapel House, Rye, 12 May 1962, quoted in *WD*, p. 154

Chapter One

1. BKS interviewed by Christopher Knowles, 1989
2. William Chappell, *Well, Dearie!*, pp. 14–15
3. Chappell, *WD*, p. 15
4. Quoted in Stevenson, *Edward Burra: Twentieth Century Eye*, p. 44
5. MacDonald Hastings, *Diane: A Victorian*, p. 133
6. BKS / BC, 13 October 1985 [BCA]
7. VKS, *Idle But Happy*, p. 23
8. BKS / Christopher Knowles, 34 Charlton Place, 3 October 1989 [CK]
9. Anthony Powell, *Afternoon Men*, p. 89
10. Julie Kavanagh, 'Queen's Counsel', pp. 341–4
11. Quoted in Stevenson, *Burra*, p. 46
12. Ibid.
13. BKS / PH, 23 May 1973 [SLA, PHP]
14. Violet Ker-Seymer, 'Christian Science: Its Attitude to Illness Explained', *Norwood News*, 14 January 1927
15. BKS / BC, 8 February 1989 [BCA]
16. BKS interviewed by Christopher Knowles, 1989
17. Quoted in Hastings, *Diane*, p. 132
18. Anthony Powell, *Infants of the Spring*, p. 57
19. Hastings, *Diane*, p. 198
20. *Western Morning News*, Saturday 1 October 1921
21. VKS / BKS, Queen's Club, West Kensington, 14 February 1922 [MKS]
22. BKS / J. Strachey, 11 Fitzroy Square, n.d. 'Thursday' [probably 1943] [Berg]

23. VKS / BKS, 26 Gledstanes Road, West Kensington, 23 February 1922 [MKS]

24. BKS / EB, 26 Gledstanes Road, 16 September 1925 [TGA]

25. Quoted in Stevenson, *Burra*, p. 74

26. Quoted in Julie Kavanagh, *Secret Muses: The Life of Frederick Ashton*, p. 83

27. Quoted in Stevenson, *Burra*, p. 41

28. Stevenson, *Burra*, p. 189

Chapter Two

1. Chappell, *WD*, p. 73

2. Quoted in Stevenson, *Burra*, pp. 62–3

3. Chappell, *WD*, introduction

4. Quoted in Kavanagh, *Ashton*, p. 82

5. David Mellor, 'London–Berlin–London', in David Mellor, ed., *Germany: The New Photography 1927–33*, p. 124

6. BKS / EB, Gledstanes Road, Friday, n.d. [17 February 1928] [TGA]

7. Stevenson, *Burra*, p. 53

8. Stevenson, *Burra*, p. 47

9. Quoted in Stevenson, *Burra*, p. 69

10. Quoted in Stevenson, *Burra*, p. 57

11. Ibid.

12. Ibid.

13. Derek Patmore, *Private History*, p. 71

14. http://www.mgthomas.co.uk/Dancebands/IndexPages/LondonDancePlaces.htm

15. Quoted in Martin Pugh, *We Danced All Night*, pp. 218–9

16. Kavanagh, *Ashton*, p. 84

17. Quoted in Stevenson, *Burra*, p. 201

18. EB / BKS [May 1927] [TGA]

19. EB / BKS, Springfield [? September 1925] [TGA]

20. BKS / EB, 26 Gledstanes Road, 14 January 1927 [TGA]

21. William Chappell, 'A Fragment from an Autobiography', in *Ballet Remembered*, p. 61

22. Quoted in Kavanagh, *Ashton*, p. 81

23. William Chappell, *Studies in Ballet*, p. 65

24. Chappell, 'A Fragment from an Autobiography', p. 61

25. William Chappell, *Fonteyn: Impressions of a Ballerina*, p. 103

26. Mary Clarke, *Dancers of Mercury*, p. 54

27. Quoted in Kavanagh, *Ashton*, p. 81

28. Quoted in Kavanagh, *Ashton*, p. 83

29. BKS / EB, n.d. [?1928] [TGA]

30. Anthony Powell, *Journals 1892–1986*, entry for Wednesday 5 May 1982, p. 17

Chapter Three

1. Quoted in Kavanagh, *Ashton*, p. 83

2. Ibid.

3. BKS / EB, 26 Gledstanes Road, n.d. [1928]

4. BKS / EB, 26 Gledstanes Road, n.d. [1928] [TGA]

5. Kavanagh, 'Burra' in *Harpers & Queen*, London: August 1985

6. BKS / EB, 26 Gledstanes Road, 28 April 1928 [TGA]

7. Chappell, *WD*, p. 24

8. EB / BKS, from Paris, [March] 1927 [TGA]

9. BKS / EB, 19 March 1927 [TGA]

10. BKS / BC, 1 February [1989] [BCA]

11. Quoted in Bevis Hillier, *John Betjeman: The Biography* (London: John Murray, 2006), p. 62

12. BKS / EB, 26 Gledstanes Road, n.d. [1928] [TGA]

13. BKS Photograph Album, 20 April 1924 [MKS]

14. BKS Diary 1924, Sunday 20 April [MKS]

15. BKS Diary 1924, 23 April [MKS]

16. Quoted in Stevenson, *Burra*, p. 107

17. National Archives Currency Converter for closest years: 1925 to 2017

18. BKS / EB, 26 Gledstanes Road, n.d. [August 1927] [TGA]

19. Quoted in Stevenson, *Burra*, p. 51

20. EB / BKS, New English Art Club, 1 December 1927 [TGA]

21. BKS / EB, 26 Gledstanes Road, n.d. 'Sunday' [?late May] [1928] [TGA]

22. BKS / EB, 26 Gledstanes Road, n.d. [1928]

23. BKS / EB, 26 Gledstanes Road, 29 August 1928 [TGA]

24. Laura Doan, *Fashioning Sapphism*, p. 1

Chapter Four

1. Kavanagh, *Ashton*, p. 97

2. EB / BKS, Hotel St Brieuc, n.d. [October] 1928 [TGA], quoted in Kavanagh, *Ashton*, p. 97

3. EB / BKS, Hotel St Brieuc, n.d. 'Wednesday' [pmk 18 October 1928] [TGA]

4. EB / WC, 5 March 1929, *WD*, p. 55

5. BKS / EB, 26 Gledstanes Road, 28 April 1928 [TGA]

6. Quoted in Kavanagh, *Ashton*, p. 68

7. BKS / EB, Tickerage Mill, 2 February 1929 [misdated between 6 and 8 February 1929] [TGA]

8. Ibid.

9. EB / BKS, n.d. 'Tuesday Evening' [pmk 12 February 1929] [TGA]

10. Quoted in Kavanagh, *Ashton*, pp. 84–5

11. BKS / EB, 2 February 1929 [TGA]

12. BKS / EB, 26 Gledstanes Road, 28 April 1928 [TGA]

13. BKS / EB, 26 Gledstanes Road, 28 April 1928 [TGA]

14. Evelyn Waugh, *Vile Bodies*, p. 145

15. BKS / EB, 24 March 1929 [TGA]

16. BKS / RL, n.d. 'Monday' [3 December 1934] [KCC]

17. Derek Patmore, *Private History*, p. 63

18. D. J. Taylor, *Bright Young People*, p. 31

19. WC / EB, n.d. [5/6 April 1929] [TGA], quoted in Stevenson, *Burra*, p. 82

20. Wednesday 3 July 1929

21. Powell, *Journals*, entry for Wednesday 29 October 1986

22. Nicholson, *Singled Out*, p. 205

23. EB / WC, 1 August 1929 [TGA], quoted in *WD*, p. 70

24. BKS / EB, 19 King's Road, Sloane Square, 2 August 1929 [TGA]

25. EB / BKS, Springfield, 2 January 1928 [TGA]

26. BKS / EB, 19 King's Road, Sloane Square, 2 August 1929 [TGA]

Chapter Five

1. Waugh, *Vile Bodies*, pp. 58–9

2. Francis Wyndham, 'Ursula', in *Mrs Henderson*, p. 60

3. Quoted in Stevenson, *Burra*, pp. 84–5

4. Quoted in Kavanagh, *Ashton*, pp. 134–5

5. Quoted in Val Williams, *Women Photographers*, p. 99

6. Quoted in Lisa Cohen, *All We Know*, p. 211

7. Quoted in Kavanagh, *Ashton*, p. 344

8. Quoted in Kavanagh, *Ashton*, p. 135

9. *Five Women Photographers*

10. Quoted in Kavanagh, *Ashton*, pp. 93–4

11. Quoted in Kavanagh, *Ashton*, p. 96; my italics

12. Stephen Lloyd, *Constant Lambert*, p. 97

13. 'Florence Mills', *Pittsburgh Courier*, 12 November 1927, p. A8

14. Lloyd, *Constant Lambert*, p. 98

15. Lloyd, *Constant Lambert*, p. 173

16. BKS / EB, 26 Gledstanes Road, 14 January 1927 [TGA]

17. BKS / EB, 26 Gledstanes Road, n.d. [early February 1928] [TGA]

18. Quoted in Stevenson, *Burra*, p. 119

19. BKS / JS, 8 July [no year] [BL Stern Papers]

20. *Five Women Photographers*

Chapter Six

1. Ken Cuthbertson, *Nobody Said* Not *to Go*, pp. 110 and 120

2. Emily Hahn, 'Aisle K' in *Times and Places,* p. 131

3. Cuthbertson, *Nobody Said*, p. 76

4. Quoted in Stevenson, *Burra*, p. 88

5. *Five Women Photographers*

6. EB / BKS, Springfield, n.d. [TGA]

7. *Five Women Photographers*

8. Kavanagh, *Ashton*, p. 135

9. V&A Museum no. E987-2007; https://www.vam.ac.uk/articles/
 curtis-moffat-life-and-work

10. BKS / HS, 1 June 1986 [HSA]

11. BKS / HS, 2 December 1983 [HSA]

12. BKS / HS, 3 January 1984 [HSA]

13. BKS / PH, 34 Charlton Place, 18 May 1986 [SLA, PHP]

14. Beaton, *Photobiography*, p. 65

15. Hilary Spurling, *Anthony Powell: Dancing to the Music of Time*, p. 119

16. Stevenson, *Burra*, p. 156

17. Quoted in Kavanagh, *Ashton*, p. 137

18. BKS / A. Stephenson, 30 May [1982] [AS]

19. EB / BKS, Hôtel Cendrillon, Cassis, 24 September 1927 [TGA]

20. Quoted in Kavanagh, *Ashton*, p. 136

21. MKS

22. Jean Desbordes / BKS, Hotel les Négociants, Toulon, 8 October 1931
 [TGA]

23. Quoted in Kavanagh, *Ashton*, p. 140

24. Quoted in Kavanagh, *Ashton*, p. 141

25. Chappell, *Fonteyn*, p. 10

26. Kavanagh, *Ashton*, p. 140

Chapter Seven

1. VKS, *Idle*, p. 66

2. VKS, *Idle*, p. 279

3. Quoted in the *Western Gazette*, Friday 15 January 1932

4. Quoted in Joan Schenkar, *Truly Wilde*, p. 46

5. Schenkar, *Truly Wilde*, p. 28
6. D. Wilde / BKS, 10 Catherine Street, Buckingham Gate, SW1, n.d. [1932] [TGA]
7. D. Wilde / BKS, n.d. [pmk 30 March 1932] [TGA]
8. EB / BKS, Springfield, n.d. [pmk April 1932] [TGA]
9. Winifred KS / BKS, The Croft, Shillingstone, Dorset, 30 October [1931] [MKS]
10. Quoted in Stevenson, *Burra*, p. 213
11. Chappell, *WD*, p. 84
12. Quoted in Kavanagh, *Ashton*, p. 163
13. Quoted in Kavanagh, *Ashton*, p. 167
14. Quoted in Lloyd, *Lambert*, p. 172
15. Quoted in Sarah Knights, *Bloomsbury's Outsider*, p. 211
16. Quoted in Kavanagh, *Ashton*, p. 156
17. Richard Garnett, *Constance Garnett: A Heroic Life* (London: Sinclair-Stevenson, 1991), p. 77
18. Quoted by Susannah Herbert, 'The Whims of Desire', *Harpers & Queen*, April 1989
19. BKS / RL, 18 July [1933] [KCC]
20. BKS / JS, 8 June 1983 [BL Stern Papers]
21. BKS / JS, 8 June 1983 [BL Stern Papers]
22. BR quoted in Stevenson, *Burra*, p. 201
23. Quoted in Frances Partridge, ed., *Julia*, p. 129
24. BKS / JS, 8 June 1983 [BL Stern Papers]
25. BKS / Pauline Spender, 34 Charlton Place, 4 April 1984 [HSA]
26. DG / BKS, Inishdown, n.d. 'Sunday' [August 1933] [TGA]
27. Quoted in Kavanagh, *Ashton*, p. 158
28. Quoted in Kavanagh, *Ashton*, p. 159
29. Man Ray / BKS, p.c. addressed to BKS at Antibes, n.d. [pmk 6 August 1933] [TGA]

Chapter Eight

1. BKS / BC, n.d. [late March 1982] [BCA]
2. EB / BKS, Springfield, n.d. [?1931] [TGA]
3. D. Mellor, *Modern British Photography*, p. 115
4. Oswell Blakeston, 'The Still Camera Today', *Architectural Review*, April 1932, p. 154
5. Paul Nash, 'Photography and Modern Art', in Andrew Causey, ed., *Paul Nash: Writings on Art* (Oxford University Press, 2000), p. 130
6. Paul Nash, *Signature*, November 1935

7. J. Kavanagh, 'Queen's Counsel', in *Harpers & Queen*, October 1986, p. 341

8. 'People of the Camera', in *Photography London*, August 1934

9. C. Beaton, *The Wandering Years*, p. 192

10. Verso portrait of Nancy Morris, 29 October 1930 [TGA]

11. Verso portrait of Kyra Nijinsky [TGA]

12. BKS letter 4 July 1982, quoted in M. Kay Flavell, *George Grosz: A Biography* (New Haven & London: Yale University Press, 1988), p. 53

13. BKS / EB, 26 Gledstanes Road, Friday, n.d. [17 February 1928] [TGA]

14. Taylor, *Bright Young People*, p. 253

15. BKS / A. Stephenson, 30 May [1982] [AS]

16. Quoted in A. Stephenson, 'New Ways of Modern Bohemia'

17. D. Mellor, 'London–Berlin–London', p. 118

18. BKS / A. Stephenson, 30 May [1982] [AS]

19. Ibid.

20. Goronwy Rees, *A Chapter of Accidents*, pp. 128–9

21. Quoted in 'People of the Camera', *Photography London*, August 1934

22. Quoted in D. Mellor, 'Modern British Photography', p. 13

23. BKS / BC, 20 September [1990] [BCA]

24. Quote in Diana Souhami, *No Modernism without Lesbians*, p. 177

25. BKS / EB, n.d. [TGA]

26. Williams, *Women Photographers*, p. 100

27. Ibid.

28. Derek Patmore, 'London Conversations: Wit and Wisdom', in *Harper's Bazaar*, December 1931, p. 30

29. Quoted in Stevenson, *Burra*, p. 57, author's italics

Chapter Nine

1. Quoted in Stevenson, *Burra*, p. 142

2. BKS / BC, 8 October [1989] [BCA]

3. DG / BKS, p.c., NS&N, n.d. [pmk 10 September 1933] [TGA]

4. Stephen Tomlin, n.d. [TGA]

5. Partridge, *Julia*, p. 126

6. DG / BKS, NS&N, n.d. 'Saturday' [pmk 23 December 1933] [TGA]

7. S. Tomlin / BKS, 56 Weymouth Street, W1, n.d. [pmk January 1934] [MKS]

8. BKS / RL, n.d. 'Sun' [March 1934] [KCC]

9. DG / BKS, NS&N, n.d. 'Saturday' [pmk 23 December 1933] [TGA]

10. Quoted in Kavanagh, 'Queen's Counsel', p. 341

11. Selina Hastings, *Rosamond Lehmann*, p. 2

12. Hastings, *Lehmann*, p. 83
13. Hastings, *Lehmann*, p. 148
14. RL / BKS, Ipsden House, n.d. 'Wed' [pmk 21 March 1934] [TGA]
15. BKS / RL, 'Monday', n.d. [3 December 1934] [KCC]
16. Rosamond Lehmann, *The Weather in the Streets*, p. 173
17. RL / BKS, Ipsden House, n.d. 'Sunday' [summer 1936] [TGA]
18. DG, 'Flying Diaries', 31 March 1934, unpublished m.s. [Northwestern]
19. DG / BKS, NS&N, 1 April 1934 [TGA]
20. DG / BKS, NS&N, n.d. [pmk 27 April [1934] [TGA]
21. DG / BKS, NS&N, n.d. [May 1934] [TGA]
22. DG / BKS, Hilton, n.d. [pmk 22 April 1934] [TGA]
23. Graham Clarke, *The Photograph*, p. 123
24. BKS / RL, 25 June [1933] [KCC]
25. DG / BKS, Hilton, n.d. [pmk 19 November 1933] [TGA]
26. DG / BKS, Hilton, n.d. 'Sunday night' [pmk 9 April 1934] [TGA]
27. WP / BKS, [4 August 1934] [TGA]
28. DG / BKS, c/o Bernard Penrose, Lamb's Creek House, Truro, n.d. 'Tuesday' [pmk 28 August 1934] [TGA]
29. BKS / RL, n.d. 'Tues' [September 1934] [KCC]
30. DG / BKS, NS&N, London, 13 December 1934 [TGA]
31. Quoted in Herbert, 'The Whims of Desire'
32. WP / BKS, n.d. [August 1934] [TGA]

Chapter Ten

1. HS / BKS, 30 September 1986 [MKS]
2. Quoted in Julie Kavanagh, 'Shutter Happy', Obituary, Barbara Ker-Seymer, in the *Guardian*, 5 June 1993
3. H. Spender, *'Lensman': Photographs 1932–52*, p. 11
4. Ibid.
5. BKS / EB, 13 October [1937] [TGA]
6. BKS / EB, n.d. 'Tues' [1935] [TGA]
7. Chappell, *Fonteyn*, p. 45
8. BKS / BC, p.c., Cornwall, 16 April 1979 [BCA]
9. WP / BKS, n.d. [August 1934] [TGA]
10. Ibid.
11. BKS / RL, n.d. 'Monday' [3 December 1934] [KCC]
12. WP / BKS, Ipsden House, n.d. [pmk 1935] [January] [TGA]
13. WP / BKS, Ipsden House, Ipsden, n.d. [pmk 1935] [March] [TGA]
14. WP / BKS, Ipsden House, n.d. [pmk 12 February 1935] [TGA]
15. WP / BKS, Ipsden House, n.d. 'Wednesday' [TGA]

16. WP / BKS, n.d. [early 1935] [TGA]

17. EB / WC, Springfield, n.d. [March 1935] quoted in *WD*, p. 90

18. BKS / BC & JC, 25 March 1987 [BCA]

19. BKS / EB & C. Pritchard, [Spring 1936] [TGA]

20. DG / BKS, Hilton, n.d. 'Thursday' [pmk 12 July 1935] [TGA]

21. BKS / EB, Villa Sull'Ouda, Juan-les-Pins, n.d. [August 1935] [TGA]

22. Ibid.

23. BKS / J. Strachey, Sunday 9 September [1934] [UCL]

24. RL / D. Rylands, 6 June 1935 [KCC], quoted in Hastings, *Lehmann*, p. 169

25. Quoted in Hastings, *Lehmann*, p. 171

26. RL / BKS, n.d. [TGA]

27. RL / BKS, Ipsden House, n.d. [summer 1936] [TGA]

28. BKS / EB, 24 February 1928 [TGA]

29. BKS / RH, n.d. [LLF]

30. BKS / RH, 25 March 1981 [LLF]

31. Roger Horrocks, *Len Lye*, p. 154

32. BKS / RH, n.d. [LLF]

33. Quoted in Horrocks, *Lye*, p. 93

34. Horrocks, *Lye*, p. 143

35. Quoted in Horrocks, *Lye*, p. 154

36. Quoted in Horrocks, *Lye*, p. 155

37. Quoted in Horrocks, *Lye*, p. 33

Chapter Eleven

1. Stevenson, *Burra*, p. 201

2. EB / WC, Hotel Aragon, Madrid, 1935, *WD*, p. 92

3. BKS / EB, n.d. 'Wed' [pmk 15 or 18 October 1935] [TGA]

4. DG / BKS, Hilton, Tuesday 2 April 1935 [TGA]

5. DG / Ray Garnett, NS&N, n.d. 'Monday' [September 1934] [Northwestern]

6. G. Rees / BKS, the *Spectator*, 99 Gower Street, n.d. [pmk 31 July 1936] [TGA]

7. Quoted in Hastings, *Lehmann*, p. 191

8. BKS / JS, 22 April 1982 [BL Stern Papers]

9. Ibid.

10. Stevenson, *Burra*, p. 199

11. DG, Obituary, Stephen Tomlin, *The Times*, 6 January 1937

12. WP / BKS, Section Sanitaire, 14th Brigade International, Spain, 22 March [1937] [TGA]

13. Ibid.

14. Wogan Philipps, *An Ambulance Man in Spain*, p. 33

15. WP / BKS, 5 June [pmk 1937] [TGA]

16. BKS / BC, 25 November 1987 [BCA]

17. Ibid.

18. The Under Secretary of State, Aliens Department, Home Office, London / G. Deutsch, 24 June 1937 [Amanda Hopkinson]

19. A. Hopkinson email to the author, 16 September 2019

20. BKS / EB, n.d. [pmk 30 September 1937] [TGA]

21. Stevenson, *Burra*, p. 203

22. BKS / EB, 13 October [1937] [TGA]

23. Quoted in Ruth Artmonsky, *The Best Advertising Course in Town*, p. 12

24. *Five Women Photographers*

25. EB / WC, Springfield, 21 December 1937, Quoted in *WD*, p. 101

26. WP / BKS, Bachelor's Club, 8 South Audley Street, W1 [*c.* July 1938] [TGA]

27. Ibid.

Chapter Twelve

1. BKS / EB, n.d. [summer 1938] [TGA]

2. BKS / EB, n.d. 'Monday' [summer 1938] [TGA]

3. *Five Women Photographers*

4. BKS / EB, Lambe Creek House, Kea, Truro, 'Wednesday' [July 1939] [TGA]

5. HP, 'Biography', unpublished m.s. [MOA]

6. EB / WC, Springfield, n.d. [September 1939] quoted in *WD*, p. 103

7. WP / BKS, Bachelor's Club, 8 South Audley Street, W1, n.d. [*c.*July 1938] [TGA]

8. WP / BKS, 40 Hill Street, Berkeley Square, n.d. [pmk 5 July 1939] [TGA]

9. WP / BKS, n.d. [pmk 5 July 1939] [TGA]

10. WP / BKS, n.d. [pmk 12 July 1939] [TGA]

11. BKS / EB, Lambe Creek House, Kea, Truro, 'Wednesday' [1939] [TGA]

12. *Five Women Photographers*

13. BKS / DG, 4 Romilly Street, Soho, 1 October [1939] [Northwestern]

14. WP / BKS, n.d. [1939] [TGA]

15. HP, Diary, 30 October 1939 [MOA]

16. HP, Diary, Sunday 3 September 1939 [MOA]

17. Quoted in Hastings, *Lehmann*, p. 200

18. WP / BKS, Ipsden House, n.d. [pmk 18 February 1940] [TGA]

19. EB / WC, Springfield, December 1940, *WD*, p. 114

20. M. Hastings, *Diane*, p. 221

21. Juliet Gardiner, *Wartime Britain*, p. 221

22. Quoted in Marie-Jacqueline Lancaster, ed., *Brian Howard*, p. 392

23. EB / Gerald Corcoran, Springfield, n.d. [1940] *WD*, p. 112

24. Chappell, *Fonteyn*, p. 30

25. EB / B. Dawson, Springfield n.d. [1941] *WD*, p. 116

26. William Chappell, 'The Sky Makes Me Hate It', p. 14

27. Chappell, *Studies*, p. 11

28. *WD*, p. 108

29. Gardiner, *Wartime Britain*, p. 337

30. HP, Diary, 15 September 1940 [MOA]

31. J. Banting / DG, 33 Roehampton Lane, SW15, 10 December 1940 [Northwestern]

32. EB / WC, Springfield, 23 October 1940, *WD*, p. 111

33. BKS, Letter, *The Christian Science Monitor*, n.d. [1941]

34. Ibid.

35. Virginia Nicholson, *Millions Like Us*, p. 70

36. BKS / BC, 23 July [1989] [BCA]

37. BKS / BC, 7 June [1989] [BCA]

38. HP, 'Daily Record of Smoking', MO Report on 'Smoking Habits 1937–65' [MOA]

39. Ibid.

40. HP, Diary, 29 April [1941] [MOA]

41. Winifred Webber / BKS, Little Hanford, Blandford, Dorset, 12 May [1941] [TGA]

Chapter Thirteen

1. BKS / BC, 23 July [1989] [BCA]

2. HP, Diary, 31 August 1941 [MOA]

3. BKS / PH, 4 June 1973 [SLA, PHP]

4. EB / Gerald Corcoran, Springfield [1941], *WD*, p. 113

5. Chappell, 'The Sky Makes Me Hate It', p. 14

6. Quoted in Stevenson, *Burra*, p. 275

7. BKS / J. Strachey, n.d. 'Thursday' [1943] [Berg]

8. Ibid.

9. BKS / EB, 11 Fitzroy Square, n.d,. [pmk 22 May 1944] [TGA]

10. BKS / EB, 11 Fitzroy Square, n.d. 'Wed' [pmk 17 July 1944] [TGA]

11. EB / BKS, Springfield, n.d. [?June] [1944] [TGA]

12. Gardiner, *Wartime Britain*, p. 118

13. BKS / J. Strachey, n.d. 'Thursday' [1943] [Berg]

14. Marie-Jacqueline Lancaster, Obituary: Barbara Ker-Seymer, *Independent*, 29 June 1993

15. BKS / EB, n.d. [*c*.April 1945] [TGA]

16. BKS / EB, n.d. [*c*.April 1945] [TGA]

17. Chappell, editorial in *WD*, pp. 126–7

18. BKS / EB, 11 Fitzroy Square, n.d. 'Monday' [? October] [1945] [TGA]

19. Chappell, 'The Sky Makes Me Hate It', p. 10

20. Chappell, *Studies*, p. 54

21. Nicholson, *Millions Like Us*, p. 343

Chapter Fourteen

1. R. Rhodes, letter to the author Geneva, 1 January 2017

2. Quoted in Marc Matera, *Black London*, p. 179

3. BKS / EB, 11 Fitzroy Square, n.d. [mid-November 1946] [TGA]

4. EB / WC, Springfield, 25 December 1946, *WD*, p. 130

5. BKS / EB, Pensione Villa Borghese, Via Sgambati 4, Rome, 29 May [1947] [TGA]

6. Ibid.

7. Ibid.

8. BKS / EB, 11 Fitzroy Square, 9 August 1947 [TGA]

9. BKS / BC, 2 November 1986 [BCA]

10. BKS / EH, 25 March [pmk 1967] [LL, HP]

11. D. Saddler / BKS, 309 West 28th Street, NYC, 22 September 1947 [TGA]

12. LL / BKS, 278 West 4th Street, NY [summer 1948] [LLF]

13. BKS / EB, 11 Fitzroy Square, n.d. [1947] [TGA]

14. BKS / EH, 11 Fitzroy Square, 'Saturday' [pmk 27 August 1949] [LL, HP]

15. Quoted in Stevenson, *Burra*, p. 325

16. BKS / E Hahn, 11 Fitzroy Square, 'Saturday' [pmk 27 August 1949] [LL, HP]

17. Ibid.

18. Ibid.

19. BKS / MKS, 8 October 1989 [MKS]

20. BKS / EH, 11 Fitzroy Square, n.d. 'Saturday' [LL, HP]

Chapter Fifteen

1. *Five Women Photographers*

2. BKS / BC, 25 November 1987 [BCA]

3. *Five Women Photographers*
4. 'A Moment in the Light: Barbara Ker-Seymer', Obituary, the *Oldie*, 25 June 1993
5. Val Williams, Obituary, Barbara Ker-Seymer, *Independent*, 29 May 1993
6. Rachel Cooke, *Her Brilliant Career*, p. xii
7. M.-J. Lancaster, Barbara Ker-Seymer, *Independent*, 29 June 1993
8. BKS / EH, 11 Fitzroy Square, 3 March 1953 [LL, HP]
9. BKS / BC, 18 March [1984] [BCA]
10. BKS / BR, 11 Fitzroy Square, n.d. [10 December 1954] [TGA]
11. Quoted in Stevenson, *Burra*, p. 330
12. Ibid.
13. Stevenson, *Burra*, p. 340
14. MH email to the author, 22 April 2019
15. Ibid.
16. BKS / BR, 11 Fitzroy Street, n.d. [pmk 10 December 1954] [TGA]
17. BKS / BR, C/O Lye, 41 Bethune St, NY14, Thursday 16 February [1956] [TGA]
18. BKS / JS, Bendix Self-Service Launderette, 21 Tachbrook Street, SW1, p.c., n.d. [pmk 26 April 1955] [BL, Stern Papers]
19. MKS in conversation with the author, July 2018

Chapter Sixteen
1. BKS / BR, C/O Lye, 41 Bethune Street, NY14, Thursday [16 February 1956] [TGA]
2. BKS / BR, Cunard Line, RMS *Queen Elizabeth*, n.d. 'Wednesday' [25 January 1956] [TGA]
3. BKS / BR, C/O Lye, 41 Bethune Street, NY14, Thursday [16 February 1956] [TGA]
4. Ibid.
5. BKS / BC, 26 July [1990] [BCA]
6. BKS / BR, 11 Fitzroy Square, n.d. [10 December 1954] [TGA]
7. BKS / BR, C/O Lye, 41 Bethune Street, NY14, Thursday [16 February 1956] [TGA]
8. Ibid.
9. LL / BKS, n.d. [1956] [LLF]
10. BKS / BR, C/O Lye, 41 Bethune Street, NY14, Thursday 8 March [TGA]
11. LL / BKS, n.d. [1956] [LLF]
12. BKS / BR, C/O Lye, 41 Bethune Street, NY14, Thursday [16 February 1956] [TGA]

Chapter Seventeen

1. BKS / BC, 19 June 1984 [BCA]
2. Herbert, 'The Whims of Desire', p. 46
3. BKS / EB, 37 Homer Street W1, n.d. 'Monday' [January 1960] [TGA]
4. BKS / BR, c/o Lye, 41 Bethune Street, NY 14, 'Thursday' [16 February] [1956] [TGA]
5. BKS / EH, 37 Homer Street, 3 June [pmk 1962] [LL. HP]
6. BKS / J. Banting, 34 Charlton Place, n.d. [January 1967] [TGA]
7. Stevenson, *Burra*, p. 339
8. BKS / J. Banting, n.d. 34 Charlton Place [TGA]
9. BKS / EB, Athens, n.d. 'Saturday' [pmk 23 September 1962] [TGA]
10. MKS in conversation with the author, July 2018
11. BKS / J. Banting, 34 Charlton Place, Islington, n.d. (1964) [TGA]
12. EB / Conrad Aiken, 17 December 1964 [Huntingdon Library, Aiken Collection]
13. BKS / EH, 25 February 1967 [LL, HP]
14. BKS, F. Ashton, WC, G. Dove, C. Pertinez / The Editor, *The Times*, 11 May 1965 [TGA]
15. BKS / JS, 34 Charlton Place, 9 February [1968] [BL, Stern Papers]
16. Chappell, *WD*, p. 177
17. BKS / EB, 34 Charlton Place, 16 May [1968] [TGA]
18. BKS / EB, 34 Charlton Place, 19 August [1968] [TGA]
19. Andrew Wilson, *Beautiful Shadow, A Life of Patricia Highsmith*, p. 270
20. Ibid.
21. Ibid.
22. Quoted in Richard Bradford, *Devils, Lusts and Strange Desires: The Life of Patricia Highsmith* (London: Bloomsbury Caravel, 2021), p. 150
23. Anna Von Planta, ed., *Patricia Highsmith: Her Diaries and Notebooks*
24. Quoted in Wilson, *Beautiful Shadow*, p. 286
25. BKS / EH, 34 Charlton Place, 22 May [pmk 1968] [LL, HP]
26. BKS / BR, 17 April [1969] [TGA]
27. BKS / PH [34 Charlton Place], 24 October [1973] [SLA, PHP]
28. MH quoted in Wilson, *Beautiful Shadow*, p. 287
29. February 1968, quoted in Wilson, *Beautiful Shadow*, p. 284
30. BKS / JS, 20 October 1975 [BL Stern Papers]
31. Wilson, *Beautiful Shadow*, p. 324

Chapter Eighteen

1. BKS / EH, 34 Charlton Place, 4 June [1968] [LL, HP]
2. BKS / EH, 34 Charlton Place, 22 May [1968] [LL, HP]

3. BKS / EH, 34 Charlton Place, 19 April 1970 [LL, HP]
4. BKS / JS, 34 Charlton Place, 14 April [1969] [BL, Stern Papers]
5. BKS / JS, 34 Charlton Place, 18 May [1969] [BL, Stern Papers]
6. BKS / EH, 34 Charlton Place, 22 October [1970] [LL, HP]
7. HP / BKS, 21 Seckford Street, Woodbridge, 17 December 1973 [MKS]
8. BKS / JS, 19 May 1975 [BL, Stern Papers]
9. BKS / PH, 34 Charlton Place, n.d. [SLA, PHP]
10. BKS / John Banting, n.d. [pmk 28 July 1970] [TGA]
11. BKS / BC, 9 November 1983 [BCA]
12. EB / BKS, 1973 [TGA]
13. EB / J. Banting, June 1971, quoted in Stevenson, *Burra*, p. 376
14. EB / BKS, n.d. 'Wednesday' [June 1971] [TGA]
15. EB / BKS, n.d. [pmk 31 December 1972] [TGA]
16. LL / BKS, 41 Bethune, 15 February 1971 [LLF]
17. BKS / LL, 2 June 1975 [LLF]
18. LL / BKS, 5 July 1975 [LLF]
19. EB / WC, 2 Springfield Cottages, April 1973 *WD*, p. 196
20. BKS / PH, 23 May 1973 [SLA, PHP]
21. BKS / EB, 29 May 1973 [TGA]
22. BKS / PH, 4 June 1973 [SLA, PHP]
23. BKS / PH, 25 June [1973] [SLA, PHP]
24. Quoted in Stevenson, *Burra*, p. 402
25. MH, email to the author, April 2019
26. BKS / PH, 25 June [1973] [SLA, PHP]
27. BKS / LL, 12 April 1975 [LLF]
28. Quoted in Stevenson, *Burra*, p. 403
29. Quoted in Stevenson, *Burra*, p. 404
30. EB / Monica Wodehouse, 2 Springfield Cottages, n.d. [pmk 24 December 1975], *WD*, p. 211
31. BKS / EB, 17 September [1976] [TGA]
32. G. Dove / BKS, North End Medical Centre, 211 North End Road, London, 22 October 1976 [TGA]
33. A. Richie / BKS, 5 Fairmeadow, Rye, n.d. 'Thurs' [pmk 29 October 1976] [TGA]

Chapter Nineteen
1. MH, email to the author, 2018
2. BKS / PH, 12 February 1978 [SLA, PHP]
3. BKS / PH, 10 June 1978 [SLA, PHP]
4. MH, email to the author, 2018

5. BKS / LL, 6 March [1977] [LLF]
6. BKS / LL, 9 October 1978 [LLF]
7. BKS / LL, 8 December [1978] [LLF]
8. BKS / MKS, 8 October 1989 [MKS]
9. MH, email to the author, 2018
10. MKS in conversation with the author, July 2018
11. Ibid.
12. BKS / BR, 8 June 1978 [TGA]
13. Quoted in Kavanagh, *Ashton*, p. 591
14. BKS /BC, 34 Charlton Place, 26 March [1979] [BCA]
15. BKS / BC, 34 Charlton Place, 1 July 1985 [BCA]
16. BC / BKS, 2 March 1980 [BCA]
17. BKS / BR, 10 June 1980 [TGA]
18. BKS / BR, Lenox, 23 June 1980 [TGA]
19. BKS / BR, Lenox, 23 June 1980 [TGA]
20. *Gurdjieff International Review*, Fall 2020 Issue, Vol. XIV, No.2, https://www.gurdjieff.org/
21. MH, email to the author, 22 April 2019
22. BKS / BC, 25 July 1980 [BCA]
23. BKS / BR, 8 June 1981 [TGA]
24. BKS / BC, 26 February 1987 [BCA]
25. BKS / HS, 29 December 1981 [HSA]
26. BKS / LL, 6 July 1979 [LLF]
27. BKS / BC, 20 June 1991 [BCA]
28. BKS / JS, 4 March 1981 [BL, Stern Papers]
29. BKS / BC, 34 Charlton Place, 12 August 1980 [BCA]
30. BKS / BC, 27 January 1982 [BCA]
31. BKS / BC, Hotel Piccadilly, 45th Street West, Off Broadway, New York, 3 March [1982] [BCA]

Chapter Twenty

1. BKS / A. Stephenson, 34 Charlton Place, 4 February 1982 [AS]
2. BKS / BC, p.c., n.d. [1982] [BCA]
3. BKS / JS, 22 April 1982 [BL, Stern Papers]
4. BKS / BR, 17 October 1982 [TGA]
5. BKS / BC, 34 Charlton Place, 1 February 1984 [BCA]
6. BKS / PH, 34 Charlton Place, 13 May 1983 [SLA, PHP]
7. BKS / BC, 34 Charlton Place, 3 June 1984 [BCA]
8. BKS / BC, 34 Charlton Place, 30 January 1985 [BCA]
9. BKS / HS, 2 December 1983 [HSA]

10. BKS / JS, 34 Charlton Place, 21 January 1986 [BL Stern Papers]

11. BKS / BC, p.c., n.d. [pmk 20 December 1985] [BCA]

12. BKS / BC, 34 Charlton Place, 10 February 1986 [BCA]

13. BKS / BC, 19 February 1986 [BCA]

14. BKS / BC, 34 Charlton Place, 10 February 1986 [BCA]

15. BKS / BC, 21 March 1986 [BCA]

16. *Five Women Photographers*

17. Powell, *Journals*, 1986 entry for Wednesday 29 October, p. 277

18. *Five Women Photographers*, publicity card, Channel 4

19. Kavanagh, 'Queen's Counsel' in *Harpers & Queen*, p. 342

20. Kavanagh, 'Queen's Counsel' in *Harpers & Queen*, p. 341, author's italics

21. Williams, *Women Photographers*, p. 103

22. BKS / HS, 12 October 1986 [HSA]

23. HS / BKS, 23 February 1987 [HSA]

24. BKS / Susan Ker-Seymer, 14 November 1990 [Susan Ker-Seymer]

25. BKS / PH, 34 Charlton Place, 30 March 1986 [SLA, PHP]

26. BKS / BR, 23 December [1991] [TGA]

27. 'A Moment in the Light: Barbara Ker-Seymer', in the *Oldie*, 25 June 1993

28. *Five Women Photographers*

Select Bibliography

Archer-Straw, Petrine, *Negrophilia* (London: Thames & Hudson, 2000)

Artmonsky, Ruth, *The Best Advertising Course in Town: The Halcyon Days of Colman, Prentis & Varley* (London: Artmonsky Arts, 2015)

Barnes, Martin, ed., *Curtis Moffat: Silver Society: Experimental Photography and Design 1923–1935* (London: Steidl in Association with V&A Publishing, 2016)

Beaton, Cecil, *Photobiography* (London: Odhams Press, 1951)

Beaton, Cecil, *The Wandering Years 1922–39* (London: Sapere Books, 2018)

Blakeston, Oswell, 'The Still Camera Today' in *The Architectural Review*, Vol.LXXI, No. 425, April 1932

Bloch, Michael and Fox, Susan, *Bloomsbury Stud: The Life of Stephen 'Tommy' Tomlin* (London: M.A.B., 2020)

Bloom, Stanley S., *The Launderette: A History* (London: Duckworth, 1988)

Bourne, Stephen, *Elisabeth Welch: Soft Lights and Sweet Music* (Lanham, Maryland: The Scarecrow Press, 2005)

Breese, Charlotte, *Hutch* (London: Bloomsbury, 1991; paperback edition 2001)

Brown, Sally and David R., *Mrs Marty Mann: The First Lady of Alcoholics Anonymous* (Center City, Minnesota: Hazelden, 2001)

Callow, Simon, *Orson Welles: One-Man Band* (London: Jonathan Cape, 2015; Vintage edition 2016)

Chappell, William, 'The Sky Makes Me Hate It', in John Lehmann, ed., *Penguin New Writing*, Number 13, April–June 1942 (Harmondsworth: Penguin Books, June 1942)

Chappell, William, 'Development of the Ballet', in Lehmann, John, ed., *New Writing and Daylight* (London: Hogarth Press, summer 1943)

Chappell, William, 'Words from a Stranger', in John Lehmann, ed., *The Penguin New Writing*, Number 19, October–December 1944

Chappell, William, *Studies in Ballet* (London: John Lehmann, 1948)

Chappell, William, *Fonteyn: Impressions of a Ballerina* (London: Spring Books, 1950/51)

Chappell, William, ed., *Edward Burra: A Painter Remembered by his Friends* (London: Andre Deutsch and Lefevre Galleries, 1982)

Chappell, William, ed., *Well, Dearie! The Letters of Edward Burra* (London: Gordon Fraser Gallery, 1985)

Chisholm, Anne, *Frances Partridge: The Biography* (London: Weidenfeld & Nicolson, 2009)

Churchill, Viscount [Peter Spencer], *All My Sins Remembered* (London: William Heinemann, 1964)

Clarke, Graham, *The Photograph* (Oxford University Press, 1997)

Clarke, Mary, *Dancers of Mercury: The Story of Ballet Rambert* (London: A & C Black, 1962)

Cohen, Lisa, 'Velvet is Very Important' in *All We Know: Three Lives* (New York: Farrar, Straus and Giroux, 2012; paperback edition 2013)

Cooke, Rachel, *Her Brilliant Career: Ten Extraordinary Women of the Fifties* (London: Virago Press, 2013; paperback edition 2014)

Crisp, Clement, Sainsbury, Anya, and Williams, Peter, ed., *Ballet Rambert: 50 Years and On* (London: Scolar Press 1976; revised edition 1981)

Cuthbertson, Ken, *Nobody Said Not to Go: The Life, Loves and Adventures of Emily Hahn* (New York: Faber & Faber, 1998; paperback edition 1999)

De Courcy, Anne, *Chanel's Riviera* (London: Weidenfeld & Nicolson, 2019)

Doan, Laura, *Fashioning Sapphism: The Origins of a Modern English Lesbian Culture* (New York: Columbia University Press, 2001)

Eliot, Karen, *Albion's Dance: British Ballet During the Second World War* (Oxford University Press, 2016)

Ewing, Elizabeth, *History of Twentieth Century Fashion* (London: Batsford, 1974; third edition 1986)

Fisher, Kate, *Birth Control, Sex, and Marriage in Britain 1918–1960* (Oxford University Press, 2006)

Gardiner, Juliet, *'Over Here': The GIs in Wartime Britain* (London: Collins & Brown, 1992)

Gardiner, Juliet, *Wartime Britain 1939–1945* (London: Headline Book Publishing, 2004; paperback edition 2005)

Gardiner, Juliet, *The Thirties: An Intimate History* (London: Harper Press, 2010)

Gordon, Lois, *Nancy Cunard: Heiress, Muse, Political Idealist* (Columbia University Press, 2007)

Hahn, Emily, *Times and Places* (New York: Thomas Y. Crowell Company, 1970)

Hallam, Christopher, *White Drug Cultures and Regulation in London, 1916–1960* (London: Palgrave Macmillan, 2018)

Harper's Bazaar, UK edition (1930–1939)

Hastings, Macdonald, *Diane: A Victorian* (London: Michael Joseph, 1974)

Hastings, Selina, *Rosamond Lehmann* (London: Chatto & Windus, 2002; Vintage edition 2003)

Heilbrun, Carolyn G., *Writing a Woman's Life* (London: The Women's Press, 1989)

Herbert, Susanna, 'The Whims of Desire', in *Harpers & Queen*, April 1989

Hinton, James, *The Mass Observers: A History 1937–1949* (Oxford: University Press, 2013)

Hopkinson, Amanda, 'Gerti Deutsch of Vienna', in *Gerti Deutsch. Photographs 1935–1965* (Salzburg: Fotohof Edition, 2011)

Horrocks, Roger, *Len Lye: A Biography* (Auckland University Press, 2001)

Houlbrook, Matt, *Queer London: Perils and Pleasures in the Sexual Metropolis, 1918–1957* (Chicago and London: University of Chicago Press, 2005)

Huddleston, Miles, *James Stern: A Life in Letters 1904–1993* (Norwich: Michael Russell Publishing, 2002)

Kavanagh, Julie, 'Queen's Counsel', in *Harpers & Queen*, October 1986, pp. 341–4

Kavanagh, Julie, 'Shutter Happy', Obituary of Barbara Ker-Seymer, the *Guardian*, 5 June 1993, p. 32

Kavanagh, Julie, *Secret Muses: The Life of Frederick Ashton* (London: Faber & Faber, 1996)

Ker-Seymer, Vere, *Idle but Happy* (London: Chapman & Hall, 1930)

Knights, Sarah, *Bloomsbury's Outsider: A Life of David Garnett* (London: Bloomsbury Reader, 2015)

Kynaston, David, *Austerity Britain 1945–51* (London: Bloomsbury, 2007)

Kynaston, David, *Modernity Britain 1957–62* (London: Bloomsbury, 2014; paperback edition 2015)

Lancaster, Marie-Jacqueline, ed., *Brian Howard: Portrait of a Failure* (London: Anthony Blond, 1968)

Lehmann, Rosamond, *The Weather in the Streets* (London: William Collins 1936; Virago Press edition 1981, reprinted 2013)

Linton, David and Platt, Len, 'Dover Street to Dixie and the politics of cultural transfer and exchange', in Len Platt, Tobias Becker and David Linton, eds., *Popular Musical Theatre in London and Berlin: 1890–1939* (Cambridge University Press, 2014)

Lloyd, Fran, 'Making Animation Matter', in Marian Malet, Rachel Dickson, Sarah MacDougall & Anna Nyburg, eds., *Applied Arts in British Exile from 1933*, Yearbook of the Research Centre for German and Austrian Exile Studies, Vol. 19 (Brill / Rodopi, 2018)

Lloyd, Stephen, *Constant Lambert: Beyond the Rio Grande* (Woodbridge: The Boydell Press, 2014)

Mackrell, Judith, *Flappers: Six Women of a Dangerous Generation* (London: Macmillan, 2013; Pan Books, 2014)

Martin, Simon, ed., *Edward Burra* (Farnham: Lund Humphries in association with the Pallant House Gallery, 2011)

Matera, Marc, *Black London: The Imperial Metropolis and Decolonization in the Twentieth Century* (University of California Press, 2015)

Mellor, David, 'London–Berlin–London: A Cultural History: The Reception and Influence of the New German Photography in Britain 1927–33', in David Mellor, ed., *Germany: The New Photography 1927–33* (London: Arts Council of Great Britain, 1978)

Mellor, David, 'An Introduction to the Period', in *Modern British Photography 1919–39* (London: Arts Council of Great Britain, 1978)

McWilliam, Rohan, 'Elsa Lanchester and Bohemian London in the Early Twentieth Century', in *Women's History Review*, Volume 23, 2014, Issue 2

Muir, Robin, *Under the Influence: John Deakin, Photography and the Lure of Soho* (London: Art Books, 2015)

Muir, Robin, *Vogue 100: A Century of Style* (London: National Portrait Gallery, 2016)

Nash, Paul, 'Photography and Modern Art', in *Writings on Art: Selected with an introduction by Andrew Causey* (Oxford: University Press, 2000)

Nicholson, Virginia, *Among the Bohemians: Experiments in Living 1900–1939* (London: Penguin Viking, 2002)

Nicholson, Virginia, *Singled Out: How Two Million Women Survived Without Men after the First World War* (London: Penguin Viking, 2007)

Nicholson, Virginia, *Millions Like Us: Women's Lives in War and Peace 1939–1949* (London: Penguin Viking, 2011)

Nicholson, Virginia, *Perfect Wives in Ideal Homes: The Story of Women in the 1950s* (London: Viking 2015; Penguin Books, 2016)

Overy, Richard, *The Morbid Age: Britain Between the Wars* (London: Allen Lane, 2009)

Partridge, Frances, *Julia: A Portrait of Julia Strachey by herself and Frances Partridge* (London: Victor Gollancz 1983; Penguin Books,1984)

Patmore, Derek, *Private History: An Autobiography* (London: Jonathan Cape, 1960)

Pepper, Terence, *Dorothy Wilding: The Pursuit of Perfection* (London: National Gallery Publications, 1991)

Philipps, Wogan, 'An Ambulance Man in Spain', in John Lehmann, ed., *New Writing*, New Series 1, Autumn 1938 (London: The Hogarth Press, 1938)

'Cheek Carried Barbara Ker-Seymer into Photography', in 'People of the Camera', *Photography London*, August 1934

Powell, Anthony, *Afternoon Men* (London: Duckworth, 1931; Arrow Books 2015)

Powell, Anthony, *Infants of the Spring* (Vol. 1 of *To Keep the Ball Rolling: The Memoirs of Anthony Powell*), (London: William Heinemann, 1976)

Powell, Anthony, *Journals 1982–1986* (London, William Heinemann, 1995; Arrow Books 2015)

Pugh, Martin, *We Danced All Night: A Social History of Britain Between the Wars* (London: Bodley Head, 2008)

Rees, Goronwy, *A Chapter of Accidents* (London, Chatto & Windus, 1972)

Sophie Fedorovitch 1893–1953: A Memorial Exhibition of Designs for Ballet, Opera and Stage (London: Victoria and Albert Museum, 1955)

Schenkar, Joan, *Truly Wilde: The Unsettling Story of Dolly Wilde, Oscar's Unusual Niece* (London: Virago Press, 2000; paperback edition 2001)

Schenkar, Joan, *The Talented Miss Highsmith* (New York: St Martin's Press, 2009; Picador 2011)

Silver, H., and Teague, S.J., eds., *Chelsea College – A History* (London: Chelsea College, 1977)

Souhami, Diana, *No Modernism Without Lesbians* (Head of Zeus, 2020; paperback edition, 2021)

Spender, Humphrey, *'Lensman': Photographs 1932–52* (London: Chatto & Windus, 1987)

Spurling, Hilary, *Anthony Powell: Dancing to the Music of Time* (London: Hamish Hamilton, 2017)

Stead, Lisa, *Off to the Pictures: Cinema-Going, Women's Writing and Movie Culture in Interwar Britain* (Edinburgh University Press, 2016)

Stephenson, Andrew, 'New Ways of Modern Bohemia: Edward Burra in London, Paris, Marseilles and Harlem' https://www.tate.org.uk/research/tate-papers/19/new-ways-of-modern-bohemia-edward-burra-in-london-paris-marseilles-and-harlem

Stephenson, Andrew, 'Our jolly marin wear': the queer fashionability of the sailor uniform in interwar France and Britain', *Fashion, Style & Popular Culture*, 3(2), pp. 157–172, http://hdl.handle.net/10552/4785, accessed 6 October 2022

Stevenson, Jane, *Edward Burra: Twentieth-Century Eye* (London: Jonathan Cape, 2007)

Taylor, D. J., *Bright Young People: The Rise and Fall of a Generation: 1918–1940* (London: Chatto & Windus, 2007)

Vane-Wright, R. I. and Hughes, Harold W. D., *The Seymer Legacy: Henry Seymer and Henry Seymer Jnr of Dorset, and their Entomological Paintings* (Ceredigion: Forrest Text, 2005)

Von Planta, Anna, ed., *Patricia Highsmith: Her Diaries and Notebooks* (London: Weidenfeld & Nicolson, 2021)

Waugh, Evelyn, *Vile Bodies* (London: Chapman & Hall, 1930; Penguin Classics 2011)

White, Jerry, *London in the 20th Century* (London: Viking, 2001)

Williams, Val, *Women Photographers: The Other Observers 1900 to the Present* (London: Virago Press, 1986)

Wilson, Andrew, *Beautiful Shadow: A Life of Patricia Highsmith* (London: Bloomsbury Publishing 2003; paperback edition 2010)

Wyndham, Francis, 'Ursula' in *Mrs Henderson* (London; Jonathan Cape, 1985; Moyer Bell paperback edition,1988)

Ziegler, Philip, *London at War 1939–45* (London: Sinclair-Stevenson, 1995)

Index

Page numbers in *italic* refer to images